# Date Due

| JAN 3 1 '89 | | | |
|---|---|---|---|
| JAN 3 0 '89 | | | |
| 2/13/92 3:15PM | | | |
| | | | |
| | | | |
| | | | |
| | | | |
| | | | |
| | | | |
| | | | |
| | | | |
| | | | |
| | | | |
| | | | |

# Native Arts
# of North America, Africa,
# and the South Pacific

### ERRATA

Color Plate 4:   *For* an ogre (left) . . . Sio Humis (right)
                 *read* an ogre (right) . . . Sio Hemis (left)
Color Plate 15:  *For* Tatanua (left) and Kepong (right)
                 *read* Tatanua (right) and Kepong (left)
Page 221         Caption #22 and caption #24 should
                 be reversed

# Native Arts
# of North America, Africa,
# and the South Pacific

## An Introduction

George A. Corbin

ICON EDITIONS

1817

HARPER & ROW, PUBLISHERS, New York
Cambridge, Philadelphia, San Francisco, Washington
London, Mexico City, São Paulo, Singapore, Sydney

This book is dedicated to my teachers:
John C. Galloway, Paul S. Wingert,
Hans Himmelheber, and Douglas Fraser

FIRST EDITION

*Designer: C. Linda Dingler*
*Copy Editor: Bitite Vinklers*
*Index by Olive Holmes for Edinex*

Library of Congress Cataloging-in-Publication Data

Corbin, George A.
    Native Arts of North America, Africa, and the South Pa-
cific.

    (Icon editions)
    Bibliography: p.
    Includes index.
    1. Art, Primitive.  I. Title.
N5311.C67  1988      709′.01′1      87-45606
ISBN 0-06-430951-7        88  89  90  91  MPC  5  4  3  2  1
ISBN 0-06-430174-5 (pbk) 88  89  90  91  MPC  5  4  3  2  1

# Contents

Color plates follow page XXX.

# Acknowledgments

Research leading up to the writing of this book was conducted in various archives and museums in Australia, Europe, Papua New Guinea, and the United States. The Robert Goldwater Library of the Metropolitan Museum of Art in New York City has been my primary source for the literature, notes, and bibliography used in this book. I am especially grateful to Allan Chapman, chief librarian, and his staff, including Virginia Webb and Ross Day, for their help and encouragement during all phases of work on this text. Thanks are also extended to Douglas Newton, Julie Jones, and Kate Ezra of the Department of Primitive Art at the Metropolitan Museum of Art for sharing their time and knowledge with me.

Conversations with various colleagues in the fields of Native American, African, and South Pacific art during the planning and writing of this text have helped me immensely. Particular thanks go to Henry and Margaret Drewel, Anthony Forge, Christraud Geary, Anita Glaze, Pamela Hearne, Aldona Jonaitis, Michael Kan, Phillip Lewis, Louise Lincoln, David Penny, Leon Siroto, Susan Vogel, and Allen Wardwell.

The hundreds of students I have taught at Lehman College (CUNY) and Columbia University over the past seventeen years helped me formulate the scope and contextual focus of this book.

At Harper and Row I would like to thank Cass Canfield, Jr., C. Linda Dingler, Pamela J. Jelley, and Bitite Vinklers for their care and assistance in the preparation of the manuscript for publication and for their enthusiastic support of the project from start to finish.

Most of all, I would like to thank my wife, Sarah Fabricant Corbin, for her unending support and encouragement during the writing of this book. I am especially grateful for her patience and assistance in reading and editing numerous drafts of the text, and for the one hundred and thirty-eight line drawings she drew especially for this book.

# List of Illustrations

*The number in italics refers to the page on which the illustration appears.*

CHAPTER 2
## Alaskan Eskimo Art and Art of the Northwest Coast

CHAPTER 3
Art of the Southwestern United States

CHAPTER 6

Art of Nigeria

## CHAPTER 7
## Art of Central Africa

## CHAPTER 8
## Australian Aboriginal and Island New Guinea Art

CHAPTER 9

Art of Island Melanesia

## CHAPTER 10
### Art of Polynesia

# COLOR PLATES

1. Abelam (Papua New Guinea) decorated men's house at Kinbangwa village. Twentieth century. Forge photo, 1962.
2. Kwakiutl (Northwest Coast) male ancestor mask with totemic crest patterns painted on the face. Height 8½″. About 1825–1875. Peabody Museum of Salem, Salem, Massachusetts. Museum photo.
3. Tlingit (Northwest Coast) shaman's rattle in the shape of an oyster-catcher with figural scene on top. Mid-nineteenth century. Peabody Museum, Boston, Massachusetts. Museum photo.
4. Hopi (Southwest) kachina dolls representing an ogre (right), a corn maiden (center), and Sio Hemis (left). Late-nineteenth century. Peabody Museum, Boston, Massachusetts. Museum photo.
5. Decorated moccasins: Iroquois, Montagnais, Nez Perce, Navajo, Northeast Woodlands, Huron, and Cheyenne. Nineteenth-twentieth centuries. Peabody Museum, Boston, Massachusetts. Museum photo.
6. Sioux (Plains) painted tipi-liner used in sacred pipe rituals. Early nineteenth century. 245 × 170 cm. Museum für Völkerkunde, West Berlin. Museum photo.
7. Dogon (Mali) Sirige masks at Bongo village, 1971. Elisofon photo, 1971. Eliot Elisofon Archives, National Museum of African Art, Washington, D.C.
8. Baule (Ivory Coast) *gba gba* dance with female portrait mask, Kami village, 1971. Vogel photo, 1971.
9. Yoruba (Nigeria) Gelede society masks from the Awori Yoruba area. Collected in 1887. Museum of Mankind, London. Drewal photo, 1982.
10. Bamum (Cameroon) *tu mola* headdress worn by the head of the king's warriors (called *tupanka*). Nineteenth-twentieth centuries. Bamum Palace Museum, Foumban, Cameroon. Geary photo.
11. Kuba (Zaire) composite animal/human mask (mukyeeng?) and a tired old man mask (Pwoom Itok). Twentieth century. Elisofon photo, 1972. Eliot Elisofon Archives, National Museum of African Art, Washington, D.C.
12. Iatmul (Island New Guinea) ceremonial men's house at Korogo village with five *mai* masks in front. Twentieth century. Stanek photo.
13. Uramot Baining (Island Melanesia) night dance headdress (*lingan*) and two *kavat* masks at Gaulim village. Twentieth century. S. Corbin photo, 1983.
14. Tolai (Island Melanesia) Tubuan (female) mask of the Duk-Duk society at Vunakulkalulu village. Twentieth century. Corbin photo, 1972.
15. Malanggan area, northern New Ireland (Island Melanesia) masks of two types called Tatanua (right) and Kepong (left). Late-nineteenth century. Peabody Museum of Salem, Salem, Massachusetts. Museum photo.
16. Maori of New Zealand (Marginal Polynesia) interior of a council house called Rauru. Mid-nineteenth to early-twentieth centuries. Museum für Völkerkunde, Hamburg, West Germany. Museum photo.

# Native Arts
## of North America, Africa,
## and the South Pacific

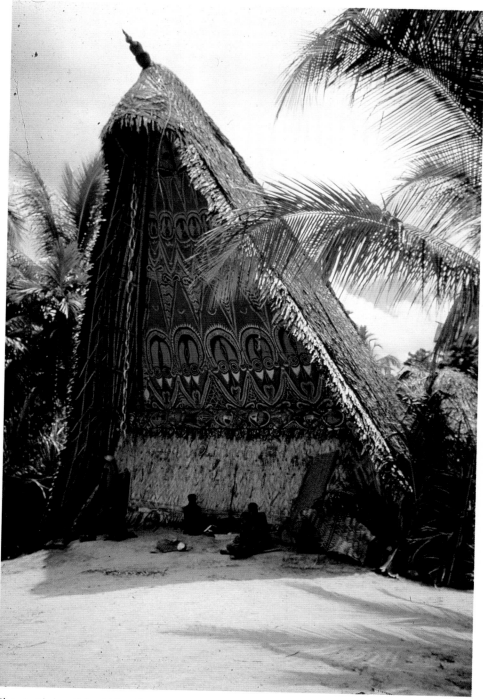

Plate 1. Abelam (Island New Guinea) decorated men's house at Kinbangwa village. Twentieth century. *Forge photo, 1962.*

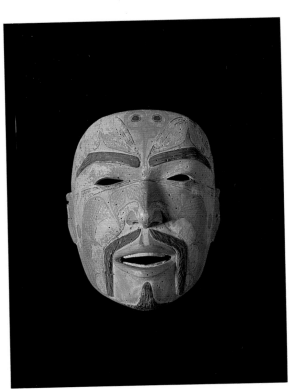

Plate 2. Kwakiutl (Northwest Coast) male ancestor mask with totemic crest patterns painted on the face. Height 8½". C. 1825–1875. Peabody Museum of Salem, Salem, Massachusetts. *Museum photo.*

Plate 3. Tlingit (Northwest Coast) shaman's rattle in the shape of an oyster catcher with figural scene on top. Mid-nineteenth century. Peabody Museum, Boston, Massachusetts. *Museum photo.*

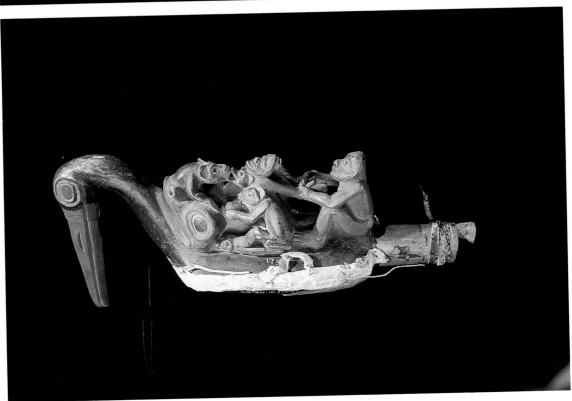

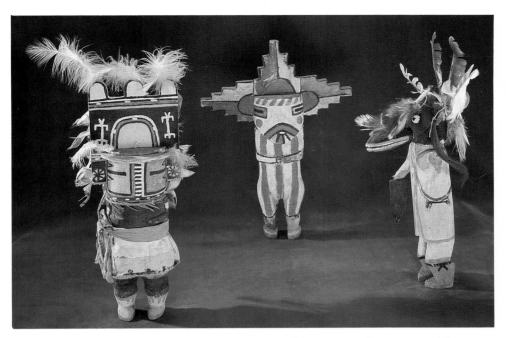

Plate 4. Hopi (Southwest) kachina dolls representing an ogre (left), a corn maiden (center), and Sio Humis (right). Late nineteenth century. Peabody Museum, Boston, Massachusetts. *Museum photo.*

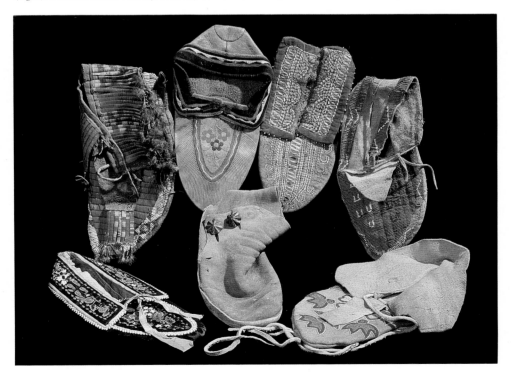

Plate 5. Iroquois, Montagnais, Nez Percé, Navajo, Northeast Woodlands, Huron, and Cheyenne decorated moccasins. Nineteenth–twentieth centuries. Peabody Museum, Boston, Massachusetts. *Museum photo.*

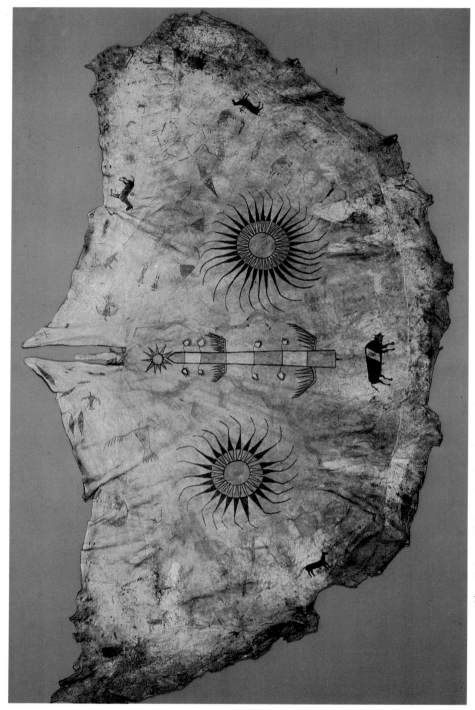

Plate 6. Sioux (Plains) painted tipi liner used in sacred pipe rituals. Early nineteenth century. 245 cm. × 170 cm. Museum für Völkerkunde, West Berlin. *Museum photo.*

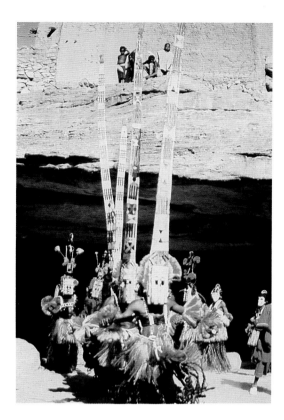

Plate 7. Dogon (Mali) Sirige masks at Bongo village, 1971. Eliot Elisofon Archives, National Museum of African Art, Washington, D.C. *Elisofon photo, 1971.*

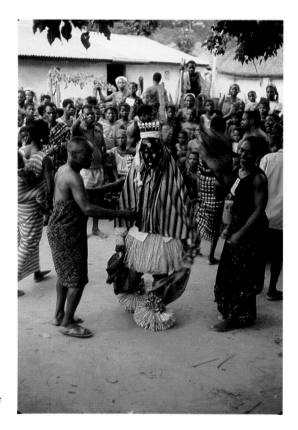

Plate 8. Baule (Ivory Coast) *gba gba* dance with female portrait mask, Kami village, 1971. *Vogel photo, 1971.*

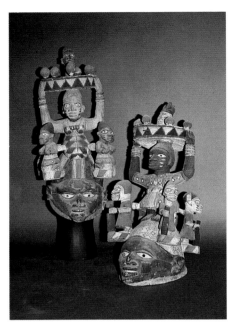

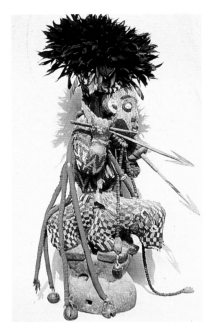

Plate 9. Yoruba (Nigeria) Gelede society masks from the Awori Yoruba area. Collected in 1887. Museum of Mankind, London. *Drewal photo, 1982.*

Plate 10. Bamum (Cameroon) *tu mola* headdress worn by the head of the king's warriors (called *tupanka*). Nineteenth–twentieth century. Bamum Palace Museum, Foumban, Cameroon. *Geary photo.*

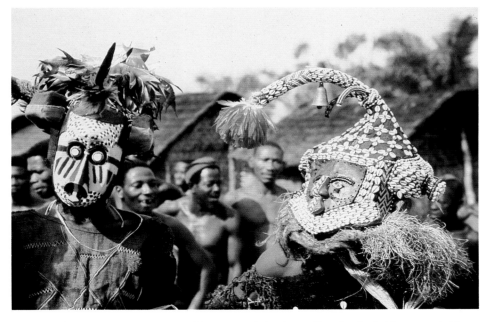

Plate 11. Kuba (Zaire) composite animal/human mask (mukyeeng?) and a tired old man mask (Pwoom Itok). Twentieth century. Eliot Elisofon Archives, National Museum of African Art, Washington, D.C. *Elisofon photo, 1972.*

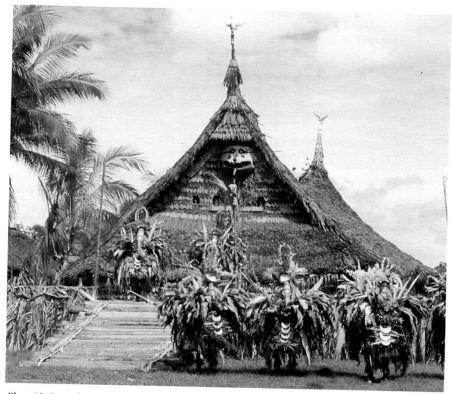

Plate 12. Iatmul (Island New Guinea) ceremonial men's house at Korogo village with five *mai* masks in front. Twentieth century. *Stanek photo*.

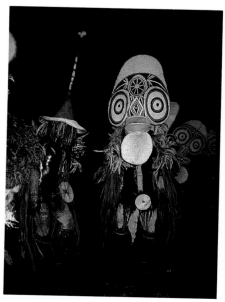

Plate 13. Uramot Baining (Island Melanesia) night dance headdress (*lingan*) and two *kavat* masks at Gaulim village. Twentieth century. *S. Corbin photo, 1983*.

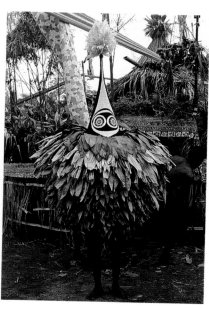

Plate 14. Tolai (Island Melanesia) Tubuan (female) mask of the Duk-Duk society at Vunakulkalulu village. Twentieth century. *Corbin photo, 1972*.

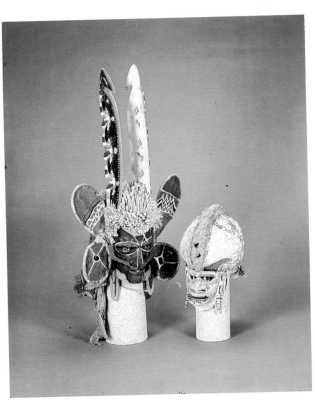

Plate 15. Malanggan area, northern New Ireland (Island Melanesia) masks of two types, called Tatanua (left) and Kepong (right). Late-nineteenth century. Peabody Museum of Salem, Salem, Massachusetts. *Museum photo.*

Plate 16. Maori of New Zealand (Marginal Polynesia) interior of a council house called Rauru. Mid-nineteenth to early twentieth century. Museum für Völkerkunde, Hamburg, West Germany. *Museum photo.*

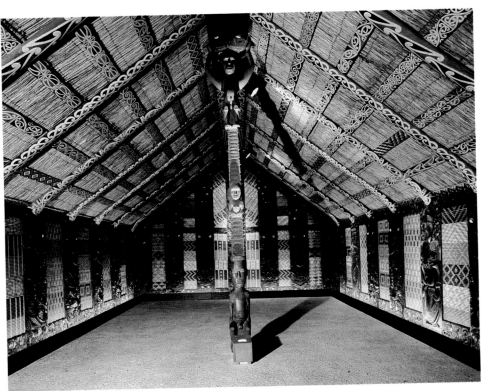

# 1
# Introduction

In the twenty-five years since Paul Wingert wrote his pioneering textbook entitled *Primitive Art: Its Traditions and Styles* (1962), the study of Native American, African, and South Pacific art has grown at an unprecedented rate, in four major areas—research, exhibitions, collecting, and publications. Dozens of journals dedicated to the art and anthropology of these three areas have evolved to serve the specialized interests of art historians, archaeologists, linguists, ethnologists, museum curators, and collectors. In addition, most major cities in the United States, Canada, and Europe and in many areas of Africa and the South Pacific now have museums dedicated, at least in part, to collecting, preserving, and exhibiting art from one or more of the three regions covered in this text.

During this same period the art market for the traditional art of North America, Africa, and the South Pacific has enjoyed phenomenal growth in the number of collectors as well as the prices paid for masterworks. And, university art history and anthropology departments throughout the United States have responded to the increased demand for courses dealing with the visual arts of these three areas. The increase in scholarship and research has led to much specialization. Many contemporary scholars of Native American, African, and South Pacific art tend to be experts on a small region or a specific art-making group,

rather than generalists. These specialists have produced many excellent papers, exhibition catalogues, and books of great value to the scholar. However, teachers and students alike will agree that there has long been a need for a general introduction to the art of all three regions that incorporates some of the vast research done in the past quarter century.

The purpose of this book is to provide one such introduction to the art of the indigenous peoples of North America, West and Central Africa, and the South Pacific. It is written from the point of view of an art historian using traditional art historical techniques and points of view. This text is not intended to be a comprehensive survey briefly covering each of the hundreds of artistic traditions found in these three regions of the world. Instead, a study of forty-five selected art styles within the three areas is undertaken using the methods and vocabulary of art history, including formal stylistic analysis and iconographic interpretation. Emphasis is on an analysis of the formal qualities of the art and its place within a specific cultural context, where it serves as part of a system of visual communication. Whenever appropriate, data from archaeology, ethnology, linguistics, religion, and other humanistic disciplines is used to help bring about a more complete understanding of the art form(s) under examination.

The format and the choice of plates is the result of more than seventeen years of teaching Native American, African, and South Pacific art to undergraduate and graduate students at Lehman College (City University of New York), New York University (Washington Square), and Columbia University. The intended audience is undergraduate- and graduate-level art history and anthropology students and the interested layman or collector. The notes and bibliography at the end of the book are provided for teachers and more advanced students of art history or anthropology who might wish to expand their knowledge and gain a broader understanding of each art style presented in the text.

Emphasis throughout the text is on the traditional art, rather than contemporary art influenced by European artistic techniques such as panel painting, graphic arts, book illustration, sculpture, and art made for the tourist market.

The plates and line drawings were selected to give the reader a broad understanding of the context of the art from each group being discussed while maintaining the notion that the work of art is the primary document for study and contemplation. The richness and diversity of this art will be apparent, and it is hoped that this introduction will inspire readers to read many of the works in the bibliography, and to go to local natural history and art museums to further their visual literacy about Native American, African, and South Pacific art.

Although the particular history of European contact, exploration, colonization, and recent political developments differs greatly from one group to another, it has had an effect on the traditional arts in all three areas. In some areas, such as Tahiti and the Eastern United States, the traditional arts were greatly altered, if not totally destroyed, by the beginning of the nineteenth century. In other places, such as the Northwest Coast of North America and Alaska and in many areas of Island New Guinea and Melanesia, traditional art has survived the hundred or so years of contact and rule by outsiders. And, in West and Central Africa traditional arts are still viable in many groups in spite of political upheaval and pressures from the competing Christian and Islamic religions.

For countless generations before, and in many cases after, European contact, the indigenous peoples of North America, of West and Central Africa, and of the South Pacific have created architectural or sculptural forms, painted surfaces or objects, or, quite frequently, decorated their own bodies. The main purpose of this chapter is to familiarize the reader with these three broad categories of traditional art.

Artistic treatment and transformation of the human body varies from culture to culture. The body can be temporarily transformed by body painting; hairstyling; and the wearing of hats, headdresses, helmets, clothing, or costumes with masks. Permanent alterations can include body extensions, perforations, scarifications, and pigmentations (such as tattoos). Virtually all artistic treatments of the human form serve as a type of group identification and as a system of visual communication within a local group.

## Body Decoration Among Native Americans

In Native American art [Map 1] many different types of body decoration were found at the time of early contact with European explorers.[1] Some of these body decorations are known to us through prints and sketches by these early European visitors, others through preserved burials and the remains of mummified or frozen bodies. In the nineteenth and twentieth centuries, photographs have documented many aspects of self-decoration of Native Americans.[2] The most im-

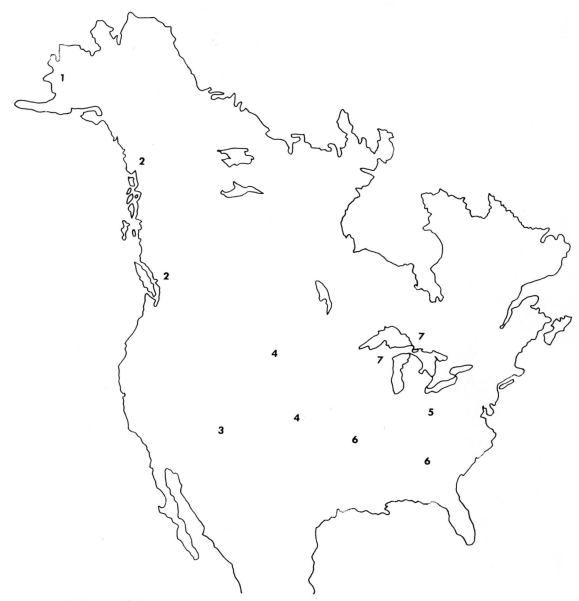

Map 1. NORTH AMERICA

1. Alaskan Eskimo
2. Northwest Coast
3. Southwest
4. Plains
5. Adena-Hopewell
6. Mississippian
7. Great Lakes

permanent types of body decoration are painting the skin with water-soluble pigments, and wearing clothing, headdresses, and removable ornaments. The Swiss artist Karl Bodmer documented a wide range of personal adornment among the Plains Indians of the upper Missouri River in the early 1830s. One of his watercolors [1] represents the Mandan chieftain Mato-Tope in full war paint. As is common with body decoration in many cultures, each design or adornment on Mato-Tope had a specific meaning within his culture. Most of the designs on him refer to his achievements and status as a great warrior. The large yellow streaks on his upper body signify the

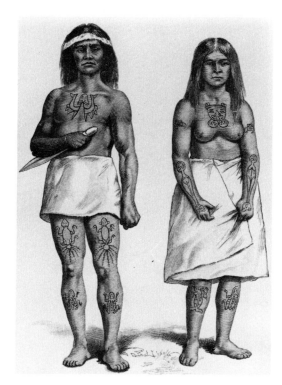

2. Haida (Northwest Coast) male and female tattoo patterns representing various totemic crest animals.

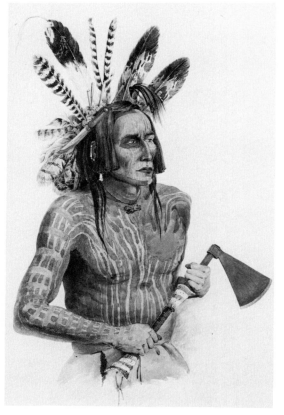

1. Mandan (Plains) Chief Mato-Tope (Four Bears) in his warrior war paint and decoration.

number of coups he had made as a warrior, and the yellow hand painted over the left part of his chest means that he has taken prisoners.[3] The ornaments on Mato-Tope's head and neck also tell of his exploits as a warrior. The carved wooden knife attached to his hair signifies that he has killed a Cheyenne chief with a knife, and the six small sticks topped with nails set vertically in the back of his hair means that he has been wounded by bullets. Turkey, owl, and eagle feathers also adorn his head. The split turkey feather means that he has been wounded by an arrow, and the owl feather tufts on the back of his head mean that he is a member of the dog band. The eagle feathers set vertically were probably associated with high chiefly status and war-

rior powers. Additional visual elements associated with warrior powers include the metal-headed war ax with beaded ornaments and the amulet hanging from his neck.

In addition to temporary body painting, some Native Americans used a permanent form of body decoration—tattooing. Examples of body tattooing are found on two Haida Indians from the Queen Charlotte Islands of British Columbia at the turn of the century [2]. The male has tattoo patterns on his upper chest and on his legs. These represent clan crest animals—such as the split-image codfish on his chest, the octopus (also called devilfish) on the top of each leg, and the frog motif on his lower legs. Clan-crest designs such as these are found in body decoration and in other art forms throughout the Northwest Coast. The Haida woman in this illustration has a frontal crest animal face on her upper chest, a profile bird-headed crest on her upper arms, and patterns on her lower arms that appear to be spatula-shaped forms terminating at each end in a crest animal face. Each of her lower legs is tattooed with different patterns: her left leg is a frog image, while the one on her right leg may be some form of fish or mammal.[4]

## Body Decoration in Africa

Although scarification was rare in Native American cultures, it was widespread among West and Central African groups [Map 2], especially at the turn of the century before sustained contact with such Europeans as colonial administrators and missionaries. Many people altered their bodies extensively with scarification (cicatrization). These raised scar patterns were frequently replicated on figural sculpture and on masks as a way of helping establish each local group's identity. In many areas males and females were given elaborate patterns of raised scars at key transition points in life, such as puberty, marriage, and childbirth.

One photograph of a woman from the forest region of Cameroon [3] documents the use of four different types of self-decoration: body scarification, insertion, plaiting of the hair, and the use of removable ornaments.[5] This woman's flesh is perforated at several points along her ears for the insertion of metal earrings. Her right nostril and lower lip are perforated for the insertion of a labret (lip plug) and a nose ornament, each made of what appears to be thin tubular pieces of ivory. Around her neck the woman is wearing three large coiled metal rings and what appears to be a chainlike necklace, also of metal. Plaiting is

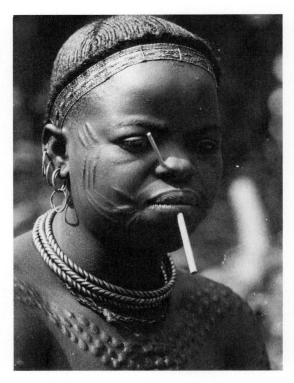

3.  Northern Cameroon woman with extensive body decorations.

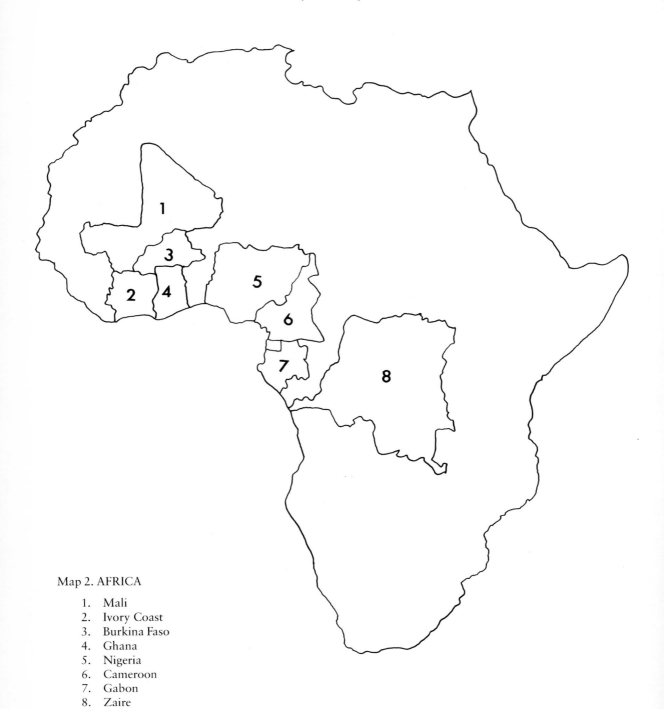

Map 2. AFRICA

1. Mali
2. Ivory Coast
3. Burkina Faso
4. Ghana
5. Nigeria
6. Cameroon
7. Gabon
8. Zaire

evident in the decorative forehead band as well as in the woman's hairstyle. Her hair has been plaited into thin, curving rows that turn back toward her face on either side of the center of her forehead. The thin, plaited band across her upper forehead serves to divide her hair zone from her skin and consists of a horizontal series of thin rows that echo the plaited rows in her hair.

In addition, there are two different patterns of scarification marks on her face, and a third on her chest and shoulders. Thin, elongated, raised oval shapes radiate outward from a point on either side of the corner of her mouth. These connect with a second pattern of scars, consisting of three parallel raised lines going up the side of her face in an ascending zigzag pattern. The raised scars on her chest and shoulders consist of more bulbous raised forms, which are arranged in a series of three curving lines across the upper chest and over the top of each shoulder. Whereas the meanings of the adornments on Mato-Tope were well documented, very little is known about the symbolism of this Cameroon woman's scarification patterns.

Another example of Central African self-decoration can be seen in a pre-1910 photograph of the front and side views [4] of a Fang warrior from Gabon in Central Africa.[6] The warrior is wearing thick metal collar ornaments on his neck, and he has a small plaited arm band on his

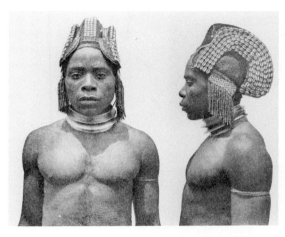

4. Fang man (Gabon, Central Africa) wearing an elaborate headdress of cowrie shells, beads, and woven materials.

upper left arm. There is evidence of facial and body scarification as well. The warrior's decorated headdress is a study in contrasting colors and shapes, with rows of cowrie shells on both side panels and on the raised central band on top of his head. The tightly woven fiber and hair covering to which the ornaments are attached contrasts texturally and coloristically with the clearly articulated shells, buttons (on the bottom of the head covering), and the thin rows of beads that hang over the ears. Elaborate headdresses of this and other types are replicated on Fang reliquary figures. (See Chapter 7 for more on the art of the Fang.)

## Body Decoration in the South Pacific

Tattooing, such as we found in the Haida peoples, was widely practiced in Melanesia, Micronesia, and Polynesia.[7] In some areas, such as the Marquesas Islands, both males and females had extensive tattoos over most of the body [5], as part of an ongoing process commencing at puberty and continuing until early adulthood. As documented in this drawing from a 1920s publi-

cation, the male's body was covered from head to ankles with elaborate abstract and simple figurative tattoo patterns in well-defined rows and zones. The Marquesan female shows patterns somewhat different from her male counterpart. First, she has many areas of her body free of tattoo patterns, especially her neck, chest, and abdomen until a line across her pubic region.

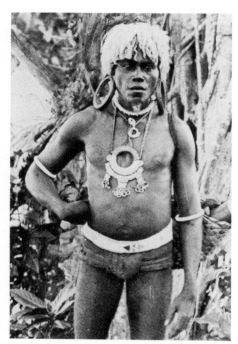

6. New Georgia man (Solomon Islands) wearing elaborate shell jewelry and large circular ear plugs.

There was probably a strong religious and power-oriented reason for this extensive self-decoration—one associated with the widespread Polynesian belief in the manipulation of spiritual power for positive (*mana*) or negative (*tapu*) ends. Here the decorations were undoubtedly associated with fertility, virility, and well-being.[8] (See Chapter 10 for a more detailed description of these drawings.)

In addition to body adornment such as tattooing and scarification, bodily extension is a common feature of body decoration among the peoples of the western Solomon Islands [Map 3] in Melanesia. A New Georgia warrior from the turn of the century [6] has ear lobes which are extended several inches to accommodate the insertion of large, circular wooden ear plugs inlaid with decorative mother-of-pearl shell patterns. Around his neck is a pendent chest ornament (*bakhea*) made up of a coil of cut tridacna shell wrapped with red braid from which hangs bead-

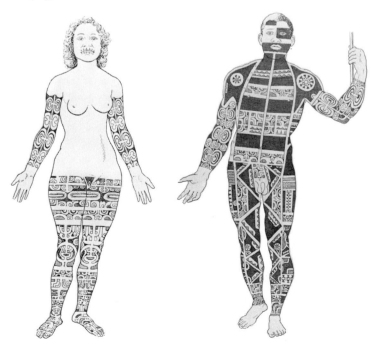

5. Marquesas Islands (Polynesia) male and female tattoo patterns.

HAWAIIAN ISLANDS

MARQUESAS ISLANDS

SOCIETY ISLANDS

NEW ZEALAND

MICRONESIA

NEW IRELAND

SOLOMON ISLANDS

ISLAND NEW GUINEA

NEW BRITAIN

INDONESIA

AUSTRALIA

Map 3. SOUTH PACIFIC

work, small shell rings, and a row of bat's teeth.[9] He also has shell rings around his upper arms and near his neck. His neck is surrounded by a necklace made up of bat's teeth. Above his pubic covering he wears an ornamental bark cloth belt with geometric decorations. His hair is colored a light color, as was common in many areas of Melanesia in the late-nineteenth and early-twentieth centuries. (See Chapter 9 for more on the art of the Solomon Islands.)

Masking has played an important part in the traditional life of many of the peoples in the three regions under study in this text.[10] Masks were donned for various purposes, including the impersonation of ancestral, mythological, and subsistence-related spirits. Frequently, masking was associated with social control, the education of youth in important values of a given society, as well as public display and entertainment. In most instances men were the makers and wearers of masks, and the manufacture of these masks was usually done in secrecy in an area set aside for it, while the fully costumed performance provided a context for display in public.

## Masking in Native American Art

Masking was prevalent among the Alaskan Eskimo, the peoples of the Northwest Coast, and some peoples of the Southwest and of the Eastern Woodlands. Mask forms ranged from highly naturalistic to very abstract, and they depicted such things as human ancestors, various flora and fauna, and supernatural spirits. Four Haida face masks [7] carved in the last quarter of the nineteenth century by a Haida artist named Quaatelth are examples of very naturalistic types of ancestral masks commonly found in the Northwest Coast.[11] The top left mask represents a male, and the three others represent females. The underlying bone structure, the facial proportions, the details of cosmetic facial painting, and the decorative ornaments in all four masks are quite naturalistic. Each of the three female masks has a small tubular labret (lip plug) sticking out from beneath the lower lip. The two masks on the bottom appear to represent young women, whereas the one on the top right may represent an older woman. The ear ornaments on the two bottom masks include long, dangling ribbons on the left and circular earrings on the right. The two masks on the right side and the male mask on the upper left have faces painted with totemic crest designs, echoing crest patterns worn by in-dividual Haida. The male mask's painted patterns across the eyebrows, eyes, and upper cheeks represent a bear's ribs. The female masks on the top right and the lower right are painted with symmetrical patterns on the faces. This symmetry is broken only by a diagonal crest pattern—possibly representing a killer whale's fin. (This pattern is not easily seen in this photograph.) The visual impression created by these naturalistic Haida masks is one of alertness and lively animation, closely echoing human facial structure and movements.

In striking contrast in form and identity to these Haida masks is a Hopi Niman kachina spirit mask [8] from Arizona. Whereas the Haida masks were clearly naturalistic in form and detail, with painted totemic crest patterns, the Niman kachina mask consists of a cylindrical head divided into two halves with rectangular and linear designs on a highly abstracted face. Attached to this head is a flat, boardlike form (called a *tableta*) with varied geometric shapes in contrasting light and dark colors. The Nimam kachina mask is worn during a harvest celebration among the Hopi of Arizona, usually held after the summer solstice, in July. (See Chapter 3 for more on the art of the Hopi.) The celebration is held at the

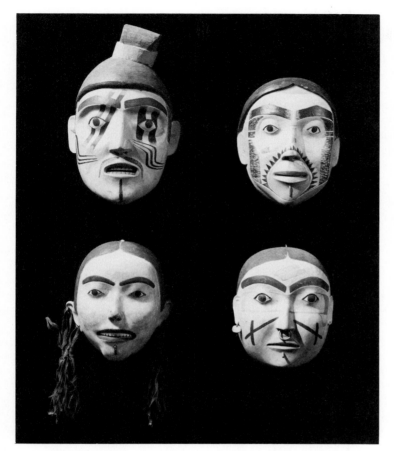

8. Hopi (Southwest) Niman kachina mask representing a rain-oriented kachina spirit.

7. Haida (Northwest Coast) portrait masks with totemic animal crest patterns.

closing of the kachina season, when it is believed that the supernatural kachina spirits retreat to their world underground, to return above ground at the time of the winter solstice, in December. The Niman kachina is associated with rain and sustenance and is covered with symbols alluding to rain and the resulting fecundity (fertility) of the earth, particularly gardening. The three-part stepped shape of the *tableta* on top of the mask represents clouds, as do the painted versions on the surface below. Semicircular shapes near the bottom of the mask are also symbols of rain clouds. Horizontal and vertical multicolored bands symbolize rainbows, while vertical lines and dark dots symbolize rain. The thin vertical shapes painted on the surface symbolize both corncobs and the phallus, a mixed symbol alluding to food and human fertility. Feathers and plant materials attached to the top are both decorative and symbolic of plant growth. Symbols such as those on this Niman kachina mask are commonly found in Hopi underground kiva ceremonial displays and in Hopi religious symbolism.[12]

## Masking in Africa

In many areas of West and Central Africa, masks are created to represent female and male spirits. In addition, masks are created to give visual form to various flora and fauna, unseen natural spirits, and man-made objects. The Igbo-speaking peoples of southeastern Nigeria (also known as Ibo) make beautiful-maiden spirit masks [9], which are worn as part of elaborately decorated costumes by young men in masked performances during certain times of the year.[13] These two masks from the early-twentieth century have an elaborate multicrested coiffure in keeping with the Ibo practice of having women create intricate hairdos, which include added elements such as combs, mirrors, bells, and other decorations. The woven costumes and masks in these two exam-

9. Ibo (Nigeria) beautiful-maiden masks and costumes worn by men.

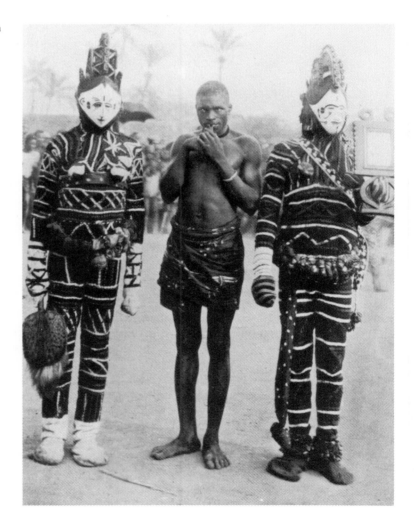

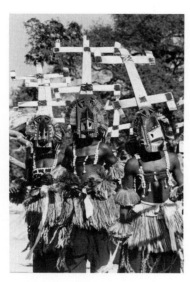

10. Dogon (Sanga region, Mali) Kanaga masks showing the full costume, including abstracted wooden masks and dyed fiber costumes.

ples are typical of the female spirit type among the north-central Ibo around Akwa. The elaborately crested coiffures, the light-colored faces, the elegant refined facial scarification patterns, and the elaborate body-painting designs represented on the costume in angular, zigzag, and curvilinear patterns all allude to traits of an ideal, youthful Ibo maiden who is eligible for marriage. The costume and masks both replicate elements of clothing, body painting, scarification, and coiffure that are part of the Ibo woman's ceremonial attire.

Some masks and costumes among the Dogon people of Mali are not meant to depict real people, but rather attempt to give visual form to symbols associated with deities. The group of several Dogon Kanaga masked spirits photographed in 1970 [10] is a good example of a mask type that embodies traits and symbols associated with the highest deity of creation, known as Amma. Unlike the mask and costume of the Ibo maiden spirits [9], these Dogon Kanaga spirits have fiber costumes replicating female skirts that are dyed red, and cowrie-shell and string breast coverings that are associated with the primordial creation period. The bright-red color of the skirts symbolizes menstrual blood, and constitutes the most sacred part of the entire costume. While special care is taken in the preparation and preservation of the skirt, the mask, on the other hand, is treated with little reverence after its use in ceremony.[14]

The lower part of the mask (placed over the dancer's face) is somewhat anthropomorphic in shape, although there is a strong abstract geometrical quality to the treatment of the pointed bulbous forehead, triangular cutout eyes, and rectangular planes of the large nose and the cone-shaped protruding mouth. Above the lower head is a transitional strut extending upward to form a vertical shape with attached horizontal planks. This two-armed crosslike shape is said to symbolize the arms and hands of the creator god Amma as he points to the heavens and the earth at the completion of creation.[15] (See Chapter 5 for more on the art of the Dogon.)

## Masking in the South Pacific

Masks are used extensively in many parts of Melanesia, as well as in some areas of Australia, Micronesia, and Indonesia. Early explorers noted limited use of masks in some parts of Polynesia, although their use was basically extinct by the late-eighteenth and early-nineteenth centuries due to the negative impact of missionary activity.

A twentieth-century Iatmul mask and costume from the Middle Sepik River in Island New Guinea represents a powerful mythological fe-

male spirit [11] and is a good example of a carved wooden mask with multimedia basketry costume and attached fibers, shells, and cut pods.[16] The wooden mask is human-like in form, with a decidedly aggressive countenance. The protruding tongue and open, toothy mouth are typical of a common power-oriented motif in Iatmul symbolism. The ears are decorated with dangling earrings, the face is painted with varied linear patterns, and the hair is cut in a curved pattern on the forehead, all based upon cosmetic practices of Iatmul women. The miniaturized breasts, cowrie shell jewelry, and decorated grass skirt relate to ceremonial clothing. A man would don this mask and costume in ceremonial contexts and would reinforce the human-like identity of this female spirit through dance steps and gestures.

A very different and more abstract visual form is found in a pair of contemporary Sulka To-ka-ti *susu* masks [12] from east New Britain in Island Melanesia.[17] Bark and fern leaf masks are set on top of dancers' heads, while their bodies are covered with skirts made of varied tiers of colored leaves. Only the lower legs of each dancer can be seen; the majority of his body is disguised. The rolled-bark, cone-shaped lower part of each mask is painted with bright, abstract, geometric shapes, as well as with a simple, human-like face. The cone-shaped top part of the mask is made of wrapped fern leaves, which create an image that represents the tip of a taro tuber that is cut off and planted in a garden. The symbolism, therefore, is specifically oriented around a garden product and the need to plant part of it to maintain one's food supply.[18] Unlike the mask of the Iatmul female spirit, these Sulka masks are decidedly nonanthropomorphic in form.

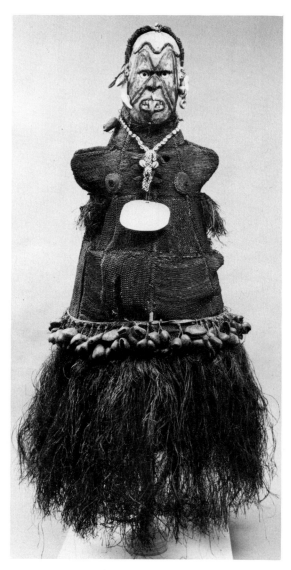

11. Iatmul (Middle Sepik River, Island New Guinea) female spirit mask and costume.

12. Sulka (Island Melanesia) To-ka-ti *susu* masks in front of a men's house at Kilalum village.

## Architectural Sculpture of the Northwest Coast

Virtually all the peoples of the Northwest Coast of North America organized their villages according to social rank around a central (high) position in the center of a beach settlement, with rank descending outward toward the edges of the village. In a like manner, the tribal religious specialist, known as a shaman, was treated as belonging to a separate caste and would live in a house toward the forest, away from the chiefly beach row.[19] Architectural sculpture was common among the Haida, Tlingit, Kwakiutl, Tsimshian, Nootka, and Salish peoples of the Northwest Coast. An example from the Tlingit from the late-nineteenth century will serve as an example of the important role permanent and mobile arts played in the life of high-ranking Tlingit and other Northwest Coast peoples.

An 1888 interior view of a Klukwan village chief's communal house of the Ganaxtedi clan is shown [13] with screen carvings, interior house posts, portable wood sculpture, and decorated clan clothing and masks.[20] The house was built for Chief Kate-tsu about 1835 by Tsimshian carvers, and the central focus of art within this Tlingit chief's house was the sunken interior meeting room, with a carved screen and the clan posts and mobile functional objects set about the built-in benches. The rectangular-shaped house had a large, sunken, square-shaped central gathering area with a fireplace. On either side of a room-divider screen with the image of a rain spirit on it were huge posts carved with images of clan ancestors. These posts served as story posts illustrating central characters in clan myths. (See Chapter 2 for a further discussion of this remarkable chief's house.)

15

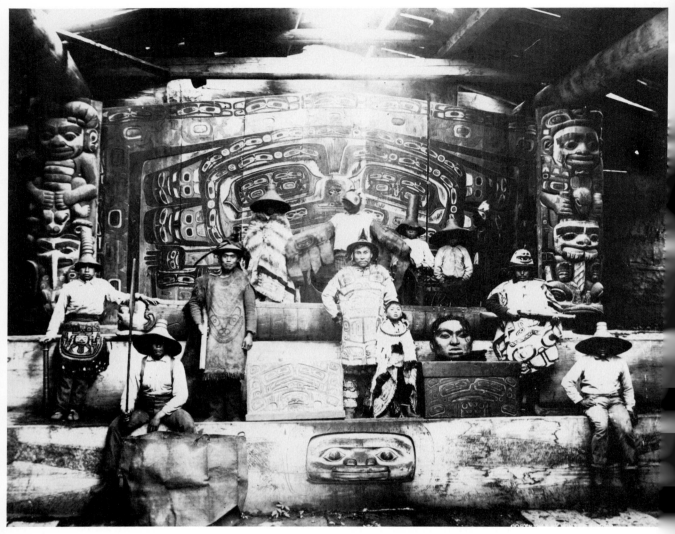

13. Tlingit (Alaska) whale house interior (Ganaxtedi clan) with carved and painted totemic rain screen, house posts, storage boxes, helmets, hats, masks, decorated clothing, and carved vessels.

## Architectural Sculpture in Cameroon, Central Africa

The architectural sculpture found at the palace of the Bamum King Njoya at Foumban at the turn of the century is less varied in forms and types than the sculpture in the Tlingit chief's house just described. Figure 14 shows King Njoya standing in an inner courtyard by a reception hall of his

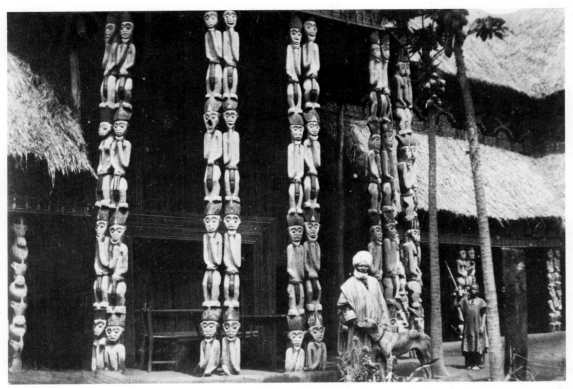

14. Bamum (Cameroon) royal palace courtyard at Foumban showing King Njoya standing in front of various carved posts representing retainer figures.

huge palace compound. The stacked pillar figures visible in the interior courtyard of this palace are just a few of the dozens of similar figures that are found throughout this vast complex of buildings, with a variety of rooms, entrances, and courtyards.[21]

The stacked figures are carved in wood in heights varying from approximately eight to as much as twenty feet in the higher, overhanging alcoves. The figures are stacked on top of each other with one hand raised to the chin and the other placed over the genital region in the manner of retainer (servant) figures displaying a proper gesture of supplication to the king. Unlike the Tlingit chief's house carvings, which had totemic clan narrative meanings and were quite varied within a single house, the norm in this royal palace architecture seems to be redun-

dancy, with the primary visual purpose of elevating, supporting, and protecting the king as an all-powerful and divine personage.

Technologically, the palace at Foumban was created as a large-scale basketry-type construction of interwoven branches of raffia palm (like bamboo) with grasses placed on the roof for protection from rain. This is quite different from the cedar-plank–built Tlingit chief's house, with its low-slung, pointed gables and heavy support-beam construction, set along a beach row with many other houses. The palace, by virtue of its central position within the Bamum kingdom, and the hundreds of family and staff members in residence, is more on the order of a large living complex with specialized functional spaces according to the needs of the royal court.[22] (See Chapter 7 for more on Bamum art at the palace.)

## A Decorated Men's House of the Abelam
### of the Maprik Mountains, Papua New Guinea, Island New Guinea

In Island New Guinea and some areas of Island Melanesia, men's houses were built as special communal gathering places for the men of the village. Frequently, these houses were decorated with elaborate art forms, including painting and sculpture. In an early 1960s photograph [Color Plate 1] one can see the decorated facade of a men's house in Kinbangwa village of the Abelam people of the Maprik Mountains in Papua New Guinea.[23] Technologically, the architecture of this house is parallel to the basket-like structure of the palace at Foumban, although the size, context, and iconography of the architectural sculpture and paintings are very different. In this view it is apparent that the upper two thirds of the facade are covered with polychromatic bark paintings as well as colorful low-relief sculpture. The overhanging pointed gable is common to the Abelam and serves to protect the elaborately painted facade from the rainy weather. The entire house is hung from several posts, including the long center post protruding from the top and others along the sides. The horizontal double frieze at the point of transition between the painted facade and the lower wall represents a pair of couples set feet-to-feet in the act of copulation, an explicit sexual reference which is also tied to more generalized fertility symbolism in both paintings and sculptures within the house.

The triangular-shaped facade is painted with a decreasing number of horizontal rows of mythological spirit faces. A row of male spirits appears on the bottom and in the middle row, and the facade is topped by a figure said to represent a dangerous flying female witch.[24] The protruding, pointed pole at the top is said to be the penis of the men's house, while the small entrance doorway at the lower right is considered to be the womb of the house. Unlike the totemic clan symbolism within the Tlingit chief's house and the royal symbolism seen in the house-post retainer figures at Foumban, the symbolism of this men's house facade is two-tiered. There is a public set of meanings for women and uninitiated boys and a secret set for the initiated males. The men's house also serves as a clubhouse for some of the clans in the village, as a place for initiation of male youths, and as a storage place for sacred objects that are kept secret from the uninitiated. Much of the symbolism of Abelam architectural art is associated with fertility/fecundity and masculine virility, hunting/warrior powers, and magic. (See Chapter 8 for a further development of these themes.)

## Some Examples of Modeling, Carving, Painting,
### and Incising in Native American Art

Modeling in clay was a common artistic process among some Native Americans prior to and after contact with Europeans. The four painted effigy pots [15] from the Anasazi period in the Southwest (c. A.D. 1100–1450) are known as Tularosa polychrome pottery (referring to the region in which they were excavated in Arizona).[25] This region is a transitional one, located historically and geographically between the pre–European contact Mogollon (Mimbres area) and Anasazi cultures. (See Chapter 3 for a discussion of Mogollon and Anasazi art.) These vessels were probably made by women using the coil method without benefit of a potter's wheel. Three of them are globular shapes with central cylindrical spouts and attached carrying or pouring lugs

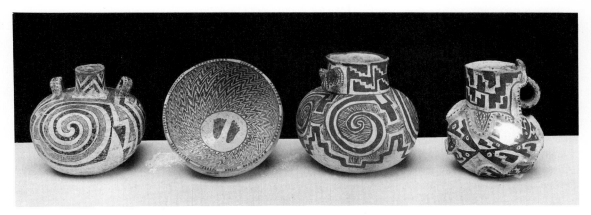

15.  Mogollon/Anasazi culture (Southwest, Arizona/New Mexico), Tularosa polychrome pottery.

(handles). The fourth (second from the left) is a shallow bowl, not unlike salad bowls used in our own culture. All four bowls are painted with elaborate geometric patterns in complex repetitive zones. In addition, the shallow bowl has patterns representing a pair of human footprints in the center of a complex zigzag-like surrounding field. The other three pots have varied spiral shapes, and triangular, stepped, zigzag, and/or circular patterns over their surfaces. In all the vessels there is a strong tendency for figure-ground reversals to occur, whereby the light background color can also be read as a distinct positive shape. The strongly geometric patterns found on these vessels is a stylistic trait common to the art of the Anasazi in the Southwest. This abstract symbolism is also found in the art of descendants of the Anasazi people—the Hopi.

Carved and painted dolls were made as miniature representations of supernatural spirits among several groups in the Southwestern United States. These include the Hopi, Zuñi, and pueblo groups in Arizona and New Mexico. One late-nineteenth-century Hopi kachina doll [16] represents a supernatural spirit called Ho. A masked dancer impersonates this spirit in various Hopi kachina ceremonies, including the mixed kachina dances in August. Kachina dolls such as this were given to children during kachina ceremonies to teach them about their religion and as a means of social control. The dolls served as visual cues for

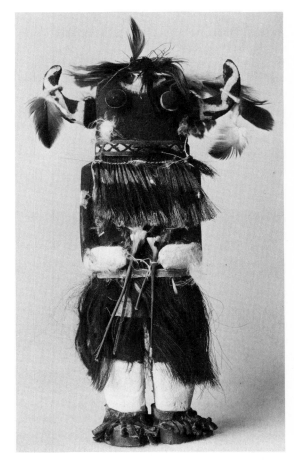

16.  Hopi (Southwest, Arizona) Ho kachina doll of wood, feathers, pigments, hide, and grasses.

stories about the kachina spirits and as a re-minder of the periodic coming of these spirits to the pueblos to punish children who had misbe-haved. The Ho kachina masker assumes a social-control role in the kivas and on the dance ground in the village by punishing youth (in the kiva) and by chasing people about the dance area with a switch or a whip. In the case of this particular Ho kachina doll, the spirit's countenance matches his aggressiveness, since he has both human and ani-mal attributes, including those of a buffalo, with his large horns curved and pointed upward from the side of his head. He also has bulging animal-like eyes and a wide, toothy, aggressive mouth. He carries arrows (which hang from his waist-band), wears a skirt, and has a long beard. His head and horns have feathers attached to them, suggesting movement in this otherwise stationary object. The arms are not cut free from the body and his legs are only slightly parted. The overall body gesture is a static one, as if his aggressive nature is held in check in this miniature image. More recent kachina dolls are larger than most of the early ones and are often much more dynamic in body posture and in three-dimensionality.[26]

Antlers and horns, as well as animal teeth and claws were sometimes used in various Native American cultures to create functional items. These include weapons, spoons, needles, as well as ceremonial objects. A combination of carving and incising on a sculptural form is evident in a Great Lakes area Winnebago people's carved antler war club [17].[27] This nineteenth-century club is irregular in shape, with the handle end maintaining the pointed shape of the top of an antler. Leather strips for hanging or securing the club to the warrior's hand were probably threaded through the two small holes on the han-dle. The handle is incised at right angles by a series of thin bands filled with diagonal, chevron, and cross-hatched lines, the meaning of which is unknown. The wide end and part of the irregular side are decorated with incised triangular shapes

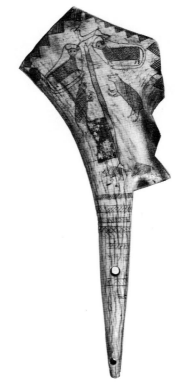

17. Winnebago (Great Lakes, Wisconsin) moose antler war club with incised supernatural animals.

which serve as a border design. In the center of the flat surface of the striking end are thin, linear, incised animal images, including, from top to bottom, a deer in movement, a pair of panther-like animals set within an encircling bubble line, a centrally located horned serpent, a pair of bears flanking the horned serpent, and a pair of bison at the tail end. The horned serpent and the panther-like images are most likely supernaturals, and probably the felines are meant to represent underwater panthers common to the shamanistic religions of the Great Lakes peoples. The bears and bison are also likely to be associated with shamanistic and/or hunting societies, which in turn were associated with masculine warrior soci-eties in the region.[28]

### Some Examples of Modeling, Carving, and Repoussé in African Art

Clay sculptures have been made in various West and Central African cultures for thousands of years. Sculptures larger than life, modeled in clay, are found among the Ibo peoples of southeastern Nigeria, particularly within the context of a large-scale display of architectural sculpture known as an *mbari* house.[29] The sculptural group from the 1960s shown in [18] is from the Akwa division of the Ibo in southeastern Nigeria. This

18. Ibo (Nigeria) *mbari* clay sculptural group representing Ekwonoche, the goddess of large families. On display at an *mbari* dedicated to Ala at Umuofeke Agwa, southeastern Nigeria.

group represents the goddess of large families (Ekwonoche), with four children. The elongated tubular treatment of her body and of her children is common to *mbari* clay sculpture. She has a mixture of traditional and modern elements, including a traditional coiffure and body painting patterns, with modern shoes and socks. Her children, likewise, have a mixture of traditional body painting (for the female children), with modern shoes, socks, shirts, and shorts. To the Ibo, many modern things taken from contact with Europeans have positive values within their society, and, therefore, are proper subjects for inclusion in an *mbari* sculptural program. Unlike the Tularosa pottery from Arizona, these clay sculptures have not been fired to harden them. In fact, after the *mbari* ceremony has been completed, the figures are left to gradually fall apart and disintegrate. (See Chapter 6 for further discussion of Ibo *mbari* sculptures.)

Although wood carving is common throughout Africa, there is one unusual combination of wood and metal sculpture that is found among the Kota of Gabon. These wood sculptures are covered with thin sheets and/or strips of metal in a technique known as repoussé. The three Kota reliquary figures from Gabon in Central Africa [19] are typical examples of this technique, where varied levels of low relief and incised decoration in the wooden sculptures have been overlaid with thin sheets of brass which were pressed into them to create a metal "skin." The Kota reliquary figures were traditionally placed in a basket of ancestral bones as protective guardian spirits. The concave and convex treatment of the facial planes and the abstracted proportions and details of the human head are hallmarks of Kota style.[30]

Highly stratified royal art traditions are found among the Asante, Benin, Bamum, and Kuba. At the court of Benin in Nigeria, artists were divided

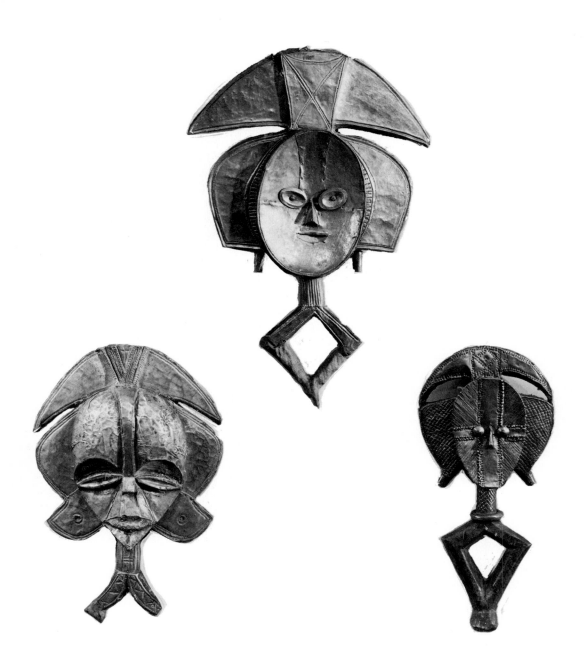

19.  Kota (Gabon, Central Africa) reliquary figures, carved in wood and covered with sheets and strips of metal.

into groups of specialists, including metal workers, wood carvers, ivory workers, and costume makers, each living in special quarters of the city and organized into guildlike units. Soon after contact with European traders in the late-fifteenth century, there developed an export art of carved ivory objects destined for the royal tables and collections in Europe. These objects were often in the form of spoons, carved horns, and salt cellars for spices. One especially elaborate ivory salt cellar [20], from about the sixteenth century, is divided into three interconnected parts. The lid has an equestrian figure of a helmeted European with musket raised in a firing position on top. On the bottom of the lid are carved low-relief heads in profile which connect to their bodies below, on the second tier of the vessel. The second level has a large, globelike form held up by European equestrian soldier figures below. At a point near their waists the lower part of the vessel is cut to form a second bowl. The horses and riders appear to be in active movement in a clockwise rotation around the central axis of the vessel. The figures are rendered in varying levels, of low, medium, and high relief. The armor on the soldiers and the trappings on the horses suggest European military clothing and hardware from the sixteenth century. Unlike traditional Benin ivory carvings from the same period, the figures are treated in a recognizably European fashion, suggesting that the royal ivory workers were quite capable of working in two somewhat different styles at the same time.[31] (See Chapter 6 for more on Benin art.)

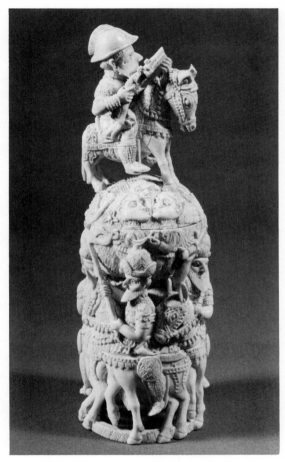

20. Benin (Nigeria, West Africa) ivory salt cellar, carved with European warriors on horseback.

## Some Examples of Modeling, Carving, and Painting in South Pacific Art

The modeling of clay over the human skull is rare in the art of the South Pacific, and virtually nonexistent in Native American or African art. It is, however, found in some regions of Island New Guinea and Island Melanesia. Among the Tolai peoples of east New Britain in Island Melanesia, the human skull was cut vertically along the area of the temporal lobe and modeled with clay to form a naturalistic ancestor mask. Tolai modeled-skull masks such as these from the late-

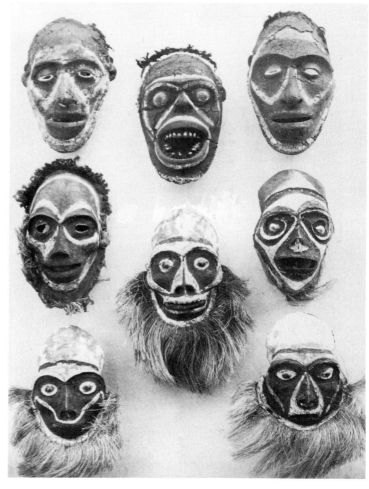

21. Tolai (East New Britain, Island Melanesia) modeled skulls, with clay, pigments, opercula, grasses, and hair.

nineteenth century [21] were worn in nocturnal ceremonies, where the maskers danced around a fire throughout the night.[32] The thickness of the covering on the underlying skull armature varies in each mask shown. On some, the upper portion of the cranium is still exposed. Some have holes in the eye areas, enabling the wearer to see as he dances about the fire, while others have inlays of the inner valve (operculum) of a sea snail to create more realistic-looking eyes. The facial expression on these eight masks varies from aggressive to relaxed and contemplative. Some have beards modeled in clay, while others have attached fiber beards, and a few have human hair stuck into the

clay. All of the masks are painted with angular and curvilinear facial painted patterns, which replicate styles of facial painting worn by the Tolai themselves.

In some regions of the South Pacific monumental-sized sculptures were made to represent deities. This was common in the Hawaiian Islands, where aggressiveness and monumental size were the hallmarks of Hawaiian wooden temple sculpture [22]. Images such as this were placed in rows within temple areas on the island of Hawaii along the western Kona coast. The exact identities of most of the Hawaiian temple images that have survived the onslaught of European mis-

sionary activity are unknown. However, this type of image is most often associated with the war god Kukailimoku (Ku) in Hawaii.[33] The figure shown is over six and a half feet tall and at one time had a carved pointed strut on the bottom so it could be planted upright in the earth in the temple area. The overly large head is a study in aggressive facial expression, with the toothy figure-eight–shaped mouth appearing to be screaming. The heavy brows and elongated eyes reinforce the grimace. The arms, the chest, and the upper and lower legs are all conceived as very muscular forms, and the frontal, slightly flexed stance gives the figure a sense of great power held in check, yet ready to be realized. The pubic area was normally wrapped with bark cloth (*kapa*); therefore, the male genitals were not articulated.

Two-dimensional art forms, such as painting, are found throughout the South Pacific. One example is painting on bark, such as the two aboriginal bark paintings from the Oenpelli region of Arnhem Land in northern Australia [23]. These were collected in 1912 and are excellent examples of Oenpelli painting early in this century.[34] Both paintings are executed in x-ray style, common to this area of Arnhem Land. In this style, bones, organs, and musculature are shown at the same time as the overall outline and clearly recognizable shape of the animal are realized. Sometimes these bark paintings had as their subject hunting scenes, where an aborigine (or a mythological spirit known as a Mimi) is shown throwing a spear at the game he is trying to kill. The smallish, nearly stick-figure humanoid is shown in active pursuit, with a spear thrower in hand, penis and scrotum articulated, and a shoulder bag (dilly bag) hanging off one shoulder. He is disproportionately elongated compared to the birds he is hunting, a trait common to Oenpelli depictions of animals and humans. (See Chapter 8 for more on the art of Arnhem Land.) The x-ray–style bird image on the right is in a posture of fright, as were the two birds on the left. The artists seem to have captured the ani-

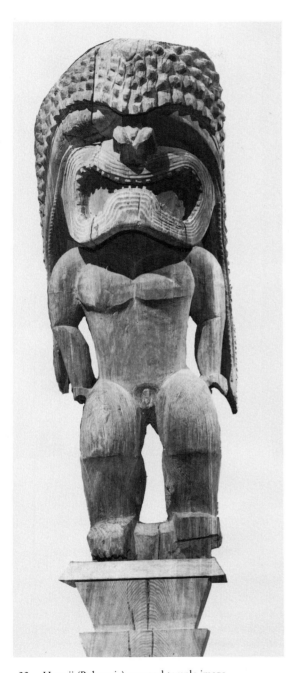

22.   Hawaii (Polynesia) war god temple image.

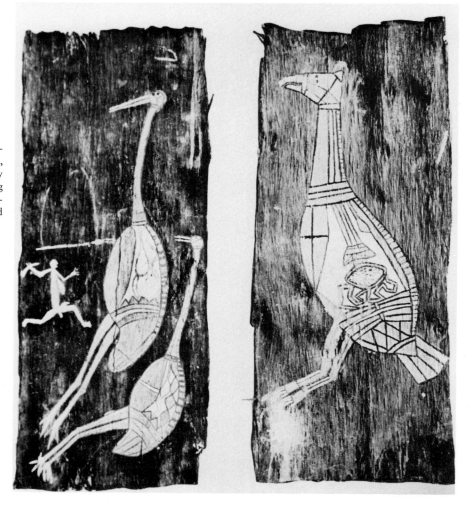

23. Oenpelli area, Arnhem Land (Australia), bark paintings in x-ray style showing birds being speared (left) by a mythological Mimi spirit and a single bird (right).

mals just as they realized they were about to face danger and possible harm. The figure/ground relationships are clearly defined in the Oenpelli style, with the figures looming large against a homogeneous red-ochre background. These images were used as teaching aids by the aborigines around their campfires to acculturate the young to hunting practices, as well as to help explain through illustrations important mythological events. There was also an element of magic associated with painting on bark (or other surfaces, such as one's own body or rocks) within ritual contexts. By painting, one gained an advantage in hunting, fertility, and other things of importance in the everyday life of the aboriginal people of Arnhem Land.[35]

I hope this chapter has given the reader a taste of the exciting and varied art forms to be found in the traditional arts of Native American, West and Central African, and South Pacific peoples. Throughout this book, many of the art forms that have been touched upon in this first chapter will be developed in greater detail, with more emphasis on understanding the meanings of the visual arts in the context of each group being discussed.

# 2
# Alaskan Eskimo Art
# and Art of the Northwest Coast

The Bering Sea Eskimo peoples of western Alaska have lived in the low, marshy areas of the delta region between the Yukon and Kuskokwim rivers for thousands of years (Map 4). At the time of early contact with Europeans in the late-nineteenth century, there were approximately twelve thousand Yupik-speaking Eskimos living there. Although this is a harsh, tundra environment, it is rich in sea and land mammals as well as fish and birds, all of which were exploited for food and functional items. Seals, bowhead and beluga whales, walrus, polar bears, caribou, brown, black, and grizzly bears, and Dall sheep were among the many mammals used by the Yupik Eskimos. Water animals, including salmon, herring, sculpin, whitefish, blackfish, lamprey eel, and king crab were taken during various seasons. During the spring and summer months waterfowl and their eggs were eaten. Ptarmigan were hunted from October through April. And, for brief periods from May through September, the Yupik Eskimos enjoyed a variety of greens, roots, seaweed, and berries.

The Eskimos living in this delta region spoke several dialects of a language called Yupik, while those living north of Norton Sound (north of the Yukon River) spoke dialects of a language called Inupiak—a language spoken by Eskimo peoples throughout the northern Arctic area, including Greenland.

## Alaskan Eskimo Art

The art of the Inupiak- and Yupik-speaking Eskimo people of Alaska is indicative of highly mobile hunting-gathering cultures. Their life, along the rivers and the coast of Alaska, was intimately associated with the seasonal migrations of mammals and fish, and the symbolism of their art relates directly to the local fauna hunted for food and the religious spirits associated with appeasement. Whereas the kayak and the umiak were the modes of transport used during the seasons when the water was free of ice, the Eskimo used dog sleds as a means of transport over the ice and across the frozen snow-covered tundra during the long Alaskan winter. Frequently, utilitarian objects such as tools and weapons were artistically decorated. Many of these objects served as magical charms to protect the hunter and to ensure a successful hunt.[1]

One of the most important functional items in Eskimo culture is the kayak. Frequently, kayaks

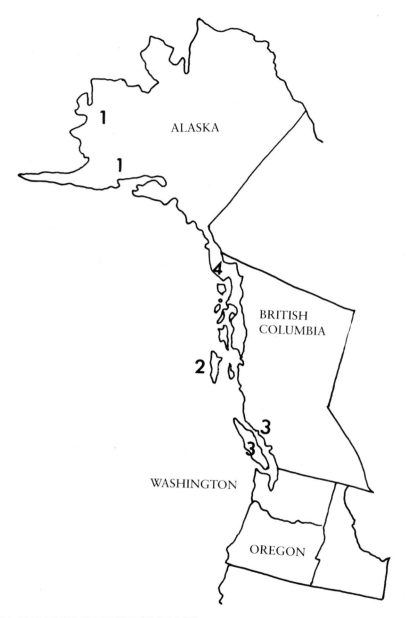

Map 4. ALASKA AND THE NORTHWEST COAST

1. Alaskan Eskimo
2. Haida
3. Kwakiutl
4. Tlingit

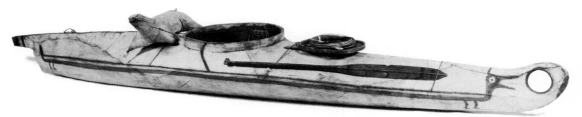

1. Alaskan Eskimo (Nunivak Island) sealskin and wood kayak for hunting; the image painted along the side represents a mythological spirit called *palraiyuk.*

were painted with images of mythological spirits as a form of protection. One example of this is the painted kayak shown [1] from the 1890s. This was collected by the explorer Nelson from the Nunivak Island people northwest of Kuskokwim Bay, Alaska.[2] The sealskin-covered, wooden-frame, two-person hunting craft is painted along its horizontal axis with an image of a mythological monster with an elongated body set on four short, stubby legs, a birdlike head, a curved crest or horn, and a thick, short upturned tail. This mythological monster, known as a *palraiyuk,* was believed to inhabit local lakes, streams, marshes, and beach areas, and to be very dangerous to people. In this case the image most likely served as a charm to protect the paddler and hunter during their pursuit of food mammals. The dense paint on this monster sets the image off against the lighter, sealskin background. The elegant linear outlines and gentle curves of the rounded tail, the chest, and the head reinforce the low, curved profile of the kayak against the background of water. Other magical images and items were to be found within and on the kayak. These included small, carved wooden charms, painted paddles, toolboxes, as well as harpoons and spear holders.

Another functional item, an ivory whaling harpoon rest [2], was carved in the shape of the upper torso and head of two benign-looking polar bears. These two images face outward from the central vertical edge of the harpoon rest, where the two pieces of carved ivory are joined by ivory dowels, and their front legs are raised upward in a somewhat anthropomorphic posture as if standing on their hind legs. On either side of the center line are incised images of two mythological thunderbirds, who are in the process of carrying off whales in their talons. Perhaps the addition of these and other mythological spirit images helped to ensure the hunter of proper magical protection when out in the Alaskan wilderness. The thunderbirds are shown with wings outstretched and appear to be moving upward while straining under the tremendous weight of the whales beneath. The simple outline of the whales is filled in by dark, vertical lines accenting the lines of the wing feathers of the thunderbirds.

Thunderbirds are important mythological spirits and appear on many examples of Es-

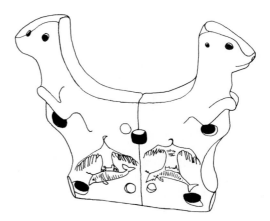

2. Alaskan Eskimo ivory harpoon rest from Cape Prince of Wales, carved in the shape of two polar bears; the lower area is incised with images of thunderbirds carrying off whales.

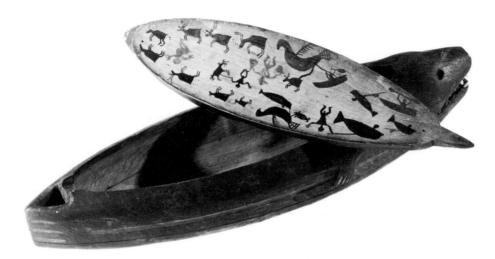

3. Alaskan Eskimo carved and painted seal-shaped wooden box from Pastolik, with underside of lid painted with various hunting, sexual, and mythological scenes.

kimo art, including the painted lid of a late-nineteenth-century seal-shaped toolbox [3] from Pastolik on Norton Sound. A series of rowlike images of caribou, whales, seals, thunderbirds, and humans can be seen as two separate scenes, one on one side of the edge, the other on the opposite side. The thunderbird in the upright scene (in the photograph) holds a caribou with one talon and an umiak with an Eskimo with the other. At the left of this thunderbird are four caribou, who appear to be in flight and who are defecating in fear of the monstrous bird. To his right is a hunting scene, with a harpoon sticking out of the back of a sea mammal. The scene which appears upside down in the photograph again depicts a thunderbird in the center. This thunderbird is grasping a whale and a seal in each talon, while four caribou run from him in fright. A large, frontally displayed hunter on the other side of the thunderbird appears to be throwing harpoons at both a whale and a seal. In the left center of the lid are three human images: a hunter who has speared a two-headed caribou, a male with top hat holding vessels, and a pregnant-looking female. The light color of the wood of

the lid serves as a ground against which the dark figures are clearly articulated, whereas the seal-shaped toolbox is painted black, with a slight reddish pigment. The white areas of the seal's front teeth and eyes serve as sharp visual accents.

Some functional objects were painted with a single image rather than the narrative images seen on the seal-shaped toolbox. One food bowl with inset ivory from the 1890s [4] has as its central image a large, beetle-like creature with a wide, toothy mouth, huge curving horns or tusks, an x-ray type of body with internal organs, and legs with clearly articulated feet and calves. The lively looking animal is set within a double-banded border following the basic curved outline of the bowl. Dark, hooklike patterns are painted on the inside of the double band within the bowl, and seven oval-shaped ivory insets appear on the upper edge of the bowl. The image does not correspond to any known animal or insect. It most likely represents a hypothetical reconstruction of a mythological creature suggested by Eskimo attempts to reconstruct the shape of prehistoric animals from fossilized mammoth bones and tusks discovered in the frozen tundra. This seems

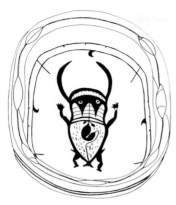

4. Alaskan Eskimo carved and painted wooden food tray from Nulukhtulogumut, with inlaid white stone lozenges; the painted figure on the interior probably represents some mythological spirit.

a likely explanation, since the large tusklike forms on the beetle-shaped image were probably based upon these prehistoric relics.

A very popular export art in the late nineteenth century was ivory smoking pipes on which elaborate graphic scenes were incised. Five long-stemmed ivory trade pipes [5] from the 1890s have shapes characteristic of Bering Sea and Siberian pipe types, which were traded into the Alaskan Eskimo area before contact with Europeans in the eighteenth century.[3] Four of the five pipes have a combination of low-relief carved images and finely incised scenes. One pipe (the third from the top) has only incised decorations. The top pipe has a series of nine small seal's heads carved in medium relief along the lower edge of

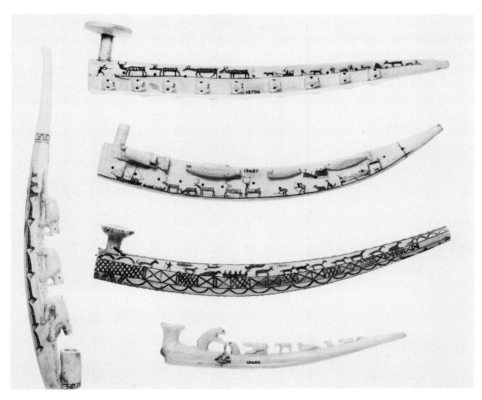

5. Five Alaskan Eskimo ivory pipes with carved and incised images. Late-nineteenth century.

the stem, beneath an incised caribou hunting scene (left side) and a dog sled and hunting scene (right side). The incised figures in both hunting scenes are depicted along a single ground line, with a great deal of narrative detail and lively body gestures. The eyes and nostrils of the seal's heads are picked out in black pigment against the white ivory, and the circular bowl of the pipe is topped by a wide, flaring disklike element. The second pipe stem lacks the flaring element on top of the bowl and has four high-relief animal images positioned along the top-side edge. They appear to be, from left to right, a bear, two seals, and some type of small whale. Beneath them is a long narrative scene depicting, from right to left, an animal in a trap, a village house, two dogs, a man with a bow, a man with a rifle, five reindeer, two Eskimo umiaks, and a European clipper ship. The third pipe has scenes of walrus-hunting from umiaks, and long-tailed animals which may be foxes. Fox pelts were a common trade item with Europeans in the eighteenth and nineteenth centuries. There is also a wide, decorative central band filled with abstract geometrical motifs with no recognizable meanings. The small pipe on the bottom and the vertically placed pipe on the left side of the photograph were each carved from

single pieces of walrus ivory. The pipe on the bottom has an animal scene depicted in varied levels of relief on the top of its stem, including images of a bear, a walrus, a dog, and a seal in diminishing size from left to right. On the top of the stem of the pipe, on the left side of the photograph, are high-relief images of two walruses and a bear, who seem to be moving toward the right in the direction of the pipe bowl. A large group of walruses is depicted in incised lines along a single ground line on the bottom of the stem. Three of these walruses are depicted as if their upper bodies and heads were sticking vertically out of the surface of the water.

Eskimo life along the Yukon and Kuskokwim Rivers and the coastal regions of western Alaska included building permanent villages with semi-subterranean dwelling and ceremonial houses. A section plan of a Saint Michael dwelling house and a Kushunuk ceremonial house is shown [6, top and bottom, respectively]. Logs are stacked in a rectangular fashion to create a large central room, lit from a skylight window and by oil lamps. Note the use of both a summer and a winter passageway in both houses in order to maintain a comfortable inside temperature beneath the sod-covered exterior walls. Persons in-

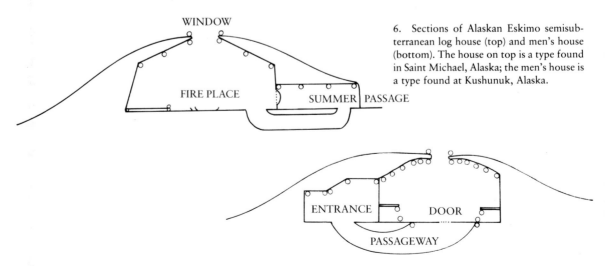

6.  Sections of Alaskan Eskimo semisubterranean log house (top) and men's house (bottom). The house on top is a type found in Saint Michael, Alaska; the men's house is a type found at Kushunuk, Alaska.

side these dwellings were usually naked or almost naked, due to the accumulated body heat, which kept the dwellings very warm. Simple sleeping benches were placed within the interior room, as were fireplaces, if needed in the dead of winter.[4]

Alaskan Eskimos used a variety of masks in the men's ceremonial house in rites performed to increase their animal food supply, and in special shamanistic medicinal and mortuary rituals. Although styles of Eskimo masks varied quite a lot from one end of Alaska to the other, the Norton Sound, Yukon River, and Kuskokwim River Eskimo peoples made masks that were very similar. Some Alaskan Eskimo masks depict an inner, human-like spirit called *inua*. Eskimos believe that every living thing has an *inua,* and Figure 7 shows an artistic interpretation of this idea. One side of this late-nineteenth-century mask depicts an elongated seal, with head and tail as sculptural forms sticking out at a slight diagonal to the ver-

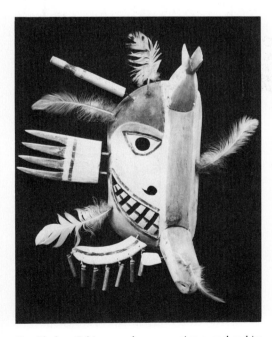

7.  Alaskan Eskimo mask representing a seal and its *inua*.

tical plane of the mask. The other side of the mask consists of a smiling half face (the seal's *inua*) with somewhat human-like placement of eyes, nose, and mouth within a squared-off half-circular face. There are additional carved elements sticking out from the half face, including a miniature harpoon shaft on top of the head and a curved flipper hanging with thin cylindrical elements beneath. White feathers are stuck into the mask on the top center, to the side of the seal's body, and on a diagonal beneath the smiling half face, thereby helping to balance the thrusting shapes of the added-on wooden elements. This split image combines clearly recognizable animal and *inua* (human-like) elements, and the protruding, added-on shapes help create an outward thrust from the center of the mask.

Another interpretation of the notion of an *inua* can be seen in a line drawing from the 1890s [8, top left] of a bird mask. It represents a somewhat anthropomorphic face with eyes like snow goggles and a nose which represents the head and upper beak of the bird whose *inua* is being shown. Six feathers radiate upward and out from the top of the head, while two large, earlike flaps are painted with simple figures of animals hunted for food. These animals include a seal, a walrus, a killer whale, a reindeer, a wolf, and a beaver. The wide range of abstraction and distortion which is commonly found in Alaskan Eskimo masks is evident in the three other masks in Figure 8. All these depict images of dangerous spirits, known as *tunghak*. The upper right-hand mask is a rounded oval shape with curved slit eyes, no nose, and a central circular hole representing a mouth. The shape of the mouth and the outer contour of the mask are echoed in a series of low-relief concentric ridges which radiate outward from the center. The only added-on features in this mask are the three feathers placed vertically on the top of the head. The lower right-hand *tunghak* mask has more easily recognizable human facial features, including a small nose, pointed downturned oval eyes, and a broad

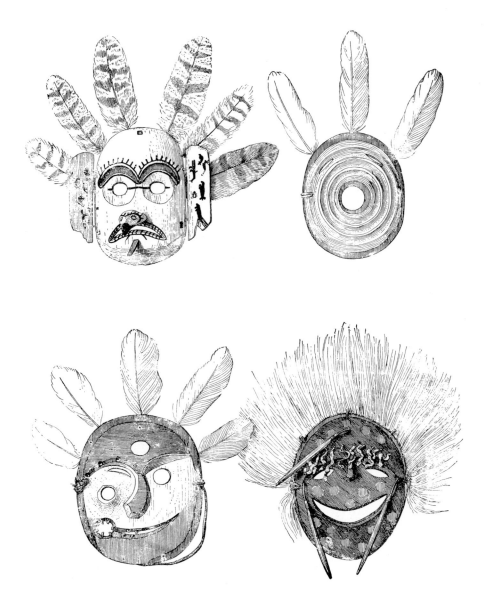

8.  Four Alaskan Eskimo masks. Top left: bird mask; other three are various forms of dangerous spirit (*tunghak*) masks.

upturned mouth. The green face with brown spots is broken up by the addition of three thin sticks, an irregular row of curled parchment strips across the forehead, and long deer hair attached to the top of the head. The fourth *tunghak* mask [8, lower left] has facial distortions in its twisted nose, multiple eye holes, and double-character mouth (slitlike on the right, circular with teeth on the left). Five feathers stick out of the top to represent hair. The use of red, green, and white paint on the face adds to the distortion.

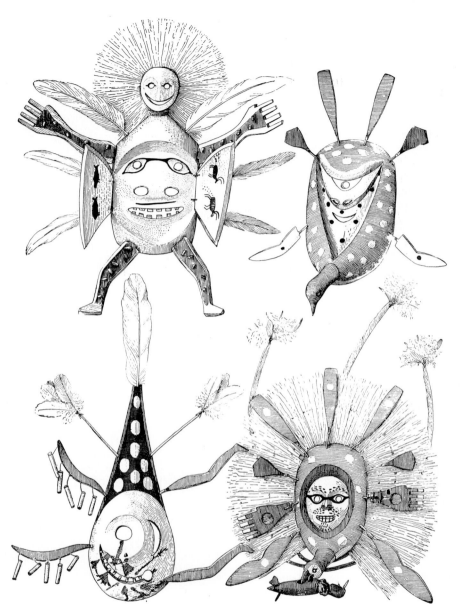

9. Four Alaskan Eskimo masks. Lower left: dangerous spirit (*tunghak*) mask; the other three may be associated with hunting and/or supernatural shamanistic powers.

A strong tendency for added-on shapes projecting outward from a central-core mask can be seen in Figure 9. These four masks include a human-like figure with outstretched arms and central *inua* face on its body (top left), a swimming bird (*guillemot*) with an *inua* face on its back (top right), a teardrop-shaped *tunghak* mask (lower left), and a puffin with a walrus in its beak (lower right). A major portion of the puffin mask is the puffin's *inua*, conceived as a smiling human-like face wearing slit snow goggles. The puffin's head protrudes outward and downward

at a diagonal and is shown biting a miniature walrus shape with tusks and tail. The puffin's body makes up the central, oval shape of the mask, on which the *inua* face is articulated. Added-on carved elements are symmetrically placed and include flipper-like shapes, hands spread open with holes in them, and paddle-like forms. These added elements create an active contour, compared to the more static bird shape of the mask itself. Symmetrically placed added elements can also be seen in the three other masks illustrated in Figure 9. This tendency to conceive of sculptural form as planar rather than three-dimensional is a stylistic trait found in virtually all Eskimo masks under discussion in this chapter.

The mask representing the spirit of bubbles in Figure 10 is yet another example of a complex symmetrical composition where elements thrust outward and move away from the flat plane of the core of the mask. The bulk of the spirit's head is a large, human-like (*inua*) face. Added-on feathers, dangling sticks, circular loops (symbolizing the bubbles rising to the surface of the water from a submerged animal), handlike ears, and flukes and fins make this mask an excellent example of active art. These masks were wearable mobiles, which moved in various ways according to the motions of the masked dancer.

In addition to using masks in hunting- and game-related ceremonies, such as the "bladder festival" and the "messenger feast," the Alaskan Eskimos created masks that were the property of and used by the shaman in various curing rituals and in special mortuary rites. Shaman's masks such as the composite mask [11] from the 1880s were often grotesque in appearance (like the *tunghak* masks previously discussed). This one represents a shaman's power spirit and includes such disparate elements as an *inua*-like face, flipper-like hands, harpoon-like shapes, squared-off eye holes, small fishlike add-ons, a miniature seal image, a rounded globular-shaped nose, and thin sticks topped with feathers. All of these ele-

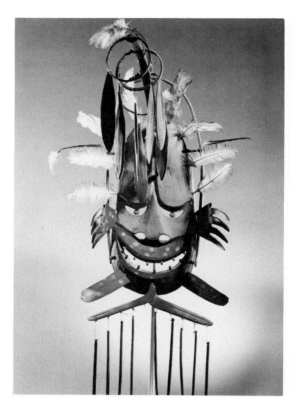

10.  Alaskan Eskimo mask representing the spirit of bubbles. Wood, string, pigment, and feathers.

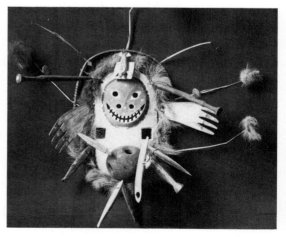

11.  Alaskan Eskimo shaman's mask.

ments add to the forcefulness of this shaman's power spirit. This tendency toward the use of composite and distorted human-like shapes is common in Eskimo masking when depicting the shaman's supernatural power spirits.[5]

Mortuary art was also found among the Yukon and Kuskokwim River Eskimo peoples. One photograph from the late-nineteenth century or the early twentieth century [12] of carved grave images from the lower Kuskokwim River documents this type of art. These wooden figure sculptures were made to stand alongside grave boxes. There are four figures in the photograph, although only the face can be seen in the lower-left figure. Three of these figures have out-stretched added-on arms (a protective gesture),

while the one on the flat backboard has remnants of clothing as well. The faces are clearly articulated, with rounded heads, broad noses, and deep-set eyes and mouths inlaid with ivory. The figure on the lower right appears to be wearing some type of decorative necklace.

The ecological environment of the Haida, Kwakiutl, and Tlingit peoples of the Northwest Coast of North America is quite different from that of the marshy tundra of the Yupik-speaking peoples of western Alaska. The entire stretch of the Pacific coast, from the Tlingit areas of southeastern Alaska to the Haida and Kwakiutl areas on the western coast of British Columbia, is rich in cedar forests, with thousands of islands and inlets

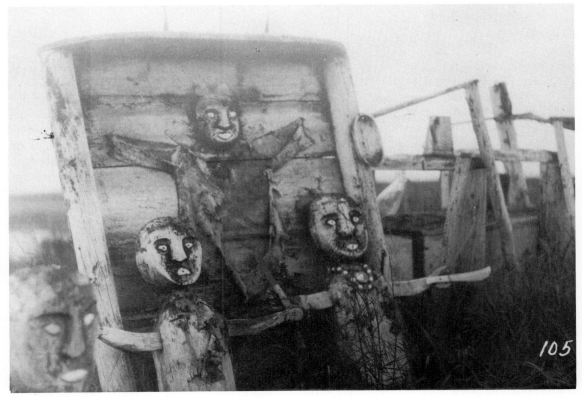

12.  Alaskan Eskimo (Kuskokwim River) memorial grave figures. Wood, cloth, and ivory.

and an abundance of mammals and fish. Inland, the forests, rivers, and lakes also abound with many species of mammals, fish, and edible plants. These rich cedar forests also provided building materials for the construction of monumental plank houses and wood carvings of massive proportions.

The Haida and Tlingit speak languages of the Na-Dene family; the Kwakiutl speak a language of the Wakashan family.

Intragroup and intergroup competition and a social system based upon totemic beliefs led to the development of clan-crest display images. These images manifested themselves in every area of cultural expression within these groups. Unlike the western Alaskan Eskimo peoples, the peoples of the Northwest Coast spent only part of their year exploiting their environment for food and useful products. In the winter season they settled into villages of several hundred or more people. Life was centered in celebrations and festivals, such as initiations, marriages, and competitive feasts (called potlatches).

Whereas the art of the Alaskan Eskimos consisted mostly of small functional items related to the hunt, or of masks which gave visible form to a wide-ranging animate world, the art of the Northwest Coast Haida, Tlingit, and Kwakiutl peoples was intimately tied to their highly stratified cultures. Totemic emblems and secret society or shamanistic spirits dominated the visual arts of these peoples.

## Art of the Haida of Queen Charlotte Islands, British Columbia

The simplified diagram of the Haida village of Skidegate [13] as it existed in the 1880s will serve as the norm for Haida, Tlingit, and Kwakiutl village layouts of the Northwest Coast.[6] The houses were usually organized in rows along the beach front, with the most important chiefs' houses near the center of the layout, and less important families occupying the peripheries. The wild forest lay behind the village while the sea lay in front, thereby limiting the village to a socially organized thin stretch of the beach. The small dots in front of the squarish houses represent both memorial poles and mortuary posts. Those attached to the center of a house represent house frontal posts. These poles and posts constitute the majority of carvings found outside Haida, Kwakiutl, and Tlingit houses. All three types were carved with clan-crest images of the type seen earlier in a Tlingit chief's house (Chapter 1, Figure 12). Exterior posts were frequently much taller and stacked with many more images than those found in house interiors. Mortuary posts were made to accommodate the corpse of a high-ranking chief or his wife and served as an elevated wooden coffin with carved, clan-crest images. The memorial pole, although taller than the mortuary post, was also freestanding and was carved with tiers of clan-crest images. A house frontal post was attached to the front of the house and had an unusual entry hole. This opening was carved into the body of a clan-crest image. Entry into the house can therefore be seen symbolically as a transformation from the secular outside world to the sacred interior. An explicit notion of symbolic death and rebirth was depicted in Kwakiutl and Tlingit art as well as in Haida art.

There are two Haida mortuary posts and a taller, memorial pole shown in the foreground of a photograph [14] of the front of several houses at Skidegate village in the 1880s. The mortuary post on the left has three clearly recognizable crest images, including (from bottom to top) a killer whale with two long dorsal fins; a mythological clan ancestor holding on to the killer whale's tail; and a supernatural spirit, known as a

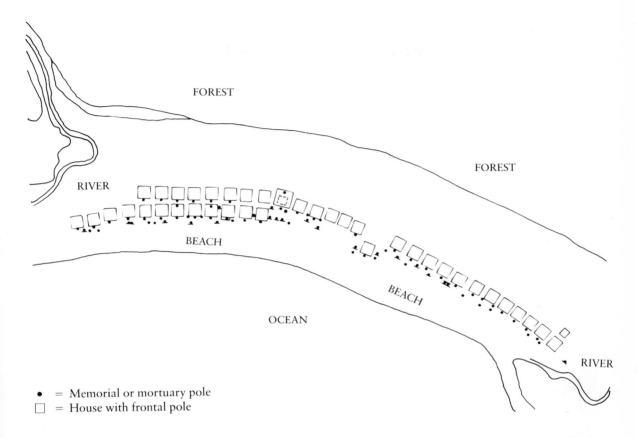

FOREST

FOREST

RIVER

BEACH

OCEAN

BEACH

RIVER

● = Memorial or mortuary pole
▢ = House with frontal pole

13. Plan of an 1880s Haida (Northwest Coast) village called Skidegate, showing the layout along the beach and location of mortuary and house frontal posts and memorial poles.

*snag,* with a four-ringed headdress on its head. This multiringed headdress refers to the number of large feasts given by the person whose body was placed in the mortuary post or on a memorial pole. This feast is known throughout the Northwest Coast as a potlatch. The mortuary post near the center of the photograph represents (at the bottom) a mythological creature called a sea-grizzly bear with what appears to be a small clan ancestor nestled beneath its mouth. Near the top of the post there is a killer whale (note the circular blowhole on its forehead) with a seal in its mouth. The plaque above has an animal crest image, possibly that of a wolf or bear. To the right side of the photograph is a memorial pole that extends upward and is said to terminate in the tail of the dogfish crest. Although the upper details of this pole are unclear, the lower crest animals include a hawk with a long curved beak and a dogfish with a dorsal fin. In the background, closer to the houses, are two additional posts, a short one with a seated human-like figure wearing a four-ringed potlatch hat, and a tall pole that is probably a memorial pole. The memorial

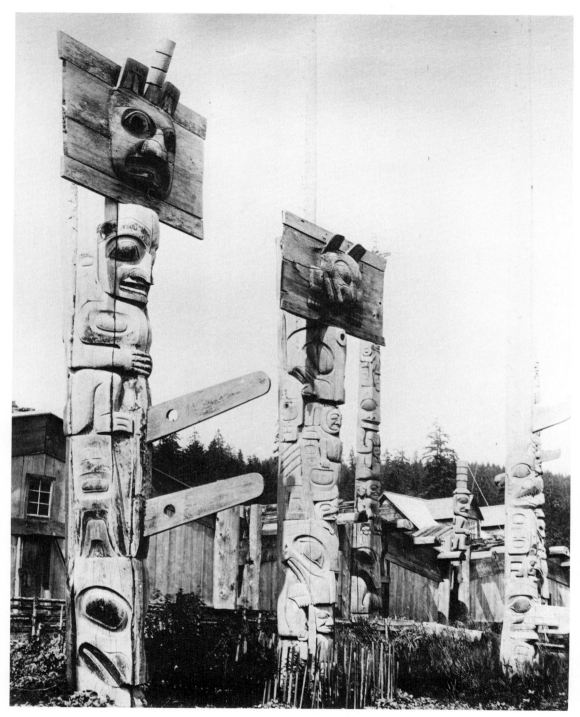

14.   Haida (Northwest Coast) mortuary and house frontal posts, and memorial poles at village of Skidegate.

40

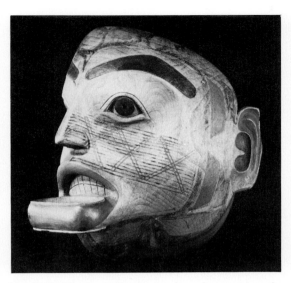

15. Haida (Northwest Coast) painted wooden portrait mask representing a female with lip plug and elaborate totemic animal crest designs.

pole has, from top to bottom, a raven (barely visible in the photograph), an image that may be a bear, and an image that appears to be a sea-grizzly bear with its cub between its ears and a raven between its paws at the bottom.[7]

All of these posts and poles are carved close to the shape of the original block (a large cedar tree), a stylistic trait common to monumental Haida carving. The only parts of the carvings which do not adhere to this aesthetic are the added-on fins and beaks, which were carved separately and joined to the carved posts. The photograph shows evidence of greatly faded polychromy, which would have enhanced the planar structure of the low-relief carved clan-crest images on the posts. (Note the ears, eyes, and mouths on the mortuary post in the left foreground.)

The restrained naturalism of four Haida portrait masks was noted and discussed in Chapter 1

[7]. An earlier female Haida portrait mask [15], from the 1820s–1840s, is very naturalistic in facial detail and expressiveness. The size of the lip plug inserted in the lower lip is accentuated in this mask. In addition, the facial planes are broken up by various clan-crest painted patterns. These include the complex pattern across the nose and left cheek, the dark patterns on the forehead, and the patterns like animal ears on the temples, lower neck, and face.[8]

One of the most popular and widespread Haida art forms, known around the world, is sculpture carved from a soft stone called argillite, which, since the nineteenth century, has been made for sale to European collectors.[9] In the early part of the nineteenth century the primary buyers were sailors and traders who worked along the Northwest Coast, but by the end of the 1800s and early into the twentieth century the making and sale of images for export had become a widespread practice and a popular local business.

These argillite images vary in adherence to traditional clan-crest images and design, depending on artistic decisions made by the individual carvers and the demands of the purchasing patrons. The group of eleven argillite carvings in Figure 16 shows a wide range of image types, including four miniaturized memorial posts (top row), four versions of single- and multiple-image smoking pipes (second row and center of the third row), and a musical instrument (possibly a flute) carved with high-relief frog and bird images (on the bottom). The memorial-post carvings in the top row adhere closely to the forms found in actual posts carved in wood, while the pipes and the musical instrument are more composite, freer in form, and more in keeping with the demands of European patrons who wanted elaborate virtuoso works for their collections.

16. Haida (Northwest Coast) argillite carvings, including miniature memorial poles, pipes, and a flute.

## Art of the Kwakiutl of British Columbia

The Kwakiutl people live on the northern end of Vancouver Island and the adjacent mainland of British Columbia. In the nineteenth century their everyday life centered on hunting and gathering, with a great proportion of their subsistence coming from the fruits of the sea. Salmon, shellfish, sea mammals, and other sea creatures provided food and other useful items for the Kwa-

kiutl. The mainland-based Kwakiutl also exploited the varied flora and fauna found in the cedar forests and in the local streams, including a wide range of mammals and fish.

Kwakiutl life was divided into summer and winter residences, with the summer exclusively oriented around gathering food resources to preserve for the long, cold winter season. During the winter, villages were moved away from the coasts to the interior, where the primary focus of life changed from subsistence to ceremony. During this ceremonial season, initiations, marriages, feasts, and dramatic performances associated with secret societies were held.

The art of the Kwakiutl includes painted architectural facades and screens, carved house posts, grave monuments, mortuary and memorial poles, as well as various ceremonial and utilitarian forms, such as masks, boxes, bowls, rattles, and weapons.[10]

Two drawings of late-nineteenth-century plank-built chief's houses [17, top and bottom] have elaborately painted facades with centralized images over the doorways. In the first, a thunderbird with outstretched wings carries off a huge whale rendered as a skeletal form across the lower width of the facade. The beak of the thunderbird is carved from wood and is attached at right angles to the center of his head, above the doorway. In the second example [17, bottom] the central totem crest represents a clan ancestor in a displayed position within a circular moon. On either side of the entrance are painted bear clan-crest images, in a similar seated, displayed position. Compared to the miniature, somewhat private two-dimensional images painted and incised on Eskimo wooden and ivory art forms, these Kwakiutl painted house facades are created as monumental public displays of clan-crest emblems. In both facade paintings there are small faces or parts of faces painted at the points where body joints articulate. These joint marks are commonly found in Kwakiutl art and even more so in Tlingit art. They may be associated with a trans-Siberian, Alaskan Eskimo, and Northwest Coast belief in spirits which inhabit all living things. Among groups of the Northwest Coast these images have been classified as clan-crest images.[11]

A pair of turn-of-the-century memorial poles [18] representing a thunderbird and grizzly bear are examples of monumental Kwakiutl sculpture. The carving of these clan totem animals does not respect the original shape of the cedar log, as it did in the Haida mortuary posts discussed previously. These Kwakiutl pole carvings are more deeply undercut, and have more of a three-dimensional presence than the Haida mortuary posts and memorial poles. The addition of carved and painted outstretched wings also contributes to the three-dimensionality of the poles. On each pole the lower grizzly bear clan ancestor holds a human figure in front of him on his chest, and the clan ancestor, in turn, holds a copper (a form of money made of copper nuggets beaten into an irregular shape) on his chest.[12] This is probably meant to suggest a protective gesture on the part of the clan totem animal toward some ancestor of the clan. Sometimes a totem animal is shown eating a small human form; usually this is a reference to vanquishing an enemy. The wings of the thunderbird are carved in low relief and painted in such a way as to suggest multiple feathers. There is a crest emblem carved and painted on the chest of each bird. Note also the ferocious expression on the faces of the grizzly bear and the thunderbird. This sort of expressionistic face is common in Kwakiutl art.

In the realm of masking, the Kwakiutl have created some of the most impressive and arresting art forms among all the peoples of the Northwest Coast. One can divide the masks of the Kwakiutl into two broad groups: those used by the cannibal society (called Hamatsa), and those used by the supernatural gift-giver society (called Dluwalakha). In many ways these masking societies embodied concepts associated with either uncultured or cultured spirits and forces.

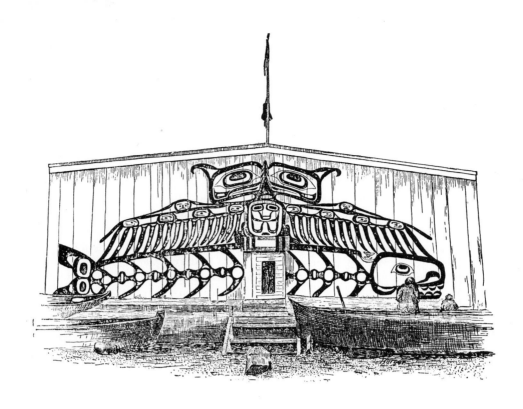

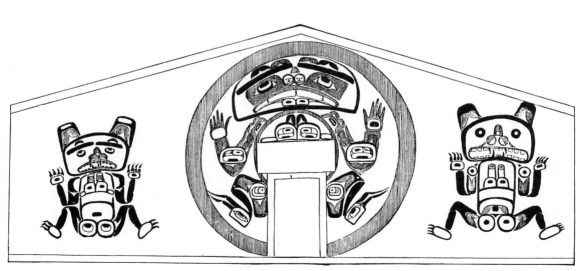

17. Kwakiutl (Northwest Coast) plank-built chief's houses with painted facades. Top: thunderbird carries off a whale. Bottom: clan ancestor within circular moon flanked by bear clan images.

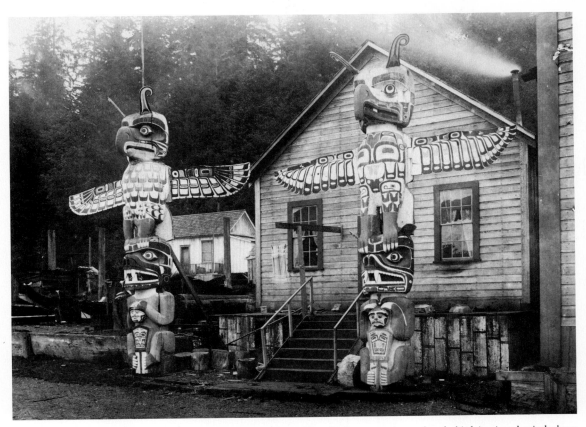

18. Kwakiutl (Northwest Coast) memorial poles (probably at Alert Bay) representing a thunderbird (top) and grizzly bear (bottom) clan crests.

The cannibal society is associated with forces of the primordial forest and spirit world, while the gift-giver society is more concerned with the hierarchical status system of clan emblems and privileges.

The masks of the cannibal society tend to embody powerful spirits often engaged in uncivilized behaviors—those which are dangerous to man's well-being. The cast of characters depicted in these masks includes the cannibal woman Tsonoqua; her husband, the wild man of the woods Bookwus; a fool called Nulmal; a sea monster spirit called I-Akim; a long-beaked, skull-cracking bird known as Hoxhok; a raven spirit helper; several multiple-headed cannibalistic spirit masks; and several masks which could change into two different identities during a ceremonial dance.[13]

Four cannibal-society masks and two gift-giver society masks are illustrated in Figure 19. The outer two masks in the top row are cannibal-society masks representing a sea monster spirit (on the left) and a wild cannibal woman mask (on the right). Between them is a sun mask used by the gift-giving society. The two masks on the bottom represent variations of cannibal-society wolf and bear masks (left and right, respectively). Each has a small human head in its mouth to represent its cannibalistic nature.

The wild cannibal woman mask (upper right) is facially very expressive, with bushy black eyebrows and hair, sunken cheeks, and half-closed eyes indicating her lumbering, sleepy quality. Even though this forest giantess was feared because she gathered up children to take home to eat, she was stupid and was normally outwitted

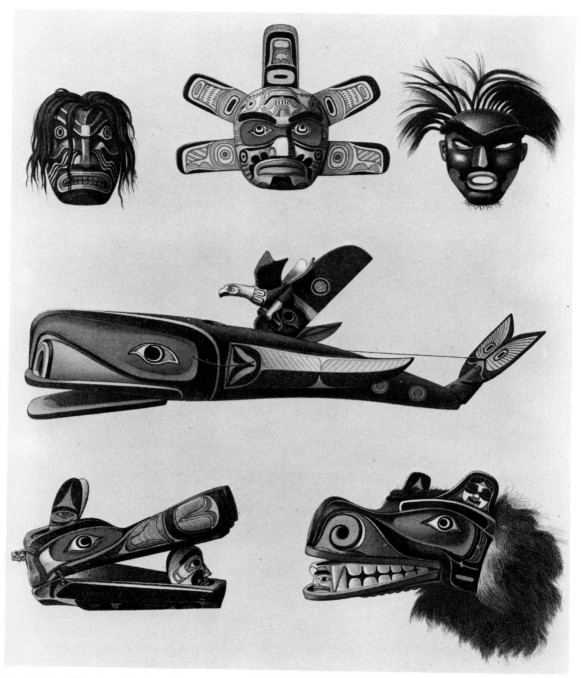

19. Kwakiutl (Northwest Coast) masks.

by them. The children were able to steal away the vast treasures she had secreted in her home in the woods before they escaped back to their home villages. The sea monster (upper left) was also a feared supernatural and was thought to live in the sea and in rivers. It was often depicted as an anthropomorphic spirit, or sometimes as having a mixture of human and fish characteristics. The killer whale mask in the center, with an eagle crest image astride his fin, is over six feet in length and was used by the gift-giving society for entertainment and dramatic effect (its flukes and tail are movable).

Sometimes the image of the cannibal woman was made into a dramatic functional object, such as a large feast dish [20]. By serving ceremonial food to the assembled cannibal society from the breasts, navel, and body of the cannibal woman, members were engaging in a type of symbolic cannibalism. Anthropomorphic vessels are unusual in most societies, although they are found in Hawaii (see Chapter 10) and among the Kuba of Zaire (see Chapter 7).

The nineteenth-century fool's mask [21] is one of the human-like masks that may, in fact, have been inspired by early contact with carved or printed images of lions. Note the extent to which the fool's mask has feline markings and de-

21. Kwakiutl (Northwest Coast) fool's mask (Nulmal).

tails, and in general appears to be lion-like in inspiration.[14]

The sea monster spirit called I-Akim was believed to cause rivers to jam up, to make lakes unnavigable, and sometimes to swallow canoes full of people. Sometimes this sea monster was portrayed in a multiple-faced transformation mask—a type of mask used throughout the Kwakiutl area. During a masked performance, when the story line dictated a change in character and required the transformation from a sea monster or a bear into a dreaded cannibal spirit, the dancer wearing the transformation mask would briefly turn away from his audience and pull on hidden strings beneath the mask, which would

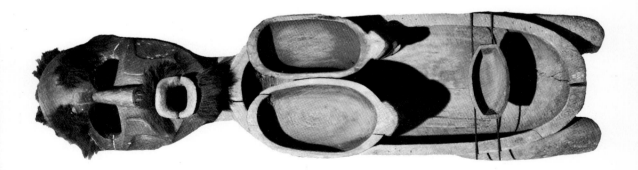

20. Kwakiutl (Northwest Coast) cannibal society feast dish in the shape of a cannibal spirit woman (Tsonoqua).

make the outer mask split apart to reveal the new spirit identity beneath, as if by magic. Some authors have suggested that there is a similarity between some Northwest Coast multiple-spirit masks and the Eskimo masks which show an *inua,* the small human-like spirit which resides in all living things.[15]

One example of a transformation mask representing a sea monster spirit [22, top] has an outer, fishlike face and an interior, human-like form. Similar outer-animal and inner-human faces occur in the bear spirit transformation mask illustrated at the bottom of Figure 22.

If we think of the cannibal-society masks as being associated with powers of an uncivilized,

somewhat shamanistic sort, then the masks used in the gift-giving society are more closely tied to totemic beliefs and high-ranking or chiefly status. There are many animal, human, and natural phenomena mask forms used by this society. These include representations of animals such as the eagle, deer, bear, halibut, and other fish, as well as human ancestors and a wild man spirit called Geekumh. There were even masks representing the sun [19, top center] and echoes [24]. The animal masks were often a mixture of anthropomorphic and zoomorphic forms, with form lines painted against a dark background of deeply carved planes, and visual accents at the eyes, eyebrows, nose, and mouth. Some basic attributes

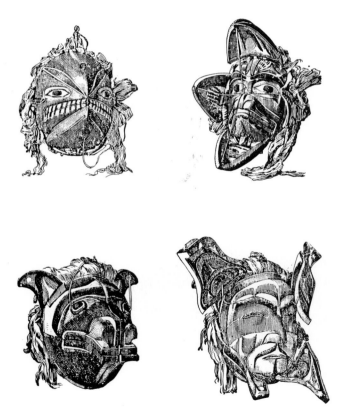

22. Kwakiutl (Northwest Coast) transformation masks. Top: sea monster/human composite. Bottom: bear/human composite.

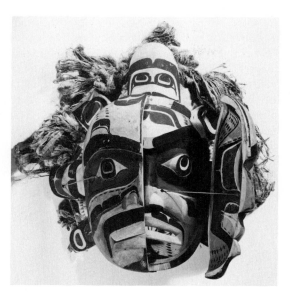

such as a curved beak, antlers, toothy mouth, or flat body with tail are easily identified in masks representing such animals as an eagle, deer, bear, halibut, or killer whale [19, center]. The late-nineteenth-century transformation mask representing the sun [23] has a very anthropomorphic face set within a radiating halo of painted wooden rays that are attached around the periphery of the mask. The finlike shapes of the sun's rays are painted with ear and eye shapes and are probably based upon fish or sea mammal fins. While the outer mask face (partly open and partly closed in this example) is bear/human-like, the face within is more naturalistic.

Natural phenomena such as sounds heard echoing off the cliffs and waterways were given visual expression in an unusual mask called an echo mask [24]. The mask illustrated here has a total of nine removable mouth pieces, each repre-

23.  Kwakiutl (Northwest Coast) transformation mask representing a sun/human composite.

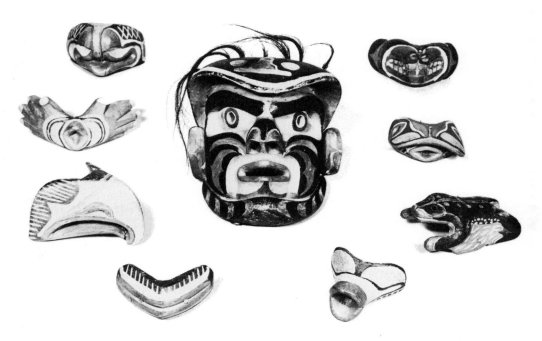

24.  Kwakiutl (Northwest Coast) echo mask with nine detachable mouths.

senting a different creature, whose sound and story are being enacted by the masked dancer. The mouths of the wild man of the woods, a bear, a frog, an eagle, a cannibal woman, and a killer whale are clearly recognizable, whereas it is unclear which animal or personage is meant to be portrayed by the remaining two mouths.

Human ancestor masks among the Kwakiutl are more naturalistic than those of animals, and, like those noted among the Haida, frequently have clan totemic patterns painted on the face as a form of ownership marking. The clan markings on the human ancestor mask in Color Plate 2 are more extensive than those on either the nineteenth-century Haida masks discussed in Chapter 1 [7] or the Haida portrait masks discussed in this chapter [15]. This striking example of a human ancestor mask, from about 1825–1875, has a low-relief carved and painted moustache and an animated, almost smiling facial expression. The light background color creates a negative form next to the clan-crest pattern. Sometimes this negative form can be read as a positive form— creating an ambiguity between figure and ground. This reversal of figure and background is common in Kwakiutl art.

## Art of the Tlingit

The Tlingit, from southeastern Alaska and the adjacent areas of British Columbia, were a highly stratified group with chiefs and a history of ancestral worship in a complex totemic belief system. Family and totemic clan names were an important aspect of a Tlingit's identity, and various art forms served as visual symbols of these totemic ancestors. They also served as prestige display objects and as part of a visual system of ranking and placement within the society. Intergroup and intragroup competition, often manifested in gift-giving potlatches, created a need for various items of prestige and wealth. These were either worn on one's person or were made conspicuous by their size and elaboration as carved memorial, house frontal, and mortuary poles, or interior house screens and posts.

A group of Tlingit men and women [25], wearing traditional clan-crest–related clothing, headdresses, and facial painting, and carrying rattles and display staffs, shows the extent to which prestige and totemic emblem display played a part in their lives at the turn of the century.[16] Two of the men wear Chilkat blankets draped over their shoulders and backs. The pattern on these woven prestige blankets consists of various animal crest images broken down into several symmetrically organized design units. Three of the men wear carved or woven clan hats topped by animal crests and/or potlatch rings indicating the number of potlatches they had held. Many of the men and most of the women wear decorative beadwork and "button blanket" decorative vests and shirts, some in traditional Tlingit styles, others with a more elaborate floral pattern in keeping with late-nineteenth-century European and Great Lakes Indian decorative design.[17] Ornamental nose rings and clan-related facial painting are evident on many faces. Two long carved chief's staffs and one large chief's rattle (in a bird shape) can be seen in the background, sticking out above the assembled men and women. A more detailed discussion of some of these art forms follows.

Drawings of six examples of Tlingit animal crest facial paintings [26] show the varied design patterns used in this type of self-decoration.[18] The top three include, from left to right, a clearly recognizable octopus body, the upper back and dorsal fin of a sea monster, and the bear-tail fin of a sea monster. The remaining three facial patterns represent, from left to right, the tracks and tail of a bear, the paws of a sea monster, and the mouth of a sea monster. Another type of Tlingit

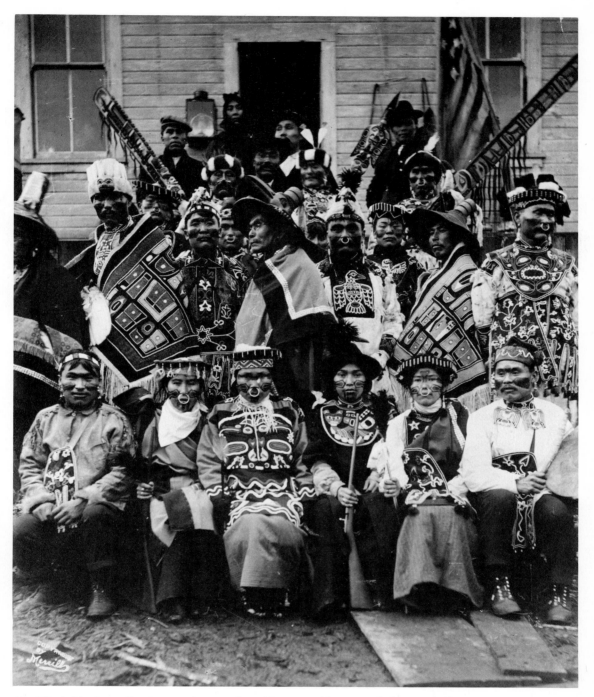

25. Tlingit (Northwest Coast) men and women dressed in ceremonial costumes before a potlatch.

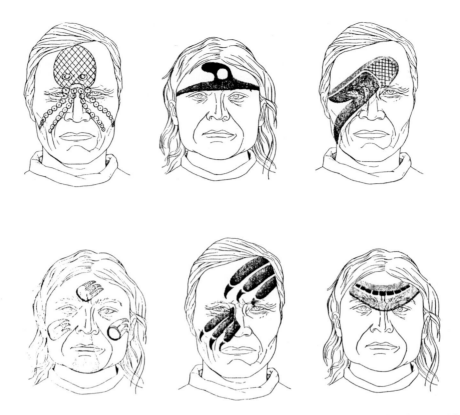

26.   Tlingit (Northwest Coast) facial painting designs representing various animal crests. From top left to bottom right: octopus, sea monster dorsal fin and back, bear-tail fin of a sea monster, tracks and tail of a bear, paws of a sea monster, mouth of a sea monster.

two-dimensional design, less clearly readable than the facial painting designs just discussed, can be seen on Chilkat blankets.

The woven mountain-goat-hair blankets called Chilkat were considered prestige objects *par excellence* among the status-minded Tlingit chiefs, and were named after the mainland Tlingit group that specialized in creating them.[19] Not only were they worn as objects of impressive beauty and design, but they were also given as presents in various ceremonies, including marriages and potlatches. Sometimes, when intergroup competition ran high, these beautiful blankets were purposely destroyed in a fire to show off one's great wealth in worldly goods. The Chilkat blanket

shown in a turn-of-the-century photograph [27] is seen next to the painted pattern board which served as a design tablet for the woman who copied the pattern into woven textile. The pattern board was painted by a man skilled in painting traditional clan crests and other totemic patterns. Afterward, a woman skilled in twined weaving would execute the overall design. One can see in the two forms in the photograph that the final result, a complex composition including a bear with young (on its head in the center), sticks closely to the design painted on the wooden pattern board. The symmetrical placement of subsidiary profile and frontal faces, and ear, eye, and paw shapes is common to two-

dimensional and low-relief Tlingit art. The beige and white areas of design tend to create a confusing figure-ground relationship, while the black lines serve as a background outline. When the blanket is wrapped around a person's shoulders and drawn over the front of the body, the outer lateral rows of patterns form diagonal winglike abstract shapes with varied clan-crest designs.

Many carved, woven, and painted objects of a functional nature were decorated with clan-crest images as well. The eagle, shark, and killer whale crest helmets from the late-nineteenth century in Figure 28 show three types of clan prestige wood

carvings of a display nature. The eagle crest helmet has a well-defined eagle head and beak with low-relief outstretched wings carved along the middle and lower portions of the helmet. Added-on human hair, paint, inlay of shell, and thin sheets of copper (on the eyes) help create a striking display of clan affiliation. The upper-wing region has a low-relief horizontally placed face on it. A similar face appears on the chest of the eagle just above the high-relief talons. The shark crest helmet [28, center] has a large bulging head with oversized rounded lips and a round eye placed on the raised forehead. To the side and

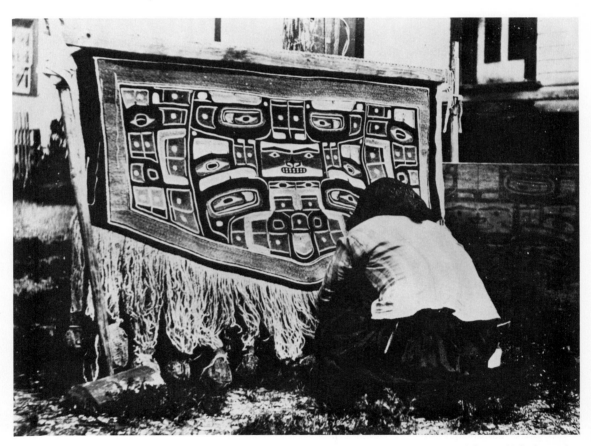

27. Tlingit (Northwest Coast) woman weaving a Chilkat blanket next to a painted pattern board from which she copies clan-crest patterns.

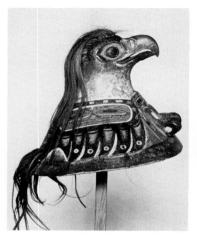
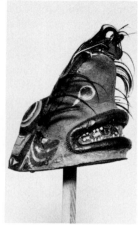
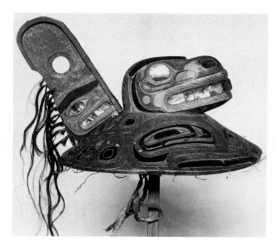

28. Tlingit (Northwest Coast) carved wooden clan-crest ceremonial helmets. Left: eagle crest helmet. Middle: shark crest helmet. Right: noble killer (whale) crest helmet.

toward the back of the head are painted metal sheets indicating the shark's gills. Human hair has been added to the sides of the face, and sheet copper has been used on the eyes. Animal teeth, sheet copper, and shell inlay have been added to the mouth. In addition, the back of the shark helmet has a large-eyed face painted in several colors. The head, protruding dorsal fin, and base of the killer whale crest helmet [28, right] are carved in various levels of relief, with inlay of abalone shell and painted surfaces.[20] The secondary faces, eyes, and ears found over the hat are consistent with Tlingit style. Small body parts such as these are frequently added to the surface of Tlingit art forms (as in the rain screen, Chapter 1, Figure 12).

Clan-crest animal images were also depicted on functional items such as a wooden dish used to contain fish fat and oils [29]. In this example the dish has been carved into a three-dimensional beaver form, complete with legs, tail, and head. Decorative inlay and low-relief patterns on the surface are common in Tlingit art. In some low-relief versions of these dishes, the treatment of the animal image was closer to the designs seen

on the Chilkat blanket discussed previously.

Two additional examples of clan-crest display images are shown in a turn-of-the-century photograph [30] of two carved memorial poles and a Tlingit man wearing a crest hat with potlatch rings. The pole on the left depicts a composite killer whale and a human ancestor, with a small secondary crest image below. The two fins on the two-headed killer whale crest image are attached to a three-ringed potlatch emblem above. This whale image serves as a hat for the human ancestor, who has his knees pulled up to his chest in a seated pose. The small crest face below has a set of arms and feet carved on either side of its head. To the right is a second memorial post, topped by

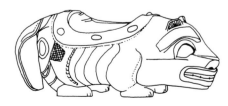

29. Tlingit (Northwest Coast) carved oil dish in the shape of a beaver.

30.  Tlingit (Northwest Coast) memorial poles at Wrangell, Alaska. Left: killer whale and human ancestor. Right: bear. The man wears a carved crest helmet and carries a double-headed killer whale crest emblem.

a three-dimensional bear who appears to be grasping the top of the post. Incised bear paw prints are carved into the post as if leading toward the bear above.

In Chapter 1 the carvings found inside a Tlingit chief's house were briefly discussed. A plan of the house [31] shows that it was nearly fifty feet square and had a large, sunken, square-shaped central gathering area with a fireplace. The door was set opposite the chief's private quarters, which were, in turn, set off from the rest of the interior space by a low-relief painted room-divider screen with the image of the rain spirit on it (Chapter 1, Figure 12). On either side of the screen were monumental posts carved with images of clan ancestors. These posts served as story posts illustrating central characters in clan myths. To the right of the screen was a "wood-worm post," with the image of a girl from a Tlingit story who fondled a woodworm, which she holds in her hands. A pair of woodworms sit on her head, and their heads become the girl's ears. Beneath the image of the girl is a crane with a frog in its bill. This post alludes to the tree, where the woodworms live; to its upper branches, where the crane alights; and to its roots, where frogs live. The opposite post, to the left of the screen, represents the "raven post," which illustrates a story about the capture of the king salmon. In this composition the raven ancestor is holding a human-like head with projecting tongue. The shape coming out of the raven ancestor's mouth is known as a "telling-lies raven," and, at the bottom, a flat fishlike head represents the salmon.[21] In front of the screen and posts are eleven Tlingit people of various

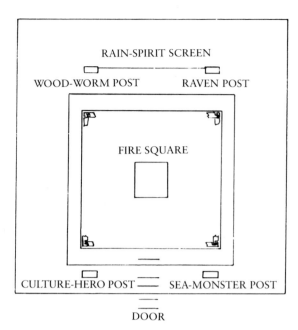

RAIN-SPIRIT SCREEN

WOOD-WORM POST          RAVEN POST

FIRE SQUARE

CULTURE-HERO POST ——— SEA-MONSTER POST

DOOR

CHILKAT WHALE HOUSE

31.   Plan of Tlingit (Northwest Coast) whale house, showing the location of interior rain screen and carved clan-crest posts.

ages, some of whom are wearing carved or woven helmets similar to those discussed earlier [28]. Others wear decorated aprons or blankets, all of which have totemic clan emblems painted or woven on their surface. These emblems are similar to those on the Chilkat blanket already discussed [27]. Two bent cedar wood storage boxes (called kerf boxes), with low-relief clan emblems on the four sides, can be seen in the center of the photograph, beneath the circular entrance to the chief's private quarters. These are larger versions of the smaller fat and oil dish mentioned earlier [29]. When one enters the chief's quarters through the room-divider screen, one is symbolically entering the body of the rain spirit. When exiting, the reverse takes place—a process that could be seen as a symbolic death and rebirth. The screen itself is made up of several low-relief

planks. When these planks are placed together vertically they create a large, frontally displayed rain spirit image, with small figures representing rain drops splashing off the ground. Faces are painted on the raven's eyes, nose, mouth, ears, hands, and legs (not shown). This face or body motif at organs of perception (especially eyes, ears, nose, and mouth) and at joints of the body is a stylistic device common to Tlingit two-dimensional design and relief sculpture.

Two interior house posts [32] that were found opposite the rain spirit screen, on either side of the entrance door, are also examples of elaborate clan-crest–related images. On the right side of the door stood a post representing a type of culture-hero sea monster [32, left]. The sea monster is depicted as a large anthropomorphic figure holding a whale in front of him, with its head between his feet and its tail in his mouth. His child peers over his head, holding a hawk in its hands, while a woman reclines on the back of the whale. The small face in the blowhole center of the whale's head represents a raven, a central character in the clan myth. To the left of the door is a post which represents a clan hero called "black skins," who is shown splitting apart a sea lion [32, right]. The hero stands on top of a head which represents the island where the hero tore apart the sea lion. The sea lion's flippers are pulled back beneath the hero's forearms and placed over his shoulders, and the protruding tongue coming out of the sea lion's mouth symbolizes its death.[22]

Sculpture on the outside and in front of the house was much less elaborate than the complex sculpture found within a Tlingit chief's house. (Compare the Tlingit interior in Chapter 1, Figure 13, with the clan-crest poles in this chapter [30].) However, totemic crest themes and lineage-related imagery were the primary motifs for house frontal, mortuary, and memorial poles placed at the entrance and in front of the chief's house.

The shaman in the Tlingit culture was seen as a liminal character, in a position somewhere be-

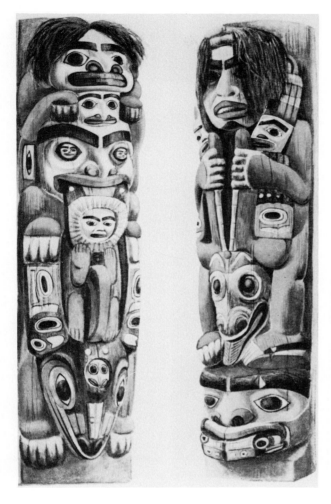

32. Two interior Tlingit (Northwest Coast) clan house posts, representing a sea monster (left) and a clan hero splitting a sea lion apart (right).

tween "civilized" culture and the "wild" creatures and powers of nature.[23] He served as a medicine man, a diviner, and as a protector of wild game. He underwent special training in the detection, diagnosis, and cure of illnesses, and he had special "spirit helpers" that accompanied him in dangerous missions against such evil forces as spirits and witches. Most natural phenomena, illness, and death were attributed by the Tlingit to the evil doings of these spirits and witches. The shaman's spirit helpers were often animals who served as his aides during his life-

time. Spirit helpers sometimes took human form as well. Both types are found as sculptural and painted images.

The front and back views of a shaman's grave guardian figure [33] from Klukwan village show examples of animal and human images associated with shamanistic powers. This figure was placed with other figures and with paraphernalia of the shaman at his grave on the outskirts of the village. The image is very naturalistic in proportion, details of musculature, and body definition, and has an expressive face with an open mouth, as if

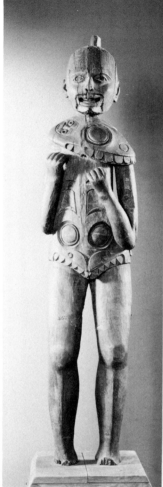
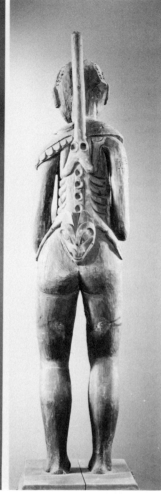

33. Tlingit shaman's grave guardian figure (front and back views) from Klukwan village, Alaska.

singing or uttering sounds. There is a large land otter with octopus suckers along his spine placed on the guardian figure's back. Its tail is raised vertically over the human figure's head. A mantle over the shoulders and an apron over the lower torso both have crest animal images carved in medium relief. The upraised arms over the chest were probably a stylistic device so that the figure could hold a weapon, rattle, or some power amulet. This figure had additional wrappings of skins, which partially hid the elaborate carving on its body.[24]

Masks of various types were used by Tlingit shamans to represent spirits in their service. These were often placed in the shaman's grave house after his death; in the late-nineteenth century several sets of these masks were collected and now reside in ethnographic collections in the United States.[25] Three masks collected from a shaman's grave at Yakutat Bay in 1886 [34] represent (from top to lower left to lower right) a man with octopus facial painting patterns, the spirit of a shark, and a bird—perhaps a hawk. The two human-like masks have facial patterns which identify the animal represented (that is, the octopus facial painting includes tentacles with

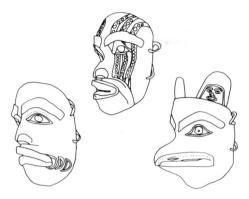

34. Three Tlingit (Northwest Coast) shaman's masks from Yakutat Bay, Alaska. Top: mask with octopus facial painting. Left: shark spirit mask. Right below: hawk(?) mask.

suckers, and the shark mask has gills). The bird mask has an extended, hawklike beak.

Sometimes a shaman's helping spirit mask was an elaborate multiple-figure composition. This type usually consists of a central, human-like head with various animals placed on it or coming out of its surface. The shaman's mask illustrated here [35] has a central human face, with a wolf image in high relief on the forehead and six low-relief land otter bodies arranged around the sides of the chin, cheeks, and forehead. The nose is extended beyond the toothy mouth in a shape which suggests a sockeye salmon.[26] The dramatic intensity of the central humanoid face and the inclusion of power-oriented wolf and land otter images help to make this mask a masterpiece of expressive art in the service of the Tlingit shaman.

Two other art forms used extensively by the Tlingit shaman were rattles of a type called "oyster catchers" and carved ivory charms (sometimes known as "soul catchers"). The rattle from the mid-nineteenth century in Color Plate 3 differs from a type frequently used by chiefs, which depicted a raven, in that it depicts a crane which dives for oysters along the coast. Also, the imagery carved as part of the scenes on top is more varied and deals specifically with power manipu-

lation by the shaman. The rattle shown here consists of a large crane with a long, somewhat straight beak and head pointing downward at right angles to its body. On top is the head of a mountain goat, with the backward-curved horns thrust between a small group of figures. Within this group is a witch, whose hair and arms are pulled back by a small, human, shaman's helping spirit. Small, froglike figures also symbolize the supernatural spirit helpers of the shaman. As was noted previously, in our discussion of a shaman's mask, the various animal and human images found on these Tlingit oyster catcher rattles represent helping spirits of the shaman.

Since it was common for the Tlingit to attribute sickness and death to the intervention of witches or some other evil spirit, the shaman had as part of his ritual gear intricately carved ivory

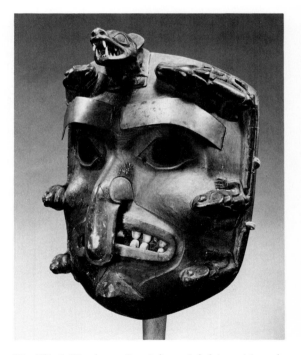

35. Tlingit (Northwest Coast) shaman's helping spirit mask with human, salmon(?), wolf, and land otter forms. Wood, copper, pigments, and ivory.

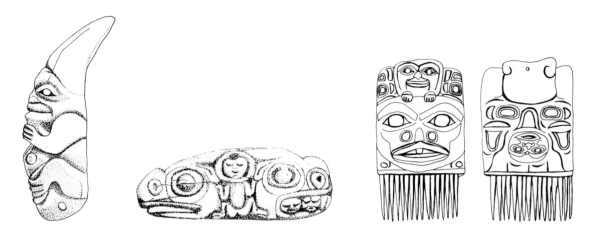

36. Tlingit (Northwest Coast) shaman's amulets (top left and right) and two views of a chief's comb carved with clan-crest images (bottom); the bear-tooth amulet is shaped into a seated human form. The second ivory amulet is shaped into a double-headed sea monster eating humans. The wooden chief's comb (from Yakutat, Alaska) represents a bear clan face on one side and a spirit face on the other.

and bone amulets. He used these to retrieve the soul or spirit substance of the sick person in order to render a cure. These amulets are known throughout the Northwest Coast as "soul catchers."[27]

Two examples of the shaman's charms and the front and back views of a chief's comb are illustrated in Figure 36. Two different types of charms are represented—one less complex than the other. In the bear-tooth charm (left) a seated figure faces to the left in profile. Although the sculpture still has the pointed top of the bear tooth as a recognizable shape, the lower body of the figure is deeply carved in relief, thereby altering the original smooth, curved tooth shape. In the second example, a two-headed sea monster (second from left), one of the monster heads appears to be devouring human-like images, while the other head contains nothing. In the center of

the sea monster body is a frontally placed image that looks like a helping spirit placed there as a mediating element. A centralized clan-crest bear image appears on the front of a chief's comb [36, right], and an inverted small face appears on the back. On the head of the clan-crest image is a small creature with its hands showing. This may represent a spirit helper of the chief.

Whereas the art of the Alaskan Eskimos focused primarily on hunting and on shamanistic images, the art of the Haida, Kwakiutl, and Tlingit peoples of the Northwest Coast emphasized totemic crest imagery as well as shamanistic powers. The art of the Southwestern United States, in contrast, focuses more on agriculturally oriented symbolism, and less on hunting and gathering. The Southwestern cultures under discussion in Chapter 3 will include the Hohokam, Mogollon (Mimbres), Anasazi, and Hopi.

# 3

# Art of the Southwestern United States

Hunting and gathering, which were the primary means of subsistence for the Eskimo and Northwest Coast tribal peoples, were also important for the Hopi and the pre–European contact peoples of the Southwestern United States, but these peoples also relied on food grown by various agricultural methods. The natural environment of the Hohokam, Mogollon, and Anasazi cultures and of the Hopi people ranges from desert grasslands to sagebrush scrubland, piñon-juniper or juniper-piñon woodlands, to ponderosa pine forests, and, at the highest elevations, mixed coniferous forests (pine, spruce, and other fir trees). Throughout the four corners area, where Colorado, Utah, Arizona, and New Mexico intersect, native peoples of the region hunted elk, deer, antelope, mountain sheep, rabbits, fresh-water fish, rodents, and various birds. Local flora includes various nuts and berries, cacti, grasses, and leafy greens. Various water storage and irrigation systems were developed by the peoples of this region, and the most common cultivated foods were corn, squash, and beans. During the later pre–European contact period, between about A.D. 1100 and 1400, their buildings and villages ranged from small hamlets of several families to centralized communities of slightly over a thousand people. The pre–European contact Hohokam, Mogollon, and Anasazi peoples of this region probably spoke some dialect of an Uto-Aztecan language, as do the present-day Hopi of Arizona. In some areas, adobe bricks, mortar, and stone were used in combination with wood for the construction of multistoried communal complexes. Among the Anasazi, defensive strategies were employed by building large communal complexes in overhanging cliff faces and/or by creating self-contained, walled-in housing units.

This chapter focuses on three pre–European contact Southwestern art traditions—the Hohokam, Mogollon, and Anasazi [see Map 5]—in addition to the traditions of the Hopi peoples of northern Arizona. The pre–European contact art traditions covered here have varied art forms, including two-dimensional painting and petroglyphs, as well as ceramics and sculpture in various media.

## Art of the Pre–European Contact Hohokam Culture

The Hohokam peoples first settled in the area of southern Arizona around the Gila, Salt, Verde, and San Pedro Rivers about 200 B.C., after having moved north from western Mexico [Map 5].[1] Their art forms included painted ceramics, carved stone palettes, mixing bowls, figures in

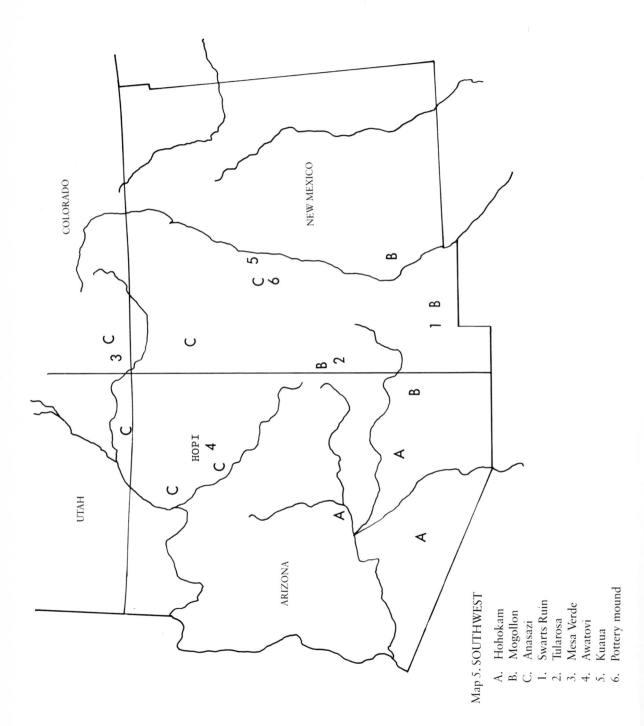

Map 5. SOUTHWEST

A. Hohokam
B. Mogollon
C. Anasazi
1. Swarts Ruin
2. Tularosa
3. Mesa Verde
4. Awatovi
5. Kuaua
6. Pottery mound

both anthropomorphic and zoomorphic shapes, ceramic animal and human figures, as well as etched and cut-shell ornaments. There were also examples of inlaid mosaics of turquoise and semiprecious stone set in shell and used as jewelry.

The Hohokam were both farmers and hunter-gatherers. And, at an early date, they used irrigation as part of their agriculture. There is some evidence of "Mexican" influence in Hohokam culture, including the practice of irrigation, the use of ceremonial ball courts, and the importation of cast-copper bells.[2] The art forms are consistent with a culture with a strong hunting-gathering component and to a large extent reflect an interest in varied animal forms as well as human images engaged in ceremonial behaviors. A very common stylistic trait in Hohokam painted ceramic design is redundancy. Motifs are repeated over and over again, often covering the entire painted surface of a vessel. This is especially true of patterns on painted ceramics from the Santa Cruz period, c. A.D. 700–900. During the Sacaton period, from c. A.D. 900–1200, the designs were more often set within definite bands of repetitive patterns, with more complex animal and human motifs. Frequently, human figures were depicted in rowlike groups engaged in dancelike activities.

Some examples of Hohokam painted ceramic jars give one some idea of the redundancy and geometric simplicity so common to their ceramics. In an example of a Hohokam painted ceramic with human images from the Santa Cruz period [1], figures are painted on the inside of the flaring bowl. There are four pairs of figures, with one of each pair a bent-over figure playing a flute, and the other a supporting one. The compositional arrangement of the bowl is somewhat random and asymmetrical, and each pair of figures is contained within a curving bloblike shape, with the red stick-figure images clearly set off from the background buff color. The containing outline forms in red around each pair and the parallel lines separating the surface into four distinct

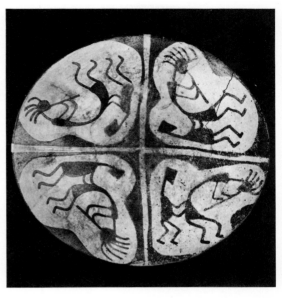

1. Hohokam (Southwest) painted shallow ceramic bowl with flute player and attendant figures. Santa Cruz period, c. A.D. 700–900.

zones help to create a continuous patterned background from which the figures can clearly be seen. The patterns and contained images on the vessel do not respect the edge of the bowl, and some appear to extend beyond the edge of the bowl shape.

The second example [2], a jar from the Santa Cruz period, is globular in shape with a continuous row of connected geometrically shaped figures who appear to be holding hands and dancing in a counter-clockwise direction around the middle and lower portion of the jar. There is a repetitive, curving, arclike ground line beneath their feet. Above their heads there is a series of slashing, diagonal lines and upward-pointing dark triangular patterns, which create a band oriented in the same direction as the dancing figures. The inside of the lip of this jar is painted with small triangular shapes that echo the triangular patterns encircling the bottom of the neck on the outside. Each figure is composed of a circular body, angu-

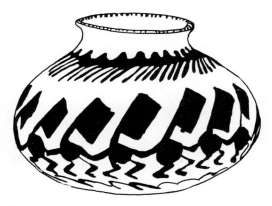

2. Hohokam (Southwest) painted ceramic jar with lines of dancing figures. Santa Cruz period, c. A.D. 700–900.

lar and bent arms, legs, neck, and a large rectangular head tilted forward as if to suggest they are leaning slightly downward. Each figure shares its arms with the figure next to it on either side so that the entire group is seen as continuous, flowing, and animated in a dancelike movement.

One wide-flaring painted jar [3], also from the Santa Cruz phase of Hohokam culture, has three horizontal bands of small stick-figure shapes encircling the body of the jar in a counter-clockwise direction. They are thin and separated from one another, yet, like those in Figure 2, they appear to be moving around the jar in a continuous dancelike pattern. The three figurative bands

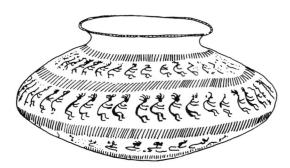

3. Hohokam (Southwest) painted ceramic jar with multiple rows of bent-over dancing (?) figures. Santa Cruz period, A.D. 700–900.

are separated from each other and from the base and lip by bands of diagonal lines encircling the entire circumference of the jar. Once again the dark figures are clearly differentiated from the light background.

Another ceramic jar [4] is more nearly cylindrical in overall shape, and the standing, inter-connected figures are much more human in proportion and details than those in Figure 3. This bowl also has a continuous band of curvilinear, arclike patterns above and below the figures, which helps to set them off against the lighter-colored background. Once again, the upper edge

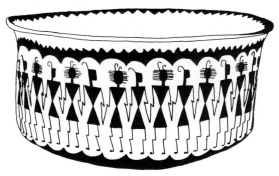

4. Hohokam (Southwest) painted ceramic jar with rows of alternating figures, possibly representing dancers. Sacaton period, A.D. 900–1200.

and inside lip of the bowl are painted with small, triangular patterns. Unlike the Santa Cruz period ceramic discussed previously, this Sacaton period painted bowl seems to differentiate between the sex of the dancers, who are holding hands around the entire body of the bowl. Their bodily proportions are more naturalistic than in the Santa Cruz ceramic, and the heads alternate between a profile type with a single feather and a frontal type with elaborate hairstyle, including a feather and horizontal elements sticking out from the head. It is possible that the single-feather figures represent male dancers, whereas the more elaborately headdressed figures repre-

5. Hohokam (Southwest) painted ceramic jar and bowl fragments with various animal and human images. Santa Cruz and Sacaton periods. A.D. 700–1200.

sent females. Lines of dancers such as this one are common to historic Southwestern Indian groups, including the Hopi, the Zuñi, and other Pueblo groups, although they usually have male and female dancers standing in separate lines rather than in the same line. Perhaps the fact that they are sharing the same line in the Hohokam example suggests that the figures were participating in a communal event where male and female dancers shared equal status.

Several examples of animal and human images from Hohokam pottery fragments [5] give some idea of the diversity of motifs and the repetitive quality of design so common to Hohokam painted ceramics. In the top row are two negative-painted reptilian images—a horned toad on the left and a diagonal row of snakes on the right. In both of these fragments, the white ground of the pottery becomes the reptilian image. The second row shows, from left to right,

an undulating group of salamander-like reptiles, and small, foxlike mammals in both positive- and negative-painted versions. The third row shows turtle-like shapes contained in rounded dark zones, and at least two types of long- and short-necked bird images. The bottom row has three kinds of human images—a row of joined figures who appear to have their heads raised in song, a woman with a burden basket on her back, and a bent-over figure walking with a cane.[3]

The horned toad was depicted on incised seashells and cut stone palettes, as well as on pottery. It was incised on seashells in a process whereby the surface of the seashell was cut by acid in areas not protected by a waxlike paste. In addition, the horned toad image appeared on cut stone palettes as an incised outline shape, or the palette itself was sculpted into a horned-toad shape [6]. These palettes were probably used in special shamanistic ceremonies to hold pieces of calcium carbonate, which were heated to a variety of temperatures and were transformed into different liquid and solid states, ranging in color from clear liquid to blood red and jet black.[4] Sometimes these palettes were made with small bird forms on their ends or with incised or low-relief lizard forms on them, and sometimes with a simple human head at the top and human feet at the bottom.

Ceramic human figures were also found in varying forms in the Hohokam culture. Simple

6. Hohokam (Southwest) stone palette in the shape of a horned toad. Sacaton period, A.D. 900–1200.

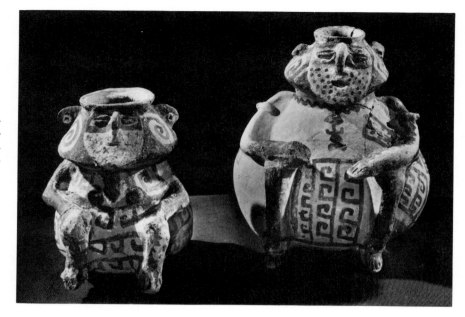

7. Hohokam (Southwest) painted ceramic effigy pots in human form. Sacaton period, A.D. 900–1200.

figurative types are probably part of some generalized fertility cult that may have originally been derived from Mexico. Elaborately painted effigy pottery vessels are in keeping with esoteric ceremonial items found throughout the pre-contact Southwest in the Hohokam, Mogollon, and Anasazi cultures. In the two seated figure jars shown [7] the arms of the figures rest on their thin tubular legs, and their bodies are painted with repetitive angular patterns over the back and lower stomach which may represent some form of geometrically patterned clothing. Their faces are painted with small dots, and their heads are painted with various geometric elements. In addition, a pendant-like shape hangs down from the neck of the larger figure, as if representing jewelry. The large, bulky shape of these effigy pots was possibly associated with an abundance of food derived from the practice of agriculture.

Another two-dimensional art form found throughout the Hohokam territories was petroglyphs. They were made in various locations near settlements, along trails to hunting areas, at sites that may have served as shrines, and along trails leading south to the Gulf of Mexico, where salt was obtained.[5] The two petroglyph compositions

illustrated [8 and 9] represent, respectively, a hunting scene and a somewhat less recognizable scene. In the hunting scene two hunters, one armed with an upraised spear, the other with a

8. Hohokam (Southwest) petroglyph showing a hunting scene. At South Mountain, Arizona.

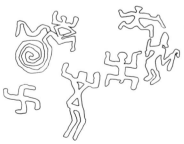

9. Hohokam (Southwest) petroglyph with geometric and simple linear patterned human and abstract shapes. At South Mountain, Arizona.

bow and arrow, take aim at two mammals. The mammal on the left seems to have long antlers and may represent an antelope, while the smaller mammal, near the bowman, may represent a mountain sheep. Like the human and animal images on painted pottery discussed previously, these pecked stone images are very simple in outline. The animals are shown in profile, with a clearly recognizable silhouette, and the human images were created by use of thin, curved and angular pecked lines. Despite the economy of means, a clearly readable composition and sub-

ject results. The second composition [9] is more complex, with at least two human images depicted, one with a cane and bent-over profile posture, the second with a triangular frontal body, with arms upraised and legs bent to the side as if dancing. In other parts of the composition one can see lizard-shaped images, spiral serpent-like shapes, zigzag serpent-like shapes, birds in profile, and several mammals. There are also a rotary-movement geometric shape similar to a swastika and a crosslike shape that may depict a star.[6]

### Art of the Pre–European Contact Mogollon Culture

The Mogollon settled in an area slightly to the east of the Hohokam—an area bordering southeastern Arizona and southwestern New Mexico, at the headwaters of the Gila and Salt Rivers, and along the Mimbres River [Map 5]. The most famous art form produced by the Mogollon people is the painted ceramic burial bowls placed over the skulls and bones of the deceased in Mogollon settlements. This shallow painted pottery was recovered from an area of the Mimbres Mountains and River and is frequently referred to as Mimbres pottery. One of the most extensively excavated sites in the Mimbres region is Swarts Ruin in the Mimbres Valley, New Mexico. A plan of the late-eleventh-century site, with burials indicated by dots [10], documents that the villagers lived in two large multiroomed adobe structures separated by a communal plaza.[7] Most of the burials were within the structures themselves, with a much smaller number in the plaza area. Many of the burials were accompanied by grave goods, including painted pottery [11], stone and bone tools, and jewelry of various stones, shell, and turquoise. The black-on-white painted Mimbres bowls were often placed on the skull or body of the deceased at Swarts Ruin, and all six painted bowls illustrated here were found over skulls. All of these bowls, from the early

twelfth century, except the small bowl with a human and animal figures at the bottom right, show evidence of having been pierced near their center and ceremonially "killed." The bowls differ in composition, although they all share a clearly readable central figure against a white background.

The bowl at the top right contains the lively image of a long-eared jackrabbit, with linear geometric patterns on his body and with ears which are subdivided into dark triangles on top and light ones on the bottom. This animal was undoubtedly an important source of food to the Mimbres people at Swarts Ruin, and may have been recorded on this burial bowl as some type of food for the deceased. The white background against which the animal form is painted is subdivided near the outer edges by four scalloped zones, which widen from the encircling outer rim lines. A sense of clockwise movement is created by these dark shapes, and counter-clockwise movement by the negative white areas. The bowl on the bottom left has a large image of two human figures who appear to be standing behind a geometrically patterned, striped blanket.

The bowl at the right in the bottom row represents a male human figure with a long-tailed wolflike animal and a fish hanging from a vertical

10.   Mogollon (Southwest) site at Swarts Ruin, Mimbres Valley, New Mexico. Small dots represent burials where painted Mimbres ceramics were found placed over and with the deceased.

11.   Six Mogollon (Southwest) painted ceramic Mimbres bowls taken from burials at Swarts Ruin, New Mexico. Top row: antelope, lizard, and jackrabbit bowls. Bottom row: humans standing behind a blanket(?), birds standing over a fish, and ceremonial scene with man and fish and coyote(?).

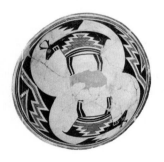

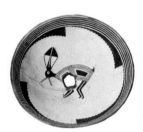
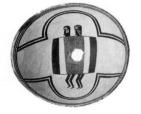
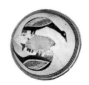
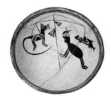

sticklike form adorned with feathers. The bowl to the left of this represents a pair of long-necked birds standing over a large fish. The animal and human images in the bowl at the right are, for the most part, painted dark against a white background, with filled-in profile forms and linear elements. Small geometric patterns on the wolf and fish, and a light, painted area across the eyes of the male figure are the only other patterns on these figures. The long-necked birds on the bowl in the center of the bottom row appear to be stretching their necks outward over their prey, as if they were caught in the act of feeding. Lines are used to differentiate their wing feathers and tail feathers from their dark bodies. The body of the fish in the center is only partly visible, due to the damage caused by the killing hole on its body.

The remaining two bowls (top left and center) depict a pair of antelopes and a long-bodied lizard, respectively. The antelopes are positioned as mirror images within encircling curved and angular dark shapes. These are, in turn, subdivided by zigzag angular bands and stepped triangular elements. These designs are echoed on the bodies of the antelopes as a stepped pattern set over slightly curving forms near their stomachs. Both animals have white rectangular forms on their throats that may represent "life lines," and have their antlers set at right angles from their true plane on the head, perhaps for ease of species identification. The body of the lizard on the bowl at the right appears to have been frozen in time as it was turning to its left. The lizard's body is dark except for white, circular eyes, arrowhead shapes along its back, and thin rows of scale designs on its tail. The encircling band toward the outer edge is painted with linear and zigzag undulating bands.

The twenty-five Mimbres-style painted bowls illustrated in Figure 12 were in a private collection in New Mexico in the 1920s or 1930s. The top row shows, from left to right, images of a large beetle-like insect, grasshoppers, butterflies

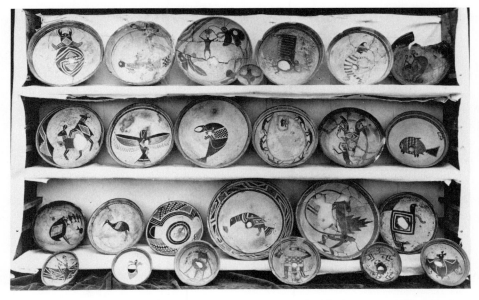

12. Mogollon (Southwest) painted ceramic bowls from various sites in the Mimbres area of New Mexico; various human, animal, and mythological spirits appear to be depicted on these twenty-five pieces.

with a human, a small bird, a large-winged butterfly-like insect, a humanoid dressed in a costume, and a female bent over and a hunchback walking with a cane. The second row, from left to right, has images of copulating antelopes, a bird with outstretched wings, a composite fish-insect person, a group of six men climbing around a person enclosed in a cave or burial-like structure, a woman with a burden basket on which sit two humans, and a small fish. The third row, from left to right, has bowls with images of a large bird standing before a row of fish, a long-beaked bird, a negative-painted bird image, a grouselike bird looking at the ground, an anthropomorphic figure holding what appears to be a war shield, and geometrically shaped weasel-like animals. The six small bowls along the bottom row represent a rabbit-like animal, an insect, a frontal humanoid, a feline standing over an altar-like structure, a porcupine-like animal and warrior, and a bat with outstretched wings. These images and those in Figure 11 attest to the creativity and variety of painted bowls made by the people of the Mimbres culture.

13. Anasazi (Southwest) ruins at Mesa Verde, Colorado, showing cliff dwellings and circular subterranean ceremonial kivas. About A.D. 1100.

## *Art of the Pre–European Contact Anasazi Culture*

The art of the pre–European contact Anasazi period anticipates and is related historically to that of the peoples of the pueblo areas of Arizona and New Mexico. Geographically, the western and eastern Anasazi cultures from about A.D. 1100–1450 are located where the present-day Hopi, Zuñi, pueblo, and Navajo peoples reside —in the four-corners region where Utah, Colorado, New Mexico, and Arizona intersect. In contrast to the smaller-scale settlements and less permanent architecture of the Hohokam and Mogollon peoples, the Anasazi often congregated in large adobe brick and stone multiple family dwelling units. These dwellings, which have often been called the earliest apartment houses in North America, were often found nestled under overhanging cliffs, where they could have protection from the weather and from raiding nomadic peoples such as the pre–European contact Navajo and Apache. The Anasazi ruins at Mesa Verde, Colorado [13], are a good example of the state of Anasazi architecture and settlement planning at about A.D. 1100.

The multistoried architecture is hidden beneath the overhanging cliff face, and there are remnants of rounded and squarish tower-like structures, attached dwelling and storage rooms of a basically rectangular plan, and circular subterranean ceremonial "kivas." Similar kiva structures were in use by various pueblo peoples at the time of contact in the sixteenth century and are still used today in sacred rites. Two basic kiva types were found among the Anasazi: a round type in the western Anasazi and a rectangular type in the eastern Anasazi.[8] By analogy with historic pueblo peoples, we can assume that various clans used individual kivas for ceremonies tied to their concepts of religion, initiation, and social order. An important form of artistic expression found in many of these kivas was painted plaster frescos depicting supernaturals and various flora and fauna associated with sea-

sonal ceremonies of an agricultural nature. At Awatovi, an Anasazi site in northeastern Arizona, there are examples of the rectangular style of kivas in which painted frescos were found. Two Awatovi frescos of agriculture-related scenes [14 and 15] can be seen in watercolor copies. The scenes appear to depict two aspects of fertility. One is agricultural, the other more clearly human. In the kiva painting in Figure 14, a warrior and a squash maiden are placed beside a border pattern with a cloud terrace emblem set at right angles to a circular pattern bisected into semicircles. The tail end of an animal sticks out from this circle as if it is jumping through it. The warrior is depicted with legs slightly bent and arm raised with a bow and what appears to be a shield. His clothing details, his quiver with arrows, and his feather ornaments are all clearly articulated. The squash maiden has a characteristically female hairstyle, and her arms are depicted as tendril-like plant forms on either side of her body. In the second kiva painting [15], a similarly attired warrior with bow and arrow in hand stands beside a sexually displayed male and female pair. The suggestion of impending coitus is clearly depicted. An unusual aspect of this scene is the upside-down circular-headed figure hovering (or possibly descending) over the displayed female's head. This round-faced human form may be a depiction of a fertility/sex-related female kachina deity, known after contact as Kokopelmana.[9]

The kiva painting from Kuaua, New Mexico [16], may represent kachina-like deities associated with agricultural ceremonies. There are two human-like figures on either side of the panel, with a central region depicting a flying eagle, a fish, a batlike creature, and a ceremonial pot overflowing with moisture. All of these stand on a base of horizontal bands probably representing a rainbow and the boundary between the underworld of the kachina spirits and the upper

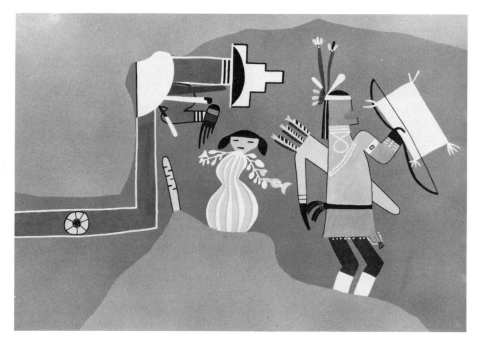

14.   Anasazi (Southwest) kiva mural painting from Awatovi, Antelope Mesa, Arizona. The scene depicts a warrior with a squash maiden and a cloud terrace emblem (half-scale reproduction). After A.D. 1300.

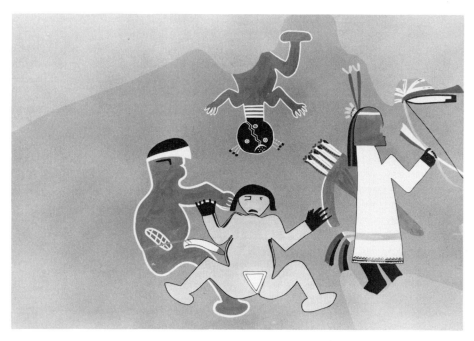

15.   Anasazi (Southwest) kiva mural painting from Awatovi, Antelope Mesa, Arizona. The scene represents sexual figures and some sort of supernatural kachina-like image. After A.D. 1300.

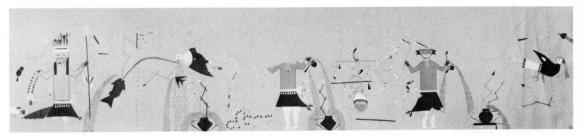

16. Anasazi (Southwest) kiva mural painting from Kuaua, Coronado State Park–Monument, Bernalillo, New Mexico. The scene appears to be associated with rain-making agricultural ceremonies in which various kachina spirits and animals are depicted. After A.D. 1300.

world of the kiva and the Anasazi clans who used it. The kachina spirit on the left appears to be a male, with a staff in one hand and a prayer stick and feather offering in the other. There are feather-like shapes on top of his headdress, and there is a kilt and skirt over the lower part of his body. Below him to the left is a bird with some form of moisture droplets coming out of its beak. The thin staff he holds appears to be set within another stream of moisture droplets, coming from the fish's mouth. Zigzag pointed arrows (representing lightning) also come from the fish's mouth, as does a rainbow which arcs upward to the tip of the centrally placed eagle. Lightning arrows and moisture or seeds are coming out of the eagle's mouth and descend over a batlike form who has droplets of moisture falling from its head. Beneath the eagle is a pot set within a shallow container, with lightning and moisture symbols flowing upward and outward from its neck. To the side, away from the pot, are small, dark arrow points and footprints set in a continuous pattern.

The figure on the right side of the panel may represent a female kachina spirit (by comparison with other images found at Kuaua), who wears a shell pendant and is pouring moisture droplets in two streams from a small vessel in her hand at the right. These, in turn, flow into another pot, which appears to be overflowing with moisture. Lightning-bolt arrow shapes shoot upward from this pot. The last set of images on the right side of the panel show (from bottom to top) a symmetrical white-and-colored stepped altar niche shape, circular hoops with sticks across them, and various lightning arrow shapes. The stepped altar

niche shape probably functioned in this kiva as an entrance to the underworld of the kachina spirits. The hoops and sticks, coupled with the lightning arrows, were probably associated with some type of curing society.[10]

A very different scene is depicted in the section of a kiva painting [17] from a late Anasazi site (after A.D. 1300) at Pottery Mound, New Mexico. The scene appears to depict a mortuary rite, with two seated male figures on either end, and a bent-over supernatural figure in the center with a reclining (possibly dead) female carried on his back. The entire upper zone of the painting is set off as a band with abstract geometric shapes, plant and flower forms, and what appears to be a half circle of corncobs as an emblem on the upper right. The seated figure on the left has a sunburst-like emblem on his side, and he carries a bow and a quiver in front of him. His back, stomach, legs, and feet have pointed shapes sticking out from them in a pattern similar to those that radiate from the circular sunburst. His head, face, and headdress are simplified and stylized. The male figure on the right side wears an arm band and a pendant, and carries a decorated staff in one hand. The supernatural figure holding the possibly dead female on his back wears an elaborate headdress and holds a staff in one hand that is decorated with feathers and snakes twisted around the shaft of the pole. The female has triangular-pointed breasts on the top of her body, and wears a skirt with a wrapped sash. One of her arms is raised upward, while the other is placed over her midsection. She appears to be reclining on the rainbow-like striped wings of the supporting supernatural.

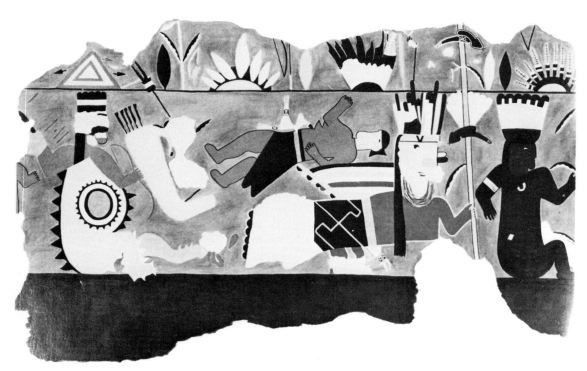

17. Anasazi (Southwest) kiva mural painting from Pottery Mound, New Mexico. The scene (Kiva 2, layer 1, south wall) seems to represent an elaborate funeral ceremony for a woman. After A.D. 1300.

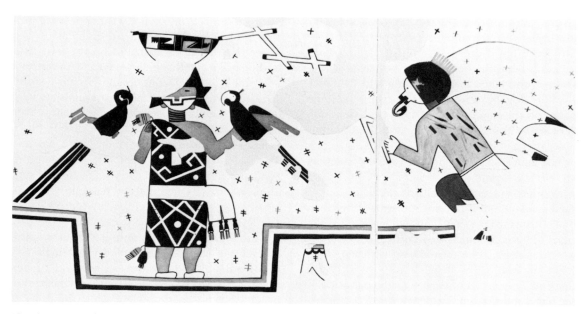

18. Anasazi (Southwest) kiva mural painting from Pottery Mound, New Mexico. The scene (Kiva 9, layer 2, south wall) appears to be associated with rain-making rites. After A.D. 1300.

Another kiva painting from Pottery Mound [18] may depict a rainmaking ceremony. The painting shows (on the left) a frontal female kachina maiden standing on a rectangular ground line and holding a pair of parrots. There is a mosquito-like person in profile on the right side of the composition. The female has a bowl on her head from which shoot lightning-bolt shapes. The little x-like shapes and double-bar x shapes may represent stars and dragonflies, respectively —both are associated with rainmaking rites.[11]

Several line drawings based on images in Pottery Mound kiva paintings [19] illustrate other images depicted at the site. On the top row, from left to right, is a kachina maiden holding a ceremonial pot and feathers in her hands, a pair of warriors with decorated circular shields, a profile of an insect-like kachina spirit (this one possibly represents a mosquito spirit), and a circular geometrical form which may relate to directional orientations associated with the solstices and ceremonial geographic orientation. The second row

shows a catlike animal who appears to be jumping through a semicircular emblem; the cat has a vessel in his front paws from which some liquid seems to be pouring. Next to it are drawings that depict a winged predator-like person in active flight and a pair of rattlesnake-like images wearing feather headdresses and a variety of body markings.

In Chapter 1, four Tularosa-type Anasazi ceramic vessels were discussed. (See Chapter 1, Figure 14.) A skeleton with a painted pitcher and bowl [20] and a group of fifteen painted pitchers from a single Anasazi room [21] (both from Pueblo Bonito) show the context of burial ceramics and a large group of individualized artistic creations from a single burial. As the grave site reveals, two geometrically patterned ceramics were buried next to the head of the deceased.[12] These two vessels and the fifteen in the accompanying photograph [21] attest to the wide variety of geometric patterns used in painting these vessels. One characteristic found in these pitchers is

19. Anasazi (Southwest) kiva mural-painting images from various kivas at Pottery Mound, New Mexico. They represent, top row, left to right: a kachina maiden, a pair of warriors with shields, a mosquito kachina spirit; a directional circle; bottom row: a cat supernatural; a winged predator and rattlesnakes with feather headdresses. After A.D. 1300.

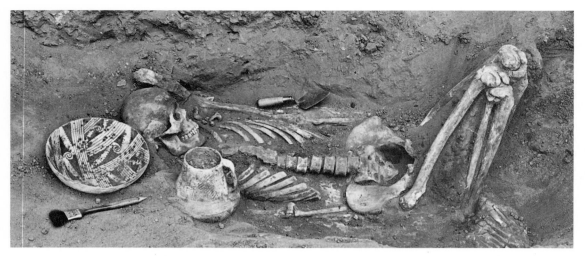

20.   Anasazi (Southwest) burial at Pueblo Bonito, Chaco Canyon, New Mexico. The geometric-style painted bowl and pitcher were excavated next to a skeleton; c. A.D. 1000–1300.

the separate yet related design treatment of the lower bowl and of the long neck of the pitcher. Frequently there is a distinct boundary line between these two parts of the vessel. Zigzag, triangular, spiral, serrated, angular, rectangular, and linear patterns were painted on these pitchers in a dazzling display of creative variations on geometric shapes. Frequently, the light background and the dark figures were treated in such a way as to

be reversible, whereby the white ground was read as a positive figure. This attribute was also noted in Chapter 1 for the four Tularosa vessels from the Anasazi period. This strongly geometrical overall pattern and the tendency for figure-ground reversals is in marked contrast to the figurative types of Mimbres vessels noted earlier in this chapter, although geometric-patterned Mimbres painted pottery does exist.[13]

## Art of the Hopi of Northern Arizona

The Hopi people of northern Arizona are descendants of the Anasazi. Like the Anasazi, the various Hopi peoples settled in villages along three mesas over three hundred feet above the surrounding valley floor. Their houses were made of adobe bricks set loosely in horizontal rows. During the late-nineteenth century, their houses were set in loosely organized rows according to family clan affiliations, and the village plan often varied according to the shape of the mesa. In each village there was what appeared to be an underlying pattern of rows of houses, separated by narrow walkways. Each village had more than one underground ceremonial kiva, the average being three or four. These were used by the various

village clans, and were the center of ritual associated with the Hopi ceremonial calendar. Many villages had a somewhat random distribution of houses by clan within the settlement. Perhaps this pattern reflects a certain egalitarianism in the Hopi, with no single section of the settlement being dominated by a single clan.[14]

The ceremonial calendar of the Hopi [22] starts with the winter solstice (Soyala) ceremony in December. This is when the supernatural spirits called kachina come to the village to participate in the celebrations. The word "kachina" has three distinct meanings in Hopi belief. It refers to a supernatural entity, a mask and costume, and a small doll. In the first meaning, a

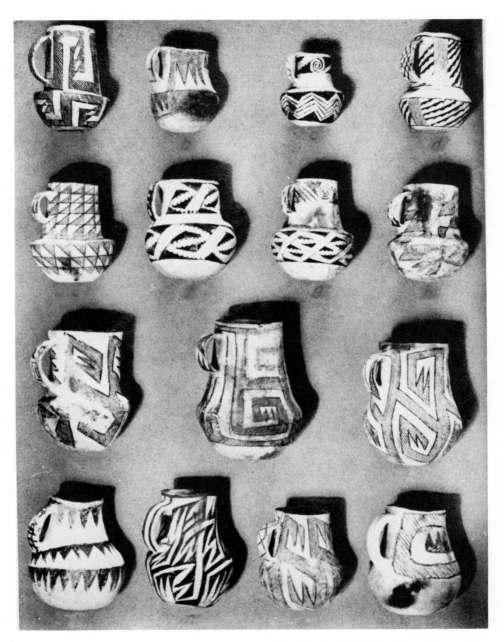

21. Anasazi (Southwest) painted ceramic pitchers from burial at Pueblo Bonito, Chaco Canyon, New Mexico; c. A.D. 1000–1300.

HOPI CEREMONIAL CALENDAR

| | | |
|---|---|---|
| December | Soyala ceremony<br>Winter solstice | |
| January | | |
| February | Powamu (Bean dance) ceremony | KACHINA SEASON |
| March | | |
| April | | |
| May | | |
| June | Summer solstice | |
| July | Niman (Home dance) ceremony | |
| August | Snake or Flute society ceremonies | |
| September | Marau (Women's society) ceremony | NON-KACHINA SEASON |
| October | Qaqol (Women's society) ceremony | |
| November | Wuwuchim (Tribal initiation) ceremony | |

22.   Hopi (Southwest) ceremonial calendar.

kachina is a supernatural who lives to the west, in the San Francisco Mountains. These kachinas are also associated with clouds and with ancestors. Their spirit essence is often said to be cloudlike and insubstantial. During the period starting with the winter solstice and the Soyala ceremonies, and ending with the Niman ceremony just after the summer solstice, the kachina spirits are present, helping with the planting of the gardens, the continued fertility of these gardens, the rainfall needed for plant growth, and the eventual harvest.

The second manifestation of kachina is that of a mask and costume worn by a Hopi who impersonates a particular supernatural being.[15] Each mask and costume has distinct morphological characteristics and meanings associated with the patterns painted on the mask as well as designs woven on sashes, skirts, and other items of apparel. The identity of a particular masked impersonator is kept strictly unknown to those in the audience who are uninitiated. The dancer dresses secretly on the outskirts of the village or within the confines of the clan ceremonial kiva(s). During the time when the masked kachina dancer is performing or present, he acts out behaviors associated with the particular kachina spirit he represents. Afterward, he takes off his disguise in secret—away from people who are not allowed to know his true identity. The masks and costumes are stored in a kiva or, sometimes, within a clan member's house (wrapped up and hidden from view).

The third manifestation of kachina is in the form of small carved and painted dolls, which are given to children as presents to help them recognize and learn about these spirits that are so important to the conceptual and religious life of the Hopi. The kachina doll serves as a miniature representation of the masked character who dances in various ceremonies during the kachina part of the ceremonial year. There is an important didactic component to the making of these dolls, since they serve as artistic visual aids in teaching children about the myriad of spirits which inhabit their universe. There are literally hundreds of known kachina spirits among the Hopi. While there are certain kachina spirits which virtually all Hopi believe in, there are many others that have their origin in specific Hopi clans as well as in neighboring pueblo and non-pueblo peoples such as the Keresan, Zuñi, Ute, and Navajo.[16]

The winter solstice ceremony (Soyala), the

bean dance ceremony (Powamu), and the home dance ceremony (Niman) take place during the kachina season in December, February, and July, respectively. During this period the kachina spirits are said to come above ground from their underworld in order to help the Hopi with important matters of subsistence and ritual. After the Niman ceremony in July, the kachinas go back to their home in the underworld through a hole in the bottom of a kiva. This hole is known as a *sipapu*. From then until the following December, the ceremonial calendar is taken over by non-kachina societies, including the snake/antelope and flute societies, the Marau women's society, the Qaqol women's society, and the tribal initiation society (Wuwuchim) during the months of August, September, October, and November, respectively. Each of these societies has elaborate ceremonies associated with its own period during the year. Each Hopi village interprets these rituals in its own way, and the bulk of our information about the meanings of these ceremonies comes to us from firsthand observations made by scholars from the late 1880s to about the mid-1930s. No single source traces all of these ceremonies in a single village during a single ceremonial year; therefore, the following discussion will first select art forms associated with the kachina season from December to July as found in the Soyala, Powamu, and Niman societies. Next will follow a discussion of the art of the Qaqol women's society used in the non-kachina season from August to November.

The winter solstice ceremony (Soyala) takes place in December, and during its nine-day period various art forms are used to accentuate, symbolize, and give physical manifestation to certain kachina spirits which take an active part in the proceedings. Over the first several days of the ceremony, special altars and altar items are created and assembled inside the kiva. In the winter solstice ceremony at Oraibi, altars were made in the kiva to receive offerings in the form of prayer sticks and feather bundles made as presents to the supernatural spirits. The partici-

pants in the ceremony frequently recited prayers over these offerings and at the same time blew smoke on them. One of the important underlying messages and meanings associated with these altars and the accompanying paraphernalia is that of fertility between the masculine sky and the feminine earth. This balance of masculine and feminine symbolism is widespread in the beliefs of the Hopi and other pueblo peoples.

A Soyala altar from Oraibi village [23] (now reconstructed in the Field Museum of Natural History, Chicago) was collected about 1901.[17] Visible in this reconstruction are two altars covered with plant materials and feather offerings (on the left and to the right in the rear), as well as a rectangular painted screen depicting the Hopi germination god Muyingwa. The screen is an assemblage of painted and added-on forms, including cotton-covered cloud shapes arcing over the top, eight four-sided blossom shapes set along the left and right vertical edges, horsehair and eagle feathers (symbolizing the sun's rays) set along the sides and bottom of the rectangle, and a painted scene that is the central focus of the composition. The germination god holds a cornstalk in his right hand, while in his left he has two ritual offerings associated with prayers. Raindrops and lightning shapes emerge from the three-part cloud symbol above his head. On either side of his legs are painted circular emblems of the sun (with a face) and the moon (with an interior crescent). Beneath, laid out in a rectangular gridlike pattern, are various seeds, including those of a watermelon, muskmelon, squash, cotton, and pumpkin, set into a mosaic surrounding three sides of another rectangular shape. The rows of circles within this form may represent a planted garden. Within this one image in the Soyala altar reconstruction there are a great number of images and objects associated symbolically with fertility and growth of garden products.

The two mannequins in the photograph represent the Hopi star priest, who officiates over the Soyala ceremony, and the war priest, who sprinkles the star priest with water from a medicine

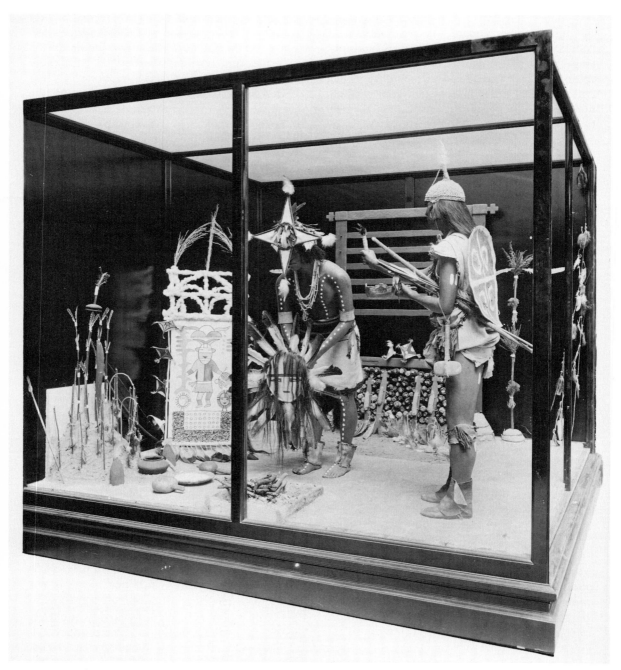

23.   Hopi (Southwest) winter solstice (Soyala) kiva altar (reconstruction) from about 1901.

bowl during the ceremony. The star priest wears a four-pointed star headdress and twirls in his hand a star-symbol display object. The Hopi war priest wears a special pointed cap, has a painted war shield slung over his back, and has a bow and arrows in his hands. This war priest is said to represent a manifestation of the war god Pookon. The ceremony is meant to symbolically re-enact the changing of the direction of the movement of the sun by the war god at the time of the winter solstice. This is accomplished through the manipulation of supernatural powers. After the conclusion of the ceremony these various altar parts are taken apart and hidden for future repair and reuse.

Various kachina spirits are represented by masked dancers during the Soyala ceremony. One of these, known as Mastop, represents Masao, the earth god. The dancer who wears the Mastop mask comes out of the kiva and runs about the village chasing women. He grabs one and engages in mock copulation with her before chasing after another. The Mastop mask [24]

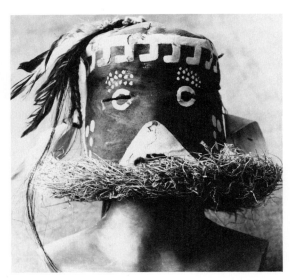

24. Hopi (Southwest) Mastop kachina mask used in the Soyala ceremony; Mastop represents Masao, the earth god.

consists of a cylindrical leather covering with concentric circular eyes and a horizontal mouth set off by a triangular light-colored area around it. The dots over the eyes represent the constellation Pleiades, while the larger dots on the cheeks represent the Big Dipper. The right-angle patterns on the forehead represent the nine days of the ceremony. Added-on materials include feathers, horsehair, cornhusks (ears), and dry grass.

In contrast to the small number of kachina masks and altar arts made during the winter solstice ceremony, the bean dance ceremony (Powamu) has a large number of kachina-masked dancers who participate during its nine-day duration. Elaborately carved and painted composite-form altar display pieces, as well as sand-mosaic paintings, were frequently made for the bean dance in February. On a symbolic level, the art forms, ritual displays, and ritual activities which take place in the kiva and outside at various shrines and in the village plaza are all aimed at the propagation and growth of garden foodstuffs. The youth, both male and female, are symbolically cleaned and put through ordeals during the bean dance ceremony. This is to ensure their proper growth, health, and future fertility as adults.

Another reconstruction in the Field Museum of Natural History in Chicago is an elaborate bean dance altar display collected about 1901 [25]. The reconstructed altar and sand mosaic were made from the fifth day of the ceremony within the kiva.[18] On the outer edges of the display are two painted images, virtually identical in style to the Ho kachina, who plays an important part in disciplining the children during the ceremony. Among the figures in the center of the display are: the carved figure of the protecting war god, Pookon, on the left; two central figures within the rectangular arch—one of the god of thunder, Cotukvnanwu (on the left), and the other of the bean dance kachina spirit Powamu (on the right). On top of the altar are four semi-

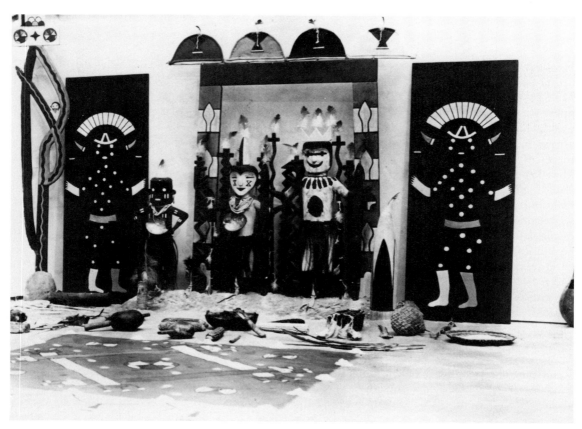

25.  Hopi (Southwest) bean dance (Powamu) kiva altar (reconstruction) from about 1901.

circular cloud symbols painted yellow, green, red, and white, respectively, from left to right. The rectangular panels on either side of the two central figures are painted with blossom and corn ear symbols. Several lightning and prayer sticks are placed against the kiva wall around the central figures.

At the far left in the display is an unusual carved and painted cloud/lightning symbol stuck in a raised mound. The geometric upper portion is in the shape of a cloud terrace and is painted with cloud patterns. The lower section tapers near the bottom, where it is stuck into the mound. There are blossom symbols on the lower large section, and the small figure peering from behind a blossom about two thirds up the front may represent the bean dance kachina spirit Po-

wamu. Directly in front of the display altar are various ritual objects used by priests in the bean dance ceremony. The tall, pointed object curving to the right on the right side of the display represents a geological formation—a bluff. At right angles to this display is a sand mosaic with rectangular, boardlike patterns set in a diamond within a square. The diamond shape is said to represent a house, while the four semicircular forms at the outer edge represent clouds, with projecting turkey feather offerings. Throughout the mosaic are circular shapes of differing sizes, said to represent blossoms of various plants, and herbs and grasses used by the Hopi for food, medicine, and ceremonies. The sand mosaic is destroyed on the eighth day of the ceremony. Afterward, other kachina spirits enter the kiva

and walk about the village. Depending upon their nature they might present people and shrines with offerings and presents, or chase and punish children and other people.

At one point during the bean dance ceremony (on about the seventh day), young boys and girls are brought into the kiva and are ritually washed by priests. Later, masked impersonators of the Hototo and Hahai-i kachina spirits whip them about their bodies with thin branches. This ritual cleansing and whipping is thought to symbolically purify and strengthen the children so that they will grow into productive (and reproductive) adults. Figure 26 shows twelve kachina masked spirits in an 1893 photograph at Walpi village, First Mesa. From left to right are a Hahai-i (female kachina), a Tahaum Soyoko (male), Soyok

Mana (female), Soyok Wu-uti (female), a white-headed Wiharu (a male kachina aide to an ogre woman called Soyoko), three animalistic Nata-askas (ogre spirits), a second Wiharu, and three Heyeya kachinas (males who accompany Soyoko). The fierce and warrior-like quality of many of these kachina spirits can be recognized by their bows and arrows and their animalistic heads.

On the ninth day of the ceremony two kachina spirits walk about the village, enter the kivas, and walk out of the village to various shrines. Throughout this period they make symbolic cloud drawings on the ground near the various kivas, and make presentations of prayer sticks within the kivas as well as at the shrines. The first of these kachina spirits is called Aototo [27], and

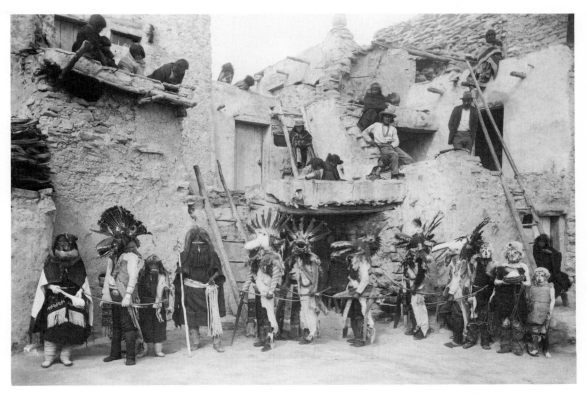

26. Hopi (Southwest) kachina masked dancers in 1893 at Walpi village, First Mesa.

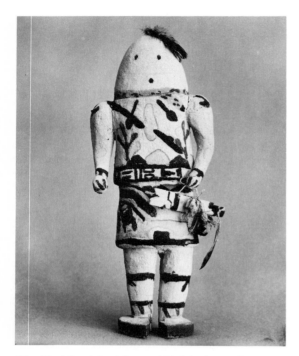

27. Hopi (Southwest) Aototo (chief) kachina doll.

28. Hopi (Southwest) bean dance ceremony (Powamu) kachina Mana (female) doll.

is recognized as being the chief of all kachinas. The other, called Aholi, is an assistant to the chief kachina. Both kachinas have unusual head shapes. The Aototo (chief) shown in the photograph has a slightly bullet-like or phallic-shaped head, set on top of a body covered with dark splotches. He is not only the chief of all the kachinas, he is also said to control the seasons. His companion, Aholi, has a tall, cone-shaped head with feathers on top and has small images of the germination god on each shoulder. Both Aototo and Aholi have simple eye and mouth shapes—simple light circles in the former, dark crescents in the latter. The most naturalistic kachina dancer to come out at the bean dance is the Powamu Kachina Mana [28]. She has distinctive, large maiden whorls of hair at either side of the

head. She and her male counterparts take part in the bean dance.[19]

The final kachina-related ceremony is the Niman (home) ceremony, which takes place in July. During this period the kachina spirits participate in various dances in public and in the kiva, then return to the kiva, from where they subsequently return to the underworld via the *sipapu* (in the bottom of the kiva). These ceremonies are harvest-related, and the return of the kachina spirits to their own underworld signals the end of the period bounded by the winter solstice in December and the summer solstice in late June. The rest of the year is set aside for various initiation and medicine society rites, including the snake/ antelope and flute societies (August), the women's Marau society (September), the

women's Qaqol society (October), and the tribal initiation society called Wuwuchim (November).

The Niman society uses an altar in a kiva during the celebration. It is often erected on the fourth day and consists of flat, painted boards with several rows of semicircular cloud symbols, painted cloth images of the germination god Tunwub, painted lightning sticks (leaning against the altar screen), and a host of portable ceremonial objects, including baskets, gourds, prayer sticks, net-covered gourds, a medicine water vessel, rattles, and an Eototo kachina mask, all laid out in front of the altar screen.[20]

One of the most common kachina spirits to dance during the Niman ceremonies is the Hemis kachina (also called Niman). When it dances,

there is usually a long row of men wearing identical Hemis kachina masks, as seen in a 1901 photograph [29]. Each of the dancers carries a rattle and a sprig of Douglas fir, and moves along in unison with the other dancers. The head mask (see Chapter 1, Figure 8, and the left-hand figure in Color Plate 4) of the Hemis kachina is one of the most impressive and complex. The lower part is a cylindrically shaped form divided into two by a vertical band from the forehead to the lower chin. The eyes are simple, rectangular slits set against a pink background on one side, and against a green background on the other side. On the forehead are painted cloud symbols, with little dots representing raindrops. The lower chin area is divided into a band of short, vertical

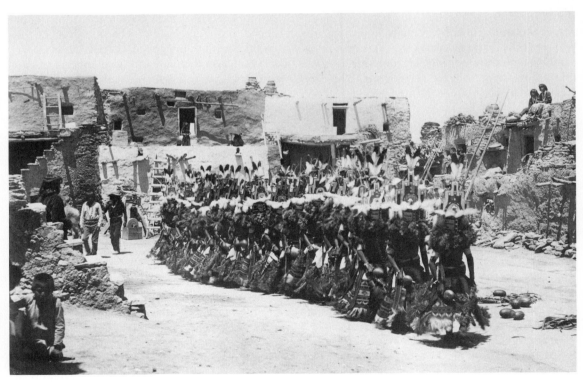

29.   Hopi (Southwest) Niman kachina ceremony with rows of Niman (Hemis) kachina spirits dancing at Shungopovi Pueblo in 1901.

shapes painted red, yellow, green, blue, and white, representing a rainbow. Attached to the helmet is a stepped *tableta,* which is covered with rainbow, phallic corn, rain, cloud, and lightning symbols. Also white down and feathers are attached to the forehead and *tableta,* as well as twigs tied to the top.

Color Plate 4 shows three examples of early 1890s Hopi kachina dolls, including, from left to right, a variation on the Niman kachina called Sio Hemis, a Shalako Mana (derived from the neighboring Zuñi people), and an ogre kachina.[21] The Sio Hemis kachina doll has a cylindrically shaped head, with a *tableta* extending above and to the sides. The face is painted blue and pinkish red, and has thin, slitlike eyes; a band of horizontal black-and-white lines bisects the face in two, and a black-and-white band encircles the bottom of the face. The *tableta* has three half-circular shapes on top representing clouds, and there are two rainbow bands: one along the horizontal band beneath the cloud shapes, the other around the yellow semicircle in the center. The Sio Hemis kachina's body is painted black, and he wears a sash over his lower skirt. On either side of the head, the *tableta* has blossom shapes painted in yellow. Feathers adorn the *tableta* on top and along the sides.

The Shalako Mana kachina doll in the center has a red-and-white striped body and a white face mask, with rectangular eye shapes and radiating lines from the mouth. Its *tableta* consists of three stepped cloud forms sticking out vertically and to either side of the doll's head. These cloud forms are divided into yellow and green areas set over a semicircle of red. Like the Sio Hemis kachina just discussed, the Shalako Mana's arms are not cut free from her body—a stylistic trait common to late-nineteenth-century Hopi kachina dolls.

The ogre kachina doll has animalistic traits in the treatment of its black head. This includes a large, toothy mouth on a long snout, and bulging eyes. In addition, it is decorated with various feathers and animal fur.

The antelope/snake and flute ceremonies which take place in August are associated with rain and curing rites. The antelope/snake ceremony alternates yearly with the flute ceremony. The former is associated with illnesses related to snake bite, and especially illnesses that cause swelling. The flute celebration is associated with lightning—and persons struck by lightning or persons whose fields have been hit by it. Serpents play a big part in the symbolism of altar sand mosaics for the snake and antelope societies. The altar cloth pictured in Figure 30 was made at Oraibi between 1890 and 1895. It has an upper register of cloud shapes with lines of rain beneath them. Each cloud has a bird sitting on top, as do the cloud symbols along the lower border. On either side is a vertical band painted with cloud and phallic corn images. The central vertical band contains a large, serpent-like lightning shape topped by a cloud symbol. On either side of this central form are images of kachina spirits: Shalako Mana on the right and what appears to be a male kachina spirit on the left. The Shalako Mana has an elaborate *tableta,* consisting of cloud, blossom, and phallic corn shapes, which radiate outward from the sides and top of her head. The male kachina spirit carries ritual objects in his hands, most likely associated with prayers. There is an additional row of cloud images beneath their feet, and two flaps from which two long, curving serpent shapes are thrust outward. These serpents are manipulated by persons hiding behind the altar cloth.[22]

The two women's societies that hold their ceremonies in September and October are the Marau and Qaqol societies, respectively. Both societies and their ceremonies are associated with fertility and curing illnesses, and lightning plays an important part in the symbolism of both societies' ceremonies. A group of several Marau society prayer wands [31] illustrates the combination of abstract symbolic forms and representational painted and carved forms. Some of these wands have recognizable images of corncobs, rain

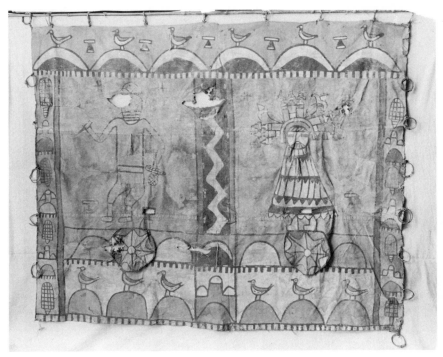

30. Hopi (Southwest) snake dance kiva altar painting on cloth.

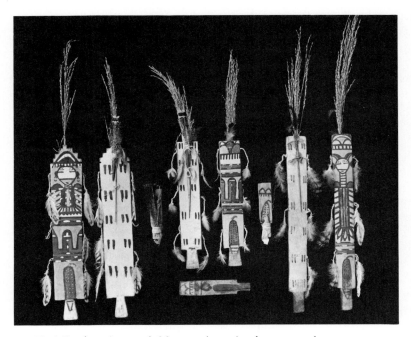

31. Hopi (Southwest) women's Marau society painted prayer wands.

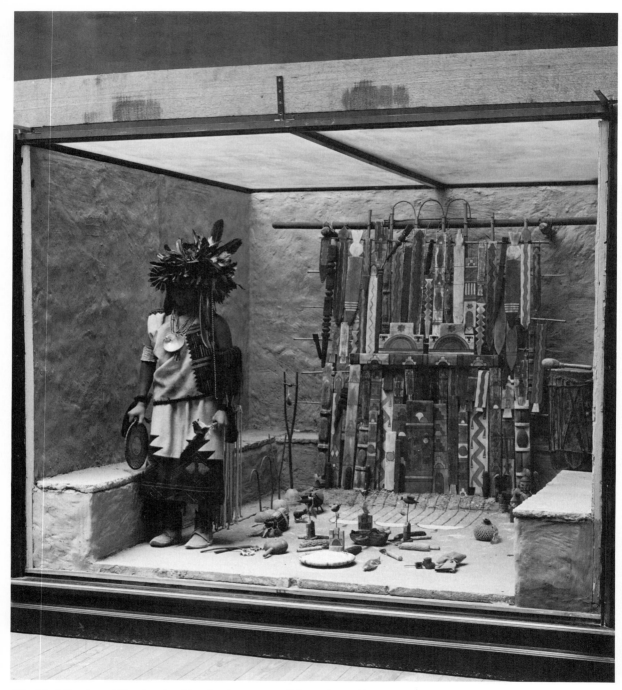

32.   Hopi (Southwest) Qaqol society kiva altar (reconstructed) from about 1901.

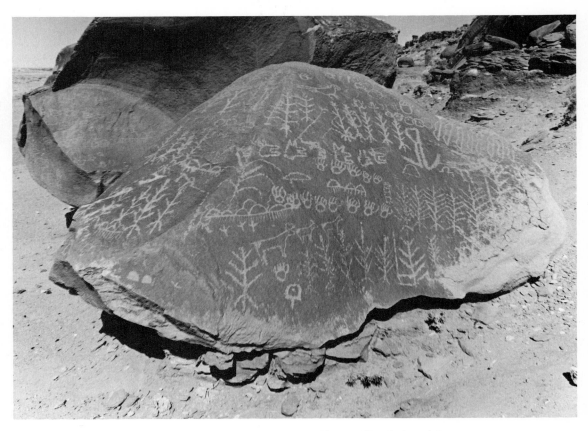

33.   Hopi (Southwest) clan-related petroglyphs carved on a large boulder at Willow Springs, Arizona.

clouds, rainbows, and versions of the germination kachina known as Muyingwa. Muyingwa is depicted as part human and part insect. A reconstructed altar of the Qaqol society [32] has an impressive display of various carved and painted prayer and lightning sticks stacked against the back of the altar. In the center of the photograph, near the bottom, is a small painted panel representing the god of germination, Muyingwa, holding onto a cornstalk. Above him are cloud symbols. On the floor in front of the altar are sand-mosaic cloud images and several carved bird and human/bird images as well as ceremonial vessels and prayer offerings.[23]

The final ceremony in the Hopi ceremonial year is the tribal initiation, called Wuwuchim, which takes place in November over a period of sixteen days (eight days when initiations take place, eight days when they do not). The symbolism of this ceremony is said to be associated with fire, earth, rain, and, in general, the strengthening of the male and female initiates to grow strong and be productive members of their clans. As in the previously mentioned societies, there are kiva components associated with these initiations. Although there is a decided lack of carved and painted decorations to be found during these rites, directional-oriented displays are made within the various kivas used for the four clans where youth will be initiated, and they all have fertility and fecundity via rain as an important component of their symbolism.[24]

34. Hopi (Southwest) painted ceramics. Left: Payupi polychrome jar, about A.D. 1680–1780. Center: Polacca polychrome style C Zuñi modified jar, about 1860–1890. Right: Polacca polychrome style B, about 1820–1860.

There is another manifestation of Hopi symbolism, found on petroglyphs made on large boulders along trails leading south to the Gulf of Mexico. The Hopi traveled along these trails during their annual excursion to obtain salt. Traditionally, each clan made a petroglyph of their clan emblem on the same rock as they passed by each year. This has brought about an accumulation and repetition of images creating a permanent record of a clan's activities along the trails. Hopi images on a boulder at Willow Springs, Arizona [33], include corn, clouds, crows (footprints and outline), coyote, bear footprints, parrots, lizards, and horns of antelopes and mountain goats.[25]

No account of Hopi art would be complete without a brief discussion of some Hopi ceramics.[26] One can divide these painted ceramics into two basic functional types, those used in ceremonial contexts (seen in some of the reconstructed altars earlier in this chapter), and those used in everyday life. Three examples of Hopi ceramics from the late-seventeenth through the late-nineteenth centuries [34] give some idea of the variations and revivals undertaken by the Hopi from about 1680 to 1890. The painted vessel on the left is known as a Payupi polychrome, dating from about 1680–1780. The upper half of the jar is separated from the bottom half by a horizontal line encircling the jar's widest diameter. The area below is plain, while the area above is subdivided into several complex zones filled with geometric and organic plantlike shapes in horizontal and vertical units. The slightly later pot on the right side of the photograph is known as Polacca polychrome style B, dating about 1820–1860. In this example, the design field includes the entire body of the vessel, and the cylindrical neck region is set off from the lower body both sculpturally (as a change in plane) and by a pair of encircling bands. Repetitive featherlike geometric units are grouped in patterns of three around the top of the vessel's body, while the lower portion of the body is covered with alternating and repeated zones of tendril-like spiral decorations and tight diamond and triangular geometric shapes which fill up most of the available design field. The Hopi pot in the center is known as Polacca polychrome style C–Zuñi modified, and has an alternating series of clearly recognizable flower and profile bird images on the upper neck zone. The lower sections alternate between kachina head images and spiral-like ornaments with strong geometric/feather patterns. In all sections the figures stand out clearly against the light backgrounds.

# 4

# Art of the Woodlands Period
# and of the Mississippian Period,
# and Art of the Great Lakes and Plains

The vast territory of eastern North America, stretching from the forest regions around the Great Lakes in the north to the swamplands and coastal regions along the southeast, all the way to the Great Plains in the middle of the continent, was the homeland of the pre–European contact Woodlands and Mississippian cultures and of the Great Lakes and Plains peoples.

Exact population figures are impossible to determine, although several hundred thousand people probably lived in this vast region during the pre–European contact period. At the time of sustained contact in the seventeenth century, most of the peoples of this region spoke some dialect of Algonkian, Siouan, Iroquoian, or Muskogean languages.

Throughout these vast areas the Native American peoples hunted and gathered various flora and fauna for thousands of years before the coming of the Europeans in the second millennium A.D. Their wide range of environments included mountains, forests, prairies, rivers, and lakes, as well as coastal lowlands. In the north, the Great Lakes region had an abundance of beech, maple, hemlock, and basswood forests, and many walnut and pine forests as well. Deer, raccoon, cottontail rabbits, gray squirrels, opossums, lynx, and porcupines were just some of the mammals they hunted. In addition, fishing was a very important source of food throughout

the region. Their primary methods of fishing included the use of seines, gill nets, harpoons, and gaffs.

Farther south, along the Ohio River Valley, in present-day Ohio, Illinois, and Indiana, the environment was mixed hardwood forests and prairies with elk, deer, beavers, bears, raccoon, foxes, squirrels, and other mammals serving as an important source of food. Various migratory birds, wild turkeys, and passenger pigeons were food sources as well. Local lakes and streams provided fish and shellfish. And, the huge herds of bison were a major source of food for the hunters on the Great Plains.

Gathering of edible berries, nuts, and roots and grasses was common throughout the Eastern Woodlands, and, in some regions, sunflowers, marsh elder, squash, and gourds were cultivated before the time of Christ. During the first millennium A.D., various species of corn (maize) began to be cultivated in the Hopewell areas of the Middle West and in some areas of the central and southern plains.

Over the last two thousand years social organization within this huge area has ranged from small, highly mobile hunting and gathering bands of about fifty to a hundred people, to larger, more permanent village settlements with as many as twenty-five thousand inhabitants. These large settlements developed specialized ritual centers

for ceremonies and burials of persons of high status. In these more permanent settlements there was evidence of a greater social and religious complexity than among the more individualized and shamanistic hunters and gatherers of the north.

Unfortunately, during the European and American expansion and exploitation of land toward the west from the sixteenth through the nineteenth centuries, many of the traditions, habitats, and social systems of the people of the Eastern Woodlands were destroyed.

## Art of the Woodlands Period, c. 500 B.C.–A.D. 600

In the area around southeastern Ohio [Map 6] there developed a series of distinct cultures, often called the Adena and Hopewell cultures. These cultures produced some of the most spectacular art forms made in the centuries before European contact. The Adena people (c. 500 B.C.–A.D. 100) buried their honored dead in large, raised circular mounds accompanied by various art forms. These included small incised stone tablets [1] and effigy pipes. In its later phases, Adena culture also included the making of huge effigy mounds [2] in various animal shapes.[1]

The incised stone tablet in Figure 1 is a study in elegant linear decoration. Within the winglike contour of the tablet is a totally asymmetrical, seemingly helter-skelter series of finely incised lines which appear to form a large, winged bird. The bird's head can be seen in the upper right quadrant, a wing in the upper left quadrant, and a neck, second wing, body and talons in the lower two quadrants. The eye of the bird appears as a circle divided into two rectangular shapes, each with a small drilled dot in its center. The beak appears to the right and is long and curved on the end, not unlike a vulture's. The wings are scalloped fanlike shapes, and the circular areas with dots are probably joint marks showing where the wing bones join with the shoulder. The entire form of the bird is compressed as if contained in an egg, struggling to get out. The purpose of these tablets is unknown, although it has been suggested that they served as stamps for body decoration or for the marking of textiles.[2]

Throughout the composition one can see that the artist who made the tablet was aware of the negative space outside the bird form in relation to the surrounding curved edges.

An example of another type of linear art form, although this time on a grand scale (over twelve hundred fifty feet in length), is the Serpent Mound in Adams County, Ohio. The serpent shape [2] consists of a 4'-high, approximately 20'-wide, and 1,254'-long earth sculpture. The tail ends in a large spiral shape, while most of the body undulates across the landscape near a small creek. The mouth appears to be wide open and is about to bite on a huge egglike shape. This serpent effigy and others, depicting various birds, bears, mountain lions, and other predators, suggest that the Adena peoples may have had strong religious beliefs in animal deities and constructed these large earthworks at sites sacred to these deities.[3]

A slightly later Woodlands culture, known as Hopewell (c. 200 B.C.–A.D. 400), also buried their high-status dead with art objects made from varied materials, including stone, bone, mica, copper, wood, textiles, and clay. The Hopewell lived in the same region of Ohio and the surrounding areas as the Adena people. However, the elaborate burials of the Hopewell were made on huge, geometrically shaped earthworks of much larger dimensions than those common to the Adena culture.[4] One type of art object that was frequently found among Hopewell burials was a carved effigy pipe. The four Hopewell period

Map 6. ADENA-HOPEWELL, MISSISSIPPIAN, PLAINS, GREAT LAKES

| A. | Adena | 4. | Omaha |
|----|-------|----|-------|
| B. | Hopewell | 5. | Potawatomi |
| C. | Mississippian | 6. | Sioux |
| 1. | Dinwoody | 7. | Arapaho |
| 2. | Peterborough | 8. | Mandan |
| 3. | Fox | 9. | Blackfoot |

1. Sandstone tablet (Woodland) called the "Berlin Tablet" from Jackson County, Ohio. Late Adena culture, middle Woodland period, about 400 B.C.–A.D. 1.

2. Engraving (slightly cropped) of the Great Serpent Mound in Adams County, Ohio. Adena culture.

carved effigy pipes in Figures 3–6 are all excellent examples of the restrained naturalism commonly found in Hopewell art. The first pipe is in the shape of a bird pecking at the head of a large fish [3], the second is in the form of a beaver, with inlaid pearl and bone eyes and teeth [4], the third is a falcon-shaped effigy pipe [5], and the fourth is a panther-shaped effigy pipe [6]. In all four examples, the elemental forms and body parts which identify the particular animal are given sculptural definition. Certain identifying characteristics, such as beak, tail, or teeth are included to help make the particular species more easily recognizable. The body gestures of each are also typical of that particular species, attesting to the Hopewell artists' keen awareness of the life habits of the surrounding fauna. All four of these sculptures were made as three-dimensional objects to be seen from many different angles.

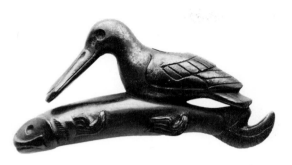

3. Hopewell period (about 200 B.C.–A.D. 400) (Woodland) carved stone effigy pipe in the shape of a long-billed bird and a fish.

4. Hopewell period (Havana culture, middle Woodland period, about 100 B.C.–A.D. 200) pipestone, pearl, and bone beaver effigy pipe. From Bedford Mound, Pike County, Illinois.

5. Hopewell period (Copena culture, middle Woodland period, about A.D. 100–400) steatite falcon effigy pipe. From Adams County, Ohio.

6. Hopewell period (Allison/Copena culture, middle Woodland period, about A.D. 1–400) panther-shaped effigy pipe. From Mann site, Posey County, Indiana.

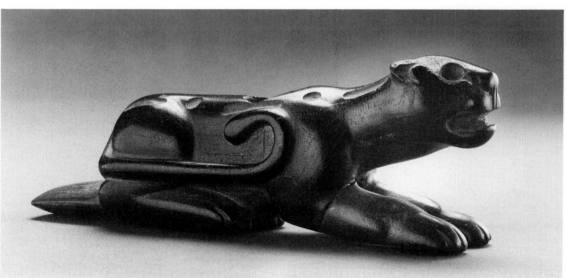

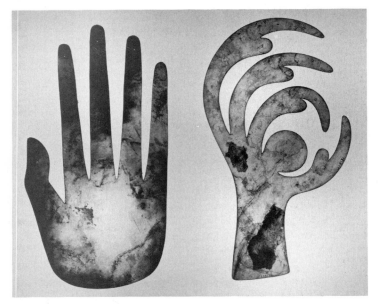

7. Hopewell period (middle Woodland period, about 200 B.C.–A.D. 400) thin sheet mica human hand and bird talon. From Hopewell site, Ross County, Ohio.

8. Hopewell period (middle Woodland period) thin sheet beaten copper in the shape of a serpent head with forked tongue.

9. Hopewell period (middle Woodland period, about 200 B.C.–A.D. 1) cut-out and beaten copper falcon. From Mound 7, Mound City, Ross County, Ohio.

10. (left) Hopewell period (middle Woodland period) cut and beaten copper sheet in an abstract geometric shape.

11. (center) Hopewell period (middle Woodland period) cut and beaten copper sheet in an abstract geometric shape.

12. (right) Hopewell period (middle Woodland period) cut mica sheet in the form of a profile human head. From Turner site, Hamilton County, Ohio.

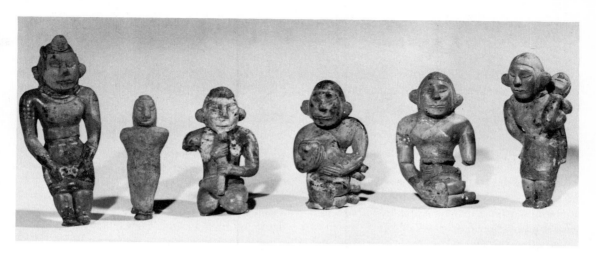

13. Hopewell period (middle Woodland period) clay male and female figurines.

Other art forms found among Hopewell burials are flat and cut-out, and were meant to be seen and understood from a single (or, if flipped over, double) point of view. These included such objects as a thin, cut-out sheet of mica shaped like a human hand, and one shaped like the talon of a predatory bird—perhaps a falcon or an eagle [7]. The human hand has fingers and an extended thumb. The digits are elongated and tapered, without any indication of knuckles, except on the thumb. In the bird talon, the exaggerated curl of the sharp claws and roundness of the pad create a dynamic sense of movement. Thin, beaten sheets of copper as well as mica were cut into various animal shapes by Hopewell artists. Some of these included a serpent head with forked tongue [8], a profile falcon shape with well-defined beak, wings, and tail feathers [9], and abstract geometric patterns that have no clear-cut relation to anything in nature [10 and 11].[5]

Hopewell art varied greatly in its degree of naturalism or abstraction. For instance, a profile cut-out mica head with an elongated nose [12] seems almost like a caricature when compared to the sensitively modeled clay figurines depicting women and men in various costumes undertaking a variety of activities in Figure 13. This wide range of styles suggests that the materials themselves and the context of their use may have dictated the specific form given to the particular art object being created. Perhaps the naturalistic depiction in the small human figurines was associated with a generalized fertility and ancestor cult, whereas the more stylized and abstracted flat art forms were meant to convey supernatural spirits.

## Art of the Mississippian Period, c. A.D. 700–1500

The art of the Mississippian phase of Woodlands cultures is distinctly different from both Adena and Hopewell art. High-status individuals were buried in large temple mounds with extremely rich grave offerings, including stone figures, effigy pipes, shell gorgets (chest ornaments), and various exotic materials brought in by trade with regions as far-flung as the Gulf Coast, the Rocky Mountains, and the Upper Great Lakes.[6] The major centers of the Mississippian period were in

Georgia, Oklahoma, Tennessee, Alabama, and Florida, south and west of the Adena and Hopewell centers.

A great many art forms from the Mississippian cultures seem to depict high-status individuals—perhaps chiefs and/or priests wearing complex costumes of a zoomorphic sort. Other, more natural-looking art forms include what appear to be seated stone ancestor figures [14], of a type sometimes found in Mississippian burials, and effigy pipes [15]. These pipes depict a variety of activities, including killing game (and humans), domestic garden and cooking activities, and ceremonial games. The male and female stone figures from Etowah, Georgia, are shown in a seated position, with arms set alongside their knees. The male sits cross-legged, the female sits on her legs. They both have well-articulated facial and body parts, and appear to be staring wide-eyed with open mouths. This alert expression was a common stylistic trait in burial sculptures from this period.[7] Traces of pigment on the faces, bodies, and clothing suggest that the Mississippian peo-ple at Etowah practiced body decoration. The bauxite (stone) effigy pipe in Figure 15 from Muskogee County, Oklahoma, represents a man sitting on his legs in a position similar to the female figure from Etowah. He wears large, circular spool ear plugs, has a circular-shaped coiffure tied in a topknot near the top of his head, wears an amulet or necklace on his upper chest, and carries a disc-shaped object in his right hand and a group of dartlike objects in his left. This figure has been identified (by analogy with historical Southeastern Native American practices) as being a "chunkey-player"; during the period after European contact, a ceremonial game was played by Southeastern Native Americans in which a disc-shaped stone was rolled along the game ground and darts were thrown at it.[8] The pose—passive and bent over with arched back—suggests a formal gesture of supplication, and the overall treatment of body parts, proportions, and details is naturalistic. Other manifestations of the chunkey-player motif are found in a more active context, on incised shell gorgets from Perry

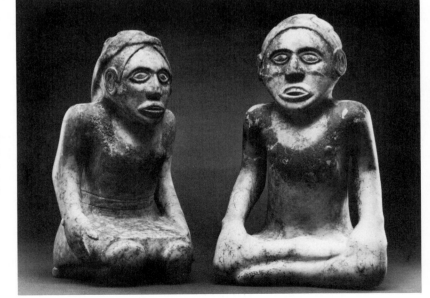

14. Mississippian period (about A.D. 1200–1450) marble human effigy (or ancestor?) figures (female left, male right). From Etowah site, Bartow County, Georgia.

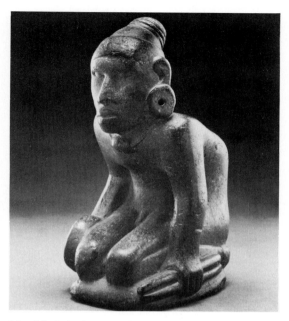

15. Mississippian period (Caddoan culture, about A.D. 1200–1350) bauxite chunkey-player effigy pipe. Arkansas River Valley, Muskogee County, Oklahoma.

County, Missouri [16], and on an incised conch shell gorget from Spiro, Oklahoma [23c]. In the shell gorget from Perry County [16], the male is kneeling on one knee, with one arm raised behind his back with a stone disc in his hand. His attire, which includes an elaborate headdress, gorgets, eye markings, waistband, shirt, and sash, suggests that he is dressed in a ceremonial costume denoting his clan or village affiliation. He also holds something in his left hand that looks like a plant. This, by analogy with historic Southeastern Native American practices, may be associated with some form of agricultural ceremony.[9] The second incised image [23c] shows a partial figure in a similar pose, with chunkey stone in hand and similar, yet simpler clothing and eye markings.

Other art forms from the Mississippian period, such as those in Figures 17–21, have images which are clearly associated with some form of

militaristic death cult. These five examples include: an incised shell gorget with spider-hand motifs from Spiro, Oklahoma [17], an incised stone palette with serpent-hand-eye motifs from Moundville, Alabama [18], an incised shell gorget with a man holding a decapitated human head, from Sumner County, Tennessee [19], an incised and low-relief shell gorget with five human heads, from Spiro Mound, Oklahoma [20], and a human-head ceramic effigy vessel from McKraken County, Kentucky [21].[10]

The spider-hand shell gorget [17] has seven hands incised around the outer circle, with split scallop-like patterns along the outer edge of the gorget. In the center of the gorget is an eight-legged spider, with a rotating four-part spiral motif pattern on its thorax. The legs, two-eyed head, and tail are clearly articulated. The second example [18] is a stone palette with fine line incisings of a central hand motif (with an eye on it), enclosed by a pair of horned rattlesnakes whose bodies are tied together at a point on either side of the central hand. The death symbolism is most apparent in the decapitation scene on the shell gorget in Figure 19, where a warrior figure kneels on one leg, and holds a ceremonial stone mace (weapon) in one hand and a decapitated head in the other. The figure is large and is set against a series of concentric circular bands. The irregular-shaped stone mace in his hand is similar to stone maces found in various Mississippian mounds. Perhaps it was used specifically in ritual decapitations. The warrior (or possibly a priest) has an elaborate headdress with attached pieces, large ear spools, and a forked-eye motif in the shape of a bird's tail around his eye, and he wears an elaborate multitiered necklace and lower body covering. The shape of the figure is clearly articulated with a naturalistic contour line of great elegance.

An incised, low-relief shell gorget with five human heads [20] may or may not depict trophy heads. The five frontal heads with forked-eye motifs around their eyes probably represented a particular group, and the fact that they are ar-

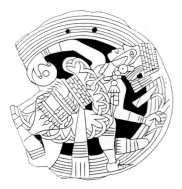

16. Mississippian period (about A.D. 1200–1450) shell gorget showing a chunkey-player in an elaborate costume. From Saint Marys, Perry County, Missouri.

17. Mississippian period (about A.D. 1200–1450) incised shell gorget with spider-hand motifs. From the Craig Burial Mound, Spiro, Oklahoma.

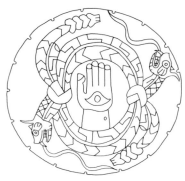

18. Mississippian period (about A.D. 1200–1450) incised stone palette with serpent-hand-eye motifs. From Moundville, Hale County, Alabama.

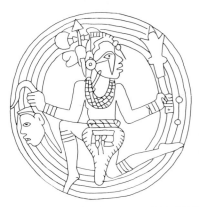

19. Mississippian period (about A.D. 1200–1450) incised shell gorget with kneeling figure holding decapitated head in one hand and a ceremonial weapon in the other. From Sumner County, Tennessee.

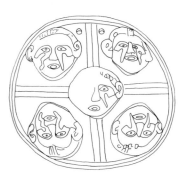

20. Mississippian period (about A.D. 1200–1450) incised and low-relief shell gorget with five human heads. From Spiro Mound, Le Flore County, Oklahoma.

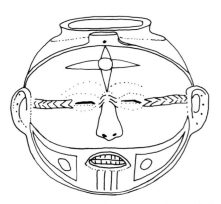

21. Mississippian period (about A.D. 1300–1500) human-head ceramic effigy vessel. From McKraken County, Kentucky.

ranged in a four-part division of the circle, including a fifth head in the center, suggests that they may have had some directional symbolism associated with their placement. The human-head effigy vessel [21] has various facial markings (probably tattoos) indicated on the forehead, on either side of the nose, and on the lower cheeks and chin. The toothy grin of the mouth and the closed eyes suggest that the head may represent a person who is dead. The shape of the vessel is globular, with only a few facial features and with ears raised in low-relief from the surface. These five examples show only a few of the many manifestations of death-cult imagery found in the Mississippian cultures.[11]

Some burial sites contained persons attired in headdresses and clothing that suggest identification with certain predatory animals. The repoussé, beaten sheet-copper plaque from Etowah, Georgia [22], depicts a person dressed in what appears to be a bird costume. The bird species represented by the curved beak-nose may be a falcon, an image common in Mississippian art. The man has one of his legs raised above the other in a dancelike pose. He carries an irregularly shaped mace in his right hand, and a decapitated human head in his left. The large, winglike forms on his back, the necklace, the ear plugs with dangling ornaments, the feathers, and the other added-on ornaments serve to create a lavishly costumed individual. Other bird-related and serpent-related guises can be seen in incised images on large conch shells from Spiro Mound, Oklahoma. These shells may have been used as ritual cups [23d and 23e]. The bird image [d] suggests a falcon (or eagle) and is shown frontally with arms and wings spread. Above his head is a zigzag form that may represent a mound, a rainbow, or lightning. The image in Figure 23e shows two figures dressed in rattlesnake capes which are intertwined between them. These figures hold various weapons and serpent staffs, and they wear related, yet distinctly different, clothing. Beneath them (at their feet) is a coiled rattle-

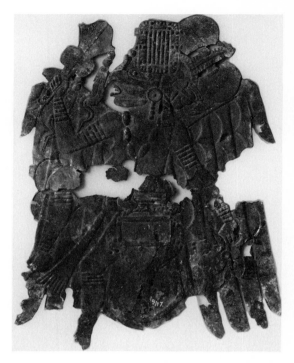

22. Mississippian period (about A.D. 1200–1450) sheet copper plaque pressed and cut into the shape of a winged human (supernatural?) carrying a human head in his left hand and a ceremonial weapon in his right. From Etowah site, Bartow County, Georgia.

snake whose head has a pair of horns. The horned snake probably represents some sort of supernatural being; therefore, the men dressed in serpent capes may be priests or devotees of a serpent cult. Another image taken from a conch shell [23a] shows a figure that appears to be moving, with his hair (or headdress) flying backward behind his head. The image taken from a repoussé beaten copper sheet [23b] is an almost portrait-like profile of a male, with forked-eye decoration around his eye, ear plugs, and short hair on his head.

The remaining two images [23f and 23g] seem to represent supernatural creatures that are composites of serpents and other animals. The first, taken from a shell gorget at Spiro, combines a serpent body with six animals—two are bucks with antlers and the other four are probably does. The image in Figure 23g, taken from

23. Mississippian period (about A.D. 1200–1450) designs representing chunkey-players, high-ranking people, and supernaturals. Taken from various shell and copper objects from Spiro Mound, Oklahoma.

pottery at Moundville, Alabama, shows a rattlesnake-like serpent with horns (or antlers) and wings like a bird's.

These bird-deer combinations are also found as images on incised shell gorgets such as the one shown in Figure 24, from Hamilton County, Tennessee. The central image on this gorget is of two men dressed in bird-wing and bird-tail costumes. Beaklike noses and talon-shaped feet further support their bird identities. Both men wear deer antlers as headdresses, also suggesting deer symbolism. They are shown in active movement, as if they are dancing or fighting, with one leg raised up behind them. Perhaps the bird and deer symbolize different realms—the sky and the earth, respectively.[12]

Burials of high-status persons wearing copper and wood replicas of deer antlers have been found in the Hopewell cultures. And, at Spiro Mound, a wooden human mask with a full set of antlers was found [25], thereby documenting the importance of the deer as an emblem or symbol in that Mississippian site as well. The Spiro piece,

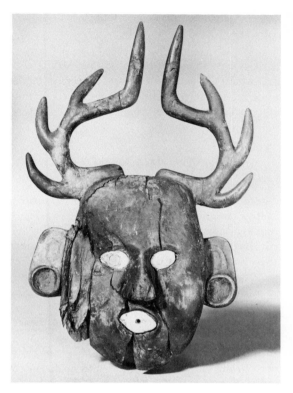

25. Mississippian period (about A.D. 1200–1450) wooden human mask with carved antlers. From Spiro Mound, Le Flore County, Oklahoma.

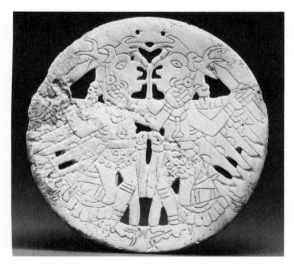

24. Mississippian period (about A.D. 1300–1500) shell gorget showing two men dressed in bird- and deer-related clothing and ornaments. From Hixon site, Hamilton County, Tennessee.

made of red cedar with shell inlays for eyes and mouth, is quite naturalistic—not unlike many of the Mississippian images seen thus far. Naturalistic features include ears that are carved as if circular ear plugs were worn in them, a sculpturally prominent nose and eyebrow region, and fairly realistic antlers. The discolored surface suggests that this mask was originally painted with facial decoration patterns.

From the artistic evidence presented, it seems clear that the Mississippian cultures were more centralized than the earlier Adena and Hopewell cultures of the middle Woodlands period, and that they lavished their high-status burials with various art forms in exotic materials, documenting a complex ceremonial symbolism. When we turn to the art of the Great Lakes and Plains peoples of the late-seventeenth through the

early-twentieth centuries, we will be dealing with many perishable and exotic art forms that can be understood only within each group's religious and social context. Fortunately, we have some accounts and anthropological reports from these periods that help our understanding of the meanings of the art of the Great Lakes and Plains peoples of North America.

## Art of the Great Lakes and Plains, c. Late-Seventeenth Century to Early-Twentieth Century

The pattern of life for pre–European contact Native Americans in the Great Lakes and Plains regions [Map 6] varied according to their ecological zones and settlement patterns. Virtually all of these peoples exploited their flora and fauna by seasonal gathering and hunting, and some (mainly in areas close to the Hopewell and Mississippian areas) practiced agriculture. Whereas some lived in seasonal hunting and gathering camps, others lived in seasonal villages, and still others lived throughout the year in permanent villages.[13] A very strong element of hunting and its attendant shamanistic magic exists in rock art sites throughout the High Plains. This is particularly true in sites at Dinwoody, Wyoming [26], and Peterborough, Ontario [27 and 28]. In many areas of the Plains, herd animals migrated over vast distances during seasonal movements. These animals had been exploited by Native Americans for thousands of years, and their images were pecked into the surface of rock faces along the runs and nearby trails used by these migrating animals. The seven figures depicted in the Dinwoody, Wyoming, petroglyphs [26] suggest at least seven distinct identities, although the overall squarish-rectangular body shape is common to them all. At least three of the figures (those on the left) have outstretched arms, with winglike feather treatment below. One of these figures has circular eyes as well as circular patterns on its lower body, with the upper chest and lower face marked with horizontal and vertical lines. The second figure from the left has diagonal lines on the upper chest, suggestive of a skeletalized ribcage. Its face and headdress differ from both of

its neighbors. The third figure has large, buffalo-like horns coming off the top of its head, and patterns on its body that suggest clothing made of animal skins and furs. The figure on the top, just right of center, is the most anthropomorphic of all the figures and has upraised arms with four-fingered hands and a differentially painted body (half vertical stripes, half meandering curves). The legs are clearly defined, with three- and four-toed feet, and irregular meandering curved lines project from its elbows. One of these lines connects to a small figure below that has down-curved, thin arms, a trapezoidal body with what appears to be a tail, and legs that suggest a bird's. This figure's head is basically round, with a pair of short, curved horns on top, and the face is painted with vertical lines. The final anthropomorphic figure, on the right, has its arms and hands raised upward; has a down-turned mouth; six short, vertical hornlike forms sticking out from the top of its head, and a body divided horizontally into five zones, with dot patterns in the lower two zones. In one hand it holds what appears to be a stick with feathers attached, and in the other it holds a line that curves downward to touch the nose of an animal (perhaps a deer or an elk). The meaning of this elaborate petroglyph panel remains unknown; however, many of these striking images suggest shamanistic hunting-related rites and spirits.[14]

A second example of rock art, from Peterborough, Ontario [27 and 28], near the northern shore of Lake Ontario, provides us with hundreds of petroglyphs on a single rock outcropping.[15] An overview of the northern section

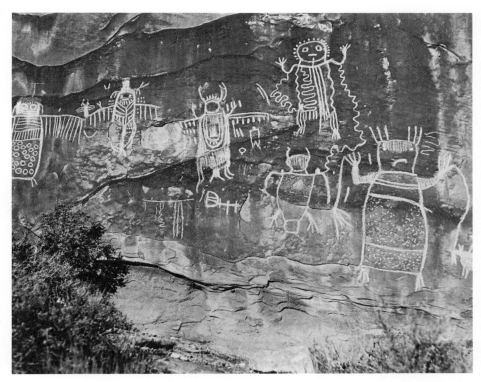

26.   Pre–European contact period (Plains culture, Dinwoody, Wyoming) petroglyphs probably representing shamanistic figures associated with hunting magic.

of the site [27] shows us the seemingly random array of anthropomorphic, zoomorphic, and abstract geometric images cut into the rock surface. They vary a great deal in size, with certain animal and human forms clearly larger than others. Drawings based on eight of these petroglyphs [28] include (from top left to right) a turtle with eggs; a horned serpent with eggs; a male figure with a large penis; a female with a clearly articulated vagina cut into a natural cleft in the stone; a large heron; a human (perhaps a shaman) carrying a rattle or staff; a canoe-shaped vessel with steering oar, upraised prow and stern, and birdlike and sunburst emblems on top; and a strange, sunburst-headed figure probably representing a supernatural being who is known among the Algonkian peoples of the area as a *manitou*. Although the exact meanings of these petroglyphs are unknown, the images suggest fertility,

hunting-related ceremonies, and a cult associated with celestial deities.

Peoples of the Great Lakes regions used various animal skins and animal parts in creating functional objects. An otter skin with porcupine quillwork, feathers, and tin cone-shaped decorations from the Fox people west of Lake Michigan [29] was used as a storage bag for sacred paraphernalia of the Midewinwin society. This society functioned among many Great Lakes peoples as a medicine and hunting-magic society. The Midewinwin society had the ability to evoke powerful helping spirits for the benefit of all.[16] It also served to preserve the oral traditions of the many groups that had been severely altered by the arrival of European peoples and institutions. The otter's front and back paws and tail have been decorated with porcupine quillwork decorations. The patterns on the paws are abstract

105

27. Pre–European contact period (Great Lakes) petroglyphs associated with shamanistic rites. At Peterborough, Ontario; probably some Algonkian-speaking people made and used the site.

28. Pre–European contact period (Great Lakes) petroglyphs, including a turtle, horned serpent, phallic male, female, heron, shaman, sun-boat, and sun-human(?). From Peterborough, Ontario.

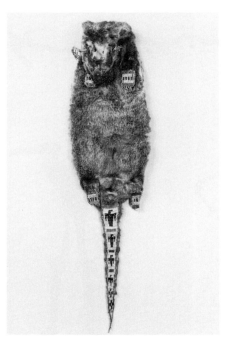

29. Fox people's (Great Lakes) Midewinwin society otter-skin storage bag. About 1850.

and geometric, while the tail has a series of four simple geometric thunderbird images along its length; as noted earlier, in the section on the art of the Alaskan Eskimo and Northwest Coast peoples (Chapter 2), the thunderbird is a powerful supernatural spirit associated with lightning and shamanistic powers. The tendency toward abstract geometric images is common in the art of the Great Lakes people. A second functional object, a deerskin tobacco pouch [30] from the Omaha people, is dated to about 1785 or before. The pouch is decorated with three underwater panthers—another important supernatural spirit associated with Great Lakes shamanistic religions.[17] The top part of the pouch is divided into bands of varied width, some with horizontal wavy patterns, others with rows of vertical elements. The zone where the underwater panthers are placed is relatively free of decoration, except for a series of seven floral-like patterns in a row and a zigzag line which appears to connect the

underwater panthers to each other at their tails; this line also serves as an enclosing device. The skeletalized treatment of the panthers' bodies suggests shamanistic beliefs and practices.

Elaborate use of quillwork, beadwork, and appliqué decoration is found on many articles of clothing among Plains, Great Lakes, and Eastern Canadian peoples. A group of seven decorated moccasins (Color Plate 5), from the Plains (upper left and upper right and lower right), Great Lakes, Eastern Canada (top two center and lower left), and Navajo of Arizona (center bottom), illustrates the diversity of decorations used on these functional objects. The more abstract geometrical patterns are traditional, whereas the ornate floral patterns are based upon European influences over two or three hundred years.[18]

Various kinds of trade goods, such as a metal pipe tomahawk [31] from the Potawatomi of Ohio, were made as special presentation pipes to Great Lakes leaders. The one illustrated here was

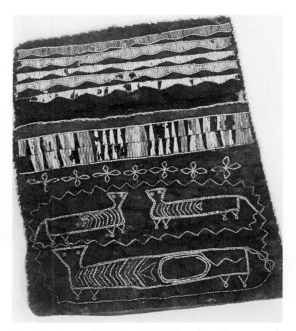

30. Omaha people's (Great Lakes) deerskin tobacco pouch with quillwork in various geometric and figurative shapes, including underwater panthers.

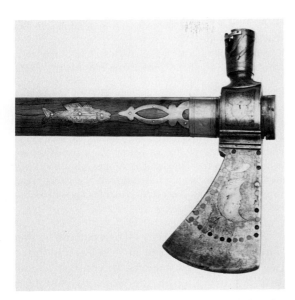

31. Potawatomi people's (Great Lakes) presentation pipe tomahawk.

made about 1820. It has inlay of silver and lead in naturalistic (fish) and abstract patterns (on the hickory handle), as well as an engraved acorn, heart, and half-moon face on the wrought-iron blade. On the top of the handle (not visible) is a silver inlay engraved with the name Ottokee, the name of a prominent Potawatomi man who lived in the Maumee River Valley in Ohio in the early 1820s. This presentation pipe might have been made and given to him by some American government official, or it might have been made by a Potawatomi blacksmith.[19] Another type of pipe, a red catlinite (stone) pipe bowl carved with a horse's head at one end [32], was made by an Eastern Sioux (from Minnesota) in the 1880s. The horse is carved in minimal sculptural planes, with its ears, nose, mouth, eyes, and mane clearly indicated. Inlaid lead dots and lines appear on two ends of the pipe, and the horse's eyes are animated by the use of an inlay of glass beads.

The ecological zone of the Plains peoples of North America is vast compared to that of the Great Lakes peoples. The Great Plains area of North America extends from Alberta and Sas-

katchewan provinces in Southern Canada, across the center of the United States, along the edge of the Rocky Mountains and the grassland plains to their east, and then south to the western area of Texas [Map 6]. Prior to contact with Europeans, most of the peoples of the Plains lived a mixed hunting-gathering mode of life, with their settlements varying according to the availability of wild flora and fauna. In the southeastern area, especially among the Caddoan-speaking peoples, such as the Caddo and Witchita, a more sedentary mode of life existed.[20] This included more permanent village sites, the practice of agriculture, and a more extensive use of pottery. After the introduction of the European horse into the Plains from the Southwest in the late-sixteenth century, the Plains people's mobility greatly increased. The next two hundred years saw population shifts, warfare, and trade within the Plains as well as with groups outside the Plains to the northwest. Trade was particularly strong with groups in present-day Washington State, in the Missouri River region of present-day North and South Dakota, as well as to the south, in Colorado, New Mexico, Texas, and Oklahoma. For the remainder of this chapter we will focus on the art of five Plains groups—the Arapaho, Mandan, Crow, Sioux, and Blackfoot. The Arapaho and Blackfoot speak an Algonkian language, whereas the Mandan, Crow, and Sioux all speak variations of Siouan languages.[21]

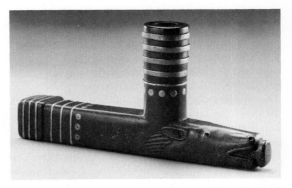

32. Eastern Sioux (Plains/Great Lakes) catlinite pipe bowl in the shape of a horse.

A very common art form found among the Plains peoples is the painted hide robe, often made from the skin of a buffalo. Both men and women painted their robes. The women painted in a geometric, abstract style, while the men painted in a more figurative style. The geometrically patterned Arapaho bison robe for women [33] is an excellent example of its type. It is one of the very few robes of this style for which a detailed explanation of the meanings of the painted patterns was collected at the turn of the century. A full description of the symbolism of the robe follows:

The border as a whole represents a buffalo. The dark lines along the edges symbolize the skin and hair of the animal, its veins; and the diamond-shaped figures, the pulsations of its heart. In these figures the red central spot symbolizes the heart; and seven yellow or green lines, the seven periods of creation. The border as a whole also symbolizes a river on which floats a pemmican (the diamond-shaped figure), this being a reference to an Arapaho legend.

The large oblong figure in the center symbolizes the earth, the red and yellow line surrounding it being the horizon. In this line the red symbolizes the Sun, the yellow, the Day. The red, green and yellow strip in the center of this design symbolizes the Path-of-Life. The three diamonds represent the eyes of One Above who watches human lives. They also symbolize a man, a woman, and animals. The red field surrounding the green triangles represents the Indian race. The designs above and below this central band symbolize the division between day and night. The long yellow line through the center of each represents the Milky Way. The black triangles containing four white squares symbolize the buffalo lodge, where the buffalo were once kept imprisoned by the white crow. The white squares represent the buffalo, but they also symbolize life or abundance, and the Four Old Men of Arapaho myth. The triangles with a red spot in the center represent another legendary lodge in which the six sisters, who had been sent away from their home for their refusal to marry, lived for a long time. The red spot indicates the fire in the lodge, the white around it, the light. The long triangular figure below the central design represents a buffalo's tail, the triangles along the edges sym-

bolize hills. The red line below it represents the Indian's way of life.

In the perpendicular figures at either end of the large central design the light central strip represents a road. The triangles at either end of this strip represent tipis; the small red spots in it, people; and the green and yellow lines connecting them, paths. The figures along either edge represent day (yellow), night (black), and water and vegetation (green), and the Indian race (red). The long triangular figures below these bands represent the limbs of animals, the color symbolism being the same. The unpainted portions of the robes were originally whitened with clay, symbolosing [sic] purity and cleanliness.[22]

A figurative bison robe [34] was painted by the Mandan chief Mato-Tope in 1833 to record various war deeds and exploits. In contrast to the abstract patterning on the woman's robe just discussed, Mato-Tope's robe is clearly organized as a series of narrative pictures set above and below a circular and linear quillwork pattern that bisects the robe where the bison's backbone had been. Animated scenes of pursuit, warfare, wounding, and killing are clearly depicted in a simple figurative style. The images include a great deal of detail of Mato-Tope and his enemies' clothing and weapons. The filling in of the different parts of the costume and the lively body gestures of the participants are most likely the result of the influence of the American artist George Catlin and of the Swiss artist Karl Bodmer.[23]

Suggestions of an earlier Plains style of painting can be seen on the front and back of a painted Sioux warrior's coat [35]. Simple stick-figure humans with short and long hair, flintlock-style rifles, long-stemmed pipes, and (on the back) a vertical row of horizontally oriented hourglass-shaped designs cover the majority of the surface of this early-nineteenth-century long warrior's coat. There are also geometric patterns of rectangles and triangles in beadwork and quillwork, along the shoulders and upper sleeves. Human scalp locks (taken from war victims) adorn the

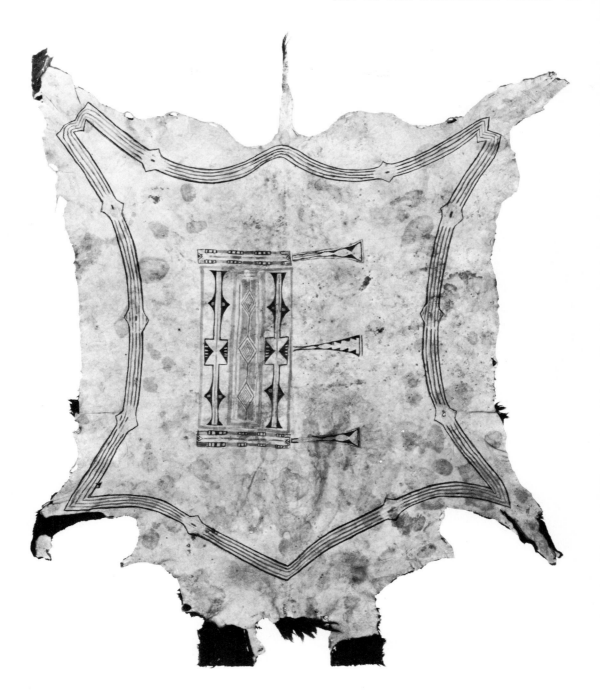

33.   Arapaho (Plains) painted woman's bison robe with abstracted painted designs.

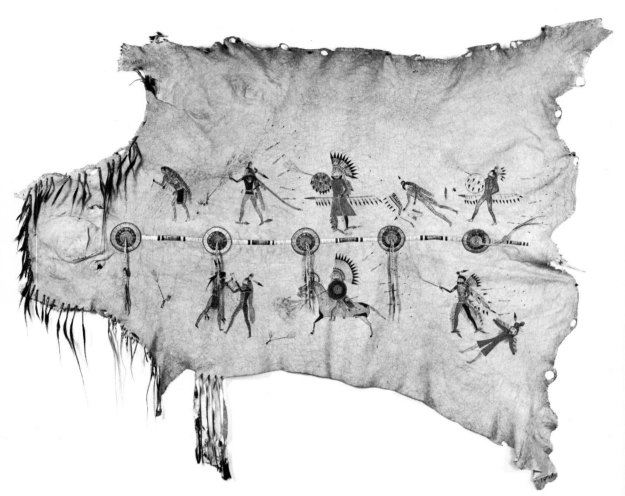

34.   Mandan (Plains) painted bison robe, painted by Mandan Chief Mato-Tope in 1833 and illustrating various of his war exploits.

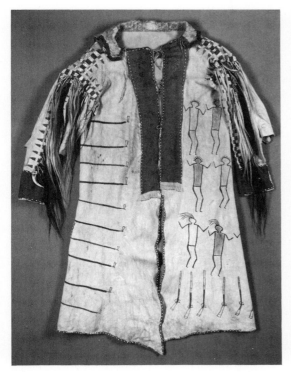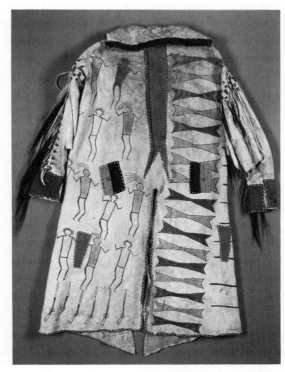

35. Sioux (Plains) warrior's coat (front and back views) with various abstract and figurative designs (rifles, pipes, and humans).

upper arm sections on both sides, attesting to the owner's success as a warrior.[24] Compared to the lively detailed and naturalistic human images seen on Mato-Tope's painted bison robe, this coat is painted in a style that appears mostly free of European and American artistic influence. However, the cut of the coat owes a great deal to European styles of the seventeenth and eighteenth centuries.

It is not surprising to find abstract and figurative motifs in Sioux and other northern Plains people's art that are similar to motifs found in the arts of the Great Lakes peoples. The Sioux and some other Plains peoples had moved to their location in the Dakotas from areas to the northeast, near the Great Lakes. An early Santee Sioux cradleboard [36], covered with quillwork and incised with geometric and simple figurative patterns, was collected by the artist George Catlin in the mid-1830s. The bird and the long-eared

mammal are the only recognizable images. They may represent a thunderbird and an underworld panther (or a deer). The board is divided into horizontal rows of quillwork decoration on the lower two thirds, and horizontal rows of incised decorations on the exposed wooden backboard above. The geometric motifs may represent such things as mountains, tipis, encampments, feathers, whirlwinds, "breath-of-life" motifs, circles with compass-like directions, and other protective and positive symbolism appropriate for a cradleboard. The attached quillwork bags beneath the cradleboard may have served as protective amulets and may have contained the umbilical cords of at least three infants.

An elaborately painted Sioux tipi liner (Color Plate 6) is covered with dozens of figurative motifs associated with a sacred pipe ritual as well as with important events and beliefs in the Sioux culture.[25] A tipi liner was placed on the inside of

36. Santee Sioux (Plains) cradleboard with incised and quillwork decorations (abstract and animal).

a small, ceremonial tipi where medicine men, warriors, and others would seek supernatural guidance during important medicine rituals. The central image on this tipi liner is a vertically placed, winged, sacred pipe in green, yellow, and red (the bowl of the pipe is bright red); this type of pipe was found among the Plains Indians. It has a shaft made of wood, in a flat elongated shape, and a bowl carved out of catlinite or other colorful stones. Above the pipe is a green radiating sun symbol, and on either side are red cranes, hares, horned serpents, and red, yellow, and green horses. A black bison bull with a red interior heart line is below. The placement of these animals, from top to bottom along the sacred pipe, may have had special meaning in the cosmology of the Sioux who used the liner; however, the meanings of the placement are lost to us today. Many of the creatures depicted are probably associated with mythological stories and characters therein, and undoubtedly had to do with power, fertility, and the importance of supernatural beings in the religious life of the Sioux. Radiating sunburst images, painted in red, green, and black, flank the sacred pipe on either side, and these are in turn surrounded by smaller images of humans and animals in various secondary compositions. To the left of the pipe and around the large sunburst image are various serpent, horse, thunderbird, tortoise, dragonfly, bison, whirlwind, and human images, which may have symbolized various personages in medicine and sacred-pipe rituals. A related, but distinctly different, cast of characters is found to the right of the sacred pipe around the second sunburst image. Here, the thunderbird, horse, bison, bear, whirlwind, tortoise, and human images are found in small groupings that differ somewhat from the opposite side. When closed and in place within the tipi, this liner would appear to have a continuous series of compositional elements rotating around a central axis. The red, yellow, green, and black colors are associated with directional symbolism, which was common to the peoples of the Plains.

A pair of late-nineteenth-century painted figurative tipi covers from the Sioux [37] provides an interesting contrast to the earlier figurative style of painting on the ceremonial tipi liner just discussed. These tipi covers have animated scenes of equestrian warriors and battle scenes depicting the tipi owner's exploits in war. The animation and the more naturalistic rendering are a later development of the style of painting we noted for the Mandan chief Mato-Tope [34]. One interesting image is the pair of American flags painted near the top of the tipi behind the horse and rider.[26]

The Plains Indian peoples excelled in the art of personal adornment. A group photograph [38] shows a Sioux delegation to the 1904 World's Fair in Saint Louis as they posed wearing their finest clothing. Compared to the earlier warrior's coat [35] and the painted bison robe [34], the

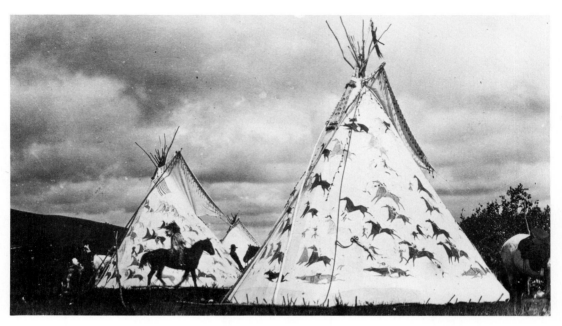

37.  Sioux (Plains) painted figurative-style tipi covers with equestrian warrior images and two American flags (far left), 1880s.

38.  Sioux people (Plains) at the 1904 Saint Louis World's Fair. The men and women are dressed in varied old traditional and late-nineteenth-century style of ceremonial clothing.

39.  Sioux (Plains) beadwork on various pouches, knife cases, and a blanket border.

clothing worn by the Sioux men and women in this photograph is a mixture of old traditional and late-nineteenth-century styles of ornament. Six of the men are wearing long eagle-feather bonnets, which were considered formal display wear. Several of the men are wearing beaded vests with simple abstract or figurative images placed against a homogeneous light or dark background. At least two pipes are in evidence, and two beaded pipe bags with elaborate geometric patterns are visible on the left side of the photograph. Many of the men are wearing simple, geometrically patterned beaded leggings and moccasins. The women wear a variety of clothing, including beaded moccasins, long skirts bordered with simple band patterns, and shawls or other coverings over their blouses. Some of the women have quillwork, shells, or tokens placed in rows on their clothing.[27] In addition, some of the men wear medallions given to them by the United States government. A constant visual element in Sioux and many other Plains Indian peoples' beadwork patterns is the use of simple or more complex arrangements of geometric patterns to decorate their clothing and/or functional items, such as bags, pouches, and horse trappings.

Several kinds of beaded functional items from the Sioux are shown in Figure 39. These include a long blanket border strip, a knife case, a belt case with awl case, and five other types of belt cases. The blanket strip has a series of three circular medallions, with a four-part directional pattern radiating from the center. These medallion shapes alternate with rectangles of dark rows of beadwork bordered by a design known as a "lazy-stitch" pattern. The knife sheath has a modified floral beadwork pattern on its top, and simple triangular, diamond, and geometric elements on its lower surface. It also has small, cone-shaped metal ornaments hanging as part of the decorative fringe. This is true in some of the other cases as well. Simple geometric bead or quillwork patterns appear on all the cases.

A photograph of a Blackfoot man wearing an eagle-feather headdress and sitting on a horse

40.   Blackfoot (Plains) horses and chief(?) with elaborate beaded, painted, and woven storage bags, blankets, feather decorations, and ornaments.

[40] illustrates some of the elaborately decorated functional items used on Plains horses in the late-nineteenth century. The horse in front has a travois (the two cross-poles) attached over the top of his shoulders. The cross-beams support a decorated bark bag (called a parfleche throughout the Plains) and other wrapped containers. Geometrically patterned rump and saddle bags are visible as well. The rider wears a patterned blanket over his shoulders, and has one rolled up across his legs. The second horse is attached to the travois by a pair of lead lines, or reins. He has a decorated neck ornament of triangular-patterned beadwork, his bridle has metal rings along its upper portion, and he is equipped with a woman's saddle with a high, raised pommel and a cantle. A rolled-up blanket is laid across the front of the saddle (behind the pommel), while a decorated saddle bag, a parfleche, and a rump bag are spread out over his middle and rear to more evenly distribute the weight he has to carry. Feather decorations on his tail probably symbolized his former role as a great war horse. It seems clear from the great care and elaborate decoration bestowed upon their horses that the Plains people considered the horse one of the most important living creatures in their universe.

# 5

# West African Art
# of Mali, the Ivory Coast, and Ghana

The Bamana and Dogon of Mali, the Senufo and Baule of the Ivory Coast, and the Asante of Ghana live in vegetation zones that vary from savanna grasslands in the north to tropical forests in the coastal regions in the south. In all these groups agriculture is the major source of food production. Millet, sorghum, maize, and rice (in some regions) are the dominant foods of the Bamana, Dogon, Senufo, and Asante. In addition, yams are an important food source for the Senufo and Baule, and oil palms and shea tree nuts (from which a form of butter is derived) are important food sources for both the Baule and the Asante.

In all three regions hunting and gathering traditionally supplemented agricultural practices. Mammals ranging in size from small antelopes to large elephants were hunted for food in many regions of southern Mali, the Ivory Coast, and Ghana. Rivers and coastal regions provided an abundance of shellfish and fish.

The languages spoken by the Bamana, Dogon, Senufo, and Asante belong to a large West and Central African language group known as the Niger-Congo family. The language spoken by the Bamana is one of a large subgroup of languages found in the western regions of Africa called the Mande language group. The Dogon and the Senufo speak languages that are part of a subgroup called Gur languages. To the east, the Baule and

the Asante speak languages that are part of a widespread subgroup called Kwa languages. Kwa languages extend to eastern Nigeria.

The Bamana, Dogon, and Senufo cultures do not have chiefs and are relatively egalitarian compared to the more centralized leadership cultures of the Baule and the Asante. The Asante origins of the Baule, coupled with later intermixing with acephalous groups in the Ivory Coast, have created among the Baule a culture with traits of both egalitarianism and centralization.

Islamic religion and culture had a strong impact on many cultures in Mali, the Ivory Coast, and northern Ghana for many centuries before there was sustained European trade, missionary activities, and colonialization. Traditional religions, culture, and arts have endured in all five groups (Bamana, Dogon, Senufo, Baule, Asante) in the face of extensive outside influences from North African and European peoples and institutions.

The habitations and building materials found among the peoples of the savanna grasslands (Bamana, Dogon, and Senufo) are predominantly mud, sticks, and thatch. These materials are used to create sculpturally defined, geometrically shaped housing and storage units, often in large multidwelling villages. In the forest regions to the south, use of plant materials to create individual household units was common practice. Among

the more centralized Asante, small household units as well as larger religious shrines and palaces are built in a wide variety of four-part structures around a central rectangular courtyard.

## Art of the Dogon of Mali

The Dogon live in the bend of the Niger River in southeastern Mali, having migrated to this area in the early part of the second millennium A.D., perhaps about A.D. 1100 [Map 7]. According to their oral traditions they encountered a native people which they call Tellum, and they intermarried with them, taking on elements of their culture. The cliff locations along the Niger River served as easily defensible positions against the intrusions of warlike raiding groups from various parts of the Sudan. Until the French ethnographer Griaule did extensive field research among the Dogon in the 1930s, their art and culture was little known or understood by Westerners.[1]

Dogon mythology sheds some light on the meaning of their figure sculptures, including a seated couple on a stool with support figures below [1]; a vertical, phallic-formed figure with arms raised over its face [2]; a ritual vessel in the shape of a dog image [3]; and two carved doors —one with over forty relief figures set in horizontal rows [4], the other with three figures in the center [5]. According to Dogon mythology, the creator god Amma had intercourse with the female earth, producing the original primordial couple and their eight children. The seated couple in Figure 1 depicts the original couple sitting on top of a stool, with four caryatid figures serving as support posts between the top and base of the stool. Each of these supporting figures has both male and female sexual characteristics, thereby symbolizing a pair. The circular seat and base symbolize the sky and earth, respectively, with the center post representing the connecting tree of life.[2] The two figures on top are examples of an abstract geometrical treatment of the human form. Their arms and legs are simplified flowing cylindrical shapes, and each of their heads is thin, crested, and helmet-like, with a thin, arrow-shaped nose. Each figure has a thrusting element projecting off the bottom of its chin—the male a beard, the female a lip plug; these projecting elements help to balance the diagonal thrust of the figure's hairdo at the back of its head. The torso on each figure is columnar and elongated, with incised lines radiating out from a protruding navel. The heads are finely incised with linear patterns which articulate hair as well as facial tattoo patterns. In addition, thin repetitive encircling bands around the wrists and arms represent rings of metal jewelry. In contrast to these large figures on top, the four small caryatid figures below are much stockier.

The phallic-shaped figure illustrated here [2] represents a mythological character known as Dyougou Serou, who is depicted hiding his face with his hands in shame for having committed incest with his mother, the earth.[3] In this piece, the sculptural forms are more abstract than those found on the stool, and this abstraction is enhanced by the object's patina—an accumulation of various sacrificial substances.

The dog-shaped ritual vessel in Figure 3 is associated with migration stories of the Dogon. During their group exodus from present-day central Mali during the second millennium A.D., they found themselves without water. According to tradition, a dog began digging in the earth and uncovered a hidden water source which saved the Dogon from certain death. This dog-shaped

Map 7. WEST AFRICA

1. Dogon
2. Bamana
3. Djenne
4. Senufo
5. Baule
6. Asante
7. Fante

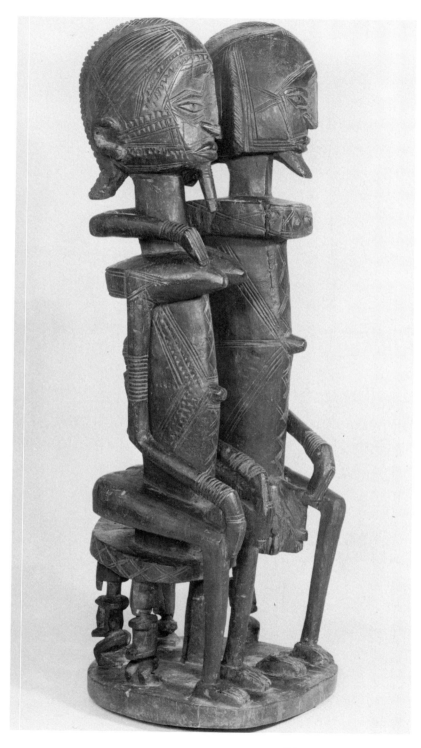

1. Dogon (Mali) wooden stool with two primordial ancestor figures (top) and four caryatid figures below. Nineteenth century. Photo © copyright, The Barnes Foundation, 1988.

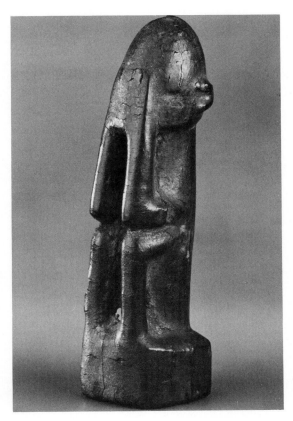

2. Dogon (Mali) wooden figure representing Dyougou Serou, hiding his face in shame for having committed incest.

3. Dogon (Mali) wooden ritual dog figure with relief-carved mythical figures on its sides.

ritual vessel has medium-relief figures with both male (beard) and female (breasts) characteristics—a stylistic trait identifying the figures as primordial mythological personages known as Nommo. The vessel on top served as a receptacle for sacrifices at an altar, and over the years the forms of the dog and the relief figures have become slightly obscured by the accumulation of a sacrificial patina.[4]

Sometimes imagery in Dogon art alludes to historical persons and events. This is particularly true in the case of carved granary doors. The granaries of high-ranking religious leaders, who are known as Hogon, often had carved doors and

shutters. These relief carvings frequently alluded to the original forty-four families who migrated to the Niger River cliffs from their homeland in central Mali. One of these doors [4] has four rows, totaling forty-three figures. The inclusion of both male and female characteristics on these figures makes their sexual identity ambiguous. The second door [5] has only three figures, with raised arms and tiered headdresses as the central image. The outside border is carved as a double row of zigzag patterns, which may allude symbolically to a serpent, an animal important in Dogon mythology. While the upraised arms with open hands allude to prayer gestures used by priests and worshipers when asking for rain to help the crops grow, the many-tiered hats have been associated with the many-storied house of the high priest (Hogon). This suggests that the door may have been owned by such a person. The mixture of male and female characteristics on the figures in both doors is a symbolic reference to mythological personages.

A larger-than-life figure of a priest with his arms raised in prayer [6] is a tour-de-force of Dogon sculpture which may date from as early as the fourteenth century.[5] The head and the groin region clearly suggest that this figure depicts a male, while the enlarged pectoral region suggests feminine characteristics, in keeping with the notion that primordial people had both masculine and feminine sexual identities. The upraised arms probably refer to the prayer gesture already seen

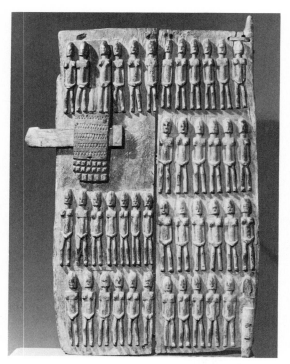

4. Dogon (Mali) wooden granary door with forty-three fig-
ures carved in medium relief.

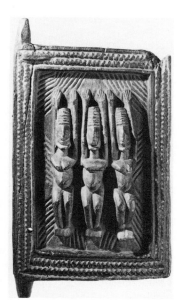

5. Dogon (Mali) wooden granary door with three figures
with raised arms.

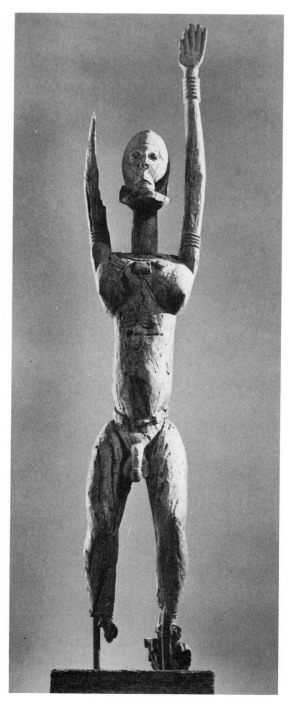

6. Dogon (Mali) wooden hermaphroditic figure with arms
raised above its head.

in Figure 5. This gesture is associated with the control of rain—a control essential to an agrarian people like the Dogon.

A form of Dogon architectural sculpture is carved support posts. These are found on special village meeting places called Toguna. These meeting places served as a shelter from the heat of the sun and were used by Dogon elders as a place to discuss matters of ritual importance to the community. The lower section of the shelter consists of a large row of forked support posts, some of which were carved with low-relief images of symbolic importance to the Dogon. Details of relief figures carved on the support posts of a Toguna at Sedourou village are seen in Figure 7. This illustration includes a female figure with prominent breasts, and images of masks and masked dancers, including a short-horned antelope (on the bottom) and a water buffalo (on top). The multilayered sod and stick roof has symbolic meaning as well. It is associated with sacred numbers and agrarian practices.[6]

All initiated Dogon males belong to a masking society called Awa, which creates dozens of different mask types for ceremonies such as initiations, funerals, and marriages. The most powerful mask of the Dogon is the "Great Mask"—a huge serpent mask which is presented at grand funeral feasts, and which serves to capture the soul (*nyama*) of the dead in order to place it in an ancestral figure. The lower part of the Great Mask is a simple, boxlike shape with two deeply cut vertical indentations and three vertically oriented raised areas. Set within the deep undercuts are pierced geometric eyes (often triangular). The upper part of the mask consists of a crudely shaped serpent form that is associated with a myth of the Dogon which explains the origin of death. In primordial times the Dogon did not die; they merely transformed themselves into serpents and lived on eternally. According to legend, an old man realized that his time for transformation had come, and he went out into the countryside and changed into a serpent. Some of the people

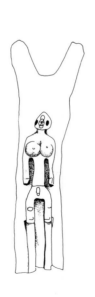
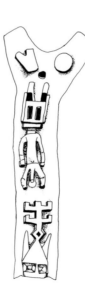

7. Dogon (Mali) men's meeting place (Toguna) with wooden tree-fork support posts carved with female figures and images of masked dancers.

from his village happened to be walking by, and he called out to them from his new identity as a serpent. This violation of taboo so infuriated Amma, the creator god, that he imposed death upon all humans from that time onward.[7]

Another powerful masked spirit of the Dogon is called Sirige, and its tall superstructure [Color Plate 7] represents the many-storied house of the high priest, Hogon. In this photograph from 1971, a group of four Sirige masks are shown in a dance with two warrior woman masks (called Satimbwe) in the background. Unlike the great serpent mask, which is merely carried about in the village, the Sirige mask is worn by a dancer who does a number of difficult athletic maneuvers as part of the mask's public display. Like the great serpent mask just described, the Sirige mask has a boxlike lower mask painted with geometric patterns. In addition, it has a connecting strut which holds up an elongated and abstracted house shape, which is also decorated with geometric patterns.[8]

The warrior woman mask called Satimbwe is seen in Figure 8 as well as in Color Plate 7. This mask type is said to celebrate the courage of Dogon women when aiding their men in battle. In the example in Figure 8, the Satimbwe figure is a simplified vertical form with a flat chest, geometrically formed breasts sticking out as cone shapes, and a simplified phallic-shaped head. Symbolically, this mask is a blend of abstracted masculine and feminine geometric forms—a style trait commonly found in Dogon sculpture.

The Kanaga mask type discussed in Chapter 1 (Figure 10) has rectangular "arms" set in upward and downward positions over a lower mask with pointed ears and a helmet-like head. The Dogon suggest that the arms represent the creator god Amma pointing upward to the sky and downward toward the earth after he created the world. Sometimes the arms are set in a rotary pattern, suggesting the active creation of the world.

Another human-like Dogon mask, called Samana [9], represents a warrior spirit. This mask differs from the previous ones in that it lacks a superstructure with emblems on top. It has an anthropomorphic head with deeply set eyes; a long, thin, vertically-cut nose with broad nostrils; a protruding mouth; and high-relief c-shaped ears protruding off the temple area.

The dozens of different animal masks made by the Dogon may have originally been used to appease the spirits of animals killed in the hunt, or possibly as some form of family crest or totem animal. While most of these animal masks are simply a set of horns or ears above a simple box-like shape, others are sculpted more three-dimensionally, as mixed anthropomorphic and zoomorphic forms. Many of these animal masks accompany the human-like masks in village ceremonies. All Dogon masks are discarded after use. They are placed in cliffside burial caves and outcroppings, except for the Great Mask, which is kept for funeral purposes until it has been destroyed by termites or other natural causes. Included here are examples of five Dogon animal masks; a short-horned antelope (Walu) [10], a long-horned gazelle [11], a black monkey [12], a white monkey [13], and a crocodile [14].[9]

Two additional art forms, forged iron staffs with figures and a painted rock face, are shown in Figures 15 and 16. The three iron staffs [15] illustrate mythological spirits (Nommos) associated with warriors, blacksmiths, and priests. In the Dogon, the blacksmith is seen as a powerful person, capable of transforming metal into functional objects of warfare, ritual, and everyday use. In Dogon mythology, one of the original creation period people was a blacksmith, who is depicted [15, center] with highly plastic arms and legs that are associated with his prehuman, boneless existence.

The painted rock face at Sanga village [16] includes dozens of simplified images of masks, animals, and abstract geometric shapes associated with Dogon ritual and mythology. They are painted in rows on different levels of the rock face, including the slight overhang on top.

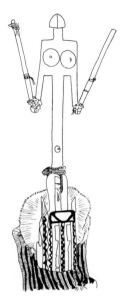

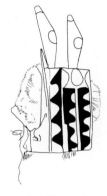

9.  Dogon (Mali) wooden mask representing a warrior (Samana).

10.  Dogon (Mali) wooden mask representing a short-horned antelope (Walu).

8.  Dogon (Mali) wooden mask representing a warrior woman (Satimbwe).

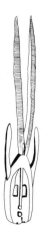

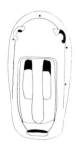

11.  Dogon (Mali) wooden mask representing a long-horned gazelle.

12.  Dogon (Mali) wooden mask representing a black monkey.

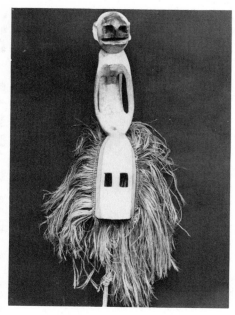

13. Dogon (Mali) wooden mask representing a white monkey.

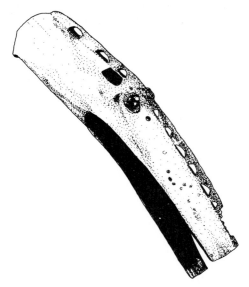

14. Dogon (Mali) wooden mask representing a crocodile.

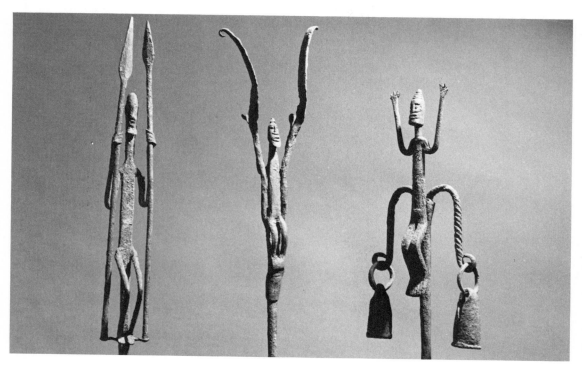

15. Dogon (Mali) iron staffs with figures of Nommo.

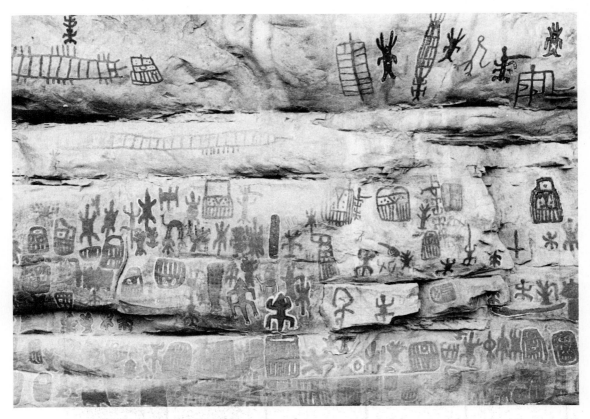

16. Dogon (Mali) rock paintings at Sanga village, where circumcision ceremonies took place.

Dancers with Sirige, Kanaga, and antelope masks are clearly recognizable, as are various reptiles, including lizards and turtles. Architectural forms with linear designs are painted in a number of places on the painted rock face, as are other animal and anthropomorphic images. These painted images are the result of the repeated use of this area during initiation rituals. Most of the images are simple frontal figures set against the background of the cliff face, while a few of them are accentuated by the use of a contrasting lighter outline.

## Art of the Bamana of Mali

The Bamana number about 750,000 and have a long history of living in southwestern Mali in West Africa [Map 7]. The expansion of Islamic rule in the eighteenth and nineteenth centuries had a strong impact on the Bamana and other Mande-speaking groups in the region just west of the upper Niger River, and large populations were displaced during periodic holy war campaigns to convert the indigenous animist farmer/hunters to Islam. By the late-nineteenth century, the mobility of the local Bamana was such that it is very difficult to localize where

some of their art styles originated. At best, one can only suggest that a certain style is from the Bamako, Segu, or Bougoni areas in the north, south, and west.

The Bamana have age-grade societies in which various masks and other art forms serve as visual markers for society identification. Each age-grade society serves to acculturate an individual throughout his (or her) lifetime to the responsibilities and beliefs associated with a particular stage of life: childhood, youth, early adulthood, marriage, family, and old age.

One of these age-grade societies is the N'Domo society, organized around the protection of young males before initiation. It is believed that the uninitiated male carries with him an evil spirit or force called *wanzo* and that at circumcision this evil is taken from him and absorbed by the community at large. The young boys under the protection of the N'Domo society and its masked spirit learn about basic societal values and their role as males in Bamana culture. The art forms associated with these age-grade societies can be seen as visual referents to powers and beliefs sought after by Bamana people, and various human and animal forms which are associated by analogy with these spirit powers.

The composite form of the N'Domo spirit mask usually includes a large, slightly abstracted human face mask surmounted by vertically oriented hornlike shapes. One example of a twentieth-century Bamako region N'Domo mask is pictured in Figure 17. According to the Bamana, the horns are associated with various levels of supernatural protective powers. Cowrie shells often decorate the surface, and create contrasting light and dark patterns which tend to obscure the sculptural forms beneath. The mask's face varies in its level of abstraction from region to region. The Segu region N'Domo mask in Figure 18 is more closely tied to the details and structural elements of a human than the Bamako region N'Domo mask shown in Figure 17, which has a

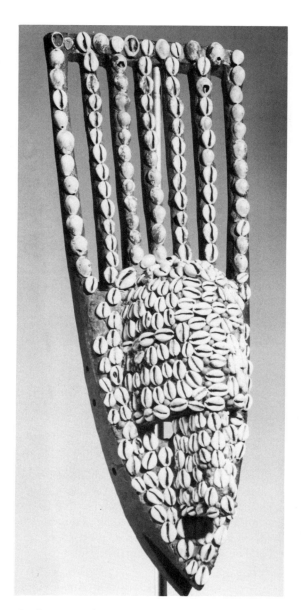

17. Bamana (Mali) N'Domo society wooden mask, covered with cowrie shells, from the Bamako region.

more highly abstracted and geometricized face. The twentieth-century Segu region N'Domo mask in Figure 18 has a standing female figure set

between pairs of squared-off horns of power on top of the mask. The presence of the female figure or, for that matter, of animals such as an antelope or crocodile may be associated with secondary nurturing or power-related symbols.[10]

Another important masking society in Bamana culture is the Kore society. This society focuses its attention on agricultural aspects, such as rainfall, maintaining order, and acculturating the male to his role of a "civilized" adult. Various stages of accomplishment within the Kore are linked symbolically to such animal masks as the horse, hyena, monkey, and lion, in ascending order. The level of cultural knowledge attained within each Kore level is seen, by analogy, to develop from the relatively unstructured, herd-like horse to increasingly more human-like and noble animals until the highest level—that is, the lion—is attained. Masks which represent these four animals serve to mark an individual's level of attainment within the society. Unlike the human and animal forms seen on the Segu N'Domo masks, where human and animal forms are clearly distinguishable, most Kore society masks combine formal characteristics of a specific animal with strong anthropomorphic traits. These masks usually have a highly abstracted geometric simplification of form, which is characteristic of Bamana sculpture. A good example of this tendency toward abstract geometric and anthropomorphic treatment of form can be seen in a drawing based on a Kore society mask representing a hyena spirit [19]. The face mask consists of two curved ears sticking above the top of the head, a globular forehead with a hornlike protrusion in the center, a pair of squared-off eyes set into a slightly concave facial plane, a broad overhanging nose, and a simplified wide mouth at the lower end. These forms are strongly geometric and have both human and animal characteristics.[11]

The headdress masks of the Chi Wara society, an agriculturally oriented age-grade society of young Bamana, are among the most varied and highly complex sculptural forms created by the

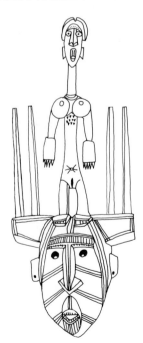

18.   Bamana (Mali) N'Domo society wooden mask from the Segu region.

19.   Bamana (Mali) Kore society wooden hyena mask from the Souroukou region.

20. Bamana (Mali) Chi Wara society wooden vertical style male and female headdress masks.

Bamana. The Bamana attribute the introduction of agriculture in primordial times to a mythical antelope known as Chi Wara. In recent years, the age-grade Chi Wara society serves to organize the young Bamana work force into a variety of communal agricultural work projects. The Chi Wara society holds ceremonies in association with planting and harvesting of sorghum (a grain) and other foodstuffs. During these ceremonies dancers wear Chi Wara headdresses and perform a variety of dances. These headdresses are made in several distinct styles, including a "vertical" style [20], with male and female animal forms clearly differentiated by the elaborate mane of the male and the presence of a "baby" antelope standing on the back of the female spirit. There is also a "horizontal" style Chi Wara headdress [21], with the long-horned head of a primary animal form in a more horizontal direction. This style of Chi Wara headdress dances with a nearly identical-looking partner. The main animal form in the horizontal type of Chi Wara varies from a single antelope-like shape to composite bird and antelope forms. A third style of Chi Wara ante-

21. Bamana (Mali) Chi Wara society wooden horizontal style antelope headdress mask from the Bamako region.

lope headdress is often called the "abstract" style, and it, more than the other Chi Wara styles, combines various animal and sometimes human elements into a tour-de-force of creative abstraction. The abstract headdress in Figure 22 consists of a lower, horselike animal and a horizontally oriented anteater-like animal, whose chin is resting on the horse's head. A pair of antelope horns

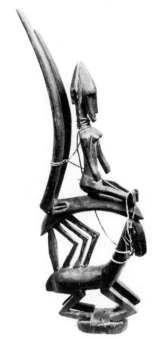

22. Bamana (Mali) Chi Wara society wooden abstract style composite animal headdress.

spring from the back of the anteater shape and curve gently upward, nearly touching the back of the head of a seated female figure who appears to be riding on the anteater's back. The artist's treatment of the various angular legs activates the negative spaces and helps to create a lively and complicated abstract composition when the headdress is seen in profile. This tendency to create an active play of positive shapes against negative shapes is common to both the "vertical" and the "abstract" styles of Chi Wara society headdresses.[12]

Komo society helmet masks [23] create a very different sense of form and abstraction when compared with the elegant, pierced shapes of the Chi Wara society headdresses. The Komo society serves as a power-oriented judiciary group of elders among the Bamana. Their primary purpose is social control and enforcing adherence to basic Bamana religious and social mores. The society also contends with powerful evil forces such as witchcraft and sorcery, and with more universal concerns, of a cosmological and religious nature. These Komo society masks are often encrusted with sacrificial blood and are constructed by attaching a variety of animal horns, animal heads, feathers, and quills to a carved helmet mask. This mask usually has a crocodile-like open mouth, hyena or antelope ears carved along the head, and a hemispherical helmet form which fits over the wearer's head. In the Komo society piece illustrated in Figure 23, long, curving antelope horns have been set into the back of the wooden mask. These two upward-curving shapes balance the slightly downward-curving, and less solid-looking, series of five bundles of porcupine quills attached to the mask near the front and along the upper side of the mask. There are two birdlike heads—one in the center and another near the top front of the mask—which create upward-thrusting silhouettes against the horizontal crocodile-like mouth. The Komo spirit, with its composite nature, represents animals from different spheres, including the sky and trees, the

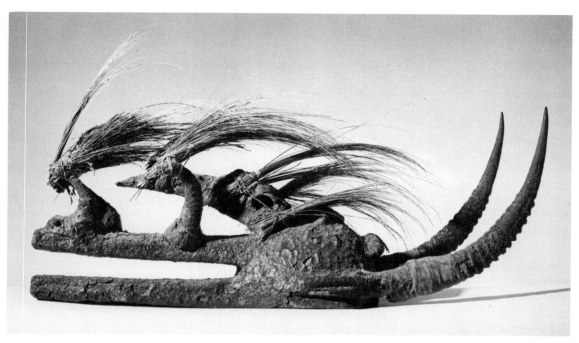

23.   Bamana (Mali) Komo society wooden mask with porcupine quills, bird skull, horns, cloth, and sacrificial patina.

grasslands and plains, and the mud and water of the rivers. These various animal elements symbolically encompass the entire world, and they give this spirit mask enormous powers.[13]

In recent years, large quantities of terra-cotta figural sculpture have come out of Bamana territory, at sites near Djenne in the Niger Delta area and around Bougouni, Dioili, and Bamako to the southwest.[14] It is uncertain whether these figures were made by ancestors of the Bamana or ancestors of the Dogon; the Dogon moved away from this region several hundred years ago. These figures depict standard male and female roles, such as the family and couples [24]; the female as childbearer, childrearer, and cook [25]; and the male as warrior/hunter [26]. These terra-cotta figures are depicted with appropriate sex-role gestures and traits. For instance, the inclusion of a bowl-like vessel in front of the seated female figure in Figure 25 suggests a domestic (or ritual) scene. Male figures are often depicted as warriors or hunters and frequently wear articles of war-

fare, such as helmets, quivers, and knives. Some sculptures even depict warriors mounted on horseback [26]. These terra-cotta figural sculptures tend to be elongated and quite cylindrical, with a great deal of ornament and detail of dress. Perhaps these figures were used in some sort of commemorative ancestor or hero cult by peoples who were the forefathers of the Bamana and Dogon of southeastern Mali. Although there is no direct known historical link between these terra-cotta figures and Bamana wooden figures, there are parallel aesthetic treatments of the human form as an elongated series of tubular shapes with underlying geometric forms set at sharp angles.

In contrast to the large variety of both male and female figure types found in Djenne terra-cottas, female figures predominate over males in Bamana sculpture. Bamana figural sculpture ranges in size from small standing female figures about twenty inches high [27], used in an initiation society organized around young unmarried

24. (left) Djenne (Mali) terra-cotta figures representing a male and a female; c. A.D. 1100–1400. 25. (center) Djenne (Mali) terra-cotta from the Bankoni area representing a kneeling figure in front of an offering (?) bowl; c. A.D. 1100–1400. 26. (right) Djenne (Mali) terra-cotta equestrian figure; c. A.D. 1100–1400.

women, to five- or six-foot-high seated and standing female and male figures [28] used in cults called Jo and Gwan. The small female figure is associated with fertility and the initiation of young girls, and it is a study in subtle abstraction and the balancing of thrusting body parts against vertical, columnar elements. In contrast, the three figures in Figure 28 are larger, have more detailed clothing and accoutrements, and have a more naturalistic quality to their body parts. They represent an equestrian warrior/hunter, what appears to be a seated chieftain, and a seated mother with child. Like the Djenne terra-cottas already described [24–26], these large wooden figures have long tubular arms, legs, and torsos. They also wear amulets, knives, and helmets covered with charms and horns, and they are seated in an erect, formal posture. Unlike those of the Djenne terra-cottas, their facial proportions are set on fairly rounded ovoid-shaped heads with clearly articulated sleepy-eyed expressions. Added power-oriented elements in-

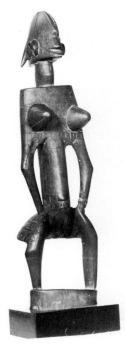

27. Bamana (Mali) wooden female figure used in female initiation rites.

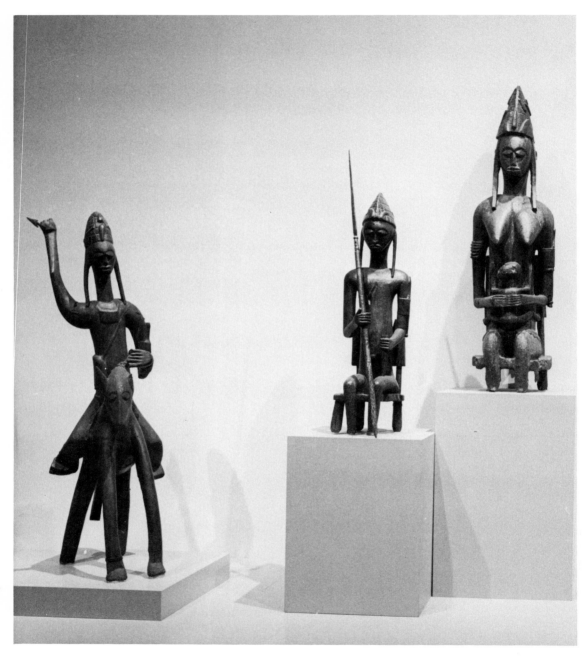

28.  Bamana (Mali) wooden figures: an equestrian warrior figure (left), a seated chieftain with a lance (center), and a woman with a child (right).

clude knives (in the equestrian warrior's upraised hand and stuck on the upper left arm of all three figures), a long spear (in the seated male figure), and representations of animal teeth and horns on all three figures' helmets. Although a somewhat rigid frontality is often seen in these figures, the asymmetry of the horse and rider creates a sense of elegant flowing movement from top to bottom.[15]

## Art of the Senufo of the Ivory Coast

The one million or so Senufo of the northern Ivory Coast, southern Mali, and southwestern Burkino Faso [Map 7] have two wide-reaching institutions—a male initiation society called Poro and a female divination society called Sandogo. The Poro serves as an age-graded society through which all males progress during their lifetime. The Sandogo also is age-graded, but more selective in membership, especially within its higher ranks. Both societies have art forms of various sorts as part of their artistic heritage.

The Senufo believe that there is a continuity of life between those who are living and those that have passed on to the realm of the ancestors. In addition, they believe in various bush spirits and the evil machinations of sorcerers, especially witches. Their art forms include masks, figures, display objects, jewelry, clothing, and architectural sculpture and decoration. These art forms serve as either visual manifestations of these ancestors and bush spirits, or as magical emblems of power manipulated to protect one against evil.

One of the most well-known mask types from the Senufo is a face mask called Kodoli-yehe (also Kpeli). Men and young boys dance as they wear these masks, which are supposed to display the beauty of young women. One of these Kodoli-yehe masks and two junior-level Poro society woven fiber masks (called Kamuru) are shown in a 1970 photograph [29]. These masked spirits often dance at the funeral of members of the Poro society. The three Kodoli-yehe masks illustrated in Figure 30 are type specimens for a broadly based style of Senufo treatment of the face. Senufo masks are often carved with a con-cave face and connected arched eyebrows, which give the mask a somewhat heart-shaped appearance. Frequently the nose is elongated and terminates in a horizontal barlike shape. The pair of chevron-like marks often found beneath the horizontal slit eyes are tribal scarification patterns. Another typical Senufo trait is a slightly protruding mouth, often with teeth showing. The two drooping shapes on either side of the face in Figure 30 (left and right) represent a Senufo hairstyle in which the body, neck, and beak of a bird is created as a sculptural form on the head. Curved horns often appear above the forehead. On either side in all three heads in Figure 30 are shapes protruding outward at right angles to the side of the head. These shapes are said to represent various planes of the head brought forward and parallel to the frontal plane of the mask, as if peeled from the sides and back and flattened out. The long-beaked face mask [30, right] is a variation on the Kodoli-yehe type, with a bird beak extension overlapping the lower part of the mask. It too has sleepy drooping eyes, a series of animal horns set on top, and a bird-shaped hairstyle.[16]

A second category of Senufo masks, one which is associated with chasing and killing witches [31–33], is a composite form of human and animal traits. These composite helmet masks are used in a number of ways—as power spirits during funerals, to help judge disputes, and to counteract the effects of evil spirits, including witches. They are associated with supernatural powers used by the elder members of the Poro society. The mask in Figure 31 consists of a human-like face carved in medium relief over the snout of a

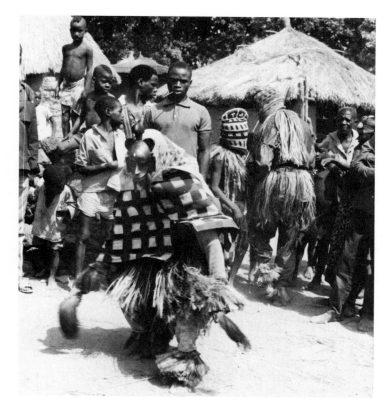

29. Senufo (Ivory Coast) wooden Kodoli-yehe mask and fiber Kamuru masks (behind to the right) dancing at a funeral.

30. Senufo (Ivory Coast) wooden Kodoli-yehe masks.

wide-open hippopotamus-like mouth. Sleepy-looking slit eyes, an elongated nose, tribal marks, and a simple mouth constitute the human elements. Carved, wild-boar tusks are thrust upward next to the human-like face, and backward from the toothy mouth. Its ears could be those of an antelope or hyena, while the pointed, upward-thrusting horns are those of a water buffalo. A chameleon and hornbill stand on top of the head, between the horns of the water buffalo. These various human and animal images represent powers of different realms of the world—water, mud, plains, trees, and air.

The drawing in Figure 32 is based on a variation on this type of helmet mask. Although there are no long protruding horns, it shows

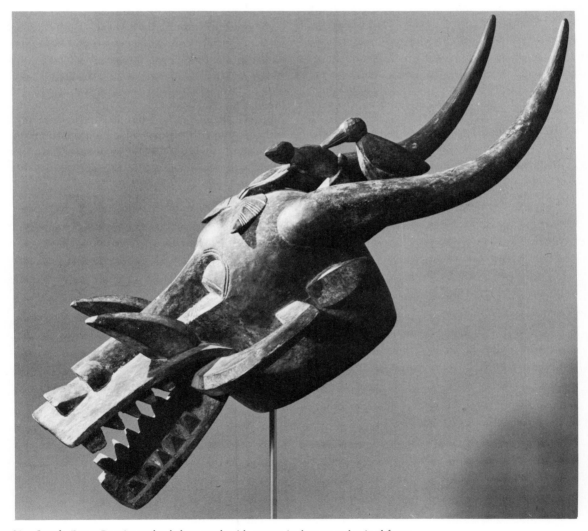

31.   Senufo (Ivory Coast) wooden helmet mask with composite human and animal forms.

32.   Senufo (Ivory Coast) wooden helmet mask.

a similar composite of human and animal forms in a single piece. A small chameleon sits on top of the bulging forehead of this composite hippopotamus, hyena, wild boar, and human helmet mask.

A matched pair of witch-killing helmet masks [33] differ significantly from the horizontally oriented mask types already discussed. These two helmet masks are surmounted by figures with simple lower torsos without feet, concentric ringlike upper torsos without arms, and breasts on the female and a quiver on the back of the male. Each figure has a characteristic heart-shaped face with toothy mouth, and both wear cock's-comb hairstyles which protrude upward and off the back of the head. It is said that the male figure shoots arrows of lightning at witches and other evil spirits.[17]

Although the female image is important throughout the Senufo as a symbol of fertility and as a representation of the primordial mother, the small female figure on top of a champion cultivator's staff in Figure 34 is diminutive in size —barely a foot high. A staff such as this is given to the champion cultivator after a day-long hoeing contest where competition between males from various villages is keen. The seated female

shown here has scarification marks on her stomach and face, is neatly coiffed, and is oiled with shiny aromatic body oils. This depiction of a female stresses controlled, civilized, fertile characteristics, which are in decided contrast to the cultivators who are hoeing in the hot, sunny fields and competing for the prize staff. During these contests the young, scantily clad competitors bend over the earth and sweat from their great effort. This is in contrast to the young women who accompany them into the fields to sing songs of encouragement. These women are beautifully dressed, with elaborate hairstyles and oiled skins. They are the picture of coolness and control. At a symbolic level, this contrast between hot/masculine and cool/feminine is depicted in the art of many West and Central African cultures.[18]

Although it is often combined with other human and with animal forms, the female image is an important element in the meaning of several other types of objects found among the Senufo. The two examples shown here represent a female seated on a stool holding up a large hornbill [35] and a seated female figure on a stool holding up a drum carved with various animal and human figures in low relief on its surface [36]. Symbolically, the hornbill is an important animal in Senufo culture, as it is one of the original five animals used by the Senufo in primordial times, along with the crocodile, tortoise, chameleon, and python. The gesture of the hornbill touching its swollen breast with its curved beak, as in Figure 35, represents a harmony between male and female elements (masculine curved beak and feminine swollen breast/belly). The female figure on this object has proper tribal scarification marks, is well endowed with mature breasts, and is portrayed with a somewhat aloof, controlled posture. The female figure holding up a drum in Figure 36 is similar in style and posture to the previous female, although her burden seems to weigh her down. The surface of the drum is carved with an equestrian warrior figure (male), a

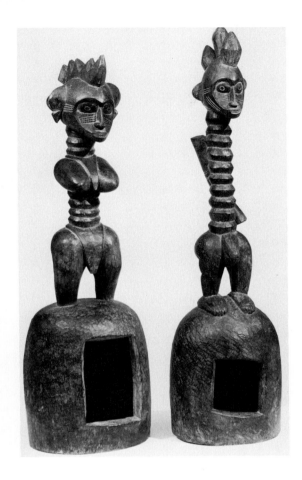

33. Senufo (Ivory Coast) wooden helmet masks (Dequele) with a male (left) and female (right) figures on top.

crocodile, a serpent, and a standing figure (barely recognizable, on the right). These images are power symbols of the women's society called Tyekpa, and they symbolize a supernatural bush-oriented spirit.[19]

The women's Sandogo society is a divination society which uses carved images of male and female ancestral spirits in its rituals. One unusual combination of a female and a male figure astride a horselike animal is illustrated in Figure 37. The female is prototypically female with her erect and mature pointed breasts, tribal markings, and elaborate hairstyle. The male figure rides behind her on the horse and is more passive than is common to this type of sculpture; more frequently, the male has a spear raised in one hand. A very common stylistic trait in these Senufo

equestrian figures is the depiction of the horse's four legs as two legs. The highly creative balance of curved and angular shapes exhibited in this piece attests to the high level of artistic quality and abstraction so common in Senufo sculpture.[20]

Chiefs and other high-ranking members of the Poro society sometimes had their storehouses adorned with elaborately carved doors in medium to high relief. The carved door shown in Figure 38 is a masterpiece of Senufo sculpture. The rectangular door is made from two vertical planks, which are divided into three horizontal panels. The scene on top consists of a pair of hornbills biting at a small-headed, large-bodied tortoise. Next to that scene is a pair of Kodoli-yehe face masks flanking a tortoise shape which

141

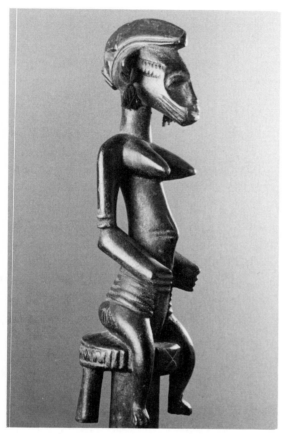

34.   Senufo (Ivory Coast) wooden champion cultivator's prize staff with a seated female figure.

has its neck extended toward the top of the door. The lower scene includes a crocodile biting at the mid-section of a curved-horned antelope, as well as two inverted hornbills who appear to be touching their beaks together. The larger, central zone is divided into two separate areas, with the one on the left containing a single crocodile shape seen as if from above. The square-shaped scene to its right is subdivided into four quadrants, with a circular form in the middle. This refers symbolically to the scarification patterns around the navel of the Senufo female, and is associated with civilization and fertility. The

35.   (left) Senufo (Ivory Coast) wooden seated female figure holding up a hornbill.       36.   (right) Senufo (Ivory Coast) wooden seated female figure holding up a large drum. 37.   (below) Senufo (Ivory Coast) wooden equestrian figure with male and female riders.

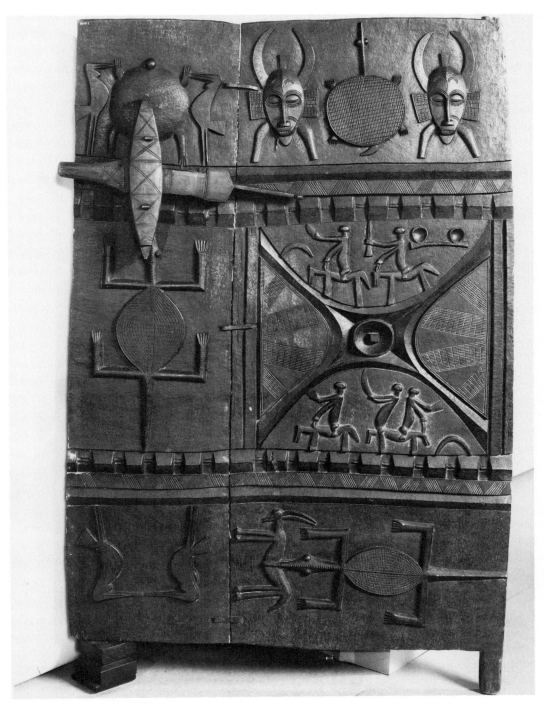

38.  Senufo (Ivory Coast) wooden door carved with various masks, equestrian figures, mythological animals, and war-related figures.

curved top and bottom of this composition contain equestrian figures, with weapons in hand. One of the horses has a pair of riders, with one seated facing backward. The inclusion of curved elephant-like tusk shapes in these curved equestrian scenes suggests hunting symbolism. The foot-shackle shapes on the upper right of one of the equestrian scenes may also allude to warfare and the taking of enemies for sale in the slave market.

## Art of the Baule of the Ivory Coast

About three hundred years ago, an Asante queen known as Aura Poka left her homeland in what is present-day Ghana and migrated to the central region of the Ivory Coast, south of the Senufo. Here, her people intermingled with Guro and Senufo peoples and eventually developed into the present-day Baule.

The Baule have masking societies which use various types of helmet and face masks to symbolize spirits or personages that are important to their world view. One class of dangerous male spirits is represented by various composite helmet masks similar to the Senufo helmet masks seen in Figures 31 and 32. These Baule mask types are called *bonu amuen,* and are associated with the bush, male wildness, and uncontrollable powers.[21] The mask shown in Figure 39 has at least four recognizable sculptural parts, including a large, toothy mouth, a bulbous face with bulging eyes and elongated nose, a pair of curved horns touching at their tips, and two protruding breastlike shapes rising from the surface of the face. The surface of the mask is covered with an accumulation of sacrificial patina, giving it a variegated texture, similar to that on the Bamana Komo society helmet masks in Figure 23.

A second mask type, known as *gba gba,* is associated with the people, animals, and activities of village life. A variety of animal and human portrait masks dance at these *gba gba* ceremonies. One of these masks [Color Plate 8] represents a beautiful young woman (although it is worn by a man). She is shown with a shiny dark-colored face and a colorful costume of woven fabrics and

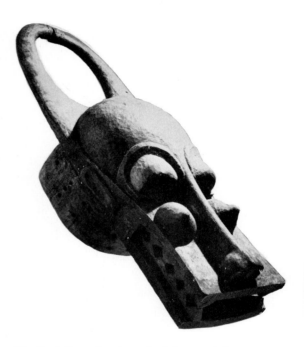

39. Baule (Ivory Coast) wooden helmet mask (*bonu amuen*).

bush grasses. Her headdress is wrapped in a white cloth and she carries brightly colored fabrics as she dances about the village. Portrait masks like this and even of twins are often accompanied during the ritual dance by the person(s) they represent. The *gba gba* mask of twins shown in Figure 40 has two faces—one red, the other black, symbolizing contrasting powers of good (light) and evil (dark). Their eyebrows curve in high arches, which connect to an elongated nose

40.   Baule (Ivory Coast) wooden face mask (*gba gba*) representing twins.

below, and their eyes are partially closed, a trait commonly seen on Senufo face masks. Each mouth is carved as a protruding tubelike shape with circular lips and hole. Each forehead and the area about the eyes is carved with raised shapes which represent scarification marks traditional to the Baule in pre–European contact times (before 1900–1930s). The upper forehead of each face is carved with a double row of curved hairline shapes, while the outer edge of each face is contained within a repetitive series of shapes, including triangles. Both faces have elaborately carved coiffures that usually differ according to the sex being portrayed.[22]

The Goli society uses a variety of human, animal, and abstract masks in its ceremonies. Two

Goli masks [41] of the circular-face-with-curved-horns type have an abstract and nonhuman look when compared with the more naturalistic *gba gba* type just described. The Goli costumes are mostly made of bush materials, and their overall look is somewhat comical. The circular wooden face masks have concentric circular staring eyes, which are carved slightly off the flat surface of the face, and the mouth is a squarish tooth shape, set low on the face. The pair of horns are curved inward and almost touch, as was the case with the composite helmet mask called *bonu amuen* [39].

Although human figure sculpture is common among the Baule, there are basically only two different types of Baule figure sculpture, and two different reasons for having a figure carved. The first sculpture type, known as a spirit partner, represents one's spirit spouse from the spirit world. If a person, either male or female, is having trouble in conceiving a child, or has another sort of personal problem, a diviner is consulted to find the source of the problem. This consultation may result in the commissioning of a carver to make a figure of the opposite sex. This figure represents one's spouse from the spirit world. The male figure is known as a spirit husband (*blolo bian*), while the female figure is a spirit wife (*blolo bla*).[23] These figures are kept clean and polished, in keeping with human cosmetic and toilet practices.

The second class of spirits carved in human form consists of nature spirits (*asie usu*), which can interfere in the lives of the living. Both categories of spirits are identical in basic form when first carved by an artist for a patron. It is only with the subsequent use of the sculpture that the surface patina is changed and the two types are differentiated from one another. The spirit spouse figures [42] eventually have a clean, shiny oiled appearance, as compared to the accumulated patina of sacrificial rites on the nature spirit figures [43]. The male spirit spouse figure [42] is seated on a short chair with a backrest. He has a

41.  Baule (Ivory Coast) wooden Goli mask (*kple kple* type).

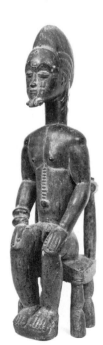

42.  Baule (Ivory Coast) wooden male seated spirit spouse (*blolo bian*).
43.  Baule (Ivory Coast) wooden female standing bush spirit figure (*asie usu*).

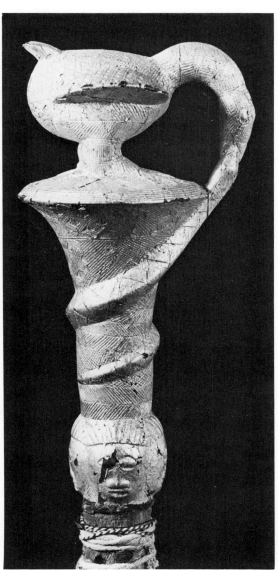

44.  Baule (Ivory Coast) wooden prestige fly-whisk staff covered with gold leaf.

a spirit spouse of high social standing. Despite the figure's disproportionate body parts, there are many naturalistic details on this figure that are common to Baule figure sculpture: the treatment of the digits on the fingers and toes, the fleshiness of the pectoral region, and the replication of tribal scarification patterns and coiffure. The swelling and constricting of the arms, legs, and body give this figure a lifelike quality suited to a spirit spouse of high standing.

The female nature spirit in Figure 43, with its surface covered with patination from ritual observances, differs in proportion from the seated male figure. She has large calves, a trait that is associated in Baule culture with female strength and ability to do good work in the gardens. Her face and body have scarification marks, although they are obscured by the surface patination. Her coiffure radiates back from her forehead in a series of plaitings and long braids, and her arms are folded over her stomach, with the hands curled around the tubular shape of her torso. The entire figure is raised on a rectangular pedestal, and remnants of beadwork adorn her lower calves and ankles.

Traces of their Akan (Asante) roots are found in some areas of the Baule, where jewelry and prestige objects are cast in gold by the lost-wax (*cire perdue*) process, and prestige fly whisks and staffs are made of wood covered with thin sheets of gold leaf.[24] Gold-leaf-covered staffs are associated with Baule notables and are used in swearing allegiances, in purification ceremonies, and as emblems of office for courtly messengers. In the example illustrated here [44], a bird stands on a flaring form, biting at a snake whose body is wrapped around the handle in a spiral fashion. Below that, four low-relief faces are carved on a bulge where the handle joins the staff. The entire low-relief surface and sculptural forms are covered with thin sheets of gold leaf that has been pressed into the surface in a technique called repoussé.

short beard and elaborate patterns of scarification on his face and stomach. His pose and body gesture are tranquil, aloof, and contemplative, and his elevated feet, jewelry, and bearing suggest

## Art of the Asante of Ghana

In one region of southern Ghana lives a large group of peoples who speak related languages known as Akan. Perhaps the most famous of these peoples are the Asante [Map 7], who live near present-day Kumasi. They came to prominence in this region in the late-seventeenth century when an Asante king named Osei Tutu defeated neighboring kingdoms and consolidated his power by having the defeated rulers destroy their emblems of authority, then pledge their allegiance to him. Also famous in the history of Ghana is the "golden stool" shown in Figure 45, lying atop a black-and-gold European-derived royal chair called a *hwedomtia*. The golden stool is symbolic of the spirit and soul of the Asante nation and people. According to Asante legend, the stool was created about 1702 under miraculous circumstances by Osei Tutu's priest, Okomfo Anoke. On a certain Friday, it is said, the priest had the stool descend from the sky and alight on Osei Tutu's lap. On either side of the curved top of the stool are lost-wax cast bells, which are rung during certain ceremonies. Between them are three cast-gold effigy bells representing defeated rulers from the early period of

the Asante confederation. One is said to represent Ntim Gyakare of Dankyrira, who was defeated by Osei Tutu, while the other two represent Ofoso Apenten of Akyem Kotoku, and Abo Kwabena of Gyaaman, who were defeated by Osei Tutu's successor, Opoko Ware.[25]

Stools of various kinds are common as functional and symbolic forms among the Asante, even to the present day. High-ranking people as well as commoners use carved wooden stools for various ceremonial and everyday activities. The higher-ranking persons, such as royalty and priests, have more elaborately carved stools, with certain symbols carved and/or attached on the surface. Among the chiefly, priestly, and royal classes there is also a practice of ritually blackening a person's ceremonial stool after death. Subsequently that stool is used as an object of ancestral worship in special shrines associated with the deceased.[26]

The carved forms between the upper curved seat and the horizontal base of Asante stools are created in a vast array of shapes which may signify the status of the person who owns the stool or the place of origin of the stool, or may refer to

45. Asante (Ghana) gold-leaf–covered "golden stool" with lost-wax cast gold figures and bronze bells on a *hwedomtia* chair.

some proverb about leadership and authority. The three stool types illustrated in Figure 46 are called, from top to bottom, a porcupine stool (*kototo'gwa*), an elephant stool (*osebo'gwa*), and a woman's stool (*mma'gwa*). The porcupine stool was used by kings, paramount chiefs, and greater priests. The elephant stool was used exclusively by the king of Asante. The woman's stool, however, is of a type given by a man to his wife when they marry.[27]

Royal regalia among Asante kings, queens, chiefs, priests, and members of the court retinue consisted of many prestige objects made of wood, cast in gold, or woven into fine cloths. In addition, cast-brass objects often served as trea-

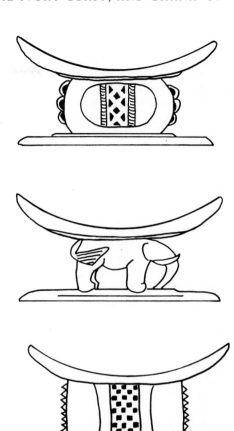

46.   Asante (Ghana) wooden stools. Top: a porcupine stool. Middle: an elephant stool. Bottom: a woman's stool.

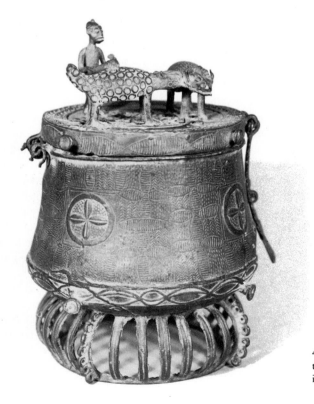

47.   Asante (Ghana) bronze gold-dust container (*kuduo*) with leopard and antelope images on top.

suries for the court. These treasuries held gold dust as well as prestige jewelry and other fine items of personal wealth. One example of this is a cast-brass gold dust container known as a *kuduo* [47]. Elaborate figurative *kuduo* such as this one (with leopard, antelope, and executioner figures symbolizing the power of the Asante king to conquer his enemies) are probably an eighteenth- and nineteenth-century stylistic development. There is a great deal of evidence that earlier *kuduo* forms derived from North African trade objects which entered Ghana after the fifteenth century. Early *kuduo* forms are stylistically close to the North African (Islamic-inspired) types. Even in this *kuduo*, with a figurative top, there are elaborate geometrical patterns incised on the sides and the top of the vessel which are very similar to Islamic patterns that entered the Akan design vocabulary before the establishment of the Asante nation at the beginning of the eighteenth century.[28]

Another art form common to Akan-speaking peoples of southern Ghana, especially in royal and chiefly contexts, is the "linguist staff" (*okyeame poma*) used by someone who acts on behalf of a king or chief as his counselor, spokesman, or adviser. These individuals carry, as emblems of their office, gold-leaf-covered, carved wooden staffs surmounted by images associated with the sayings and proverbs of the Asante and other Akan groups. The two linguist staffs shown in Figure 48 depict a man touching a lion (on the left) and a man helping another climb up a tree (on the right). The two proverbs associated with these staffs are "When a man offends a chief in all innocence he should be forgiven" and "It is when one undertakes a worthy enterprise that one gets assistance and encouragement," respectively.

One of the most popular art forms made by the Asante and other Akan groups in southern Ghana and in nearby Ivory Coast are *cire perdue* brass weights used in the weighing of gold. Their form appears to have developed over at least three hundred years in parts of Ghana among the Akan

48.  Asante (Ghana) wooden linguist staffs (*okyeame poma*) covered with gold leaf.

groups in the south. These weights developed into elaborate figurative types over the past two hundred years. Many are geometric in form or represent objects associated with royal regalia or activities, while others represent images which are associated with Asante (and Akan) proverbs. Most likely, more than one interpretation was traditionally given to each figurative weight.[29] Twenty-three gold weights and two functional objects (a spoon and a box with a lid) are illustrated in Figure 49. The three figurative weights shown in the top row are an equestrian warrior, a high-ranking chief or king seated on a royal chair while holding up a ceremonial state sword, and a seated drummer with two drums in front of him. The second row consists of six geometrically styled weights, of a type thought to be early in date. The third row contains five animal weights: a double-headed crocodile, a serpent striking at a bird, three birds perched around a circular form,

49.   Asante (Ghana) brass weights used in weighing gold, plus a spoon and a box. The weights represent various human, animal, and abstract geometric shapes.

and two species of fish. The fourth row has a square knot in a rope, a long-horned antelope, and a grasshopper cast directly from life. The last row, from left to right, shows a flintlock-style pistol and an old European-style cannon, a state sword, an ax, a pair of royal sandals and a stool, a thin spoon for gold dust, and a small storage box for gold dust. Some of these forms have proverbs associated with them. The two-headed crocodile is associated with the Asante proverb that says: "The crossed crocodiles have but one belly, but when eating they struggle." Essentially, this translates as: "Relatives should not quarrel, for all belong to one family and depend on it for

their well-being." The snake biting a hornbill is associated with the saying "A man should not despair at getting anything, however difficult it may seem." The three birds standing together are associated with the proverb "The bird's relation is the one he sits with." The square knot in a double strand of rope is symbolic of the Asante "wisdom knot," which is associated with longevity and security in marital and domestic affairs. The simple ax shape may refer to the proverb "However difficult a case may be, it must be settled by counsel, not with an ax." This emphasis on visual symbols with proverbial meanings was commonly found in gold weights used by the

Asante during the eighteenth and nineteenth centuries.

A number of other Asante art forms contained images that may have had complex religious and proverbial meanings associated with them. In many Akan-speaking cultures special shrine houses with sculpted facades were used to house images of deities and as a place for priests to officiate.[30] One of these, a late-nineteenth-century Asante shrine house at Ajwinasi [50], has a pair of seated clay figures along its bottom—a female on the left, a male on the right. Between and around them are elaborate s-shaped spiral forms—a motif repeated on either side of the entrance doorway. Above the lower frieze, a large crocodile image faces the entrance door,

and bites on a small animal form. The roof is pitched high and is covered with thatch. The building behind this shrine house has low-relief patterns that may have been influenced by Islamic design. Inside this shrine, altars were erected for various deities. Sometimes clay figure sculptures and single- and multiple-figure groups were placed on these altars as objects of worship and sacrifice. These figures are related to another Akan sculptural art form in terra-cotta—that of funerary figures used in a widespread ancestor cult in southern Ghana. The Fante terra-cotta in Figure 51 depicts a woman seated on a stool with two children on her lap, and is a good example of one of these styles. In this case, the woman's body is a series of tubular cylinders, with her

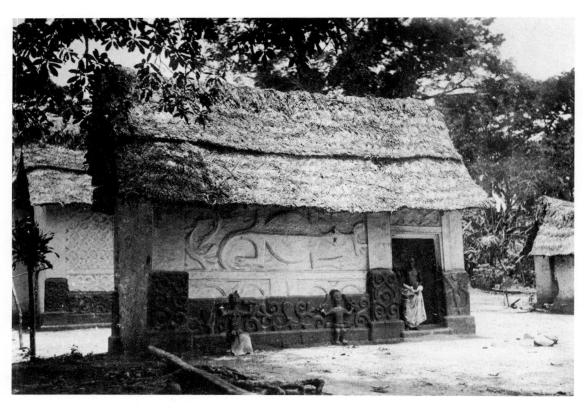

50.   Asante (Ghana) shrine house at Ajwinasi, Ghana.

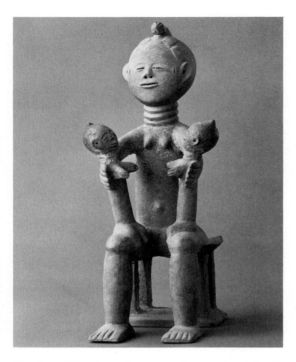

51.  Fante (Ghana) seated terra-cotta funerary figure (female with two children).

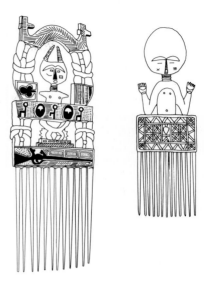

52.  Asante (Ghana) wooden combs with fertility figures.

hands and feet modeled slightly. She and her children have bulbous, egg-shaped heads with topknots in their hair, and simple raised shapes defining the ears. The slitlike eyes, eyebrows connecting to the nose, and ringed treatment of the neck are all commonly found on Akan terra-cotta figures.[31]

The two Asante carved wooden combs shown in Figure 52 are examples of a complex (on the left) and a more simple (on the right) version of sculptures that were given to women as gifts prior to marriage. In the more complex comb, a small fertility doll with a pointed hairstyle stands beneath a wreathlike shape with Christian crosses (broken), square knots, and a heart image carved in varied levels of relief. Beneath, a frieze of key and lock motifs is carved in low-relief over a second pair of square-knot shapes and a stool.

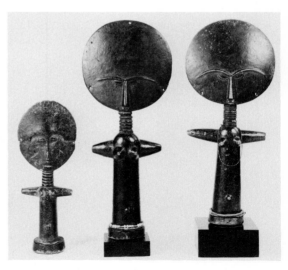

53.  Asante (Ghana) wooden fertility dolls (*akua-ba*).

On the border below, an old-style European rifle is carved in low relief. These symbols most likely refer to fertility, longevity, stability, and protection—all hallmarks of an enduring marriage. The second comb [52, right] has a simple fertility doll shape carved over a rectangular area covered with low-relief patterns, including a heart.

Three Asante fertility (*akua-ba*) dolls are shown in Figure 53, and are related to the miniature images seen on the combs just described. These dolls were worn by women who were trying to conceive, and they symbolized a healthy, perfectly formed child. Fertility dolls were sometimes worn as part of a woman's coiffure, or tied onto a sash on her back. They were also used as fertility cult objects at shrines where sacrifices were made to various deities on behalf of women.[32] The large rounded head with eyebrows and nose set low on the face, the trunklike body with rudimentary breasts and navel, and the eyes and connecting eyebrows over a triangular, elongated nose are all stylistic traits commonly found on Asante *akua-ba* dolls.

# 6
# Art of Nigeria

The various cultures and groups in central and southern Nigeria are the result of many thousands of years of development in the region. Southern Nigeria consists of savanna grasslands (in the northern part), tropical forests (over much of the south), and fresh- and salt-water swamps (in the southern deltas of the Niger River). Traditional agricultural products include millet, maize, sorghum, rice, and, in some regions, yams and kola nuts. Depending upon the ecological zone, various animals and plants were hunted and gathered for food as well.

The contextual evidence from pre–European contact art traditions suggests that art was made by various sculptural techniques (modeling in terra-cotta and brass cast by the *cire perdue* technique) to serve ancestral and funerary purposes for high-status elites, in what were probably centralized leadership societies.

The Ibo, Yoruba, and the kingdom of Benin vary in their level of centralization. The Yoruba and the kingdom of Benin have fully developed royal art traditions and centralized societies. The Ibo are also leadership-oriented, although less centralized than either the Yoruba or the kingdom of Benin. All three groups, the Igbo-speaking Ibo, the Yoruba-speaking Yoruba, and the Edo-speaking Bini of Benin, speak languages of the Kwa subgroup of Niger-Congo languages.

Large-scale villages and cities centered in high-status families and/or chiefs and kings are common among the Ibo and the Yoruba and at the royal city of Benin. Specialized religious shrines, dwellings with walled compounds, palaces with courtyards, and areas for guildlike specialists are found to a greater or lesser degree in all three of these groups.

## Art from the Pre–European Contact Nok, Igbo-Ukwu, and Ife Cultures of Nigeria

The arts of Nigeria prior to European contact [Map 8] have been studied extensively over the past three decades and have served as the basis for many important exhibitions, articles, and books. The chronological sequence of three of these important pre–European contact traditions, from earliest to most recent, is the Nok, Igbo-Ukwu, and Ife cultures.[1]

Nok sculptures consist of terra-cotta human and animal forms dating from about 500 B.C. to A.D. 200 and are the earliest-known sculpture found in present-day Nigeria. The corpus in-

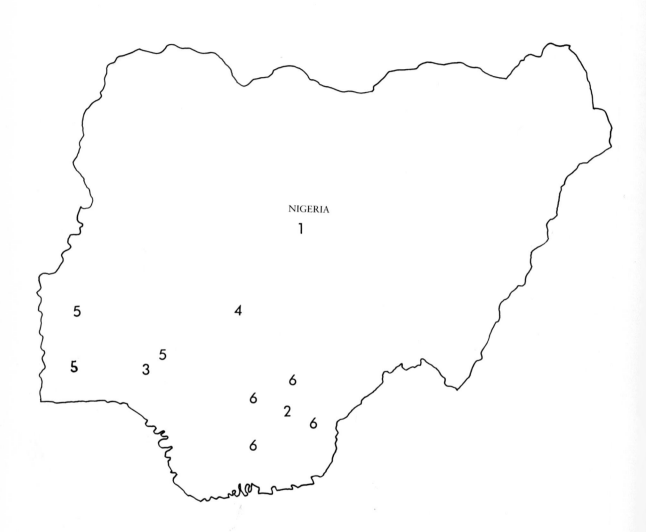

Map 8. NIGERIA

1. Nok
2. Igbo-Ukwu
3. Ife
4. Benin
5. Yoruba
6. Ibo

cludes several small full figures in kneeling [1] or sitting poses, many human heads in various stylized shapes [2], and some figural fragments showing elaborate costume details suggesting that the images may have represented persons of high rank and status. There are also a few terracotta sculptures of animals, including a fragment of an elephant [3] and a monkey seated on a bulbous stand. The full figures, such as the one shown in Figure 1, and body fragments document the elaborate costumes worn by males and females. Two factors suggest that these figures were used as part of an early commemorative ancestral cult and were analogous to later forms found at Igbo-Ukwu and Ife—the evidence of

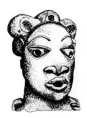

2.  Nok culture (Nigeria) terra-cotta head. From Rafin Kura, Nok, Nigeria.

3.  Nok culture (Nigeria) terra-cotta elephant head. From Agwazo Mine, Udegi, near Nassarawa, Nigeria.

costume on the figures and the context of their evacuation. (These figures were excavated from the bottom of a river bed near habitation sites.) Heads such as the one illustrated in Figure 2 show a simplified naturalism with highly stylized treatment of facial features, especially the eyes, eyebrows, and nose. The shape of the head is often elongated, rounded, or nearly conical, as if the Nok sculptor tried to maintain some unique underlying geometric shape for each head.[2]

Some early art forms, such as the elaborate bronzes excavated at Igbo-Ukwu near the Niger River, suggest that in the central Ibo area there developed a high-ranking, status-oriented culture with elaborate burials of persons, accompanied by lost-wax and lost-latex cast-bronze grave goods. These bronzes are usually dated to about the tenth century A.D.[3]

One unusual characteristic of these bronzes is

1.  Nok culture (Nigeria) terra-cotta kneeling male figure. From Bwari, near Abuja, Nigeria.

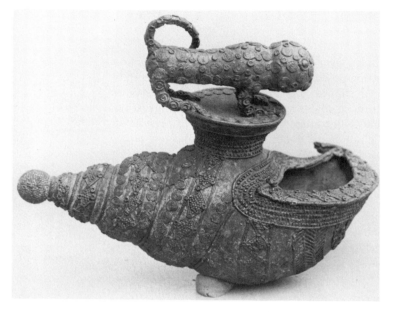

4. Igbo-Ukwu (Nigeria) leaded bronze vessel in the form of a shell surmounted by an animal (possibly a leopard). From Igbo Isaiah, Igbo-Ukwu, Nigeria.

that many of them replicate utilitarian vessels, wrappings, animal skulls, seashells, insects, and human heads and figures in cast bronze. Many are covered with embellishments that represent beadwork and other decorative ornaments. A typical example of this elaborate embellishment is a bronze seashell surmounted by a small leopard [4]. At first glance, the seashell appears naturalistic, compared to the leopard, which is highly stylized. The surface decoration of the shell, however, creates patterns and zones of bands which owe more to the imagination of the artist than to an exact replication of patterns found on such a seashell. A similar elaboration of surface decoration can be seen on the small bronze equestrian figure [5], which may have served as a staff finial or a fly-whisk handle. The facial marks on the human figure suggest scarification patterns still found on high-ranking Nri Ibo peoples around Oreri, west of Igbo-Ukwu. The presence of a horselike animal from a tenth-century site suggests that this area of West Africa was one of the earliest which saw the importation of horses from Arab areas north of the Sahara.[4] It is likely that the horse served as an emblem of high rank and titled status in a number of early art forms made in Nigeria as well as to the west, in the Sudan (compare with Djenne terra-cottas in

Chapter 5). In more recent times equestrian warfare became more common among elite states as an expression of political, economic, and social power.

Even though the art of Ife has been known since the early decades of the twentieth century,

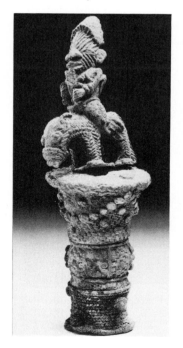

5. Igbo-Ukwu (Nigeria) leaded bronze fly-whisk handle with equestrian figure. From Igbo Richard, Igbo-Ukwu, Nigeria.

158

it has been extensively studied in proper archaeological programs only in the past two decades, and is now universally appreciated for its elegance, naturalism, and sophistication.[5] Historically, it is also considered important as an ancestral tradition for the Yoruba people, who consider Ife as the place of origin of their group in mythical times.

The best-known art forms from Ife are the refined terra-cotta heads and finely cast brass heads which date from about the twelfth to the fifteenth centuries A.D. These are very naturalistic and individualized in details, and probably represent highly individualized images of persons with distinctive physiognomy, hairdos, headdresses, crowns, and/or scarification marks. Brass heads such as the one shown in Figure 6 were made by the lost-wax technique and often had small holes drilled along the hairline, around the mouth, and along the chin. These may have been used to attach either crowns, false beards, or beaded veils to the heads during rituals, where they were meant to represent a deceased ruler (known as an Oni), or another important personage from within the court.[6]

The beautifully preserved full figure shown in Figure 7 is of a male ruler (Oni), with thin, linear scarification patterns on his face and torso and elaborate ceremonial jewelry, crown, and clothing. This sculpture gives us the basis for an understanding of Ife canons of naturalism and proportion. Although many details are rendered naturalistically, the disproportionate head is a style trait commonly found in many West African sculptural traditions.

The elaborate brass queen mother shown in Figure 8 is perhaps the most expressive and enigmatic art work to have been found within the Ife tradition. The queen mother figure is wrapped, serpent-like, around an irregularly shaped stool, with a secondary substool below her. She carries a small human-headed staff suggesting that this image may have had something to do with extraordinary rituals or even human sacrifice. The theme of sacrifice is depicted in other Ife art forms as well; a number of Ife brasses and terracottas depict gagged and bound captives destined for sacrifice. And, in several terra-cotta animal heads the heads are depicted upon a circular offering plate. Such animal heads include those of a ram, a chameleon, an antelope, and even an elephant.[7]

A group of four terra-cotta ritual vessels was recently unearthed and shows a style clearly associated with Ife. One of these pots [9] has a head with snakes protruding from its nostrils, a pair of ceremonial staffs, a nude female figure in medium relief, bushcow horns, a severed human head, and other snake motifs. On the opposite side of this pot (not visible in the photograph) are images of a drum, a bracelet, a bundle of sticks, a machete, and a calabash. By analogy with later Yoruba ritual objects, this pot may have been used by the powerful Ogboni society, a group of elders who play an important role in social control, in medicine, and in determining the line of succession of kings.[8]

One of the most naturalistic images in an Ife-related style was found over a hundred miles from Ife, in Nupe country at Tada village on the Niger River [10]. The figure's seated posture, with asymmetrical placement of the body parts, and the naturalistic proportions are rare in Ife brasses, although similar gestures are found on terra-cotta fragments from Ife.[9]

6. Ife (Nigeria) brass head of an Oni. From Wunmonije Compound, Ife, Nigeria.

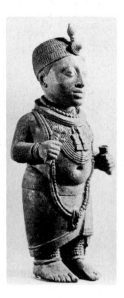

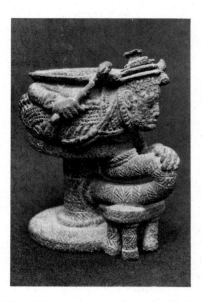

7. Ife (Nigeria) brass figure of an Oni. From Ita Yemoo, Nigeria.

8. Ife (Nigeria) brass ceremonial vessel with figure of a queen. From Ita Yemoo, Nigeria.

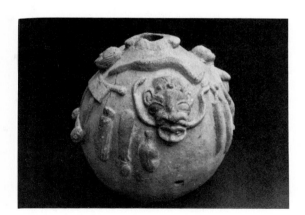

9. Ife (Nigeria) terra-cotta spherical ritual pot. From Koiwo Layout, Ife, Nigeria.

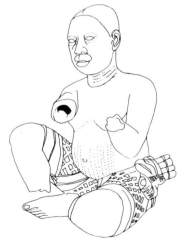

10. Tada (Nigeria) copper seated figure. From Tada village, Nigeria.

## Art of Benin

The royal art of Benin city in Nigeria constitutes one of the most impressive collections of West African sculpture. The several thousand existing works in bronze, ivory, clay, and wood are visual historical documents, ranging from the fifteenth to the end of the nineteenth centuries.

When first contacted by European explorers and traders in the late fifteenth century, Benin was a cosmopolitan center with a highly organized centralized government and a large palace protected by compound walls. The surrounding city, of over fifty thousand inhabitants, was divided into guildlike districts of people who served the king (Oba) by engaging in a variety of specialties, such as brass casting, ivory work, beadwork, and woodcarving.[10] The city of Benin was organized with the king's palace in a central position, and early descriptions and prints depict the palace as having spirelike architectural features with huge bronze birds on top and gigantic serpent forms on the sloping wood-tiled roof below.[11] The high-ranking people of Benin rode on horseback and were accompanied by foot soldiers and equestrian warriors, as well as acrobats and domesticated leopards. This clearly indicates the vastness and richness of the court of Benin during this early period of trade with Europe. The eighteenth and nineteenth centuries were periods of great upheaval in Nigeria, as well as in surrounding West and Central Africa, with extensive African and European trade in slaves as well as intertribal warfare. During this period, Benin did not have direct diplomatic and trade relations with Britain.

In 1896, Britain reestablished trade relations with Benin as part of its worldwide economic and political colonialism. The British representative, Vice Consul Phillips, sent messages to the Oba of Benin that he and a group of unarmed carriers would enter the city to work out details of a recent trade agreement between the two powers. The Oba, Ovonramwen (reigned c.

1888–1914), sent back a message that it was not an opportune time for the delegation to visit the palace and the city, as they were engaging in sacred ancestral rites. Vice Consul Phillips proceeded against the Oba's advice and was ambushed outside Benin city; he and many others were killed in the battle. In retaliation, the British sent a naval expedition under the command of Admiral Rawson in February 1897 to attack Benin. The resulting battle caused the city to burn extensively, and the punitive expedition forces took back to England several thousand "spoils of war" in the form of Benin bronzes and ivories from the palace. Early in the twentieth century, about half of these objects were auctioned off and purchased by German and American museums. Therefore, the majority of Benin art forms that had been housed in the palace until 1897 can be seen today in English, German, and American museums, and most of the works extant today in Benin were made after the British restored the Oba to nominal power in 1914.[12]

The palace itself is depicted in several art objects, including a lost-wax cast box with a hinged lid [11]. The entire box is a miniature version of a palace building, with a single, raised spire surmounted by a large bird with outstretched wings. A serpent is seen undulating downward from the top of the spire. The roof is clearly articulated as a series of wooden shingles, while the support posts below have decorative elements suggesting either low-relief mud or bronze sculpture. On either side of the roof are two warrior-like men with rifles aimed toward birds (the bird on the right is missing except for portions of his feet). These bird and serpent images allude symbolically to the Oba's supernatural powers. He is capable of transforming himself into certain birds and snakes in order to combat the machinations of witches, who conduct their evil matters under the guise of night-hunting birds and/or serpents. The two armed warrior/hunters have European

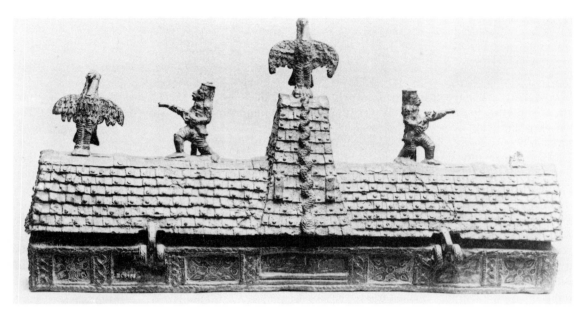

11.   Benin (Nigeria) bronze storage box in the shape of a palace.

weapons, which documents the use of Europeans and their weapons by the king of Benin to help in his political military crusades against various enemies.

Another palace-related image [12] is a bronze relief depicting a group of warrior/priests standing at the entrance to a palace structure. The roof, spire with serpent image, and entrance are clearly articulated, as are columns of European soldiers' heads on either side of the doorway. Whether these heads are meant to be trophy heads or merely allude to political, military, and economic ties between Portugal and Benin is unclear.

In the palace interior there were and still are ancestral shrines which serve as altars for ritual and ancestral art forms that are used in ceremonies to honor deceased Obas. In Figure 13 a pair of ancestral shrines—one to Oba Eweka II (reigned 1914–1933) in the foreground, and one to Oba Ovonramwen (reigned about 1888–1914) in the background—show how various bronze, wooden, and stone objects are displayed in the context of royal altars at Benin. The raised circu-

lar mud altar platforms in this photograph contain various objects of worship and ritual, including late-period ancestral heads with a carved elephant tusk sticking out from the top of each head. These high-collared ancestral heads were

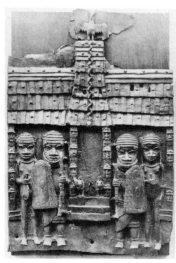

12.   Benin (Nigeria) bronze plaque representing the front of a palace.

13. Benin (Nigeria) ancestor shrines to the Obas of Benin at the Palace of Benin. Bronze portrait heads with elephant tusks dedicated to Oba Ovonramwen (background) and Eweka II (front).

cast in the lost-wax technique in a style associated with Oba Osemwede, who reigned in the early nineteenth century (c. 1816–1848). In addition to the ancestral heads, there are a variety of cast bells and gongs on these altars, which are used during a ceremony and create a variety of sounds. Groups of carved wooden rattling staffs (*ukhurhe*) lean against the wall. In the center of Eweka II's altar is a sculptural group representing the Oba flanked by attendants. There are also stone celts (adze or ax blades), covered by sacrificial blood, laid out on the top surface of these shrines.[13]

According to oral traditions, the Benin practice of casting bronze by the lost-wax technique was learned from the neighboring Ife culture during the reign of Oba Oguola in the first half of the fourteenth century. Based upon this historical data, art historians and scholars of Benin culture attribute some naturalistic ancestral altar heads to an early period (about A.D.

1500–1550).[14] These male and female ancestral heads have thin, beaded collars around their lower necks and chins and are more naturalistic in facial details and proportions than late-period ancestral heads, from the late-eighteenth and the nineteenth centuries. Late-period heads have more highly developed decorative beadwork collars and more stylized facial forms than the earlier pieces, which have a fleshy naturalism. Queen mother bronze ancestral heads are characterized by a curved cone-shaped cap which depicts a coral beaded hat, whereas Oba heads appear to have had a hole on top for the insertion of a carved elephant tusk.

Another Benin art form that probably represents a queen mother is nearly life-sized ivory pectoral ornaments [14 and 15, center]. The naturalistic faces suggest an early date, perhaps about A.D. 1500–1550. The faces once had pieces of iron inlaid in the vertical scarification marks on the forehead above the eyes as well as in the

iris of the eyes. The treatment of the ears, with outer and inner helix, tragus, and lobes clearly articulated, is in keeping with an overall naturalism of form. The mouths, noses, and eyes, however, have a slightly rigid stylization. An unusual trait in these heads is the use of an alternating series of Portuguese and mudfish heads as part of the coiffure and a row of Portuguese heads as a collar decoration around the lower face and chin [14]. It has been suggested that the Portuguese were seen as extraordinarily powerful beings, having come to Benin from across the sea in ships carrying cannons, crossbows, and a variety of guns. In Benin religious belief the god of the rivers and seas is Olokun, whose emblem is a mudfish. Therefore, by combining Portuguese heads and mudfish emblems on the head of a queen mother image, the Benin artist may have been depicting a royal supernatural power that was a combination of traditional and of newfound European images.[15]

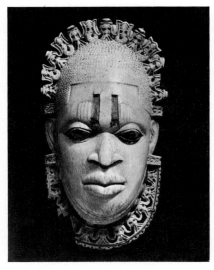

14.  Benin (Nigeria) ivory belt mask of a queen mother. From Benin, Nigeria.

15.  Benin (Nigeria) ivory belt mask of a queen mother (early period) and two ivory bracelets (middle period).

A distinctly powerful set of combined images associated with royal powers can be seen in the profile view of a bronze "altar-to-the-head" [16]. The head is modeled in three-dimensions, with a set of four birds encircling a band on top. From the corners of the eyes and nostrils, four snakes protrude outward, curl around, and terminate with each head biting a frog. On the forehead are miniature stone ax blades, similar to the real celt blades noted on the ancestral shrines discussed previously. The meanings of this head are complex and probably allude to the supernatural medicine powers used by the Oba to counteract the machinations of witches, who often took the form of night-flying birds and serpents and who were believed to be able to sicken and kill their victims. The Oba was capable of superhuman acts and feats of medicine and magic to counteract any evil and dangerous forces aimed against him and those under his protection.[16]

Counterparts to the Oba's medicine powers are his political and military powers, including his ability to command armies, set up alliances with neighboring peoples, and defeat any enemy. Special wooden and lost-wax cast bronze "altars-to-the-hand" were called *ikegobo* and were used as part of special sacrifices to the Oba's military and political powers. In an altar group [17], possibly representing a type of *ikegobo,* the Oba is seen standing in the center of the figural group, holding a stone celt in his left hand and a staff of office in his right. He is flanked on either side by attendant priests, who hold up his arms at the elbows. In front of the Oba are two small leopards, with a hole between the Oba's feet for receiving kola nut sacrifices. The base with flange below depicts two tied-up sacrificial victims whose heads are separated from their bodies. Just above the heads and the bodies are flanking arm motifs, with each hand holding a three-part leaf-like form. Behind the Oba (unseen in this view) are smaller supporting figures, including one of a queen mother with a characteristically curved and cone-shaped headdress.[17]

Benin bronze relief plaques vary a great deal in subject matter and complexity of composition. Some clearly depict historical events that are remembered and commemorated by their creation, while others depict animals or people associated with the court and the powers of the king. Many plaques depict Portuguese soldiers or diplomats engaged in some recognizable activity, such as hunting, or these are depicted in a more static, frontal formal posture. Images of Portuguese soldiers and diplomats can also be found as freestanding bronze sculptures, on ivory and bronze bracelets, and on some of the carved elephant tusks used on top of the bronze ancestral heads.[18] It is important to note that they are also shown as minor figures on many types of art forms from Benin, and by no means are they to be seen as dominating over traditional Benin subjects as iconographic motifs.

Some bronze plaques depict scenes of Benin warriors and their war chief as if they had just defeated an enemy. In the complex figural plaque in Figure 18 a defeated equestrian warrior (or perhaps a chief) has been speared through his body and is being yanked off his horse by a large Benin war chief. The diagonal, helpless thrust of the defeated enemy's body is in sharp contrast to the frontal, upright, controlled posture of the seven Benin warrior figures. The varied sizes of the figures most likely alludes to their status and relative importance in the army of Benin. The large warrior chief has a curved sword in his upraised right hand, and it appears that he is about to dispatch the wounded enemy in his clutches. In the upper-left side of the composition, a second Benin warrior has hold of the arm of another warrior, perhaps another symbolic capture or defeat scene. Other, smaller figures above and below the large figure appear to represent soldiers and, perhaps, warrior priests. On the lower horizontal band of the plaque there is an unusual combination of floral treelike motifs coupled with bovine heads and skulls that have small defeated enemy soldiers beneath them

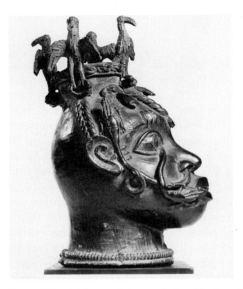

16. Benin (Nigeria) bronze "altar-to-the-head" of an Oba. From Benin, Nigeria.

(these might refer to sacrificial dead). The entire background of the plaque consists of repeated, incised floral motifs—a stylistic device found on many Benin plaques. Two of the bronze plaque fragments in Figure 19 (center of the top row, and bottom left) seem to depict the same Oba. In the piece in the center, top row, this Oba is flanked on either side by priestly personages who are holding his arms in a gesture of support. The lower part of the Oba's body is unusual in that his legs are mudfish shapes, which extend downward and curve outward toward the outer edge of the composition, where they nearly touch small crocodile and frog images in low relief. The Oba's penis is in the shape of a large serpent, which extends downward and is biting some form of animal, perhaps an antelope. There was an Oba named Ohe who became paralyzed during his reign, so that his legs were immobile. In order to save his position and most probably his life, he claimed that he had been possessed by the god of rivers and the sea, Olokun. The mudfish is one of the primary emblems of Olokun; therefore, mudfish legs on the figure of an Oba might allude to Oba Ohe as possessed by this powerful god. Perhaps other serpent and reptilian images on the plaque symbolically refer to Olokun and

special supernatural powers which Oba Ohe claimed for himself.[19]

In the second piece, a rectangular plaque [19, bottom left], this Oba is once again flanked by two priestly attendants. He has the same mudfish legs protruding outward from beneath his skirt, as well as a pair of leopards lying below. The mudfish and leopards may symbolize various supernatural and secular powers attributed to Benin Obas throughout time. In the relief plaques on the upper right and upper left of Figure 19, single human images (perhaps priestly attendants) are depicted, holding a mudfish in each hand. Perhaps this refers symbolically to certain rituals associated with the worship of Olokun at the court of Benin. The dual-figure plaque in the lower right may also represent priests from the royal court.

Traditional ivory bracelets from Benin [15, left and right] sometimes have images of the Oba and elephant skulls in complex figural combinations. Both bracelets have images of an Oba with mudfish legs and a serpent/hand penis (perhaps a symbolic reference to Oba Ohe), and symmetrically placed elephant skulls with grasping-hands

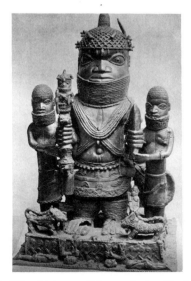

17. Benin (Nigeria) bronze "altar-to-the-hand" of an Oba. From Benin, Nigeria.

166

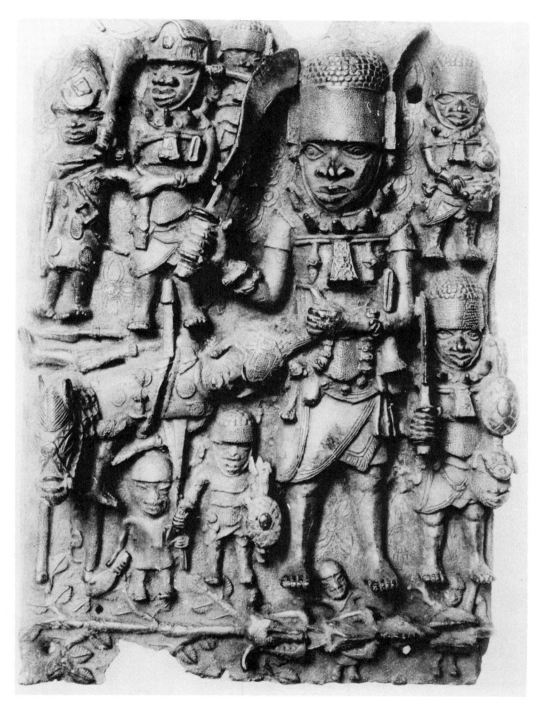

18.  Benin (Nigeria) bronze plaque representing a defeated equestrian warrior and soldiers from Benin.

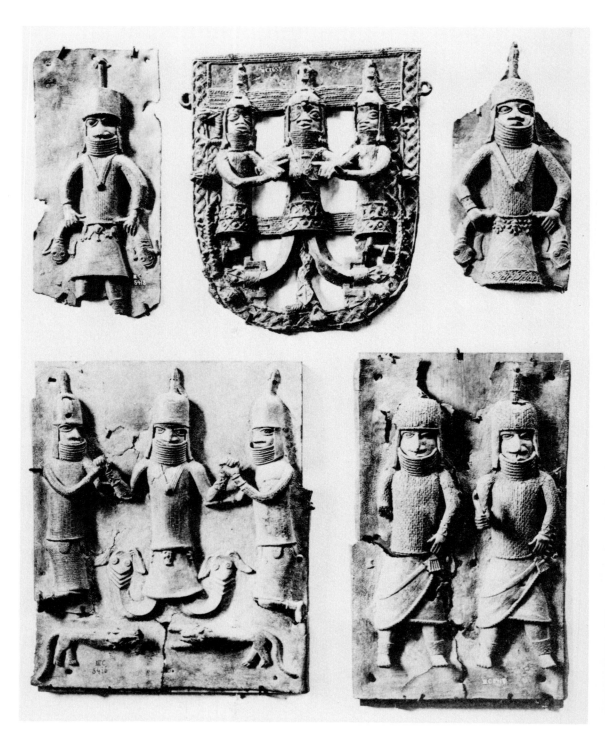

19. Benin (Nigeria) bronze plaques representing various Oba and attendant figures with mudfish and leopards.

motifs. The low-relief and static repetitive composition in these bracelets is in stark contrast to the European-inspired imagery in the Afro-Portuguese ivory salt cellar discussed in Chapter 1, Figure 20.

The vast economic and political powers of the kingdom of Benin included the use of mercenary soldiers of both African and European origin. Among the northern peoples of present-day Nigeria there has been a long history of equestrian warriors, and some of these groups served the king of Benin. Freestanding images of European and African warriors dressed in European armor exist, as well as a small number of equestrian bronze figures. One of these [20] may depict a Fulani warrior in the service of the Oba of Benin. His distinctive headdress and fancy horse trappings are in keeping with the elaborate formal battle dress displayed by these northern equestrian groups.[20]

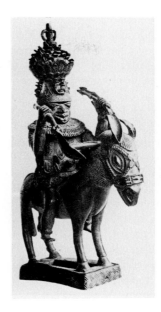

20. Benin (Nigeria) bronze equestrian figure probably representing a Fulani warrior.

## Art of the Yoruba of Nigeria

The Yoruba people of southern Nigeria and southeastern Benin [Map 8] are one of the most prolific art-producing peoples in all of Africa. There are over eight million Yoruba, and hundreds of individual carvers and carving styles which have been identified by students of Yoruba art. Yoruba religion, various masking societies, and the stratified kingship traditions are three of the primary motivating factors in the creation of Yoruba art.

The Yoruba worship deities which number in the hundreds throughout Yoruba territories, and are known generically as *orisha*. Many of these deities are probably localized culture heroes and rulers, who, after death, were raised to the status of deity, and accorded a cult and a place of worship. Several *orisha* are worshiped widely among the Yoruba. These include Orunmila (and its attendant Ifa divination), Eshu (the trickster god), Shango (the thunder god), Ogun (the iron god), and Osanyin (god of herbalism). The cult of twins

(Ibeji); the masking societies known as Gelede, Egungun, and Epa; and the judicial group of elders called Ogboni are also Yoruba institutions for which much art is created. The leadership arts of the Yoruba include title staffs, beaded crowns, and carved doorways for palace compounds.[21]

Yoruba deities are rarely given representational form. Instead, an emblem and/or an image of a devotee is often created to mark altars where the cult is worshiped. Several examples of this type of image are discussed below. The caryatid bowl for holding kola nuts in Figure 21 is used in Ifa divination in the worship of Orunmila and is carved with an image of a kneeling female with a child on her back. This maternal image is commonly found on Yoruba ritual objects, as is the image of an equestrian male culture hero called Jagun-Jagun (see Figure 29). The female and child are rendered naturalistically in many details of anatomy, and yet they are also stylized in their proportions and abstracted in ways which create a

powerful balance between naturalism and stylization.[22] This bowl is a portable functional object which would be set upon a flat shrine altar along with other portable objects of worship and appreciated when seen from several different viewpoints.

Another mother and child figure [22] is associated with Shango, the thunder god, and depicts the figures beneath a double-bladed ax, which appears as part of the mother's hairdo and represents thunderstones (prehistoric stone ax blades), referring to Shango's lightning bolts and supernatural energy and power. It is interesting to note that here, once again, women are depicted as calm, cool, and under control. This is a vision of feminine behavior and temperament which we frequently find codified and represented in African art. (See the art of the Senufo in Chapter 5.)

A ritual wand carved by Bamgboye of Odo-Owa in the northern Ekiti Yoruba area [23] represents a standing male figure wearing an elongated headdress associated with the deity, Eshu. The male figure blows on a whistle, also associated with the worship of Eshu. The angular chevron-like incised patterns on the headdress

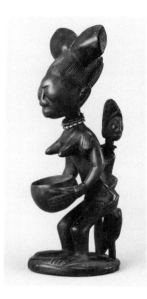

22. Yoruba (Nigeria) wooden mother and child figure. From Oshogbo, Yoruba.

echo the angularity of Bamgboye's treatment of the contours of the figure's body and head. The secondary male profile head at the back of the headdress balances the head of the figure and may symbolize the all-pervasive presence of Eshu, who makes people act irrationally.[23]

One of the most powerful Yoruba societies is that of the Ogboni.[24] It is a group of male and female elders who are dedicated to the powers of the earth goddess, Onile. This society serves a medicinal function, acts as messengers between humans and various *orisha,* and judges disputes, especially those involving the spilling of blood. If, for instance, a dispute resulted in bloodshed, the Ogboni society would be summoned; they would probably stick a pair of brass and iron male and female figures called Edan Ogboni [24] into the "defiled" earth, thereby ending the dispute. This action would appease Onile, whose ground had been violated with the bloodshed. In its medicinal role, the Ogboni society might engage in healing actions or in negative killing actions, depending upon the cause for the activity. The Edan Ogboni pair [24] is cast in bronze and represents a male and female linked by a chain at the

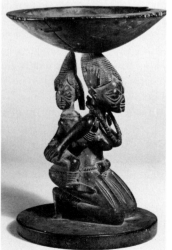

21. Yoruba (Nigeria) wooden diviner's bowl.

heads. The figures frequently carry medicine spoons or weapons in their hands.

Another bronze image sometimes made for the Ogboni society may possibly represent Onile. In the example in Figure 25, Onile is depicted seated on a stool of authority, wearing a double-peaked hornlike hairdo. The Ogboni society used large carved drums to announce ceremonies or, in earlier times, executions. The drum illustrated in Figure 26 has typical Ogboni motifs, including a centralized image of Onile, the goddess of the earth, whose legs and feet terminate in mudfish forms. This may be a symbolic reference to Onile's extraordinary powers, associated with the earth and rivers, and her role as patron of medicine and messenger to the *orisha*. On her chest are two miniature low-relief images of the brass Edan Ogboni used by members of the Ogboni society.[25]

One of the best-known art forms of Yoruba art is the small, carved twin figures called *ibeji* [27]. Twin births are high among Yoruba people, and, since infant mortality was high, many of the twins died at birth. Since multiple births are thought to be somewhat animalistic, and because

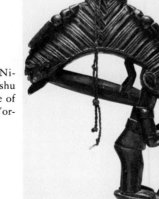

23. Yoruba (Nigeria) wooden Eshu staff by Bamgboye of Odo-Owa, Ekiti Yoruba.

twins are thought to have supernatural powers, the death of a twin would require the parents to seek the counsel of a diviner. The diviner might suggest that the parents make special sacrifices to the dead twin(s) and possibly paint certain patterns on their local shrine. Or, he might tell them to have an *ibeji* figure carved to represent the dead child. When a pair or a group of three *ibeji* figures was made, it was the result of the death of twins or triplets. The *ibeji* figures are conceived as male or female, with adult sexual characteristics, elaborate hairdos, and local scarification marks. They differ a great deal in style and can be placed stylistically into at least five geographical regions, including the southwestern, southern, central, eastern, and northern styles. Within each region there are distinct substyles, with a complex manifestation of forms and variations on a given thematic type. The pair depicted in Figure 27 is probably from the central region, around the area of Oshogbo near Ife. The addition of jewelry in the form of beads and metal bracelets and ankle rings is common to *ibeji*. In this region (and especially to the north) one often finds carvings on the upper chest which represent amulets carrying verses from the Koran—an Islamic practice found widespread among the northern Yoruba, who have come under heavy Islamic influences.[26]

At least three major Yoruba societies use masks extensively. One of these societies, known as the Gelede society, is found in southwestern Yorubaland and is dedicated to the powers of "the mothers."[27] The men who carve the masks make them for at least two overt purposes: one, to entertain and celebrate the fertility and power of women; the other, to guard against the dangerous powers of women in various manifestations as witches. The masks represent male and female personages, although they are always worn by male dancers. In the more public entertainment aspects of Gelede imagery, the iconography focuses upon the role of women as child bearers and child rearers, upon their stabilizing effects on

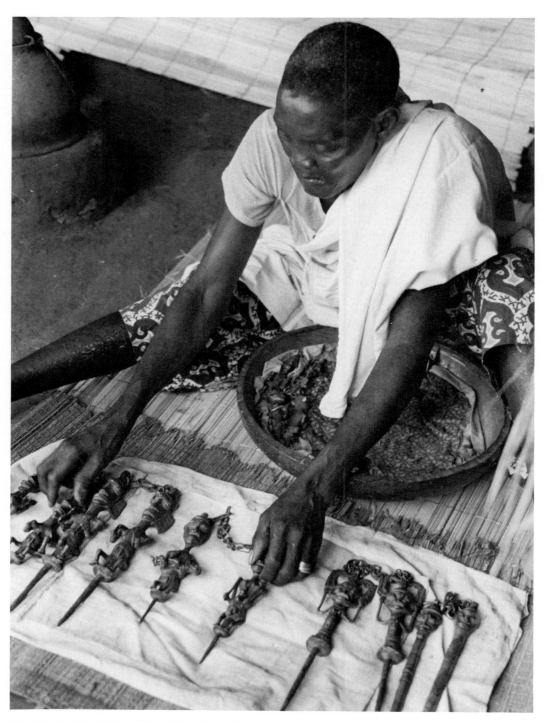

24.   Yoruba (Nigeria) brass Edan Ogboni being displayed within an Ogboni lodge in 1977.

25. Yoruba (Nigeria) brass figure of a female (possibly Onile). From Iperu, Nigeria.

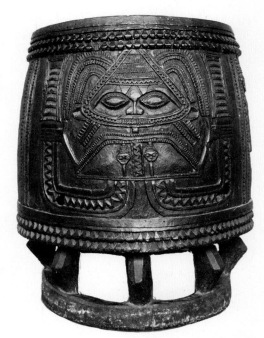

26. Yoruba (Nigeria) wooden Ogboni society drum. From southern Nigeria.

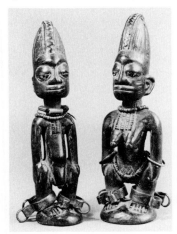

27. Yoruba (Nigeria) wooden *ibeji* (twin) figures. From southern Nigeria.

the family, and upon positive values within the community. Masks of this type reflect these positive images and values. The more dangerous aspects of the Gelede society's role, combating the evil machinations of witches, often include images of power which combine a lower human head with an image on top, such as leopards and serpents. The six Gelede masks from the Mekeo Yoruba area photographed in 1971 [28] include four with lower human heads surmounted by animal and insect forms, and two which represent animal forms. The top three are, from left to right, a light-faced human mask with a spider form carved on top, a female mask wearing a vessel, and a dark-faced human mask surmounted by a bird attacking a writhing serpent. The lower row shows a ram mask with long curved horns, a dark-faced human mask with a writhing serpent on top, and a wart hog mask with a bird attacking a writhing serpent. These various animal forms are associated with the supernatural powers of the Gelede society in its magical control of female witches, and they are also associated with the Gelede society's admiration for the supportive role and powers of women within Yoruba society.

A pair of Gelede society masks from the 1880s [Color Plate 9] from the Awori Yoruba illustrates male and female images with complex figure groupings on top. The male on top of the mask on the right represents a priest who is surrounded

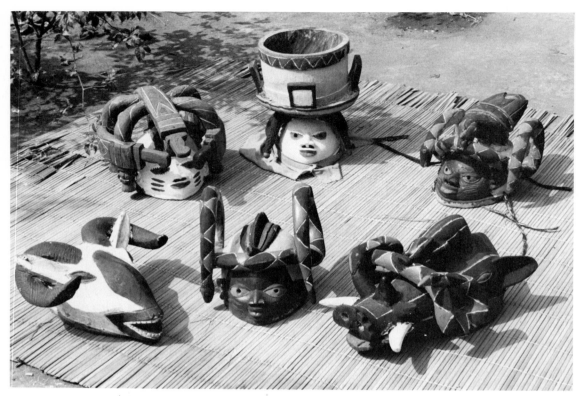

28.  Yoruba (Nigeria) wooden Gelede
society helmet masks. From the Mekeo
region of southern Nigeria.

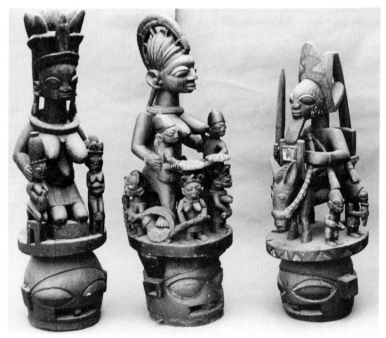

29.  Yoruba (Nigeria) wooden Epa so-
ciety helmet masks, including an eques-
trian type and two female with children
types.

by four warriors holding rifles. On his head he carries a tray with covered containers and a human head, both symbolizing sacrifices. The predominant theme is warfare and sacrifice. The other mask on the left has a female figure on top. She is surrounded by female figures who are holding their breasts in a gesture of supplication to some deity. She also carries a tray with covered containers and a human head in it. The lively and complex figure groups on these two Gelede masks and the interplay of carved and multicolored painted surfaces create two impressive examples of late-nineteenth-century Yoruba art.[28]

Another important masking society among the Yoruba is known as the Epa society. It is found in the northeast Yoruba territories among the Ekiti and Igbomina subgroups. Unlike the Gelede, which partly functions as a witch-controlling society, Epa is associated with clan and village groups. Their huge helmet masks with a gro-tesquely carved face in front and back are carved with elaborate superstructures associated with important Yoruba societal values. The three Epa masks shown here [29] represent the importance of female (fertility) and male (hunting and warfare) roles and duties in Yoruba society. The two masks on the left depict a central female figure surrounded by smaller figures which most likely represent her children. In the case of the mask with only two children, it is likely that the large female is associated with the birth of twins. The Epa mask in the center is more complex in its carved superstructure, yet exudes the same theme of protection, fertility, and family. The equestrian warrior figure on the right is probably a version of the Jagun-Jagun theme in Yoruba culture, that of the role of the male as hunter and warrior/protector.[29]

The front and back of one of two palace door panels [30] from an area near the Ekiti Yoruba

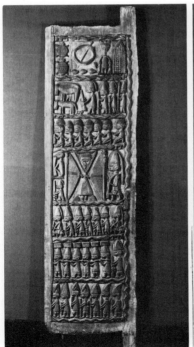
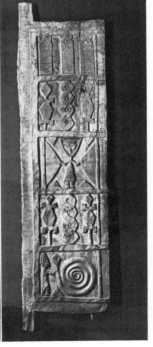

30. Yoruba (Nigeria) wooden door (front and back views). From the Ekiti Yoruba area of southwest Nigeria.

(northeast Yoruba) documents the complex carving lavished on palace compound entrances about the turn of the century. The front panel (seen on the left) is divided into seven horizontal zones, or rows, with various figures carved in low relief in each. The borders that divide each row from the next are made of relief-carved images of serpents biting at various animals. These undulating serpent bodies frame each scene along the right vertical side and through each of the horizontal zones. The bottom three rows include groups of standing figures with rifles, some carrying loads on their heads, and once in a while an equestrian figure. The center row on both sides of the door has a frontal figure with a beard who wears a long robe. In the center image on the front panel, he is flanked by staffs which terminate in figures, an equestrian figure, a man with a gun, and a monkey. On both the front and back panels of this door the figure holds on to what may represent nets or bags. This central person may represent the patron himself—the ruler who lived in the palace. The figures along the bottom three rows in the front panel may allude to his economic power in trading various goods, including slaves. The top three rows on this panel have kneeling figures, hunter or warrior figures with animals, and, on top, turtles, snails, and a dried fish (in a circle on a stick). All of these are animate things given as sacrifices to various *orisha*. The five horizontal zones on the back panel probably allude to the shrine used by the patron and include forms that may be some sort of cowrie-shell-covered ritual objects (on the top row), and various reptile and human images associated with ritual sacrifices. In general, these door panels seem to suggest the patron's wealth, power, and devotion to some Yoruba deity.[30]

We turn now to a brief discussion of the art of the Ibo people, who are less centralized than the Yoruba and who live in southeastern Nigeria near the Niger River.

## Art of the Ibo of Nigeria

One form of wood carving found among the Ibo is a personal shrine figure called an Ikenga. The personal shrine figure shown in Figure 31 was used by the head of an Ibo household as a way of controlling his aggression and helping him to properly administer his responsibilities. The male figure in this type of sculpture depicts the head of the household, either standing flex-legged or sitting on a stool to denote high rank. In this example [31] the male figure holds a long knife in one hand and a severed human head in the other. On both sides of his head rise impressive curved horns. On his chest he wears an ornament associated with the Ikenga cult. The severed head is symbolic of his ability to protect his family during warfare and his ability to defeat his enemies. The long knife is symbolic of his warlike abilities and of his work in the gardens, where yams are harvested with long knives. The scarification

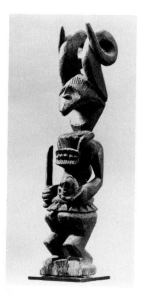

31. Ibo (Nigeria) wooden Ikenga figure representing a man holding a weapon in one hand and a human head in the other.

32. Ibo (Nigeria) wooden Ikenga figure. From the Awka region of southeastern Nigeria.

sculptures ranged from a single figure on a base (number 75, an airplane pilot) to a house with thirty-two figures, including various deities, animals, and personages (numbers 1 through 32). The goddess of large families (Chapter 1, Figure 17) was one of the figure groups at this *mbari* (number 24). Another figurative group from this *mbari* [34] depicts a scene, in a modern hospital, of a mother who is giving birth; she is attended by a midwife (next to her) and two standing nurses. The mother is painted with traditional body painting patterns. The bicycle on the wall in the background and the telephone on the wall are, like the hospital setting, examples of modern things which are seen as positive and good by the Ibo. Evil, dangerous, and forbidden things are also given sculptural expression in this large *mbari*. An evil rapist/cannibal spirit named Okpangu, who is part ape and part human (number 49), and a leopard and a lion (numbers 47, 48) are some of the dangerous things depicted in this house. This *mbari* house also depicts things which are forbidden, such as a man wearing a type of mask that women are forbidden to see. In Figure 35 this man is shown standing with one arm extended, brandishing a long-bladed knife. His mask is of a type used in a cult called Okorosia (in other areas it is called Mmuo). Within the context of the *mbari,* good, evil, dangerous, and forbidden things are presented, as if to represent the universe known to the Ibo. After the ceremonies associated with the *mbari,* the house is abandoned and the sculptures are left to gradually deteriorate into the earth.[32]

marks on his forehead are indicative of his adult status, since he has received them as a youth during initiation into adulthood. The curved horns on top of his head are associated with his virility and masculine powers, and his ability to father a large family. Another Ikenga sculpture [32] shows the male figure sitting on a stool. In addition to the curved horns, severed head, and long knife just mentioned, this figure has a pair of chickens on his head (symbolizing his family).[31]

Earlier (Chapter 1, Figure 17) we discussed the sculpture of the Ibo *mbari* house, in which the goddess of large families was shown with four children seated on her lap and shoulders. In *mbari* houses, various clay sculptures were modeled as part of a group ceremony aimed at pleasing various deities. They were often made as a response to unusual events, such as an overly high number of infant deaths, drought, or disease. The fertility theme is just one visual manifestation of things which are perceived by the Ibo as good— namely, having large families. The number and variety of clay sculptural groups varies from a single group scene in a simple *mbari* to dozens of figures comprising various themes in a more elaborate *mbari*. In an unusually large *mbari* [33], dedicated to the earth goddess Ala at Umuofeke Agwa, there were seventy-five distinct figures set out in five separate architectural contexts. These

In Chapter I (Figure 9), we also discussed the beautiful-maiden masks (Agbogho Mmuo) of the Ibo people in the north-central region. This spirit can be seen as elegant, composed, aloof, and refined in facial details and elements of design. In contrast to these female masked spirits are various male and animal-spirit masks found among the Ibo in the same region. An example of a composite male mask, called Mgbedike [36], embodies powerful masculine forces associated with

33. Ibo (Nigeria) plan of an elaborate *mbari* clay sculpture ceremonial display dedicated to Ala at Umuofeke Agwa southeastern Nigeria.

34. Ibo (Nigeria) *mbari* clay sculptural group representing birth in a modern hospital setting, at the *mbari* to Ala at Umuofeke Agwa, southeastern Nigeria.

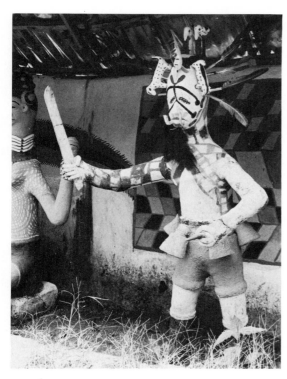

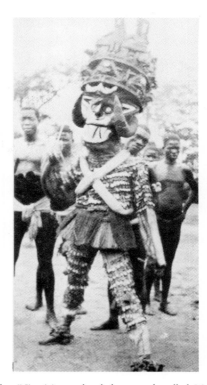

35. Ibo (Nigeria) *mbari* clay sculptural group representing a man wearing an Okorosia mask, at the *mbari* to Ala at Umuofeke Agwa, southeastern Nigeria.

36. Ibo (Nigeria) wooden helmet mask called Mgbedike. From the north-central region of Ibo country.

the hunt, war, and dangerous creatures of the bush. The mask is huge and aggressive in comparison to the beautiful-maiden masks and has large pointed teeth, large upward-curving horns on either side of the face, and a large carved headdress with multiple figures on top.

Another Ibo mask of a composite human/animal type is found among the northeastern Ibo and is called Ogbodo Enyi [37]. This mask type also embodies masculine protective and destructive powers. Unlike the Mgbedike type just discussed, the Ogbodo Enyi mask consists mostly of elephant characteristics. The horizontal thrust of this mask emphasizes the pair of horizontal tusk shapes seen on the left and the curved, horizontal trunk shape on top of the head. Bulging cone-shaped eyes thrust forward from a concave face. The upturned pug nose may be an anthropomorphic element, as is the well-defined human head protruding from the back of the mask. The sur-

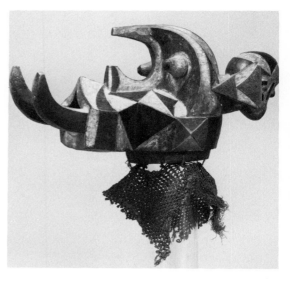

37. Ibo (Nigeria) wooden helmet mask called Ogbodo Enyi. From the Northeastern Ibo country.

179

face is painted with angular geometric patterns which create a visual complexity causing the viewer's eyes to return to various sculptural surfaces on the mask. The fragment of a woven string bag costume beneath the mask alludes to an extensive body covering worn from the mask to the ground, thereby completely hiding the dancer's identity. The coarse and bushy quality of the costume is in stark contrast to the beautiful-maiden costumes, which echo "civi-lized" body decorations (Chapter 1, Figure 9). In many ways the Ibo Mgbedike and Ogbodo Enyi masks, with their combination of human and animal traits and their powerful protective natures, seem similar in concept to the composite helmet masks of the Bamana Komo society (Chapter 5, Figure 23) and the witch-killing masks of the Senufo Poro society (Chapter 5, Figures 31 and 33), although they remain distinct from each other stylistically.[33]

# 7

# Art of Central Africa

The grasslands of Cameroon, and the tropical forests of Gabon and Zaire are the homelands of various centralized and noncentralized groups, all of whom speak languages of the Benue-Congo subgroup of the Niger-Congo family. In traditional times, during the late-nineteenth century, the Fang numbered about two hundred thousand, while their neighbors, the Kota, numbered about twenty-eight thousand. The centralized Bamum numbered about seventy-five thousand and the Kuba numbered about thirty thousand. Neither the Fang nor the Kota had chiefs, whereas the Bamum and the Kuba had both chiefs and kings. The Fang are spread over vast areas of present-day Cameroon (the southern region), Equatorial Guinea, and Gabon; the other three groups are located in much smaller geographic areas in Gabon (the Kota), Cameroon (the Bamum), and Zaire (the Kuba).

The lush grasslands and dense tropical forests provide an abundance of flora and fauna for hunting and gathering, and agriculture is practiced adjacent to the smaller settlements and some distance away from the centralized capitals. Many forms of reptiles, mammals, and birds are found in these two regions and are exploited for food, feathers, skins, horns, and tusks.

Architectural structures throughout Cameroon, Gabon, and Zaire are made from organic materials such as trees, saplings, thatch, and grasses. They range from small lean-to structures, to individual homes, to communal structures, and, in the case of the Bamum, to a large palace with dozens of rooms and many courtyards.

## *Art of the Fang of Gabon*

The Fang live in parts of southwestern Cameroon, Equatorial Guinea, and Gabon (Map 9). There is strong evidence that various Fang-speaking groups migrated south and southwest from the Cameroon area in the past two hundred years. The resulting Fang art forms, dating from the late-nineteenth and early-twentieth centuries, suggest a common ancestry, yet are clearly differentiated into several geographical styles. In the north, Fang styles include the Ngumba, Ntumu, and Mabea substyles, with a strong tendency toward elongated proportions in figure sculpture. In the central and southern Fang areas, the Betsi, Okak, and Mvai substyles tend toward a bulkier,

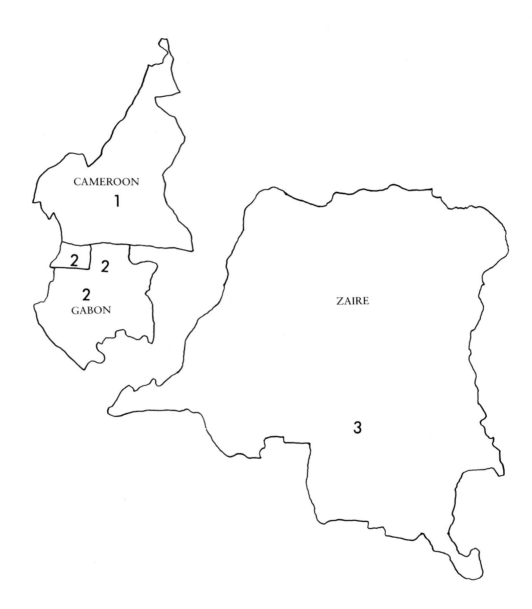

Map 9. CENTRAL AFRICA

1. Bamum
2. Fang
3. Kuba

broad-headed figure sculpture, with the Betsi and Upper Okano regions having a type of sculpture where only a carved head is used on reliquary boxes and bundles.[1]

The typical layout of a northern Fang village [1], at the turn of the century and still today, is on a rectangular plan with two parallel rows of dwelling houses facing each other across a cleared plaza. These houses were used by various clan units as dwellings and cook houses. At either end of these parallel rows were the clan ceremonial houses, where men congregated for ceremonial activities as well as for group discussions and the conducting of everyday affairs within the village. As one radiated outward from this rectangular village plan, one saw the nearby clan garden plots, then further away the forest.[2]

Perhaps the best-known types of sculpture from the Fang are the reliquary pieces, including carved heads, half figures, and full figures, which were used on top of a cylindrical box containing the skull and bones of an ancestor.[3] Figure 2 shows a group of two half-figure and seven full-figure types from the Ntumu, Ngumba, and Mvai Fang regions. Full figures such as these were placed on the edge, and half-figures were placed in a hole in the top of the cylindrical reliquary box. These figures served a guardian function, and the container represented a sacred place where ancestral remains were kept near the village. Some of the figures have elaborate feather headdresses on them, documenting how they probably looked when dressed up for ceremony. Today, most surviving figures have lost their added-on clothing and headdresses, thereby appearing as pure sculptural forms. Two additional examples of full-figure reliquary figures from the Mvai and Okak Fang groups are shown in Figures 3 and 4, respectively, and are considered to be among the most beautiful Fang sculptures known. The Mvai Fang figure [3], probably from the turn of the century, represents a female in a

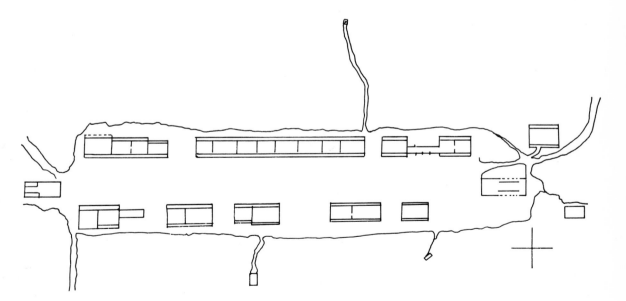

1.   Fang (Gabon) village plan in northwestern Gabon, 1908.

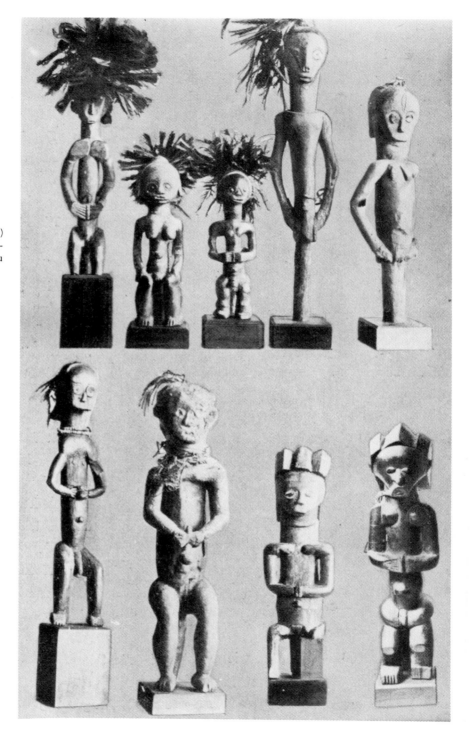

2. Fang (Gabon) wooden reliquary figures. From the Ntumu Fang.

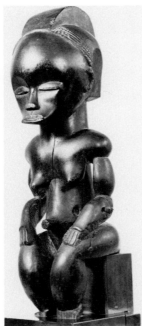

3. Fang (Gabon) wooden female reliquary figure. From the Mvai Fang.

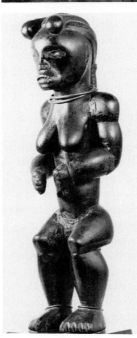

4. Fang (Gabon) wooden female reliquary figure. From the Okak Fang. Late-nineteenth century.

seated position with her hands touching her curved upper legs. The overall feeling of this figure is a dynamic blend of powerful muscular body parts with a soft, somewhat feminine quietude. The heart-shaped face, with closed eyes, terminating on the bottom with a wide slitlike mouth helps to create a quiet, contemplative facial expression. The curved, smooth forehead terminates in a wide, crested hairdo that sweeps gracefully backward from the front of the head, and the powerful cylindrically shaped neck blends subtly with a curved full-volumed shoulder and pendulous breast area. The upper and lower arms are carved as bulging forms, which are clearly demarked from each other and from the shoulder above and the hand below by a change of volume. In addition, there is great plasticity in the treatment of the buttocks, and upper and lower legs. The cylindrical protruding navel and the oversized head are style traits commonly found in Fang sculpture.[4]

The early standing female figure shown in Figure 4 is from the Okak Fang, and it too creates a feeling of power held in dynamic balance. In this Okak Fang piece, each body part, from the head to the arms and legs, is given full volumetric treatment, suggesting that the figure is extremely powerful. The standing pose, with arms held in front of the lower chest, gives the figure an especially alert and somewhat threatening demeanor. This is reinforced by the slightly down-turned toothy mouth and even by the hornlike thrusting elements that appear as part of the figure's coiffure. This figure has a great sense of power held in check, even more so than the Mvai figure.[5]

At the turn of the century the northern Fang had at least six major cults. Initiations and ceremonies connected with these various cults were held either in sacred areas in the surrounding forest or in temporary structures attached to the men's ceremonial house at the edge of the village. These cults were divided into negative (evil) and positive (good) types, the former being associated

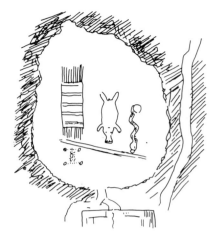

5. Fang (Gabon) plan of a Sso cult place. From the Ntum Fang.

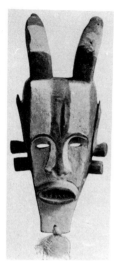

6. Fang (Gabon) wooden antelope mask of the Sso cult. From the northern Fang.

with a cult of the moon, the latter with the sun. A negative cult called Sso was associated with the moon, while its positive opposite, the Ngong-mba cult, was associated with the sun. These subsumed four additional cults: the Bokung cult and its complement the Elong cult, and the Schok cult and its complement the Ngi cult. Certain images were used as power emblems for each of these cults. The antelope was associated with the Sso cult, and a horned antelope mask was used in ceremonies associated with the dead and the underworld. The owl, cock, elephant, and gorilla were emblems of the Bokung, Elong, Schok, and Ngi cults, respectively.

Many of the cult ceremonies had gigantic temporary clay ground sculptures within the confines of the temporary spaces (often shielded from view by a fence). A ground plan for a Sso cult place [5] shows a temporary clay sculptural group representing a large pig and serpent adjacent to the men's ceremonial house. The short path was used during the initiation of young boys, during which time they were taken into the fenced-in area as part of their ordeal.

An antelope mask associated with the Sso cult is shown in Figure 6. This carved wooden frontal mask combines human and animal attributes and has eyebrow and nose areas that connect into a continuous curved shape. The eyes are pointed oval slits through the front of the mask, which are echoed in the treatment of the larger, heavily dentated, mouth below. The protruding horn shapes are slightly curved outward from the top of the head and are slightly rounded-off rectilinear forms. Contrasts of light and dark pigment are used horizontally across the horns and vertically on the forehead, nose, and the sides of the head to further subdivide the face.[6]

Just as the antelope was associated with the Sso cult, the elephant is the power emblem most associated with the Schok cult. A ground plan for a Schok cult place from the turn of the century is shown in Figure 7 and includes images of two pigs, a large elephant, a serpent, and a turtle. The elephant clay sculpture was constructed over a corpse, and the entire sculptural display was associated with the medicinal role of the Schok cult—an aspect of the cult which was tied to the fertility and health of its members.[7]

In a ground plan of a Ngi cult place [8] one can see a special tunnel that was constructed from

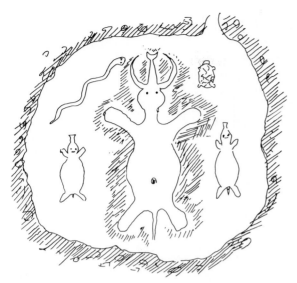

7. Fang (Gabon) plan of a Schok cult place. From the northwestern Fang.

the men's house to a point near the genitals of a large, female, clay ground sculpture. This tunnel was built so that the initiates could enact a symbolic rebirth when crawling out through the tunnel between the large female figure's legs. Huge male Ngi figures were also made of clay. An example of a Ngi male clay sculpture with simplified head and face is shown in Figure 9.[8]

Aside from the Sso cult antelope mask already discussed, various Fang masks were made in simple face mask styles, as well as complex multi-faced helmet mask styles. The elongated and elegant Fang face masks with pronounced heart-shaped faces are usually identified as Ngi society masks [10], although a type with animal horns from the northern Fang may also be associated with the Ngi cult [11]. A more complex, multiple-headed type of helmet mask is usually

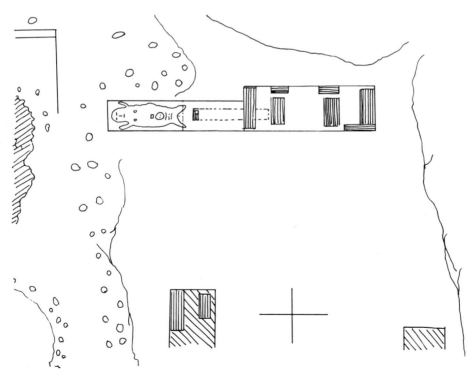

8. Fang (Gabon) plan of an Ngi cult place. From the northern Fang.

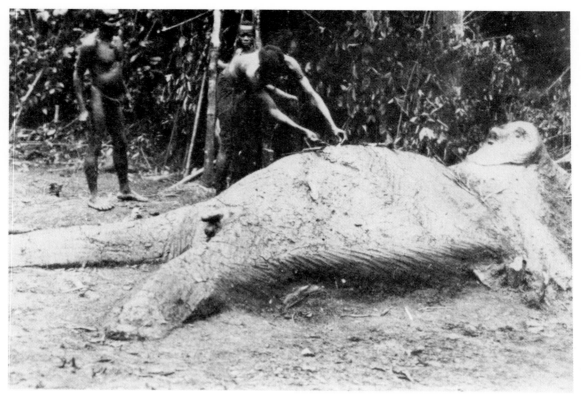

9.  Fang (Gabon) clay sculpture from an Ngi cult place. From the northern Fang.

10.  (left) Fang (Gabon) wooden mask of the Ngi cult. From the northern Fang.     11.  (center) Fang/Bula (Gabon/South Cameroon) mask with horns.     12.  (right) Fang (Gabon) wooden mask with multiple heads of the Ngontang cult.

188

said to be used in another masking society, known as Ngontang. An early-twentieth century example of a Ngontang mask, with four faces of varying sizes, is shown in Figure 12 and has long been identified as a masterpiece of Fang sculpture.[9] Each of the four faces on this mask has a characteristic heart-shaped brow and nose line, and a gently curving convex forehead against a slightly concave facial plane beneath the arched eyebrows. Each forehead is bisected by a slightly raised line, which extends down to the tip of the thin, triangular-sectioned nose. The slit eye holes echo the oval slit at the center of the raised lips of the mouth. Thin semicircular tablike ears extend out from the side of each face, serving as a slight break in the oval contour of each face. A raffia beard and/or a costume was probably attached to the row of holes at the lower chin area.

## Art of the Bamum of Cameroon

The royal art tradition of the Bamum of the Cameroon Grasslands is one of the most elaborate and decorative traditions found anywhere in Africa. The decorated throne shown in Figure 13 (on the following page) was given by King Njoya to the German government in the first decade of the twentieth century. It is said to have been made for Njoya's father, Nsangu (ruled c. 1870–1887). This throne has a rounded stool area with intertwined serpent images, a pair of male and female retainer figures (palace servants), a pair of guard figures holding guns, and a lower panel with five bent-over support figures. The entire carved surface was covered with cloth. Then, tiny colored beads were sewn onto each figure and various flat and rounded surfaces of the throne. Cowrie shells were also attached as linear elements and were used to create large repetitive areas on flat surfaces. The overall effect is one of stately grandeur, and protection and power, all befitting a royal person who was seen as a living god.[10]

Another royal stool, this one a single supporting leopard figure beneath the rounded seat [14], uses varied patterns of colored beadwork to create the leopard's spots and decorative border patterns. Like the serpent images in Nsangu's throne, the leopard image was associated with royal power. Other prestige objects which would be found in the possession of the Bamum king (and other notables) are decorated appliqué caps [15] and anthropomorphic lost-wax cast pipes

14.  Bamum (Cameroon) wood and bead-covered stool in the form of a crouching leopard.

[16]. Animal and insect (especially spider) symbolism was also common.[11]

The palace at Foumban was vast, with at least seventy-two rooms and twenty-six courtyards.[12] One of the courtyards, a reception area, was shown in Chapter 1, Figure 13, where King Njoya stood in front of several carved support posts depicting retainer figures. Other early-twentieth-century photographs [17 and 18] show various parts of the vast palace complex and various art forms found within. A photograph of King Njoya's queen mother, Njapundunke [17] shows her standing next to a small carved chair with abstracted leopard heads with legs (on the bot-

13. Bamum (Cameroon) wooden bead-covered royal throne. From the Palace at Foumban.

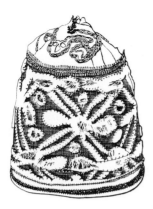
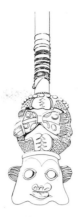
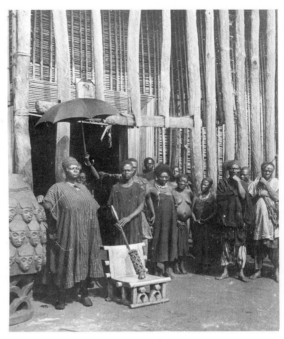

15. (left) Bamum (Cameroon) fiber appliqué prestige cap with spider and frog motifs.    16. (right) Bamum (Cameroon) brass lost-wax cast prestige pipe with human and frog images.

17. Bamum (Cameroon) Palace courtyard with Queen Mother Njapundunke standing next to a carved drum and a royal chair, 1906.

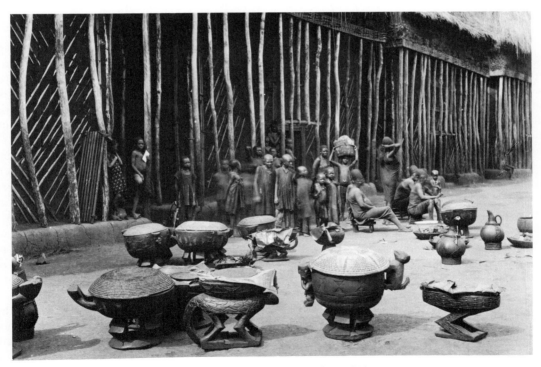

18. Bamum (Cameroon) Palace courtyard with carved feast bowls, about 1910.

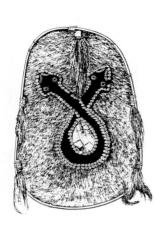
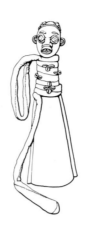
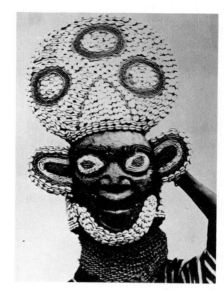

19.  (left) Bamum (Cameroon) hide- and cowrie shell–covered war shield with crossed serpent motif.     20.  (center) Bamum (Cameroon) cast metal war gong with trophy head motif on top.     21.  (right) Bamum (Cameroon) wood, bead, and cowrie shell palace mask, about 1912.

tom), a large brass ceremonial pipe with multiple spider figures on the bowl, and a huge drum carved with multiple human heads in three rows around its body. The leopards and spiders allude symbolically to royal powers, while the multiple heads probably allude to trophy heads taken during war. The second photograph, depicting a courtyard with women, children, and carved serving bowls [18], shows several examples of wooden feast bowls made with animal and human images as part of their structure and/or decoration.

In traditional times, before the advent of European contact and control at the turn of the century, warfare was an important aspect of the rule of a Bamum king and his subjects. Emblems of this preoccupation and practice are found in many Bamum art forms. A bead-covered headdress [Color Plate 10] represents a warrior armed with pointed spears standing on top of a spotted leopard. This headdress was worn by the king at special war-related ceremonies, and today still

resides in the palace at Foumban. The lively figure has a dark, feathered headdress, large protruding ears, almond-shaped eyes, and stocky yet powerful body proportions. The figures are covered with light-blue beads, which contrast markedly with the dark beads and the feather hair. The figure's blue, bead-covered feet blend visually with the leopard form below, while the leopard stands on a small wooden cap which is worn on the king's head. An animal-skin-covered war shield with crossed-serpent images on its front [19] and a cast-metal war gong with a human head on top [20] are also war-related art objects used by the Bamum at the palace. All of these art forms document the importance of animal-related power symbolism and the trophy head in Bamum culture.[13]

Masks of several types were used by the Bamum at the palace of the king. The palace masks of an anthropomorphic type [21] were worn by men who served as part of a private police force for the king. These masks have a

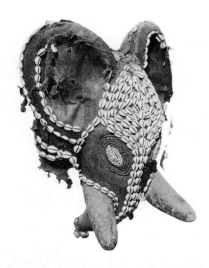
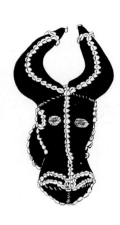
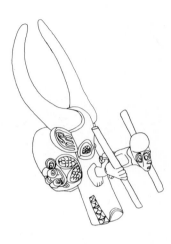

22.   (left) Bamum (Cameroon) wood, cloth, bead, and cowrie shell elephant crest mask.    23.   (center) Bamum (Cameroon) wood, cloth, bead, and cowrie shell water buffalo crest mask.    24.   (right) Bamum (Cameroon) wooden water buffalo mask used in the Nja festival.

treatment of the human head similar to that seen in the figures on the royal throne [13] and on a warrior headdress [Color Plate 10]. The large almond-shaped eyes, large circular ears sticking out from the side of the head, the almost circular prestige cap on the head, and the fringe of cowrie-shell beard below are all style characteristics of Bamum art. The use of the extensive bead and cowrie-shell covering is especially associated with royal masks. Other similarly shaped masks, without extensive bead and cowrie-shell coverings, were used throughout the territory of the Bamum as village masks.[14]

Animal masks that were extensively covered with cloth, beads, and cowrie shells included many powerful animals associated symbolically with the king of the Bamum. The elephant mask in Figure 22 was carved in wood, then covered with cloth, beads, and cowrie shells, and was used at the court as a symbol of the king's awesome powers. Even though the elephant is somewhat simplified in form, when compared to the composite elephant/human mask of the Ibo peo-

ple of Nigeria (Chapter 6, Figure 37), this mask seems quite decorative and naturalistic. Cowrie shells line the outer and inner rings of its large ears, cover most of its forehead, and circle around its stubby tusks. Small, colored beads are attached around the eyes in a light and a dark color, creating an ever-expanding oval of beads. The rest of the face, most of the ears, and the back of the mask are covered by a dark-colored cloth, creating a stark contrast with the beads and cowrie shells. Another powerful animal mask used at the palace represents a water buffalo [23], and it too was covered with dark cloth and accented with lines of white cowrie shells and small, colored beads.

The water buffalo is represented again in a drawing of a large, composite wooden mask [24]. This mask has a standing male figure (holding staffs), relief heads of humans wearing prestige caps, and frog-leg motifs carved in its ears. The mask was used at the Bamum court in a special fertility festival called Nja, and it, too, is consistent with Bamum court style.

## Art of the Kuba of Zaire

The Kuba peoples consist of several related groups living between the Kasai and Sankuru Rivers in central Zaire (Map 9). Their art tradition, like those of the Asante, Benin, and the Bamum, is essentially a royal art tradition, although the forms and institutions of the palace have filtered down from the king to the chief's level in some villages. Even so, all Kuba people show allegiance to the king.[15]

Kuba royal art is frequently associated with a sumptuous display of the king, surrounded by art objects symbolizing his high status. A 1970 photograph [25] of King Kot aMbweeky III sitting on a raised platform throne during his coronation ceremony illustrates the richness of Kuba royal art. He is adorned with an elaborate ceremonial costume and is flanked on either side by two large royal drums (*pelambish*) covered with cowrie and pearl shells arranged in various geometric patterns. The checkerboard-like patterns around the top and lower portions of these drums represent an architectural motif. The elab-

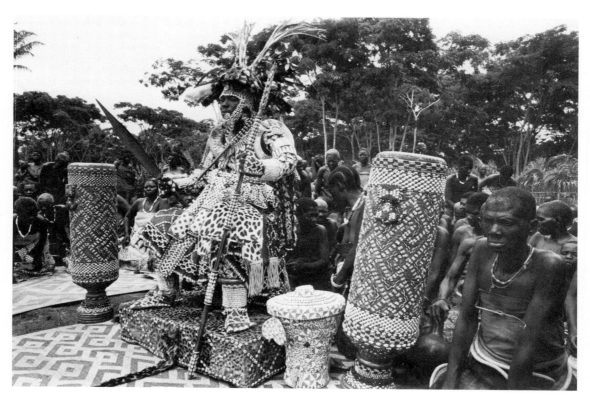

25.  Kuba (Zaire) royal ceremony with King Kot aMbweeky III, 1970.

orate interlace pattern around the middle section of each drum is a royal pattern called *kweethwiin*, which was derived in the early 1920s from architectural decoration used by the nearby Bangyeen and Bangwoong peoples to the northeast. Each drum has a medium-relief carving of an inverted ram's head set beneath a rectangular raised form which itself is subdivided into triangular shapes by cowries and dark pearls. This type of drum is handed down from generation to generation and is used for any important royal ceremony, as well as at the beginning of the new moon. The narrow neck that flares out into the base has a thick metal ring encircling it as a decoration. The platform the king sits on is covered with leopard skin which has cowrie shells added to it in simple geometric patterns. The flattened tail of the leopard extends downward at the front of the platform and extends out on top of a cut-pile mat decorated with an angular pattern set around a square center. This pattern is called the "branch of the leopard" and represents an abstraction of a branch on which the leopard spends the greater part of his day at rest.[16]

The small vessel to the right of the king in the photograph is called the "vessel of wisdom," and is covered with a lid from which hangs a water-lily-shaped decoration. All of these parts are covered with cowrie shells and pearls in an intricate series of triangular geometric patterns called *lantshoong*. That pattern is commonly found on the clothing of the *Moshambwooy* royal mask.

The clothing of the king creates an arresting visual display, compared to the sparsely dressed subjects seated and kneeling around his raised platform throne. The king's headdress consists of eagle and ibis feathers which protrude upward and outward from the top of his broad-rimmed feathered hat. A light, down-covered protruding shape hangs down from the front just over his forehead. His head and lower face are covered with cowrie and pearl shells, which combine to create a false beard. On his forehead is a spiral-shaped seashell. A leopard tooth collar hangs around his neck, while on each of his shoulders he has a circular-shaped ring of pearls set off with an interlace royal pattern called *imbol*. Leopard skins and woven tunics covered with cowrie and pearl shells are draped over his entire body. His hands and feet are covered with special mittens and soft foot coverings, which are patterned with geometric designs set off with pearls and cowrie shells. He carries in his right hand a special ceremonial sword, and in his left, a long iron spear covered by alternating encircling bands of cowrie shells. This particular mode of royal clothing is called *bwaantshy*, which translates as "eater of the python."[17]

One of the best-known sculptural forms made by the Kuba is the wooden portrait figures called *ndop*. They are said to be carved for the king during his reign and served as a type of symbolic substitute for him when he was away from the palace. In fact, the *ndop* was kept with the king's wives as a companion and reminder of his power and prestige. There are at least twenty-two of these figures extant, although only seven or eight are probably early in date (eighteenth or nineteenth century) and of high aesthetic quality.[18]

One of these eight figures, the *ndop* sculpture of Kata Mbula pictured in Figure 26 depicts the king seated cross-legged holding a ceremonial knife in his left hand by his side.[19] In front of him, carved in high relief, is his emblem, *ibol* (a miniature *pelambish* drum similar to the two discussed above in the photograph of Kot aMbweeky III's coronation ceremony). The drum is decorated with geometric patterns in low relief that are similar to the types of patterns found composed of pearls and cowrie shells on royal court drums. Unlike the costume worn by the living king (as seen in Figure 25), the costume on the *ndop* figure is sparse, with low-relief carved imitations of arm and waist band cowrie shell wrappings. Each wrist is shown with five circular bracelets, the originals being made of metal, while these are in low relief. The horizontally oriented headdress, covered with low-relief

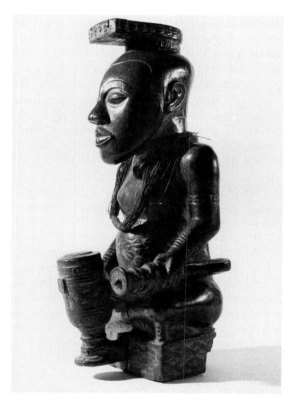

26. Kuba (Zaire) wooden figure (*ndop*) representing King Kata Mbula.

from the bridge of the nose, and the outlining of the shape of the mouth. The head is large compared to the rest of the figure, giving it a visual dominance.

The contrasting shiny surface treatment of most of the body and skin contrasts subtly with the low-relief patterns carved on the drum, base, headdress, and wearing apparel. In contrast to the living king, dressed in visually bright and arresting ceremonial clothing (which had an underlying theme of power and sumptuous display), the *ndop* figure of Kata Mbula gives the viewer a relaxed and contemplative feeling. Both of these attributes would be appropriate for the ruler of the Kuba. The public display image would tend to separate him from the viewing public, whereas the *ndop* figure most likely functioned within the more private space of the wives' palace enclave, where the ruler subtly asserts his wisdom and peaceful nature.

Another art form intimately tied to the royal art tradition among the Kuba is the making of cut-pile embroidery on plain-weave raffia. Figure 27 shows two women working on cut-pile embroidery at Mushenge, the capital of the Kuba kingdom. Men wove ceremonial items for the king and his palace attendants and chiefs, while women were the embroiderers.[20] The most common visual element found in Kuba textiles is a geometric design that is either angular or curvilinear. The two women in this 1970 photograph are both working on a similar pattern, called the "house of the king"—a pattern commonly found on royal textiles. The woman on the left has added rectangular boxlike areas between the overlapping "house of the king" pattern, and has further subdivided these rectangles with crisscrossing dark lines. Both the mats they are working on and the plaited wall behind them display the Kuba use of abstract two-dimensional geometric designs.

A patchwork-like assemblage of over twenty different pieces of Kuba cut-pile embroidery with dozens of different patterns [28] gives the viewer

cowrie shell patterns, is a replica of a royal headdress called *shody*. The overlapping interlace pattern on the raised platform is geometric abstractions based on lianas (vines) found in the forest. The pattern is known generically as *nnaam*.

The treatment of the body is a study in subtle contrasts. There are many naturalistic features, including the soft, fleshy treatment of the stomach and chest, the articulation of finger and toe nails, the contemplative, seated posture with closed eyes, and the overall feeling and proportion of the face, ears, and head. There are, however, subtle abstractions, such as the treatment of the eyebrows and the separation of the nostrils

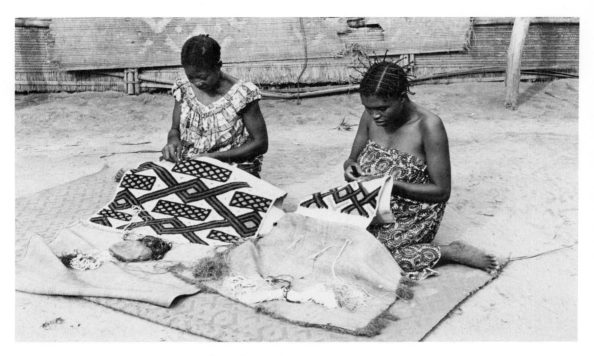

27. Kuba (Zaire) women embroidering raffia cloth at Mushenge, Zaire, 1970.

28. Kuba (Zaire) patchwork cut-pile embroidered raffia.

some indication of the creative interpretation of a few geometric shapes in this elite art form.

The Kuba are also famous for their beautifully carved palm-wine cups, storage boxes for cosmetics, and other prestige objects. A royal palm-wine cup in the form of a human head with a sweeping pair of ram's horns as a headdress is shown in Figure 29 and attests to the elegance of Kuba sculpture. The ram, as noted earlier, is associated with royalty among the Kuba, and this cup is an example of a small-scale piece (only about nine inches high) that has a monumental quality. The treatment of the eyebrows, nose, and eyes is consistent with what we saw on the statue of Kata Mbula; however, this head has additional elements on its surface, including scarification patterns over the eyebrows; concentric, circular seashell-like scars on each temple; and ears which are more like those of a ram

29. Kuba (Zaire) wooden palm-wine cup.

than those of a human. The horns flare upward, back, then turn back toward the lower face, thereby guiding one's eyes back to the face. The repeated double row of raised scarification patterns found below on the flange of the cup texturally echo the patterns on the forehead and the teeth, and serve to guide one's eyes back toward the center of the face. The bulbous cup part of the top of the head is textured with fine cross-hatchings and has a concentric circular emblem identical to the two found on the temples of the face below. This helps to tie the top and bottom elements together as a related unit.

The art of masking is found among the Kuba both at the royal and nonroyal levels. At the palace and court there are three major masked spirits, which were embodied in specific costumes, masks, and dances. These are the powerful Moshambwooy mask of a composite human/animal nature, the hydrocephalic Bwoom mask, and the beautiful female mask called Ngady amwaash. The Moshambwooy mask and costume embody the power and awesome strength of the mythical ancestor Woot as a composite human/leopard/lion nature spirit (*ngesh*). The mask is made of animal hide, cloth, beads, cowrie shells, and feathers of various sorts. It is the embodiment of supernatural power vested in the hands of the ruling king. In contrast to Moshambwooy is a carved mask called Bwoom (who is said to be either a hydrocephalic or a pygmy, depending on which version of its origin myth one reads). The third major dance character is the beautiful female spirit called Ngady amwaash, the incestuous wife of Woot.[21]

Beyond the royal context, similar masks are used in initiation ceremonies throughout the Kuba. These nonroyal masks are often so similar in style to the royal masks that only seeing the complete costume and local attribution by users of the masks can correctly differentiate them. An example of one of these nonroyal masks is a composite mask shown in Color Plate 11. This mask has a protruding elephant-like trunk and a pair of

tusks placed on either side of the trunk. The beard on this mask is of fiber (possibly raffia). The human attributes of this mask are played down to a minimum, with a bead and cowrie-shell face set low and central to the head, and a broad fiber beard spreading outward from the angular chin. As seen on the Kuba king discussed previously [25], there is a great deal of cowrie shells and beads used on the lower face, side of the head, and on the conelike headdress on top. The nose and mouth are metal-covered wooden attachments which have been partially covered with a wide vertical band of blue and white beads. The elephant trunk and tusk shapes grace-fully extend above and in front of the head of the mask, and are covered with cowries and beads as well. A metal bell hangs from the center point of the arching trunk, and the front terminates in a tuft of bright-red feathers. The colorfully painted, carved, humanlike mask to the right side represents a personage called Pwoom Itok, who plays a subsidiary role to the other three royal masks and is depicted as a tired old man who is consulted for his wisdom. The Pwoom Itok mask is carved as a human-like form, with bright-yellow facial markings which radiate downward from his bulging eyes. Additional yellow facial markings are oriented at right angles to the facial plane along the sides of the head. The alternating bright-yellow and dark-black areas are accented on its head by small white dots, and the fiber and cloth headdress serves as a foil to the active de-sign elements within the planes of the face and head.

The hydrocephalic Bwoom mask shown in Fig-ure 30 is essentially anthropomorphic in shape, although the bulging forehead gives it a certain grotesque appearance when one compares it to the quiet, self-absorbed, contemplative face on the figure of Kata Mbula discussed previously. Like other royal objects, this mask has a complex interplay of sculptural forms, with added-on beads, cowrie shells, fur, cut seeds, and strips of metal. The bulbous forehead form is divided into

30. Kuba (Zaire) wood, bead, metal, cowrie shell, fiber, and cloth mask representing the mythical spirit called Bwoom.

three parts by three bands of small beads radiat-ing out from the region of the nasion (where the forehead and nose meet), and the curved areas between these bands are covered with sheets of cut metal. The outer and inner helix and tragus of the ear are articulated as high-relief forms, and they are visually set off from the rest of the head by elaborate beadwork around them on the top, back, and bottom. The broad band of white beads which covers the area of the eyes termi-nates at the ear with large dark-colored beads (possibly pearls). The nostrils and ridge of the nose are covered with alternating blue and white bands of beads. The way they are placed on the nostrils tends to reinforce the bulbous and curvi-linear sculptural forms of the nostrils, whereas

the vertical band on the ridge bisects the nose and echoes the vertical band on the forehead. The entire lower face from below the eyes to the edge of the chin (where the beard begins) is carved with intersecting lines which create small rectangular shapes which collect reflected light on them to add variety to the face. In the center of the cheeks is a metal-covered area of varied width curving downward from the edge of the eye area to a point near the ears. This shape echoes the semicircular arching eyebrow forms created by the addition of large light-colored beads above the broad band of small white beads across the face. The mouth is raised slightly off the plane of the face and appears to have a somewhat toothy smilelike gesture. It is also covered with metal and surrounded by a single band of alternating blue and white beads. The beard area consists of small beads, cowrie shells, and pointed oval-shaped cut seed pods inset with small pearls.

The beautiful-female mask [31], known as the Ngady amwaash, is the most human-like of the royal masks among the Kuba. The proportions of the face are more human than in either the Moshambwooy or the Bwoom masks. The almond-shaped, closed eyes and the similarly shaped mouth combine with the well-articulated nose to create a face of composure and contemplation, not unlike that of the *ndop* figure discussed earlier [26]. In contrast, her face is more colorful and is painted with variegated geometric patterns. Her nose, mouth, and chin are covered with a broad vertical band of zigzag colored beads. Triangular patterns cover the forehead, sides of the face, and the areas on either side of the nose. The headdress area is covered with a repetitive floral pattern of beads and cowrie shells. Perhaps these facial decorations are based on patterns found in royal embroidery.

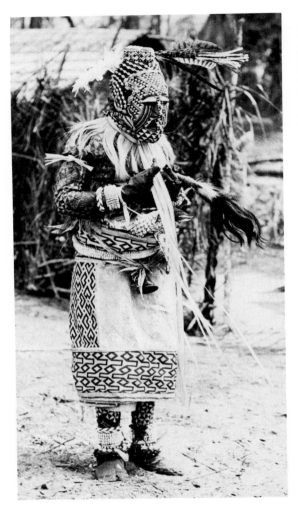

31. Kuba (Zaire) man wearing a Ngady amwaash mask with bark cloth and cut-pile clothing, and cowrie shell ornaments.

# 8
# Australian Aboriginal and Island New Guinea Art

The ecological zones of the aborigines of Arnhem Land in northern Australia, the Asmat of southwestern Island New Guinea, the Iatmul of the middle Sepik River of Island New Guinea, and the Trobriand Islanders off the southeast coast of Island New Guinea helped to shape their settlement patterns, the form (if any) of agriculture they practiced, and the availability of flora and fauna for gathering and hunting.

The three regions of Arnhem Land in northern Australia (Oenpelli, Yirrkalla, and Melville Island) correspond to three small language groups called Kakadu, Dangu and Djangu, and Tunuvivi, respectively. Their territories in the subtropical coastal regions of Australia provided an abundance of flora for gathering. This included various roots, fruits, nuts, seeds, shoots, and leaves. Sea and land animals such as shellfish, turtles, stingrays, fresh- and salt-water fish, and a variety of land mammals and birds were important food sources. A hunting and gathering life-style led to a mobile, nomadic existence with no permanent forms of agriculture or architecture.

In the riverine and delta regions of southwest Island New Guinea where the Asmat live, and in the largely swampy and grassy areas of the middle Sepik River where the Iatmul live, more permanent settlements developed. In both groups there is specialized large-scale architecture for men as part of the ceremonial and gender-differentiated social system. Today, the speakers of Asmat number about thirty-four thousand, whereas there are only about eight thousand Iatmul speakers. Hunting and gathering of fauna and flora indigenous to the rivers and swamps help the Asmat and Iatmul provide for their daily needs.

The nearly thirty thousand Abelam peoples of the Maprik Mountains, north of the Iatmul, live in villages set along mountain ridges. Here, too, large-scale decorated architecture for men developed into a fine art. Among the Asmat and Iatmul, sago palms are grown and exploited for food, whereas the Abelam specialize in growing various species of yams and taro.

The Asmat, Iatmul, and Abelam languages are part of an old language group called non-Austronesian (also Old Papuan), found on Island New Guinea and to some extent on neighboring Island Melanesia, whereas the Trobriand Islanders speak an Austronesian language. In general, peoples who speak non-Austronesian languages tend to be much older inhabitants (perhaps several thousand years) and tend toward egalitarian social systems without chiefs. The Austronesian speakers, on the other hand, arrived in the region more recently (perhaps one to two thousand years ago), and they tend toward more stratified social systems, including chieftainships. The use of the outrigger canoe is asso-

ciated with the sea-going Austronesian-speaking peoples who eventually populated the central, southern, and eastern Pacific regions that are known today as Polynesia. In Island New Guinea and Island Melanesia both the non-Austronesian and the Austronesian-speaking peoples are dark-skinned, not unlike the peoples in West and Central Africa, although no historical link between the two regions has been proved as of this time.

### Aboriginal Art in Arnhem Land: Oenpelli, Yirrkalla, and Melville Island Art Styles

The art of the aboriginal peoples of Australia is little known outside Australia, and yet it constitutes an important chapter in the history of South Pacific art. Due to their relative isolation from later population movements into the Pacific, their adaptations to varied ecological conditions of hunting and gathering, and the diversity of their artistic styles throughout the entire continent, this chapter will focus on only one area, that of Arnhem Land. Three distinct styles of aboriginal art in Arnhem Land will be discussed: those of Oenpelli, Yirrkalla, and Melville Island.

The archaeological record suggests that aboriginal occupation of most of Australia took place by at least 10,000 B.C. In all areas, a hunting/gathering mode of life in small family units and the scarcity of resources led to a highly mobile pattern of everyday life. Because of this nomadic life-style there were no permanent places of occupation nor was there the need for shelter beyond simple bark lean-to enclosures.

There is, however, evidence that certain sites in pre–European contact and post-contact times were considered sacred to a particular clan and that seasonal use of the site for ceremonies included the making of varied art forms. These art forms ranged from painted and incised rock patterns and images to more temporary arts, including body decoration, construction of stick and feather clan emblems, ground markings and sculpture, and bark paintings. Aboriginal peoples also made small and portable incised and painted wooden objects for both ceremonial and utilitarian purposes. The art from three regions of Arnhem Land will serve to introduce the reader to localized artistic developments within the northern region of Australia.[1]

In the Oenpelli area of Arnhem Land [Map 10] the aborigines painted images on rock faces and on a type of bark stripped from a tree called "stringy bark." These images depict several themes, including hunting-related activities and their attendant magic, and fertility magic. These paintings also served as agents of social control. The Oenpelli x-ray style of bark paintings of a bird and of a Mimi (a small mythological spirit) throwing a spear at two long-necked birds (Chapter 1, Figure 22) were associated with hunting magic and may also have served a didactic function in explaining hunting techniques to aboriginal youths. Thin stick-figure images, often identified by aboriginal informants as Mimi spirits, are frequently found painted on rock faces. They represent male Mimi who are in active pursuit of game. In a drawing based on an aborigine rock painting [1], two male Mimi figures are running along, from left to right, with spear throwers and spears in their hands and with dilly bags slung over their shoulders. These mythical stick-figure personages are thought to be from an early mythological period in aboriginal history, called "dream time." This period should be seen as a mythological period of aboriginal history that still exists today and that can be reached through various rituals, including the painting of these images on rock and bark sur-

Map 10. ARNHEM LAND AND ISLAND NEW GUINEA

1. Oenpelli
2. Yirrkalla
3. Melville Island
4. Asmat
5. Iatmul
6. Abelam
7. Trobriand Islands

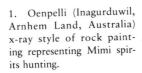

1. Oenpelli (Inagurduwil, Arnhem Land, Australia) x-ray style of rock painting representing Mimi spirits hunting.

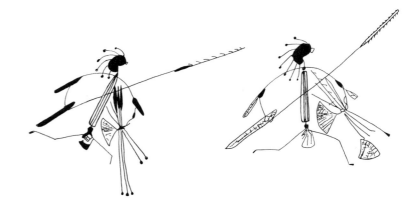

faces to the accompaniment of certain songs and chants.

According to Arnhem Land aboriginal tradition, the Mimi spirits taught the aborigines about proper ritual and social clan-related behaviors; practical everyday skills, such as hunting and gathering; and anything which is unique to aboriginal experience, including myth and ritual. The Mimi spirits are evoked as aids in hunting magic, and they are used as visual aids when hunting and social behavior stories are taught to youths.[2] The figures themselves have a graceful linear fluidity, even though they are clearly disproportionate when compared to the normal human. They also have a characteristic see-through quality, often called the x-ray style, as evidenced in the next several illustrations.

A drawing of a fish, based on a rock painting in the x-ray style [2], gives us an example of the naturalistic treatment of animal forms in Oenpelli style, in contrast to the elongated stick-figure Mimi shapes. The fish is shown from an easily identifiable profile view, with dorsal and pectoral fins clearly articulated. In addition, interior organs, muscles, and skeletal structures are shown, as if in an x-ray image. As is typical in Oenpelli images, thin contour and filler lines serve as the vehicle for creating the image. These lines stand out clearly from a homogeneous

background color, whether it is painted on a rock surface or stringy bark.

Oenpelli bark paintings served social control functions and frequently represented spirits that were thought to be dangerous to people. Two examples of this type of bark painting can be seen in Figure 3. The male spirit on the left is known as a Nangintain, and the one on the right is called Auunau. The Nangintain spirit is believed to lure boys and young men away from their encampment to steal their spirit essence, which later causes them to become sick and die, unless a tribal medicine man intervenes, so that the Nangintain gives up the stolen spirit essence and it is put back into the body of the victim, thereby curing him. The depiction of these kinds of evil spirits most likely served a social control function

2. Oenpelli (Wellington Mountains, Arnhem Land, Australia) x-ray style of rock painting representing a fish.

in this area of Arnhem Land. It helped to keep young people from getting lost in the outback, by keeping them near the camp or family. In Figure 3 the Nangintain (left) is depicted in the x-ray technique, which shows his spinal column and ribs, both eyes on a profile plane, and long, sweeping ears which look like a headdress. His features are mostly human but also somewhat animalistic (especially the mouth). The figure stands out clearly against a reddish-ochre background. The Auunau spirit on the right is said to stay around corpses and to frighten people. His body is thinner than that of the Nangintain spirit, and his skin is covered with thin, feather-like hair.[3]

Another social control spirit frequently depicted in Oenpelli painting is a Namandi, an evil rapist/cannibal spirit. In Figure 4, he is shown in a drawing based on an Oenpelli bark painting in x-ray style, with a large penis set off to one side of his body, and human bones hanging from his elbows. An unusual anatomical detail depicted here is the crossing of the optical nerves behind the eyes, suggesting that the aborigines had an extensive knowledge of anatomy. The x-ray style of paintings in Chapter 1, Figure 23, and this chapter (Figures 2–4) from before or about 1912, have similar counterparts from the post–World War II period, suggesting a continuity of bark-painting tradition over several decades—at least until the late 1940s. A bark painting from the Oenpelli area that was used in love magic (usually associated with some form of fertility magic) is shown in Figure 5 and depicts a pregnant female. In this drawing, based on a bark painting, the female is depicted frontally with elongated arms and legs spread outward, and her body is rendered in x-ray style, with ribs and vertebrae showing. The unborn child is depicted as if a miniature of its mother, set slightly off to the right side of her abdomen. The mother's enlarged breasts and vaginal region refer to her advanced stage of pregnancy, and both of these areas are painted with designs which probably are clan markings from this region. The feathers sticking

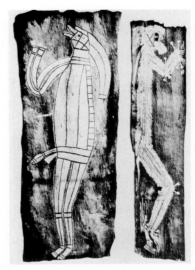

3. Oenpelli (Arnhem Land, Australia) x-ray style of bark painting representing supernatural spirits.

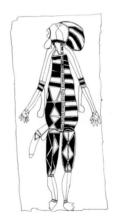

4. Oenpelli (Arnhem Land, Australia) x-ray style of bark painting representing a rapist/cannibal spirit.

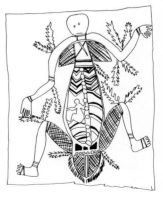

5. Oenpelli (Arnhem Land, Australia) x-ray style of bark painting representing a pregnant woman.

out of various areas of her body, particularly from her shoulders, elbows, knees, and vagina, are associated with the attendant fertility rites practiced to help a barren woman conceive. Like the earlier x-ray style of bark paintings from Oenpelli, this painting has a very clear figure-ground separation, and the figure looms large against the reddish-ochre background.[4]

In the Yirrkalla area of Arnhem Land, to the east of Oenpelli, a markedly different style of bark painting is found. Comparing the bark paintings from Oenpelli with a bark painting from Yirrkalla [6], one is immediately struck with how much more complex the Yirrkalla image is. The Yirrkalla painting, depicting scenes from a creation myth called Djanggawul, was painted by four men, named Mawalan, Wandjug, Madaman, and Woreimon.[5] It consists of eight distinct rectangular scenes depicting the creator spirits Djanggawo and his two sisters, Bildjiwururu and Madalait, and various scenes associated with their creative acts and travels in mythological times. The bottom panel on the right depicts Djanggawo carrying the magical sticks he uses to make fresh-water springs. He carries them raised in his hands, while a sea turtle swims in the water above him. Both the water and the land are covered with zones of right-angle and diagonal patterns which serve as conventional land and water symbols for artists of Yirrkalla. To the left, on the bottom row, the morning star (above) and the shining sun (below) aid the three spirits in their travels. The sun shape seems to be radiating beams of light in at least eight directions from its egg-shaped body. The star is a four-pointed form arranged around a squarish center. In the scene on the right in the second row from the bottom, sea animals (possibly some sort of fish) surround a large egg-shaped dark form which may represent a covered place where children are placed for protection after birth. The scene to the left of this depicts a Thunderman with a long penis, standing among wavy forms that represent rain. In the third row

6. Yirrkalla (Arnhem Land, Australia) bark painting representing scenes from the Djanggawul myth.

up from the bottom (on the right), the three spirits travel in a canoe (one sister reclines on the bottom, while the brother paddles and the second sister sits in the front). In the scene to the left of this, three sea turtles swim through the sea from right to left. In the left-hand scene on the top row, various animals (fruit-eating bats, a mangrove bird, a pigeon, and a lizard), rocks, and sea cucumbers in water pools are depicted as elements of the landscape. The final scene, on the upper right, depicts Djanggawo as he sets foot on shore, carrying his sacred emblems (called *rangga*). Unlike the Oenpelli bark painting, this complex painting from Yirrkalla has multiple scenes associated with a long narrative cycle. There are also distinct borders containing each of the eight scenes and dividing the forms of the composition. The recognizable figures are placed in a variety of perspectives, as if seen from above, to the side, and as if standing on the same plane. The figures are clearly articulated from their backgrounds by contrast of color and simple outlines. However, the surrounding backgrounds are completely filled in with linear, wavy, and undulating forms which are very different from the plain, homogeneous background found in Oenpelli bark paintings. Frequently in Oenpelli paintings, a single figure (or a small number of figures) looms large against its background and takes up a large amount of the available space. In Yirrkalla paintings, there are many small figures set within discrete zones with clear-cut borders. Unlike the Oenpelli rock and bark paintings discussed earlier, this Yirrkalla painting is not done in x-ray style.

The area of Yirrkalla is one of the few regions in Arnhem Land where aboriginal peoples painted figure sculpture depicting sacred or secular beings. The three figures shown in Figure 7 depict two mythical sisters on the left and a mythical male figure on the right. The younger of the two sisters is on the far left, her older sister is in the center. All three figures are sculpted so that their lower legs are seen in profile, while the

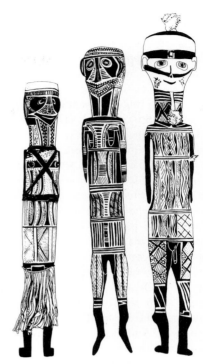

7. Yirrkalla (Arnhem Land, Australia) carved wooden figures of sacred female (left and center) and male (right).

other parts of their bodies appear to be presented frontally. Their arms are cut close to their torsos, and all three have their bodies divided into squarish painted zones clearly separated from one another by horizontal bands. Age is suggested in the older sister by the sagging, pendulous breasts, as compared to the erect, nubile breasts of the younger Wawalag sister. The patterns within the panels on their bodies depict various totemic emblems as well as real things.[6] These designs might appear to the uninitiated viewer to be merely decorative fillers, but in fact they are images with clan-related meanings associated with myth, ritual, and dream-time spirits.[7]

Like Oenpelli and Yirrkalla art, Melville Island art includes bark paintings of a sacred and secular sort.[8] Stylistically, Melville Island bark paintings are distinct from both Oenpelli and Yirrkalla

bark paintings in three ways. Melville Island paintings often lack definite borders, and there is typically an overlapping sense of space and a very strong tendency toward abstraction of natural shapes. An excellent example of a Melville Island secular bark painting representing sea and shore creatures [8] consists of red, yellow, white, and black shapes arranged in what appears to be a helter-skelter of movement across and out of the surface of the bark. Various shells, sawfish, sea snakes, a shark, a sea slug, boulders, and a sand bank are represented as unrecognizable shapes interwoven over the surface of the painting. The small lattice-like patterns in white serve as a background for the larger colored shapes and help to tie the composition together visually. Unlike the clearly readable figure-ground style of paintings from Oenpelli and the multiple narrative scenes from Yirrkalla, this Melville Island bark painting is nearly totally abstract—none of the animals or items depicted are recognizable without information from the artists.

This use of abstract shapes is also common in Melville Island painting of carved wooden poles used in a special mortuary rite called Pukamuni.

8.  Melville Island (western Arnhem Land, Australia) bark painting representing a totemic site and sea creatures.

This commemorative mortuary rite entails the making of large numbers of carved and decorated wooden posts which are eventually placed upon the grave site of the ancestors being honored.[9] The five Pukamuni ceremonial posts visible in the photograph here [9] are studies in abstract geometrical form and decoration, even though they are intended to represent people. This 1950s photograph documents the time during the Pukamuni ceremony when payments are being distributed to the men who carved the poles. One of the ritual leaders, a man called Wurarbuti, stands on top of a pole representing an unmarried woman, and orchestrates the distribution of payments from his elevated perch. The payments are visible on four of the posts. To his right, a woman stands next to an eighteen-foot-high pole which represents a middle-aged man, who has a wife (pole) to the extreme right of the photograph, and a second wife (pole) to the extreme left back of the photograph. At the bottom of the male pole, the woman has leaned a painted-bark basket from which food has been distributed. The surface of the bark basket and the various surfaces of the decorated carved poles are painted with abstract geometric patterns which have symbolic references to things observable in nature. The fifth pole, the one being held by an old woman in the near left side of the photograph, represents a young girl, about twelve years old. Four of the poles are covered with geometric patterns which cannot be read without specific information from the makers and users of the poles, while the pole on the far right is painted with recognizable zoomorphic and biomorphic images. This more recognizable treatment of design elements is a recent innovation in Melville Island style, most likely due to an increasing European influence on their paintings.

The meanings of some of the geometric designs and sculptural elements in the pole in the front left are as follows. This pole represents a twelve-year-old girl, and the cylindrical top over two support struts represents a white cloud. The

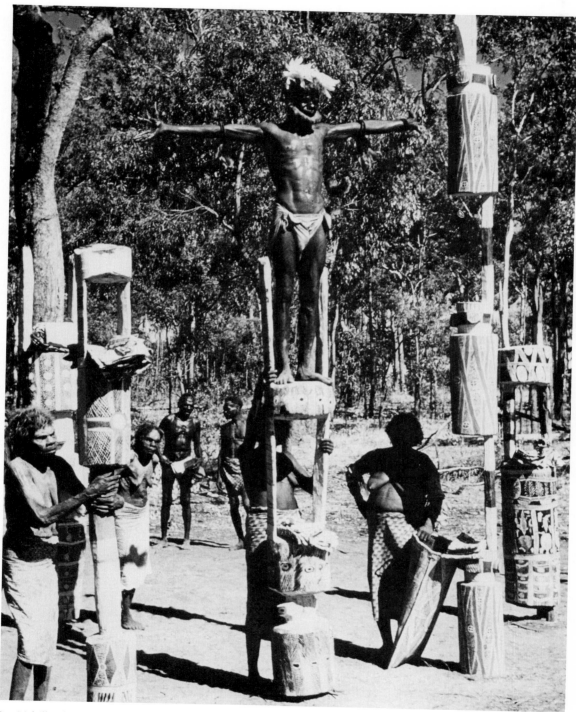

9. Melville Island (western Arnhem Land, Australia) painted funeral poles (Pukamuni).

support struts represent a door to a house. The large cylinder below the struts represents a large boulder, and the circular white shape in its center depicts the light from a torch. Decorative patterns around the torch are typical of patterns painted on many objects and people in Melville Island. The thin strut below this is meant to represent a house support post, and the large cylinder on the bottom is subdivided into two discrete zones, both representing trunks of a fan palm tree. The upper zone is painted with alternating triangular and circular patterns. These small circles depict rocks in the sea, while the white lines around the diamond shapes depict fishing lines used to catch turtles in the sea. The diagonal patterns on the lower zone are similar to body decorations used on old men and women.

The fifth pole, on the extreme right, by far the most complexly painted one of the five, has a pair of forked throwing-stick shapes protruding from the top, and two large boulder shapes (the massive cylinder above the bottom strut and the shorter one near the top). A complicated landscape with animals, plants, and man-made objects is painted on the lower cylinder. A roll-out drawing [10] illustrates that this landscape represents (from top to bottom) the highlands with eucalyptus trees, jungle trees at the edge of a cliff,

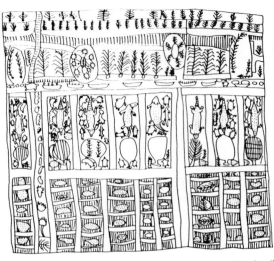

10. Melville Island (western Arnhem Land, Australia) detail of a painted funeral pole.

horizontal roads, casuarina trees along the sea coast, a group of canoes on the water, the surface of the sea, various sea animals and plants, and an area of waves coming in and breaking on the shore.[10] After the distribution-of-payment part of the ceremony, these poles are erected over the burial place of the deceased being honored, and in earlier times these poles would have been destroyed by burning.

## Art of the Asmat of Irian Jaya, Southwest Island New Guinea

To the north of Arnhem Land is the large island of New Guinea, which has dozens of distinct art styles over its twelve-hundred-mile length. We will discuss four distinct art styles from differing regions of New Guinea to give the reader a glimpse of the diversity of art found on the island.

The first group, the Asmat people, lives on the southwestern coast of the island of New Guinea [Map 10], in a part of Indonesia that is now called Irian Jaya (formerly Dutch New Guinea). There are over thirty-four thousand people, speaking various dialects of the non-Austronesian Asmat tongue, and they are spread throughout a complex delta region of rivers, mangrove swamps, grasslands, and forests. Although the coastal Asmat had intermittent European contact early in the twentieth century, sustained European

contact came about only after the Second World War with the development of missions in the area.

The life of the Asmat centers on male and female activities. Male activities focus on warfare and head hunting, although, after World War II, the increasing control of the area by government patrols and missions curtailed traditional head-hunting activities. Female activities focus on food gathering and village activities, including the raising of children. Asmat art can be divided into four distinct style regions, at least two of which (the Kaimo group and the Brazza River area regions) are located in the eastern interior.[11]

The symbols found in most Asmat art refer to the powers of the ancestors and especially the various animals and emblems of head hunting. Among the Asmat, it is believed that the loss of one's clan member to a head-hunting raid upsets the balance of power and the ancestral spirit essence. Consequently, it is necessary to set this imbalance in order by taking a head from the offending enemy. Once a village clan member is lost, the Asmat believe that the spirit of that individual, having not been given a proper ritual burial, is wandering around potentially angry and able to cause great misfortune and illness. Therefore, various counter-measures are enacted to mollify the dead person's spirit. In the coastal regions, a tall sculpted figural pole called an *mbis* is carved to serve as a vessel for the wandering spirit, whereas in the interior regions a nonfunctional spirit canoe called an *uramon* serves a similar purpose, in addition to being a visual prop in initiations.[12] An early example of an *mbis* pole (from the early 1920s) is shown in Figure 11 and serves as a good example of the type. About twelve feet tall, it comes from the Eilanden River Asmat, and has images of ancestors on the top half of the pole, a canoe-like form on the bottom of the pole, various abstract pierced shapes, and four human skulls hanging from its upper part. The top terminates in a pointed form that sug-

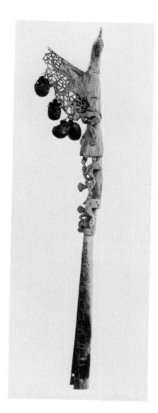

11.   Asmat (Irian Jaya, southwest Island New Guinea) *mbis* pole with ancestor skulls.

gests a bird's head with beak sticking up into the air. Similar forms in Asmat art are sometimes identified as an erect penis, and are associated with masculine virility and warfare. The protruding pierced shape to the left on top of the pole is also called a penis, and it has s-shaped forms, small seated human figures, and other small beaklike forms hidden within its pierced wooden shape. The s-shapes and the seated figures are references to ancestors, while the beaklike shapes refer to birds, who eat fruit and break nuts with their beaks. Both of these bird-related activities are seen symbolically by the Asmat as analogues to head hunting. The large figure below the protruding pierced shape has a sharply receding, horizontally oriented chin, large head, and rubbery arms and legs. Smaller ancestor figures are

12. Asmat (Irian Jaya, southwest Island New Guinea) *mbis* poles from the Faretsj River.

placed on various parts of this figure, beneath its chin and between its legs. The surface of this figure's body has incised s-shaped designs associated with Asmat scarification patterns. The lower part of the pole is shaped like a cut-off canoe, and serves as another visual reference to the function of the *mbis* pole—that of a type of spirit canoe, allowing the spirits of clan members killed in head-hunting raids to be given a proper spiritual burial.

A group of three, more recent, *mbis* poles [12]

serves to illustrate the larger size and increasing sculptural complexity of Asmat art in recent times, after the introduction of metal tools to supplement the traditional stone tools.[13] All three poles are over seventeen feet tall and have images of specific ancestors carved on them. In addition to the elongated standing figures on the main pole, there are seated ancestor figures carved into the protruding pierced forms on top and the abstracted openwork shapes at the bottom of each pole. The seated figures are in a pose

212

based upon the praying mantis, a predatory insect whose form is widely used among the Asmat as a symbol of head hunting. The Asmat divide the pole into three regions. The first region (called the pole's penis) is the elaborate openwork area protruding outward on a diagonal from the groin of an ancestor. The second region is the main shaft of the pole with varied figures, and the third is the base. The abstracted openwork shapes near the base of each pole represent a sacred banyon tree's roots.

When a village has had members of its community lost to head hunting, there comes a point where the elders decide that the *mbis* poles must be made in order for the spirits to be set to rest. The men go out into the mangrove swamps and stalk and hunt the trees as if they were game or potential head-hunting victims. After ceremonially killing them and cutting them down, they bring them back in canoes to the village, where they are treated as ancestral objects. The men undertake the entire carving process, ranging from roughing out the shapes to the eventual finishing and ritual painting, before the *mbis* ceremony.[14] After the poles have been erected outside the men's house, and various dances, chants, songs, and rituals have been carried out around them, the *mbis* poles are ceremonially taken out into the sago grounds and serve a type of spirit protective function for the Asmats' major foodstuff, the sago palms. The Asmat believe that their ancestors are descended from trees carved by a culture hero named Fumeripits, who carved men and women who then came alive as the original ancestors of the Asmat.

At least two other ancestor images are found among the Asmat as either freestanding sculptural figures or as seated figures in a praying mantis (*wenet*) pose. The seated figure shown in Figure 13 has an elongation of the arms, legs, and other body parts commonly found in Asmat figure sculptures. The anthropomorphic aspects of this type of figure are played down and combined

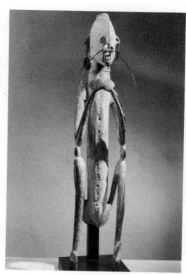

13. Asmat (Irian Jaya, southwest Island New Guinea) wooden ancestor figure.

with an insectile quality, derived from the praying mantis. Figures such as this are also found on the canoe prows of head-hunting canoes.

Another type of spirit vessel sculpture is the *uramon* (spirit canoe), found in the interior Asmat areas. *Uramons,* such as the one shown in Figure 14, are used in initiation ceremonies where the initiates undergo a ritual death/rebirth. The canoe is nonfunctional in that it has no bottom. It is carved with elaborate pierced-prow sculptural forms and various animal and animal-human "victims" inside the canoe. Traditionally, during initiation, newly circumcised boys would sometimes straddle the figures in the *uramon,* letting their blood (from circumcision) flow onto the carvings. They would do this while holding the freshly taken bloody head of an enemy. This intermingling of blood on the *uramon* served to activate the powers of the ancestors and also served as a form of self-sacrifice for the new initiate.[15]

Another type of canoe-related sculpture is found on "revenge canoes" and is very similar to

14. Asmat (Irian Jaya, southwest Island New Guinea) spirit canoe (*uramon*).

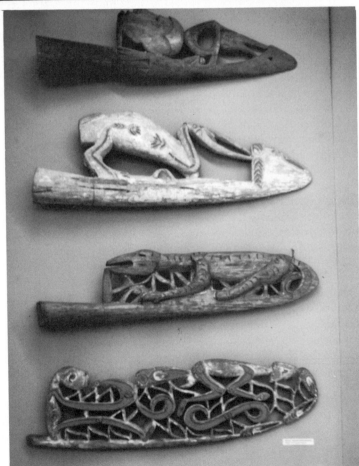

15. Asmat (Irian Jaya, southwest Island New Guinea) four canoe prows.

the pierced carving on the upraised portion of the *mbis* poles and the prow and stern carvings on the *uramon*. The pierced forms on revenge canoes frequently include images of seated ancestors, bird's beaks, and s-shapes. The group of four revenge canoe prows shown in Figure 15 illustrates some of the varied approaches to composition and form in different areas of the Asmat. The prow on top consists of a disembodied human head laid next to a long-beaked bird's head—both visual symbols for head hunting. The second prow has a large long-beaked bird form and probably also refers to head hunting. The third prow represents a crocodile facing the back of the canoe. The crocodile is surrounded by pierced struts that may refer to blood spurting from wounds. Its lack of animation suggests that it represents a victim of a head-hunting raid. The fourth prow (on the bottom) is the most complex of the four in that it has multiple human, animal, and abstract shapes combined in a complex pierced composition. The seated figure near the back is a variation on the praying mantis motif, while the figure on top appears to be a victim of the head hunt. The bird-beak shapes are also head-hunting symbols. The s-shapes are, once again, symbols of ancestral power.

In a culture so dedicated to warfare and head hunting, it is not surprising that the Asmat created war shields as part of their artistic heritage. The war shields illustrated in Figures 16–18 depict five types of shields, each with symbolism commonly found throughout the Asmat. The first, probably from the Etwa River area of the southwestern Asmat [16], is a carved wooden shield with male and female ancestor figures carved in medium relief and presented in a displayed position, with arms and legs outstretched and genitals articulated. This type of display posture probably served a magical, protective role, warding off spears and protecting the shield bearer. The vertical protruding shape on top is said to be both the nose of the shield and/or its erect penis.

16. (left) Asmat (Irian Jaya, southwest Island New Guinea) wooden war shield with a male and female figure, probably from the Etwa River.    17. (right) Asmat (Irian Jaya, southwest Island New Guinea) wooden war shield with abstracted figures, probably from the Etwa River.

The theme of ancestors is also depicted, although more abstractly, in a second shield [17], probably also from the Etwa River area. In this shield, the arms and legs of the two figures represent the flying fox (a fruit-eating bat). The s-like shape connecting the flying fox's arms and legs represents spinal columns, another symbolic allusion to ancestors. Flying foxes eat fruit from the tops of trees, and the Asmat liken that to the taking of heads. This shield contains two ancestor images and a separate flying fox image above, within a clearly defined narrow border strip. The vertical protruding shape on top of the shield has a clearly articulated head, and yet is also seen as the shield's penis. In both of these shields [16 and 17] the figure-ground relationship is clearly defined, with the figures standing out as relief shapes against a white background.

The three shields shown in Figure 18, from the Upper Pomatsj River (left) and the Upper Undir River (center and right), are more complex than those seen in 16 and 17, although their symbolism is also tied to head hunting and the protective powers of ancestors. The top of the left-hand shield represents the head of a ray fish, and can

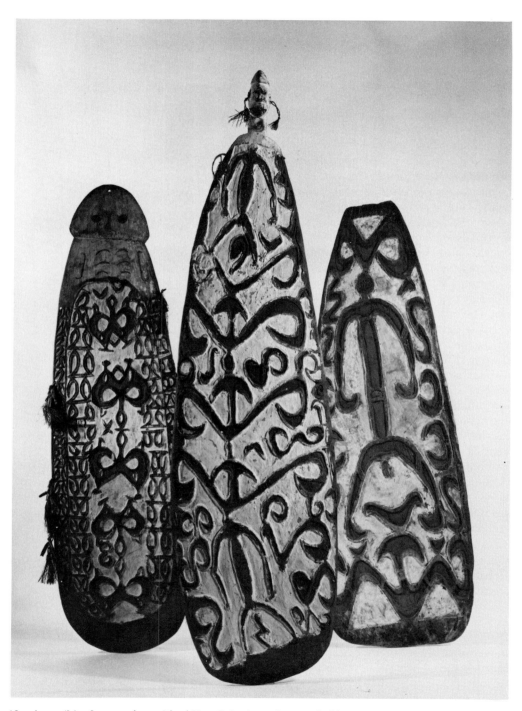

18. Asmat (Irian Jaya, southwest Island New Guinea) wooden war shields.

also be seen as the head of an erect penis (the lower part of the shield is seen as the shaft of the penis). Near the center of the shield are five animated flying-fox images associated with head hunting. Once again, two of the pairs are tied together by a connecting design element, thereby creating the abstract image of a frontally displayed ancestor. The small double-curved shapes placed along the outer border are probably based upon a nose ornament worn by the Asmat known as *bi pane*. The shield in the center terminates on top with a carved human head with ear ornaments and well-defined neck. Beneath this, in low relief, is a frontal figure whose head may be the carved form above. The three large, curved, winged shapes below this figure probably represent a large bird, such as a heron, that wades near the shore catching fish. The bottom of the shield has a human-like figure in low relief, probably representing an ancestor or a head-hunting victim. Various s-shapes and birdlike winged shapes are carved throughout the rest of the shield. In contrast to the shield at the left, this shield has a looseness of composition, with subtle, undulating forms. The third shield (on the right) consists of an ancestor image (named after the carver's father), variations of the curved nose ornament, a large heron shape (below), and a few s-shapes.

The head-hunting symbols that we have seen on spirit canoes, canoe prows, *mbis* poles, and war shields are also found on many functional objects in every Asmat village. Objects as varied in function as paddles, war spears, horns, food bowls, neckrests, and drums were carved in relief and in three dimensions, and were incised and painted with figures and emblems related to power and head-hunting motifs.

One functional item, a beautifully carved drum, is shown in Figure 19 and combines several of the now-familiar symbols found throughout Asmat art. The handle is an openwork form consisting of a pair of seated human figures facing each other, with a hornbill beak between their

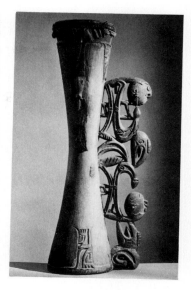

19. Asmat (Irian Jaya, southwest Island New Guinea) wooden drum with lizard skin, fiber, shells, and beads.

faces. The figures are carved in a seated, praying-mantis pose. Both figures display an erect penis—another emblem of warrior prowess. At the bottom of the handle, a second hornbill head is carved, with its beak pecking at the back of one of the figures. On the top and near the bottom of the body of the drum are low-relief hands, which probably represent the hands of another head-hunting symbol—the flying fox.

Asmat masked costumes of twisted string or woven rattan are found near the coasts. Three distinct types are illustrated in Figure 20 and serve as good examples of the Asmat use of "soft" perishable substances when creating masks for funerary, initiation, and other important ceremonies. One of these ceremonies is called the Jipae and is associated with funerals.[16]

The Jipae ritual is an expulsion ceremony which takes place in the late afternoon and at night, during which time men wear masked costumes (the upper two in the photograph). They dance throughout the night to the light of a bon-

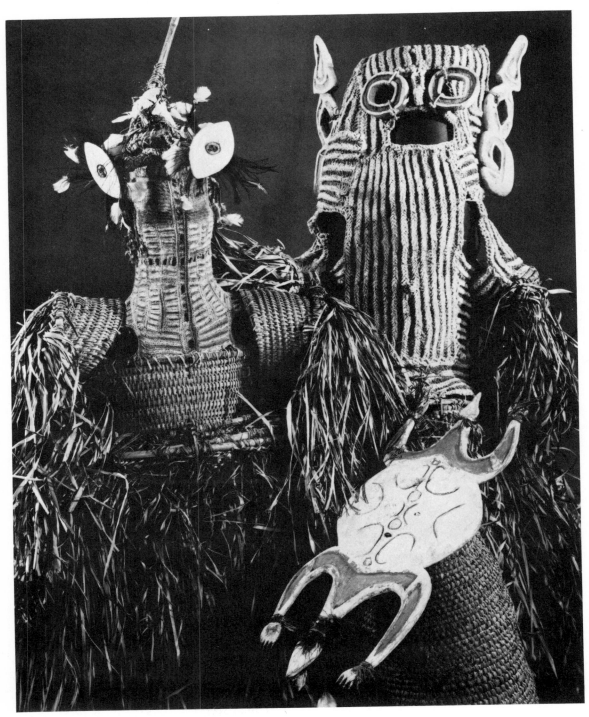

20. Asmat (Irian Jaya, southwest Island New Guinea) basketry masks from the Upper Pomatsj River.

fire. As dawn approaches, other men from the village attack these men and drive them into the men's house, where they are symbolically killed. This ceremony allows the spirits of dead ancestors to be driven to the ancestral homeland so they will not return to the village to cause trouble. The two masked costumes on top have alternating patterns of woven materials on their heads, necks, and bodies, creating a variety of abstract surfaces. The masked costume on the left also has attached eye shapes which stick out from the head, giving an otherworldly quality to the image. The upper right masked costume is more anthropomorphic, with eyes, nose, and

wide-open mouth clearly recognizable. It has carved, circular eye rings and attached ear forms (abstracted bird's head and body) sticking out from the woven costume. The mask on the bottom is used in initiation ceremonies. The carved wooden turtle shape on the top is associated with fertility. During initiation, this spirit touches a young girl's nipples and a young boy's testicles, magically assuring them a fertile adult life.[17]

Just as head hunting and related symbols permeate the art of the Asmat, monster human and animal images permeate the art of the Iatmul of the Middle Sepik River in Island New Guinea.

## Art of the Iatmul of the Middle Sepik River, Island New Guinea

The nearly eight thousand Iatmul speak a non-Austronesian language of the Ndu family and live between seventy to ninety miles from the north coast of New Guinea on the Sepik River [Map 10]. When first contacted by German explorers in the 1880s, the Iatmul and their neighbors were hunters/gatherers/fishers who exploited the sago palm. They were often in a state of aggression and war with neighboring groups. Head hunting and warfare were positive male traits, and the art of the Iatmul reflects a preoccupation with protective power as well as the supernatural powers of females. These ideas found artistic expression in Iatmul ceremonial architecture, in various masquerades, and in modeled skulls, shields, drums, slit gongs, storage hooks, stools, clay pots, and canoes.[18]

The Iatmul men's ceremonial house [Color Plate 12] was raised off the ground on four huge corner posts which were carved to represent a monstrous protective bush spirit. Each of the raised double-spired ends had a carving of a bird with wings outstretched over a male ancestor. This bird image (also shown in a drawing in Figure 21) represents the fighting spirit of Iatmul villages and was a common element on the spires

21.   Iatmul (Middle Sepik River, Island New Guinea) wooden men's house finial carving (bird and male ancestor).

of Iatmul men's houses. In the upper center of the gable on each facade was a huge "monster" face with big eyes and a large, open mouth with tongue and teeth sticking out. This represented one type of protective female supernatural monster. In fact, the entire house was conceived of as a female monster, with the roofing and decorative horizontal surface on the facade being the skirts of the female monster. When someone climbed the ladder and stepped onto the first-floor level of the house, that person symbolically entered the belly of the monster. This was seen as

either a protective or destructive act. On a horizontal beam above the floor, attached to a center post at each end, was a female ancestor figure with arms beside her body, and legs spread wide apart in a birthing position [22]. When one exited the house (at either end) one passed beneath one of these female ancestor carvings, thereby being symbolically reborn. These three images—a monster, a protective bird-human, and the fertile female—are widespread in Iatmul art.[19]

Another type of female image found in Iatmul men's houses is associated with female power, fertility, and the fecundity of the earth. One such image is shown in Figure 23 and depicts a frontally displayed female engaged in a sexual act with a tuber. In this example, the tuber image is repeated an additional six times in the lower part of the composition, and the woman is flanked by totemic birds. The displayed frontal position, coupled with the curved arc of the lower part of the hook, creates an arresting image. The drooping, pendulous breasts are almost phallic in form, and serve to reinforce the phallic symbolism explicit in the phallic-shaped tubers along the inside of the arc. The two long-beaked birds are attached to the female's shoulders, while she grasps at their beaks with her upraised hands. The surface is carved in low relief and painted with alternating red, white, and black pigments—colors commonly found in the art of the Iatmul. Objects like this were kept hidden inside the men's house and probably served as a symbol of female power and as a sacred object in initiation rituals.

Modeled ancestor skulls [24] were kept inside the men's house as well. These were frequently the skulls of men who had great reputations as warriors or leaders, or of women known for their great beauty or accomplishment. The skulls were overmodeled in clay to create an accurate naturalistic rendition of the deceased. Distinct features of physiognomy were re-created, then the face was painted with body-painting patterns worn by the deceased during his or her lifetime. During initiation rituals, these skulls were at-

tached to armatures, which were then dressed up in feathers, jewelry, and other adornments. At key points during the ritual these puppet-like ancestral constructions were moved about behind a special screen in front of the men's house. Afterward, they were returned to the men's house.[20]

Elaborate masked costumes are used by the Iatmul to represent a variety of spirits, including war spirits, clan ancestors of various mythological types, and monster spirits. The basketry mask shown in Figure 25 represents a head-hunting/war spirit of the Iatmul, and combines anthropomorphic and animal images. It was created as a woven basket-like form—essentially a broad, conical shape with raised eyes, nose, and mouth made of woven elements attached to the surface. On top, there is a large bird form (a sea eagle) made of woven materials, with a carved, curved beak. The sea eagle and the somewhat anthropomorphic shape of the mask itself represent the Iatmul's war and head-hunting spirit. When a war party returned to the village with a killed victim, this spirit greeted them and accepted the body for proper care. As is so often the case, the predatory animal (in this case the sea eagle) is associated with male warfare and the resultant death. For the Iatmul, the taking of an enemy's head added spiritual power to their clan and village, and most likely paid back some previous affront or damage to the prestige and power of their village. With a world view so tied up with warfare and danger, it is understandable that the Iatmul created objects such as this mask to represent a being not subject to recognition and chastisement for acts of brutality against one's fellow man.[21]

In the foreground of Color Plate 12, five masks are shown dancing in front of the men's house at Korogo village. These masked dancers represent a type of mythological spirit called *mai*. *Mai* masks often dance as male and female pairs during initiation celebrations; they consist of a carved facial mask combining human and animal (bird-beak) forms set onto a bark and cane su-

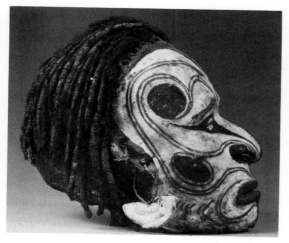

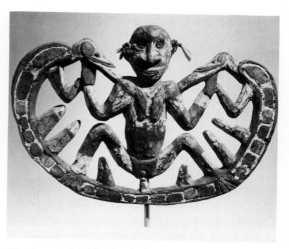

22. Iatmul (Middle Sepik River, Island New Guinea) wooden men's house female ridge pole figure from Palimbei.

23. Iatmul (Middle Sepik River, Island New Guinea) wooden men's house suspension hook with a female figure.

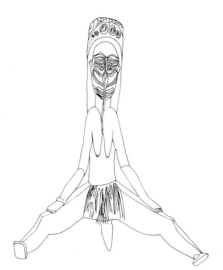

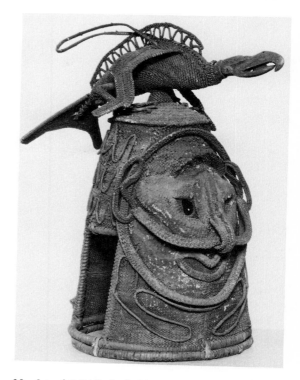

24. Iatmul (Middle Sepik River, Island New Guinea) modeled human skull (ancestor) from Palimbei II.

25. Iatmul (Middle Sepik River, Island New Guinea) basketry fiber mask from Yentschemangua.

perstructure which fits over the upper body of the dancer. This costume, like those used on the modeled skulls mentioned earlier, includes shell pectoral ornaments, elaborate feather head-dresses, and grass skirts and leggings. The male spirits carry decorated spears. The pairing of male and female masked spirits appears to be related to the fact that the newly initiated youths are of marriageable age. During this early stage of initiation certain sexual mores and flirtatious behaviors are acted out by the mythological spirits.[22]

Various naturalistic ancestral spirits are also depicted as masked costumes among the Iatmul. The female masked spirit costume already shown (Chapter 1, Figure 11) has a more human-like carved and painted wooden face than the face of the war spirit basket mask or the *mai* masks, although she has a more aggressive countenance. Her tongue is sticking out in defiance, and the

clan design patterns on her face add to the dynamic and aggressive appearance of this powerful spirit. The remainder of the costume is sparse when compared to the *mai* masks; however, the basket-like body, with attached breasts, shell decorations, and long skirt, helps to create a strong visual presence, befitting a spirit associated with creating earthquakes.

Along the Sepik River and its tributaries, the Iatmul not only had to watch out for their fellow man, but also had (and still have) to contend with the forces of nature (floods, tidal bores, and whirlpools) and with living creatures which lurk beneath the surface of the water and along the edges of the swampy terrain. Crocodiles, sawfish, snakes, and other denizens of the Iatmuls' environment were constantly the object of their fears. Sometimes these powerful and deadly animals were represented as large basketry masks.

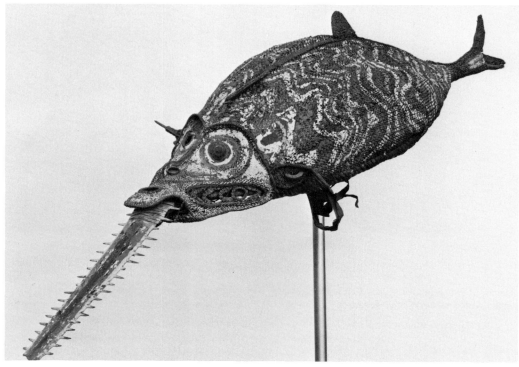

26.  Iatmul (Middle Sepik River, Island New Guinea) basketry sawfish mask from Kararau.

The sawfish mask shown in Figure 26 is huge in size and deadly in form when one contemplates the bladed, jagged sawfish teeth that have been incorporated into the hulking body. It was also common during Iatmul initiations to create huge basketry masks representing crocodile monsters and to stuff young boys into the gaping, toothy mouths of the masks as a symbolic death. Later, scarification marks cut into the initiates' shoulders and chest were said to be the tooth marks made by this devouring monster.

During initiation rites, various elder clan members debated the names which would be given to the newly initiated youths as they entered adult status. Among the Iatmul there developed a carved stool with an attached human ancestral figure [27] which was used during these debates as a focus of attention and as a repository of ancestral spirit power. When a man wanted to get on the debating floor or accentuate his point, he would strike the stool with a bundle of branches or leaves. The ancestral figure is often depicted as a male with a large head, huge penis, and, in this example, a nose elongated into a curved form which touches his chin. The addi-

tion of human hair, inset cut-shell eyes, and elaborately painted facial decorations add to the expressive power of this debator's stool.

The motif of a tongue sticking out of a monstrous face is a protective device commonly found on war shields. One such shield is shown in a drawing in Figure 28. Not only is the monstrous face on this shield visually arresting in size and aggressive facial gesture, but the Iatmul believed that this image had a protective power associated with their ancestors. This singular aggressive facial image is in stark contrast to the more complex and abstract symbolism associated with head hunting already seen on the Asmat shields discussed earlier in this chapter.

The war canoe shown in Figure 29 has a composite crocodile-shaped prow and an attached winglike shape with an ancestral protective face, thereby combining two common Iatmul motifs, the crocodile and the ancestor. Various animal motifs are also carved on hourglass-shaped drums, on spear throwers, and on lime containers. The drum shown in Figure 30 has a long-beaked, parrot-like bird as the handle, while the two spear-thrower handles [31 and 32] illustrate a

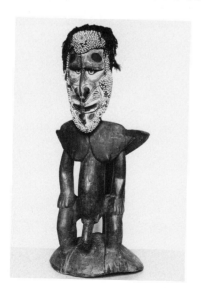

27. Iatmul (Middle Sepik River, Island New Guinea) wooden debator's stool from Yentschemangua.

28. Iatmul (Middle Sepik River, Island New Guinea) wooden war shield from Palimbei (?).

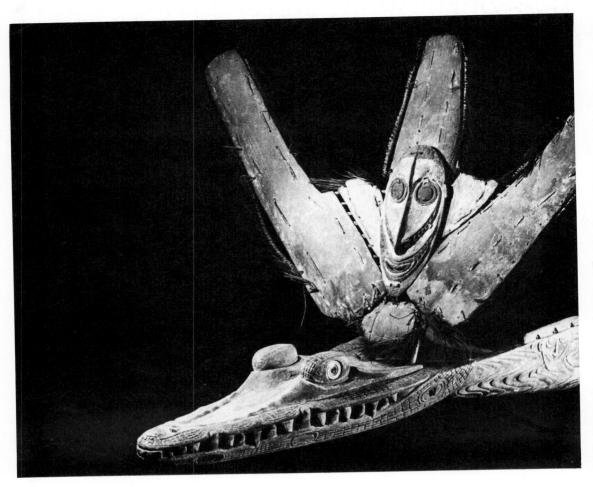

29. Iatmul (Middle Sepik River, Island New Guinea) canoe and canoe shield with mask.

30. Iatmul (Middle Sepik River, Island New Guinea) wooden drum from Kararau.

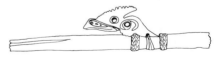

31. Iatmul (Middle Sepik River, Island New Guinea) wooden spear thrower decoration in a bird's head shape from Tambunum.

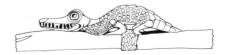

32. Iatmul (Middle Sepik River, Island New Guinea) wooden spear thrower decoration in a crocodile's body shape from Kararau.

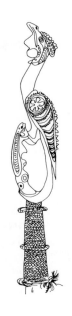

33. Iatmul (Middle Sepik River, Island New Guinea) wooden lime-container stopper in the shape of a bird's body.

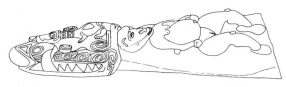

34. Iatmul (Middle Sepik River, Island New Guinea) wooden ceremonial canoe prow with crocodile's heads and a pregnant female figure.

bird's head and a crocodile's body, respectively. A combination of the two images can be seen in a lime-container stopper [33], which has a cockatoo-like bird standing on the tip of a crocodile's head.

A combined crocodile and female human image is frequently carved on Iatmul ceremonial canoes. In the example shown in Figure 34 the monstrous crocodile has an elongated wild-boar tusk sticking out of its mouth and a human-like tongue sticking out at the forward end of the canoe. On the crocodile's head is a miniature version of itself, most likely its infant. Behind this monster form is a pregnant reclining female figure who appears to be in a birthing position. She most likely represents a female clan ancestor, perhaps related to the type of female figures found in the men's ceremonial house. The crocodile is associated with mythical times, when the meandering course of the Sepik River was said to have been created by the movements of a giant mythical crocodile swishing its tail.[23]

## Art of the Abelam in the Maprik Mountains, Island New Guinea

Whereas the art of the Iatmul is associated with human and animal monster images, as well as with protective ancestors, the art of the Abelam people is preoccupied with fertility and the growing of various garden products, especially yams.

The nearly thirty thousand Abelam people live in the Maprik Mountains, to the north of the Iatmul. They live in villages of several hundred people, and practice intensive agriculture and hunting/gathering. The gaily painted men's house at Kinbangwa village was briefly described in Chapter 1 [Color Plate 1]. This house was built about 1961, a year before the photograph was taken. The house itself is feminine, with a pointed spire on top of the ridge pole—the only overtly masculine part of this female house. Unlike the double-spired saddle-shaped Iatmul men's house from Korogo village, this Abelam house is triangular in plan and consists of a tall, nearly pyramidal shape with a covering leaning over the facade to protect it from torrential rains. Although this Abelam house lacks the carved spire images found among the Iatmul, the sym-

bolism on the facade is more complex than the gable monster-mask motifs found on both ends of the Iatmul men's house. The carved frieze over the lower wall represents an overt sexual act, with two couples facing each other and the male's penis entering the female's vagina. The moderate-relief sculptures are painted brightly with the yellow, red, black, and white pigments commonly used in Abelam art.[24]

The row of large faces (five in this facade) just above the frieze represents male spirits associated with the clan that owns the house. Above them is a smaller row of male figures, also associated with the clan. Both types of male images wear white shell necklaces, of a type commonly worn by Abelam men. A single large face at the top represents a female flying witch, a personage greatly feared and associated with the feminine power of the house itself. The small crawl-through entrance door on the lower right is meant to represent the womb of the house. As one enters and exits the house one goes through symbolic death and rebirth.

A second view of the house in Figure 35 shows a partial view of the interior initiation chamber used for an intermediary stage of initiation. Visible in the photographs are three large half-figures, representing mythological spirits, gaily painted and wearing elaborate feather head-dresses. The lower part of the bodies is made from painted split sago palm fronds. The human-like heads are carved in wood before being painted. Behind these figures is a wall-like plaited screen painted with zigzag motifs that are abstractions of displayed arms and legs. The small cylindrically shaped figures between the major figures are miniature spirit figures associated with the larger ones. In a later stage of initiation, the initiates will be confronted with full-figure carved and painted versions of these mythical spirits. To the far left is a painted version of these spirits, a two-dimensional variant of the more three-dimensional image. The thin curved fence in front of the figures was made to protect them

during rituals. During the ceremony, the sponsoring clan (whose boys were being initiated by another clan from the village) placed clan shell rings and other forms of wealth on the ground in front of and around the figures to signify a period of ritual. A bone dagger was stuck in the ground through one of the shell rings to symbolize a period of peace, when hostilities were suspended.[25]

Among the Abelam, men grow special yams called "long yams" in their own gardens, separate from those cultivated by the women. During the growing season, special care is taken and garden magic performed by the men to enable their long yams to grow to enormous proportions. At special ceremonies after the harvest, these long yams are decorated with masks or carved and painted heads with elaborate headdresses [36]. They are adopted as ancestors, then displayed and traded with other clans. Afterward, each clan's ancestors/long yams are consumed by other clans. The two decorated long yams in this display have carved heads and painted wooden forms decorated with fine feather-covered basketry headdresses. Their sides are decorated with feather and seed-pod decorations, as well as with shell rings and breast ornaments. These beautifully decorated long yam displays are certainly one of the most impressive ways of presenting food anywhere in the world. Here, they are also an important part of Abelam ceremonies related to masculine and feminine virility, fertility, and fecundity.[26]

Masking among the Abelam is limited to the use of basketry masks, which are worn with long sago-frond costumes. These spirits, as shown in Figure 37, appear during important ceremonies, brandishing spears and chasing after people. It is said that in years past these spirits went to war and attacked enemy men, women, and children. In more recent times their aggressiveness is somewhat subdued, although they are said to rape girls who get in their way.[27] The mask consists of a large basketry form, with simple oval-shaped eyes

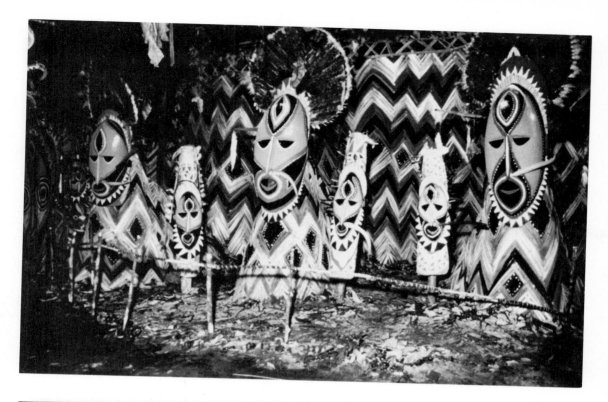

35. Abelam (Maprik Mountains, Island New Guinea) interior initiation chamber of a men's house in Kinbangwa village.

36. Abelam (Maprik Mountains, Island New Guinea) decorated long yams with carved wooden faces and decorated headdresses.

227

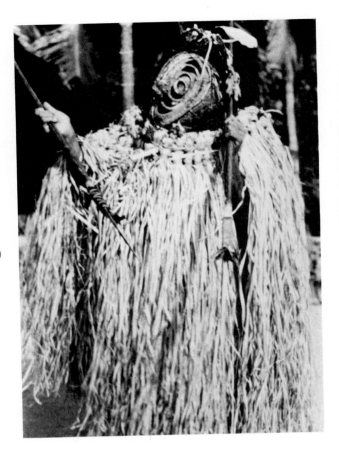

37. Abelam (Maprik Mountains, Island New Guinea) basketry mask representing a warlike spirit.

and a decorated crest with feathers and leaves attached. Like the composite human and sea eagle basketry mask from the Iatmul that was discussed earlier [25], this spirit probably served as a symbol of the Abelam male's aggressive, warlike spirit. Masks of this type are sometimes said to be based upon either parrot-like or piglike heads, although the mask's shape is very abstract, with little clear resemblance to either animal.

## Art in the Trobriand Islands, Island New Guinea

In contrast to the art and cultures discussed earlier in this chapter, the art of the Trobriand Islands reflects a strong maritime Austronesian culture which engaged in long-distance trading throughout southeastern New Guinea. The social structures and need for temporary alliances and treaties between various islands in the area led to the spread of various artistic traits. The Trobriand Islanders used sea-going outrigger canoes when they traded over long distances from the Trobriands to the D'Entrecasteaux Islands to the south.[28]

Decorated architecture in the Trobriands falls into two major types: decorated yam storage houses [38] and chief's dwelling houses. In both of these structures, simple images of sea mammals, especially dolphins and slender fish, were painted along the slightly curving barge boards on each side of the sloping roof. In the case of the chief's house, additional geometric and botanical

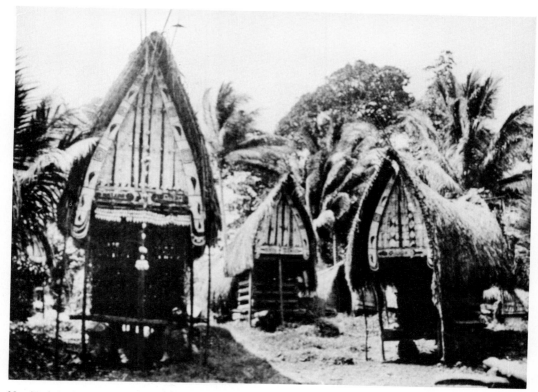

38. Trobriand Islands (southeast Island New Guinea) decorated yam storage huts on Kiriwina Island.

patterns were painted on the vertical and horizontal planks on the facade. Sometimes there were simplified bowl-like forms at the lower center of the triangular facade, a symbolic reference to plentiful supplies of food for feasting and trading. In the case of the yam storage huts, similar patterns were put on the facade, as symbolic references to the chief's storage houses.

The Trobriand Island outrigger canoes that were used for inter-island trading and travel had elaborate transverse boards with vertical elements at both ends. These boards were carved with curving spiral-like forms which were asymmetrical in size and covered with low-relief and incised decorative patterns and images picked out in red, white, and black. Many prows have single or double, frontal or profile figures in seated positions carved near the center top to

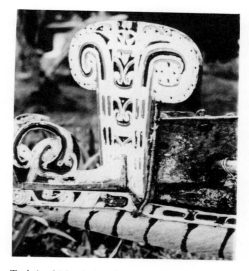

39. Trobriand Islands (southeast Island New Guinea) decorated canoe prow.

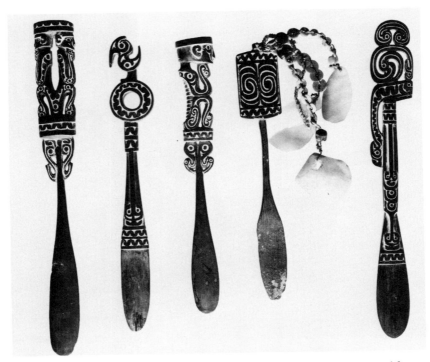

40.   Trobriand Islands (southeast Island New Guinea) carved lime spatulas with varied figurative and abstract motifs.

serve as a protective spirit [39]. Bird images abound on these transverse prows, as well as on the vertical element. Small repetitive bird shapes often represent the sandpipers who sit on logs along the shore. Other bird images include the frigate bird—a bird known for its effortless gliding over the waves of the sea. By analogy, the carvings on these canoe pieces were thought to impart similar positive qualities to the function of the canoe as it rode over the water. Even the asymmetrical shape of the transverse piece was thought to help counteract the added weight of the outrigger, thereby making the canoe balance in the water.[29]

Various small carved and decorated items in wood, stone, and shell, including adzes, mortars and pestles, and lime spatulas, were traded in the Trobriands. A group of five decorated lime spatulas [40] from the Massim/Trobriand Islands region illustrates the elegance and creative variation given these functional objects. The spatula on the far left depicts a back-to-back pair of seated figures, with knees, elbows, and chin connected by a flexed pose. Their bodies, and the other shapes on the upper part of the spatula, are decorated with fine linear and circular patterns that, when rubbed with white kaolin, create a marked contrast of black and white designs. The small circles that appear at points of bone articulation, such as the shoulders, elbows, wrists, knees, and ankles, may, in fact, be a type of joint marking. The only other art form studied thus far that included extensive joint markings was the decorated rain screens and totemic carvings of the Tlingit of Alaska (Chapter 2). The second lime spatula (from the left) has a simply carved bird (possibly a

frigate bird) standing on top of a circular shape with a pierced hole in the center. The handle below has wavy patterns carved near its top and halfway down its blade. The spatula in the center has a single flexed figure as its primary form. Here there is a more daring abstraction and tendril-like treatment of the arms and legs of the figure than was seen in the first spatula on the left. Beneath the figure's feet is a pair of inverted birdlike shapes, with clearly defined heads with beaks and abstracted bodies. The fourth spatula from the left terminates in a squarish form carved with wavy and curved incised lines. It has decorative shells, buttons, and beads attached to the top. The fifth spatula (on the far right) is the most asymmetrical in composition, with several animal (possibly bird) shapes integrated into the overall design.

One of the most striking and at the same time enigmatic art forms from the Trobriand Islands is the decorated war shield.[30] These shields are somewhat pear-shaped in outer contour, curved slightly backward at the top and bottom, and generally about an inch and a half thick. The surface is covered with recognizable figurative designs and abstract black and red linear designs. Sometimes these designs echo the outer contour edge of the composition. Other times they set up discrete patterns inside the central portion of the shield. In a late-nineteenth-century example [41], the lower portion of the shield contains a thick oval-shaped form that has sometimes been identified as the vagina of a mythical flying witch.[31] The pointed oval shape within this area is said to represent a penis within the vagina. Subsidiary serpent-like and bird-beak shapes are painted on the surface of the vaginal shape. The circular patterns near the center of the shield may represent the breasts of the witch. In most cases, the images on Trobriand Island war shields are highly abstract and not as clearly anthropomorphic as were the images on some of the Asmat war

shields discussed previously. The e-like shapes painted over most of the surface in this Trobriand war shield serve to tie together the disparate linear and flat painted shapes that cover the entire surface.

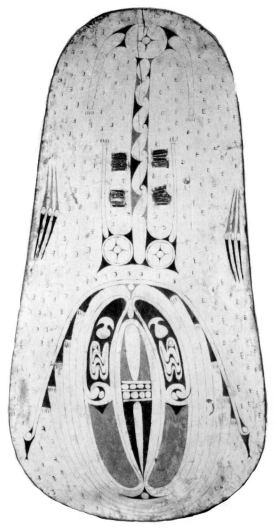

41.   Trobriand Islands (southeast Island New Guinea) painted wooden war shield, 1890s.

# 9

# Art of Island Melanesia

Various groups of people are concentrated either in the interior highlands or along coastal zones in the region of Island Melanesia that includes New Britain, New Ireland, and the western Solomons. The flora and fauna available for gathering and hunting (and fishing) vary according to each ecological zone. In areas where peoples of the same language group lived, there often developed localized specialization and intergroup trade. All three of these island groups are tropical and volcanic in origin, with rich forests, grasslands, swampy areas, and many wild species of plants. These islands have an abundance of reptiles, small mammals, birds, fish, and edible insects as well. Agriculture is practiced by the Uramot Baining, Sulka, and Tolai of east New Britain, as well as by the peoples of northern New Ireland and the western Solomons. Taro and yam cultivation is common, as is the planting of breadfruit, banana, and coconut trees.

Linguistically, the Uramot Baining and Sulka speak non-Austronesian languages, while the Tolai of east New Britain, the peoples of northern New Ireland (at least six distinct language groups), and the peoples of the western Solomons all speak Austronesian languages. Most of these language groups probably numbered only a few thousand at the time of first European contact, although some, like the Tolai of east New Britain, now number close to one hundred thousand. The non-Austronesian Uramot Baining and Sulka cultures tend toward acephalous and egalitarian social systems, whereas the Austronesian groups are more stratified and frequently have chieftainships. The use of outrigger and plank-built dugout canoes in Austronesian-speaking groups led to sea-going mobility and trade as well as interisland communication and warfare. The Uramot Baining and Sulka are essentially interior forest dwellers, even though the Sulka have moved from the interior to the coast in the past forty years.

## Art of the Uramot Baining of East New Britain, Papua New Guinea

The Uramot Baining are a non-Austronesian–speaking people, numbering a few thousand, who live on the Gazelle Peninsula in east New Britain, Papua New Guinea [Map 11]. They are one of six dialect groups of a language known as Baining.[1]

The Uramot live in the interior mountainous jungle, and traditionally lived a pattern of subsistence including hunting/gathering and shifting agriculture. Their ritual life today still centers on a series of daytime and nighttime dances during

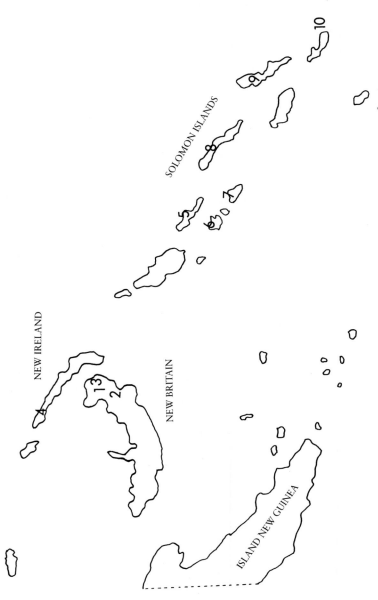

NEW IRELAND

NEW BRITAIN

SOLOMON ISLANDS

ISLAND NEW GUINEA

Map 11. ISLAND MELANESIA

1. Uramot Baining
2. Sulka
3. Tolai
4. Malanggan area
5. Choiseul
6. Vella Lavella
7. New Georgia
8. Santa Isabel
9. Malaita
10. Santa Anna
11. Santa Cruz

which masks, headdresses, display pieces, and body decorations are used. When a ceremony is organized by an Uramot group, other Uramot groups from neighboring farming hamlets participate as audience and/or dancers, depending upon the number of youths to be initiated and the period of time elapsed since the last ritual sequence. In the early decades of the twentieth century, the Uramot celebrated the harvest, mourned the dead, initiated the youth, and celebrated the newborn in a single day-night ceremonial sequence. Afterward, the art forms were destroyed, and the audience and participants returned to their farming hamlets throughout the Gazelle Peninsula. Today, this pattern has changed and dances are less frequent. They often take place on Christian holidays (Easter and Christmas), National Day celebrations, or at the completion of important community projects, such as the erection of a school, health facility, or church.

The art forms made for these celebrations are of fragile, perishable materials, such as sticks, leaves, bark cloth, and feathers. The Uramot males learn to make art in an age-graded sequence as part of their initiation into adulthood in their late childhood or early teens. By the time they learn to make the more complex helmet masks for the night and day dances, certain individuals are recognized as being better at making, and/or painting the art forms, and they then become specialists who teach other, younger men.

The night dance of the Uramot usually takes place in a cleared dance ground in the village. An all-male orchestra sits to one side of the dance ground, singing and creating percussive rhythms by striking logs and rocks with the ends of bamboo poles. While the orchestra sings, a huge bonfire is lit in the center of the dance ground. Once the sun goes down, dancers wearing leaf and bark headdresses and various helmet masks enter the cleared area one at a time and dance in place in front of the male orchestra before pulling back and standing in line with previous dancers. After all the participants in the night dance have entered the line in this manner, dancers break into a frenzy of active movement about the dance ground and many of the persons wearing headdresses and small helmet masks jump into the huge bonfire, kicking the burning logs and embers about. Throughout the night this activity ebbs and flows until about sunrise the orchestra chases the spirits back to the bush from whence they came.[2]

The day dance, by contrast, has a female orchestra, which sings and uses similar percussive instruments. The small headdress masks and the huge composite masks which are brought into the day dance and presented to the female orchestra are somewhat similar in style to the night-dance art forms, although much larger.

The headdresses used in the night dance [Color Plate 13, left] are made by wrapping sheets of bark into a cone shape, which is painted red. There is a flat rim around the bottom to which long pandanus or fern leaves are attached to cover the face of the dancer. The dancer's body is painted black with charcoal. His body is then covered with liquid made by mixing water with chewed-up sugar cane, which forms a protective glazing over the black pigment on his body. This helps to protect the dancer's skin from flames and sparks when he dances through the bonfire during the night. His penis is covered with a bark cloth sheath in the shape of a mushroom, symbolic of masculine genitals. His upper arms and shoulders are covered with various long leaves and grasses, and he has a long bark cloth "tail" attached to the skin at the base of his spine to give him a birdlike attribute. To the right (in the center of Color Plate 13), another dancer wears a painted bark cloth helmet mask of a type known as *kavat*. In general these small helmet masks represent a wide range of spirits associated with products of the bush, particularly useful plants and trees, foodstuffs, and animals and insects which are eaten.[3] This *kavat* mask represents the spirit of a leaf used in cooking ceremonial food.

There is another version of the leaf spirit *kavat* mask, barely visible in the background. Like the headdress on the left, the masked dancer in the center also wears a mushroom-shaped bark cloth penis sheath, has grasses and leaves over his shoulders, black charcoal and white clay painted on his body, and wears a long bark cloth tail stuck to the skin at the base of his spine. The Uramot believe that these night-dance spirits live in trees like birds, and therefore must have bird-like tails.

The three *kavat* masks shown in Figure 1 are probably from the Uramot area (or their nearby neighbors, the Kairak people), and were collected before the First World War. The center and right-hand masks are variations of the leaf spirit mask (often called *rengit* in the region), while the left-hand mask represents the spirit of the vertebra of a pig (called *salabam*). Both spirits are associated with food and things derived from hunting and gathering in the wild bush. Certain patterns are used over and over on night-dance art forms, including red and black "tear" forms which are frequently found beneath the eyes of the spirit masks. The Uramot claim that the spirits are crying and mourning their own death. The black, curved patterns across the forehead (on the center and right masks) probably represent fern leaves—a favorite food of *kavat* spirits. The wavy, dotlike linear patterns (seen around the face of the mask on the right) are usually identified as the tracks made by a caterpillar or snake on the ground. To the Uramot, both creatures are seen as unusual in their ability to tran-

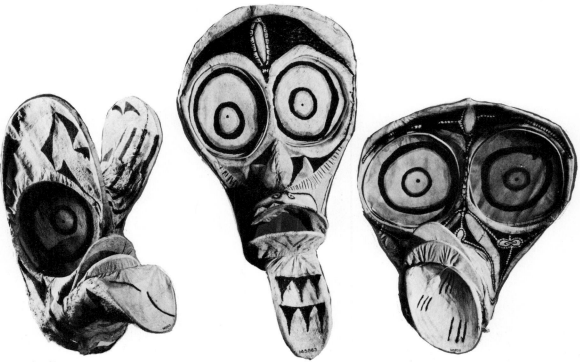

1. Uramot Baining (Island Melanesia) night dance *kavat* bark cloth masks representing the spirits of a pig's vertebrae (left) and a leaf (center and right).

scend various environmental zones and in their ability to transform themselves. The transformation sequence of caterpillar to cocoon to butterfly was taught as part of the initiation ceremony among the Uramot.[4] The serpent is associated with hunting in the bush, and the shedding of its skin is seen as analogous to rebirth and immortality.

Larger masks, called *vungvung,* are also used in Uramot night-dance ceremonies and are composite forms made up of a small helmet mask shape with a bamboo tube covered by bark cloth coming out of the mask's mouth, and three vertical struts for hanging side panels. The basic shape of these masks often represents the spirit of a leaf [2], a tree fork, a praying mantis, or the vertebra of a pig. When the side panels are attached, the elaborate painted patterns cannot be clearly seen by the audience. This suggests that there may be varied levels of understanding for the painted decorations. One level of understanding is accessible only to the initiated males who construct and paint the sculptural forms. These masks and headdresses are painted in various patterns of

black and red against the white ground of the bark cloth. The *vungvung* mask in Figure 2 has teardrop triangular patterns beneath its eyes, and a fern leaf pattern on its forehead—patterns seen earlier on the *kavat* mask. In addition, the *vungvung* mask has a variety of other patterns painted on the bamboo tube covered with bark cloth. These include the tracks of caterpillars or snakes, the tooth marks of spirits (the white marks on the black triangular patterns on the tube), spear points (the sharp triangular form near the open mouth), and the cross section of a cut betel nut (the red and black diamond shape made up of four triangles). Betel nuts are commonly chewed by the Uramot to produce a mild state of intoxication.

A very rare and recently revived mask, shown in Figure 3, is called Siveritki. This mask is worn by women, and it often is used in dances of small groups of four or five at the beginning of the night dance. There is some evidence that it may be associated with mourning the dead at the end of the day dance, and thereby it serves as a transitional spirit. The women who accompany these

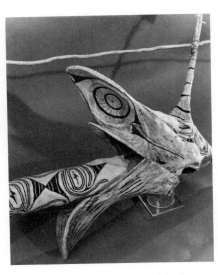

2.   Uramot Baining (Island Melanesia) night dance *vungvung* bark cloth mask representing the spirit of a leaf.

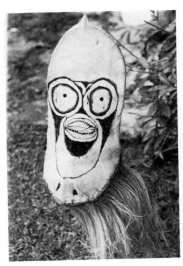

3.   Uramot Baining (Island Melanesia) night dance Siveritki bark cloth mask, made by Ezekiel Nirop of Gaulim village, 1972–1973.

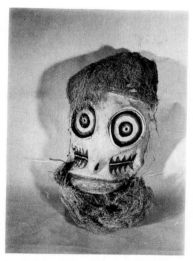

4. Uramot Baining (Island Melanesia) night dance bark cloth mask called Sarlek (cannibal spirit), made by Daniel of Gaulim village, 1982.

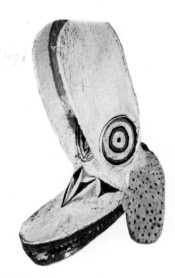

5. Uramot Baining (Island Melanesia) night dance bark cloth mask called Siraigi (Sarlek's wife), made by Daniel of Gaulim village, 1982.

spirit masks wear woven net bags laden with cooked taro and other garden foods, symbolizing the fruits of the harvest. The form of this mask, covered by bark cloth, is quite different from the night-dance masks described earlier. It does not have a long, croplike protruding form beneath its face, but rather a flattened face with rounded upper head. Long, dyed grasses are attached to a costume which covers the entire body of the female wearing the mask. The toothy, wide-open, painted mouth and the black connected triangular tear shapes beneath the eyes are typical of this mask type.[5]

At least since the mid-1970s the Uramot and other Baining peoples have begun reviving mask forms made earlier in the twentieth century. These include a dangerous male and female couple known as Sarlek [4] and Siraigi [5], cannibal spirits who live in big trees near creeks. Sarlek is more anthropomorphic in shape than the night-dance masks previously discussed, and his form may be related to similar anthropomorphic ancestor spirit masks (see Chapter 1, Figure 20, and Figure 14 in this chapter) made by the interior

Tolai peoples, who live close to Uramot settlements. His wife, Siraigi, has a large toothy mouth, a long flap hanging behind her head, and triangular-shaped red and black tear patterns defining negative white bird footprint patterns—a style trait common to night-dance helmet masks.

Another revived mask type is a feminine, singing spirit called Rongari [6], which has a long tubular extension coming out of the area where one would expect a mouth. The men wearing these masks wear women's clothing and net bags slung over their bodies. They dance just prior to the night-dance bush spirits, perhaps serving a transitional role between the daytime and night-time dance ceremonies.

The Uramot day dance has long been associated with the harvest, the initiation of youth, and the mourning of the dead. Huge composite masks (called Mendaska, singular, and Mendas, plural) are made of bark cloth, thin strips of wood, and leaves, and are used as part of the dance celebration. They take on various identities, including three species of trees; the banks of a river or stream; mist; and at least three animals,

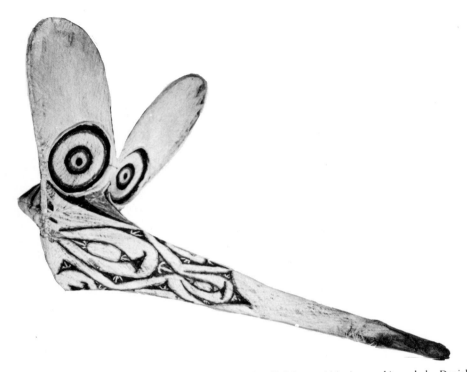

6. Uramot Baining (Island Melanesia) night dance bark cloth mask called Rongari (singing mask), made by Daniel of Gaulim village, 1982.

including the dog, the crocodile, and a lizard with sawlike skin on its back. The surfaces of Mendaska masks are painted with patterns handed down within a clan from generation to generation. These patterns are variations on the motifs seen on night-dance masks and use a similar black and red line or color area against a white ground. As in the night-dance masks, the white bark cloth is often used to create a negative painted form. One of these huge composite day-dance masks, shown in Figure 7, is over fifteen feet tall and represents a huge tree trunk in back and the spirit of a leaf in front.[6] The forehead design represents fern leaves, while red and black tear patterns are seen beneath the concentric circular eyes. The triangular forms in the center of the forehead represent the cross section of cut grasses or leaves. The large trunklike form which protrudes from the back of the mask represents a species of tree which takes many decades to rot away after it has fallen to the ground; the Uramot are impressed by its longevity. The black, red, and white patterns painted on the trunk are variations on the three-part footprint patterns seen earlier. The circular-shaped protruding form beneath the mouth is the chin of the spirit—most likely based upon the crop of a bird. When these large day-dance masks perform, they are frequently accompanied by women wearing net bags laden with cooked garden foods. The masked dancer carries wild pig meat, symbolizing products of the bush. At some point during the ceremony these foodstuffs are exchanged, thereby acknowledging the interdependent roles of male and female activities in the bush and garden, respectively.

238

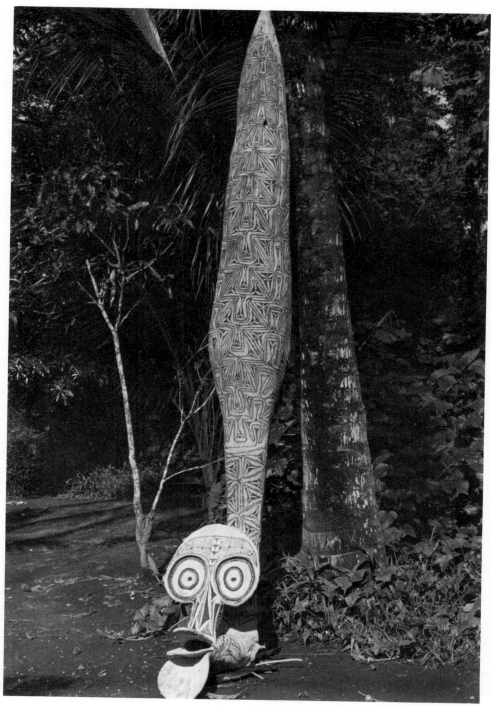

7.   Uramot Baining (Island Melanesia) day dance bark cloth mask called Mendaska, 1982.

239

## Art of the Sulka of Wide Bay, East New Britain, Papua New Guinea

One of the most interesting and hitherto little understood art styles in Island Melanesia is that of the Sulka people of Wide Bay, east New Britain, Papua New Guinea. The Sulka, who number about one thousand, are a non-Austronesian–speaking group, as are the Asmat, Iatmul, Abelam, and Uramot. However, they have had sustained contact with Austronesian-speaking Mengen peoples, to the south, for many hundreds of years, and their art seems to be a blend of characteristics from both language families. In fact, there is a Mengen group contiguous to the Sulka which is known as Sulkanized Mengen. The Sulkanized Mengen share many language and culture traits with the Sulka.[7]

At the time of early contact with German expeditions and colonial expansion at the turn of the century, the Sulka were in a continual state of warfare with the south Bainings on the southern coast of the Gazelle Peninsula. Large numbers of Sulka were evacuated from Wide Bay and resettled north of the Warongoi River at a site called Mope, where many Sulka still live today. Those who remained in their ancestral homelands along the coast and several miles inland have maintained their traditional artistic culture even into the 1980s, despite massive economic and cultural changes brought on by missionaries and the Second World War.

In traditional times, the Sulka made fantastic basketry masks of pith fibers which were painted acidic greens, pinks, and yellows with paints derived from mineral and plant pigments. These large helmet masks were made in many shapes, including umbrella-covered masks [8 and 9], cone-shaped masks with serpent-related sculptural forms [10], simple, pointed, cone-shaped helmet masks [Color Plate 1], as well as extravagant sculptural forms depicting such things as dancing male and female figures, and various bird and animal shapes on top of sculptural bases. These masks and others like them were often brought out during special mortuary rites to commemorate the death of an important man or woman.

These masks took as long as six months to prepare, and were used once in a ceremony, then destroyed. They served as a temporary representation of a spirit held in high esteem by the Sulka, and their presence lent dignity and power to the sacred rites surrounding mortuary ceremonies, as well as birth, initiation, and marriage.

The mask with a painted umbrella-like form [8] is of a type called *hemlaut* ("old man") by the Sulka. This name is a term of respect for elders. (There is strong respect for one's elders in Sulka society). The pith fibers are woven into elaborate basketry sculptural forms, which are then painted with vivid mineral and plant colors. The lower, cone-shaped part of the mask represents a species of wild taro (a tuber that is commonly eaten throughout Papua New Guinea). On the taro stands a praying mantis shape with a well-defined pointed head, flexed front legs, and a large thorax. To either side of the base of the taro form are protruding shapes meant to replicate the pincer legs of a mantis. Beneath the helmet part of the mask are long leaves placed there to hide the identity of the man wearing the mask. The underside of the umbrella shape is painted with patterns which represent the wings of the mantis in flight (top) and another pair of pincer forms (below). This particular backward diagonal pose is a traditional one for Sulka *hemlaut* masks. During their dance, they are thrown back slightly, in order to show off the elaborately painted umbrellas to the audience. Afterward, the whole mask is set back in a vertical position with the umbrella horizontal to the ground, and the dancer stands in place, jumping up and down in a display of strength and athletic ability. Later, the mask is danced out of the dance ground and taken to a secret staging area in the surrounding bush. Only then does the wearer of the mask

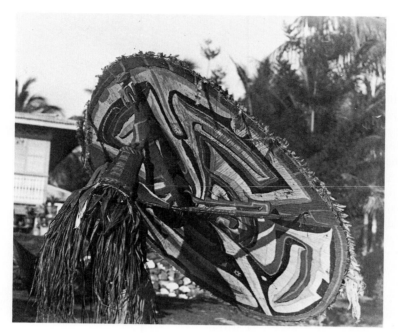

8.  Sulka (Island Melanesia) *hemlaut* mask with praying mantis figure.

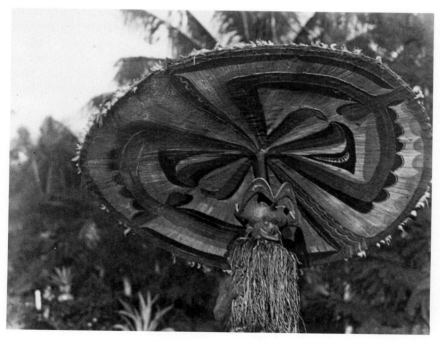

9.  Sulka (Island Melanesia) *hemlaut* mask with human-like head.

reveal his identity to men initiated into adult status. Women, children, and uninitiated males are strictly forbidden to see the dancer or the mask outside the context of ceremonial display.

The *hemlaut* mask shown in Figure 9 has an anthropomorphic sculptural form at its base and an elaborately painted underside to its umbrella. In this example, the circular shape of the umbrella is divided into two even parts by a thin dividing strip painted with zigzag linear patterns, and the outer edge is outlined in a reddish band. The forms directly below the central supporting strut represent a pair of crab claws opened and about to clamp down on some form of round-shaped fruit. The Sulka consciously organize the patterns painted on the underside of the umbrella to focus the audience's attention to the center of the composition. The human-like sculptural form beneath the umbrella has pierced ears and septum, and has a broad set of blackened teeth, in keeping with Sulka body decoration, associated with the initiation of youth. The added-on carved and painted teeth have blackened outlines which refer to an essential part of male initiation when the initiate's teeth are stained black. To the fully initiated Sulka male, a set of properly blackened teeth would attract a suitable female for marriage. The long grasses and leaves attached to the bottom of the mask give the spirit a bushlike character and help hide the identity of the wearer.[8]

An elaborate cone-shaped woven pith mask, of a type known generically as *susu*, is shown in Figure 10 and depicts a special type of spirit with a dual symbolic meaning. The shape of the mask is based upon a locally sought-after seashell. (The Sulka eat the snail from this seashell.) A serpent form visible on the back of the mask has a pointed tail at the top of the composition, a geometrically painted wide body beneath, and a head which serves simultaneously as the protruding tongue of the masked spirit and the serpent's head. This serpent-related image is based upon a mythological spirit called Kot, which lives as a sea

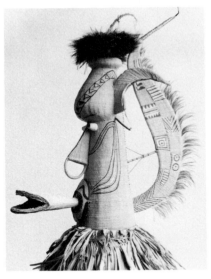

10.   Sulka (Island Melanesia) Susu mask (also *gitvung*).

snake near the reefs and as a python in deep caves along the coast. This powerful mythological spirit was greatly feared by the Sulka and reveals itself to men during dreams. Masks such as this one were probably made in response to such a dream. By creating the dream image in tangible form, the dreamer avoided the destructive machinations of Kot.[9]

The two-tiered cone-shaped helmet masks illustrated in Color Plate 1 have direct symbolic references to food and gardens. The pointed cone shapes on top of these masks represent the cut-off tips of taro tubers (a staple food throughout New Britain), which are planted in the earth to produce new gardens. Once again, the painted geometric patterns beneath the cones and along the sides of the lower mask are eye-catching devices.

The Sulka still make several types of elaborate woven pith helmet masks. The ordination of a Sulka man into priesthood in 1982 was the occasion for a gala celebration and display of these traditional art forms by the Sulka and their neighboring Sulkanized Mengen and Mengen-speaking

peoples. The photograph in Figure 11 shows *susu*-type masks dancing in a procession accompanied by women carrying leaves. These masks, created by the Sulka artist Paul Anis, are a contemporary manifestation of the masking tradition. The three-dimensional geometric shape at the top of each cone-shaped mask represents an abstraction of an ant's nest made of mud. The Sulka use these nests to catch fish. They take the ant's nest over shallow reefs, break it apart, and spill the ants into the shallow water. The ants attract huge schools of fish, which are then netted and/or speared. The gaily painted pointed forms sticking out of the top of the nest shapes on the masks are meant to catch the attention of the viewers as the masked spirits dance by.

At the turn of the century, when the Sulka were engaged in constant warfare, carved and painted wooden war shields were an important part of their everyday life. The two men in the photograph in Figure 12 carry shields painted with patterns which are symmetrical from top to bottom. The shield on the left has a pair of spirit faces, only vaguely anthropomorphic, which were believed to protect the warrior from harm by scaring away the enemies' spears. The protective image on the shield to the right is based upon pairs of eyelike patterns found on the backs of local snakes, which were also thought to have magical protective powers.[10]

Another art form, created in traditional times by the Sulka, was carved wooden figure sculp-

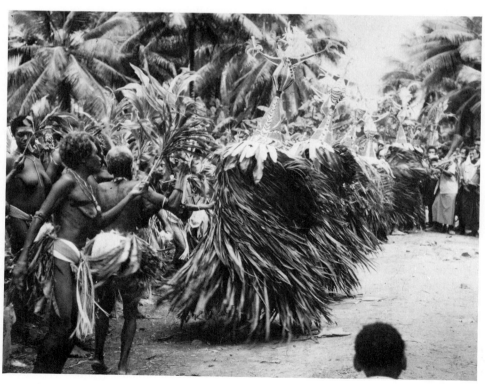

11.   Sulka (Island Melanesia) Susu mask, made by Paul Anis of Kilalum village, 1982.

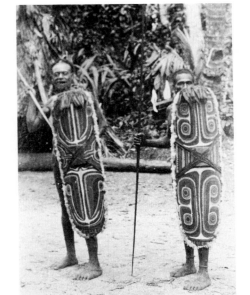
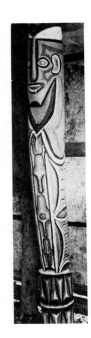

12. Sulka (Island Melansia) wooden war shields.

13. Sulka (Island Melanesia) wooden male commemorative figure, made by Paul Anis of Kilalum village, before 1982.

ture. These figures were used as part of the Sulka mourning celebration and were usually carved as a matched male and female pair. The figures were erected in the interior of the Sulka men's ceremonial hut, and were left there for several years as a visual reminder of the men and women who were commemorated in the mourning celebration. The carved and painted male figure shown in Figure 13 was carved by Paul Anis of Kilalum village, the same artist who created the ant's-nest *susu* masks discussed earlier. The figure still maintains some of the shape of the original log, as only the upper head is cut to form a blocky overhanging face and chin. The arms, torso, and lower stomach are rendered in low-relief carving which is nearly hidden by the complex geometrically painted relief patterns over most of the lower figure. This particular figure, one of a matched male and female pair, was commissioned by the local government council as an example of traditional art for display in the local meeting house.

## Art of the Tolai of East New Britain, Papua New Guinea

The Tolai people are an Austronesian-speaking group, numbering about one hundred thousand, who live in the northeast part of the Gazelle Peninsula, the Duke of York Islands, and nearby islands near southern New Ireland. At the turn of the century there were about six or seven thousand Tolai concentrated along the coastal areas, as well as inland in regions adjacent to the Xaxet, Kairak, and Uramot Baining. There is strong historical evidence that the Tolai migrated from the Duke of York Islands and the areas of southern New Ireland in the centuries preceding contact with European explorers in the eighteenth century. As recently as the late-nineteenth century, the Tolai were still at war with the Baining and actively pushing into Baining territory. Tolai traditional art included at least three types of masking traditions, carved wooden ornaments and ceremonial forms, elaborate mortuary canoe carvings, and carvings of humans and animals in chalk. These chalk carvings were used in the context of a medicine society known as the Iniet.

Perhaps the best-known Tolai masking tradition is that of the Duk-Duk society. In traditional times this society served the needs of various chiefs as a type of social regulatory society which punished transgressors of a chief's edicts and rules. There are two types of cone-shaped masks used by the Duk-Duk—a simple cone-shaped bark cloth (or other soft fiber) type [Color Plate 14], representing a female spirit, and a male spirit with elaborate superstructures encircling the cone. The female mask is called Tubuan and is said to be immortal. Each year she gives birth to male Duk-Duk spirits, who die and are burned after they dance in various ceremonies. The female Tubuan illustrated here has a simple, pointed, cone-shaped head topped by a bright bundle of white feathers. Her head is painted with white geometric forms that articulate her concentric circular eyes, facial outline, and surrounding shapes against a black painted background. The lower part of the costume consists of large reddish and green leaves set in circular rows from the bottom of the mask to a point slightly above the male dancer's knees. The overall effect is a globular body beneath the sharply pointed cone-shaped head, with white plumage echoing the rounded shape of the leaf body below. This Tubuan mask is standing in front of a temporary fence and hut which houses various slit gongs used as message and musical instruments during a mortuary rite for a dead Tolai "big man." In this 1972 photograph, the long expanses of imported cloth stretched around the fence and displayed in the spaces surrounding the temporary slit gong and shell money shelter are meant to show off some of the wealth of the family of the deceased. Gifts of shell money, bananas, and pork were distributed to the hundreds of people in attendance at the ceremony.[11]

The male Duk-Duk mask shown in Figure 14 is an excellent example of a Duk-Duk type of mask with cone-shaped upper portion ringed with appendages sticking out from the surface. This turn-of-the-century photograph also shows one of the functional outrigger canoes found throughout the area of the Tolai. The prow and sterns are upraised in pointed arclike shapes that are based upon the long, upward-curving horns of a rhinoceros beetle.

The Tolai also made masks in anthropomorphic shapes. These included naturalistic modeled skulls (see Chapter 1, Figure 21, and accompanying discussion) and carved wooden masks with elaborate superstructures [15]. Both types are called Alor (meaning human-like ancestor), and serve as powerful manifestations of ancestral beliefs in traditional Tolai society. The masks and costumes of the two Alor masks illustrated in a turn-of-the-century photograph [15] differ strikingly from those of the Duk-Duk type. The underlying dancer's body is not hidden, as in the Duk-Duk society Tubuan mask. In fact, the body is emphasized by decorations on the upper chest and neck of the maskers. This is similar to ceremonial body painting practiced by Tolai men in east New Britain and the Duke of York Islands. The masks themselves consist of three distinct parts: an abstracted carved frontal face, a dome-shaped hatlike upper part fringed with white down, and an elaborate superstructure. In these two examples, the vertical serrated struts surround a virtuoso carving of a snake form coiled around itself on top of the hat. A simple leaf skirt and painted legs complete the costume. The face on each mask consists of a simplified triangular form pointed at the chin; thin, pointed slitlike eyes; a thin vertical nose ending in small horizontal nostrils; and a sweeping, smiling dark-shaped mouth. Painted carved facial patterns echo the mouth shape, while the chin terminates in a fringelike beard of cut raffia.[12]

One of the most elaborate art forms found among the Tolai is the decorated mortuary ceremonial canoe made for ceremonies honoring the death of Tolai "big men." In the late-nineteenth century these canoes were made by Tolai clans in the Duke of York Islands, then transported and sold to Tolai on the Gazelle Peninsula.[13] This

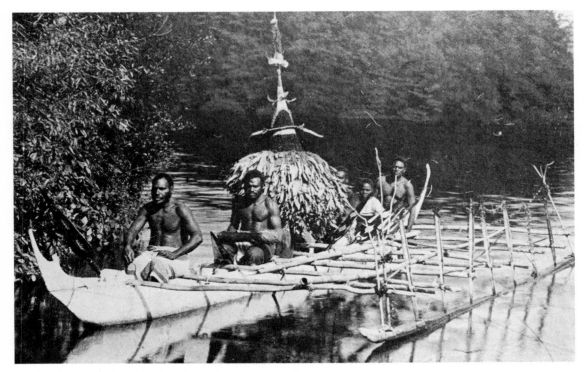

14. Tolai (Island Melanesia) Duk-Duk (male) mask in an outrigger canoe.

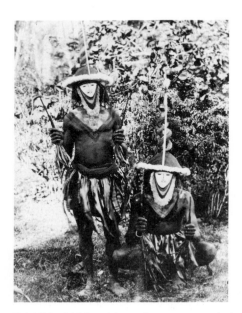

15. Tolai (Island Melanesia) wooden ancestor masks (called Alor).

type of canoe was generally not functional, although there is some evidence that actual canoes were sometimes launched and set afire at the conclusion of the mortuary rite when food and shell monies were distributed to the assembled audience. A detail of a late-nineteenth-century canoe carving [16] documents the complex pierced openwork forms found on these mortuary ceremonial canoes. The entire ornament is pierced with thin linear negative spaces which read visually as dark lines in the photograph. The front end is bordered by a thin strip carved in low relief and painted in repetitive triangular patterns. This is continued along the top of the body of the canoe, creating a strongly geometric border for the pierced carving above. The ornament itself contains broad areas of painted triangular shapes, which surround a pair of confronting scorpion shapes who appear to be facing off against each other in the center of the composition. Their bodies are carved and painted with

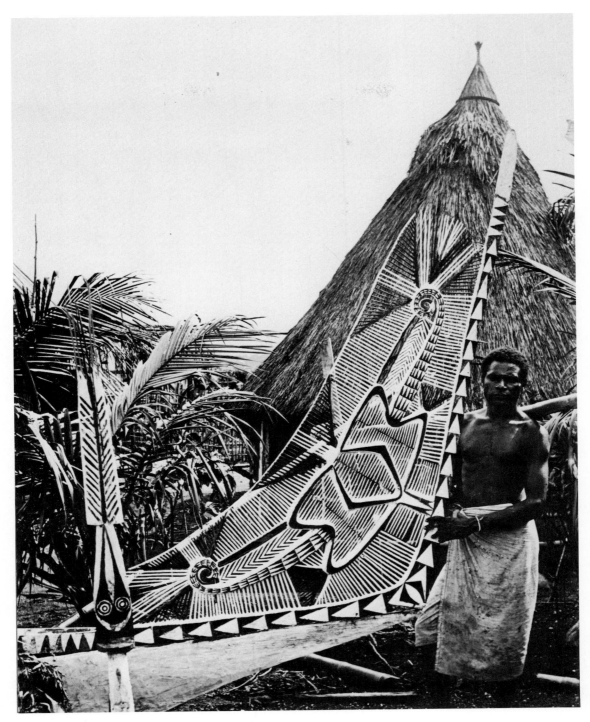

16. Tolai (Island Melanesia) wooden canoe prow for a mortuary canoe.

247

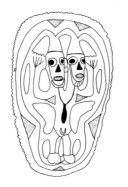
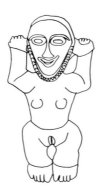

17. (left) Tolai (Island Melanesia) two-headed chalk figure used by the Iniet society.    18. (right) Tolai (Island Melanesia) male/female chalk figure used by the Iniet society.

19. Tolai (Island Melanesia) Iniet society wooden dance wands.

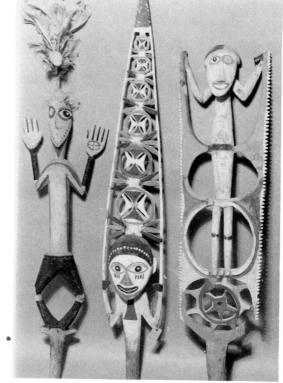

repetitive bands of thin triangular patterns which diminish in size gradually toward the narrow curved tail. The chevron and linear patterns created by the negative spaces probably represent fish bones, a visual device still employed by the Tolai in recent years on similar canoe carvings. In the lower left-hand-side of the photograph, there is a Duk-Duk society wand with a cone-shaped masklike head and a fish-bone pattern above. The redundancy of black and white contrasting patterns employed by Tolai artists is evident in this wand. The opposite end of the mortuary canoe would have another complex canoe ornament, echoing the piece seen here. At various points along the outrigger, Duk-Duk society wands would be placed for ornamental purposes.

The Tolai and other peoples of the southern New Ireland region had a secret medicine society (referred to by some as sorcery) which employed chalk figures of humans and animals, as well as wooden dance wands and large figures, in its rituals.[14] The chalk figures are often simpler and somewhat cruder in form when compared to traditional Tolai wood carving. The chalk figures shown in Figures 17 and 18 are somewhat blocky in form and squat in proportions, with a combination of male and female sexual characteristics articulated. Two-headed versions [18] are rare but suggest a complex notion of a spirit with multiple characteristics or identities. In most instances it may be simply a way of showing both masculine and feminine identities within a single chalk figure. Dance wands of the Iniet society [19] are frequently made with a standing figure in the center with arms raised and outstretched in a lively, engaging gesture. The forms usually push out into the surrounding space, compared to the contained quality of the chalk figures. Openwork pierced shapes are also commonly found on these wands.

248

## Art of Northern New Ireland

In contrast to the art of the Uramot Baining, Sulka, and Tolai peoples, which has been known only since the last decades of the nineteenth century, some of the art of northern New Ireland was seen, illustrated, and appreciated as early as the seventeenth century by European explorers. An illustration [20] first published in the explorer Abel Tasman's journal in the late-seventeenth century depicts an elaborate shark fishing canoe with carved prow and stern pieces, elaborately carved paddles, special propeller-like floats used in subduing and killing sharks, and men with hairstyles peculiar to this region of northern New Ireland.[15] While the carved prow and stern pieces look somewhat distorted and fanciful, similar pieces collected in the late-nineteenth and early-twentieth centuries are equally abstract and complex in their composition. Prow and stern carvings from a northern New Ireland shark fish-ing canoe from about 1908–1910 are excellent examples of a masterful combination of human and animal forms in a complex openwork com-position [21]. They have angular, curved, and straight-line elements combined with feather, bird-head, serpent, and human shapes in a form that reads best in profile. Like the canoe carv-ings depicted in Tasman's journal, these early-twentieth-century pieces are so complex that they seem abstract and unreadable to the un-trained eye. The similarity of these carvings to those illustrated on the late-seventeenth-century canoe and the similarity of fishing gear used then and in the early-twentieth century suggests at least three hundred years of continuity of shark fishing in this area and art related to this practice.

The complex artistic forms seen in the shark fishing canoe carvings are a hallmark of most northern New Ireland art, especially art used in

20.  Malanggan area, northern New Ireland (Island Melanesia), engraving of a shark fishing canoe.

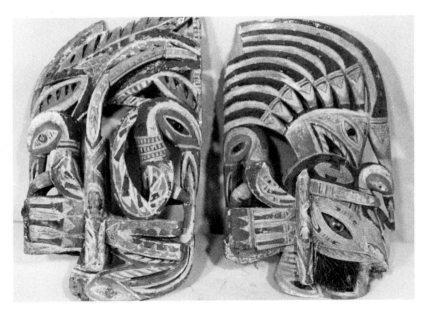

21.  Malanggan area, northern New Ireland (Island Melanesia), pair of shark fishing canoe prow and stern carvings.

the complex rites known as Malanggan. Throughout northern New Ireland there are communal rites called Malanggan which serve as mortuary ceremonies for various clan members. These rites are held in special houses or enclosures, and the contents of these houses are kept secret before the special "unveiling" day, when the ceremony goes public. Malanggan rites serve to unite clan members from various villages in communal work aimed at mourning the dead, initiating the youth, and participating in various dances and presentations. At these presentations display masks of various sorts are shown in addition to complex totemic clan carvings, which have both educational and aesthetic display functions.[16]

The masks shown in Color Plate 15, from the 1870s and 1880s, illustrate two distinct mask types, one known as Tatanua (right side, from the early 1870s), the other probably a Kepong type (on the left, from the mid-1880s). The Tatanua type is said to represent a male whose head is shaved on the sides—a cosmetic practice associated with mourning the dead. The lower part of the mask is a human-like form with eyes, pierced

ears, toothy mouth, forehead, and cheeks clearly articulated. The integrity of the sculptural forms are broken down, however, by the use of linear painted patterns over the broader planes of the face. The shape and color of the crestlike hairdo are also consistent with Malanggan cosmetic traditions, in which people change their hair color and hair shape by using natural ochres and dyes and by shaving and shaping their hair. This type of mask is usually worn by groups of men dancing in double lines and is less visually complex than the canoe prow carvings seen earlier (left side of Color Plate 15) and the masks and figure carvings we will see in Figures 22 and 23. The more elaborate mask on the left side of the color plate is often called a Kepong and may be a type of totemic-display mask for clans participating in the Malanggan rites. The large circular and pointed oval-shaped forms protruding to the sides of the dark, aggressive-looking face create flat shapes which seem to emphasize the bushy-haired human-like face in the center. Two carved struts push vertically from the back of the head, with a multicolored sea-snake shape undulating along the outer surface of each strut. On top of

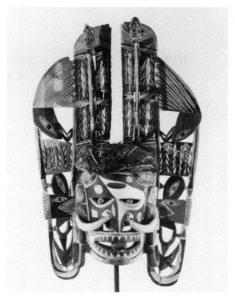

22. Malanggan area, northern New Ireland (Island Melanesia), wooden mask, probably of a type called *matua*.

each is a triangular shape that may represent the head of some sort of fish. The lower part of the mask depicts a human-like face with elongated ear lobes and a dark, aggressive-looking face with eyes and nose outlined by a thin white line.[17]

The elaborately carved and painted mask in Figure 22 is probably of a type known as Matua. Bird and fish shapes surround an aggressive-looking human face with teeth showing and tongue sticking out. The overall visual effect is one of complexity, aggression, and confusion,

due to the bizarre juxtaposition of disparate animal and human shapes. This visual confusion is largely due to the asymmetrical painting of the face, which tends to break down its natural shapes and curves, thereby making it more abstract. In addition, the elongated pierced ears are vehicles for birdlike and fishlike heads shown in profile. The pierced planar shapes of the ears extend above the face and depict upside-down bird heads complete with head and neck feathers. Between these bird heads above the human face are two pierced planklike shapes covered with feather-like patterns. Undulating in and out at right angles to these flat frontal planes is a pair of sea-snake serpent shapes, which create a complex visual pattern. At the top of these flat planar shapes are two fish-head shapes which are partly hidden by the heads of the undulating sea serpents. These animal images probably identified important clan-related species. Masks such as these are visually arresting—an aesthetic function which appears to be a hallmark of the northern New Ireland artist when creating display objects for the Malanggan rites.

In addition to masks, various carved and painted images were also created for display in Malanggan houses. These include individual ancestor carvings, clan-related animal and human images, composite carvings, and group compositions associated with a specific event or catas-

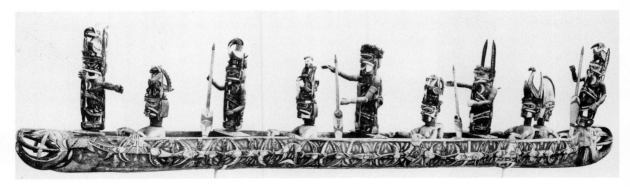

23. Malanggan area, northern New Ireland (Island Melanesia), wooden spirit canoe with ten ancestor figures.

trophe. The spirit canoe illustrated in Figure 23 was carved to commemorate the loss of several men at sea in the first decade of the twentieth century. The canoe is zoomorphic in form, with both ends terminating in mammalian heads, while the entire sides are covered with flying-fish and centralized human faces carved in low relief. The occupants of the canoe represent the ten persons lost at sea. Five serve as paddlers, while the other five sit as passengers. The images are elaborately painted with patterns which break up the sculptural forms and serve to create even more complex plays of positive and negative (pierced and painted) shapes within each figure. Complex spirit canoes such as this one were probably rare even in pre–European contact times. The fact that most of the carvings made for Malanggan ceremonial houses were later destroyed explains why only two of these pieces exist in museums today.[18]

Six Malanggan figure carvings collected early in the twentieth century [24] document the complexity and refinement of commemorative figure carvings at that time. Four of the pieces are carved as vertical compositions set on top of a pointed cylinder which is set in the earth of the temporary Malanggan house. The two horizontally placed pieces appear to be virtuoso display pieces. The one on the left (bottom) is composed of two carved half-figures, joined at the center by a carved wooden chain with two links. Both half-figures in this piece wear shell ornaments on their chests, replicating in wood the tortoise shell and tridacna shell ornaments worn in many areas of Melanesia. The other horizontal piece (on the right) is a single figure with elaborate animal shapes flanking its body from head to toe. The vertical figures are similar in their sculptural complexity; however, each is unique, with its own combination of human and animal elements

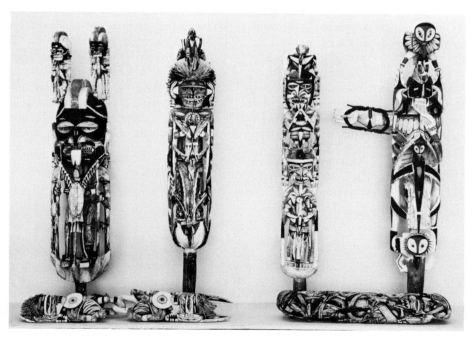

24.  Malanggan area, northern New Ireland (Island Melanesia), wooden ancestor figures.

in a highly polychromatic, pierced openwork composition. The extended tongue on the large-headed dark figure on the left is drooping downward and is being pecked by the beak of a bird-like form. The raised crestlike hairdo on this figure is flanked on top by a pair of small figures that appear to be miniaturized versions of the large figure. The large figure itself is flanked by thin struts which are snake and feather forms. The second vertical carving (from the left) is a single figure with a bushy hairdo surmounted by a bird biting on a serpent. Other animal and feather shapes surround the figure, thereby obscuring its body beneath. This figure, like the first one, stands on top of a large, open sea-shell shape. The third vertical piece (second from right) consists of one figure standing on top of another figure's head. In addition, the uppermost figure has a pointed-beaked bird standing on its head. The fourth vertical piece (on the far right) has a central figure with two owl forms—one standing on the figure's head, and another at the bottom of its feet. The central figure has one arm sticking out at right angles to its body, creating an interesting visual accent; its left hand holds a small pan pipe up to its mouth as if it were playing music. Each of the four figures in this photograph displays the creative genius of Malanggan carvers at the turn of the century.[19]

## Art of the Central Solomon Islands

Various art forms, including decorated plank-built war canoes, carved zoomorphic coffins, modeled human skulls, carved shell mortuary plaques, woven shell-covered war shields, tortoise-shell and tridacna ornaments, and tattooing, were common in the central Solomon Islands [Map 11] until the last half of the nineteenth century. The islands of this area include (from north to south) Choiseul, Vella Lavella, Santa Isabel, New Georgia, Malaita, Florida, and Santa Anna.

At the time of early contact with Europeans, in the sixteenth century, many central Solomons villages were razed to the ground by overzealous military seamen who perceived the traditional arts of these peoples as evidence of devil and animal worship.[20] By the time of the next sustained contact with Europeans, which was nearly two hundred years later, the people of this area were very aggressive head hunters who were hostile to their surrounding enemies and to Europeans alike. Even in the late-nineteenth and early-twentieth centuries there were still excellent examples of large plank-built war canoes which had tall pointed bows and sterns, elaborately inlaid shell decoration, and geometrically painted patterns.

A detail of a prow of one of these plank-built canoes from Vella Lavella Island [25] shows a striking contrast between the black color applied to the planks and the inlaid shell decorations. This detail also shows one type of prow sculpture—a guardian figure in the shape of a human with elongated ear lobes, arms and hands raised up near its chin, and elaborate irregularly shaped shell inlay articulating tattoo patterns common to the area. These figures usually have a long, horizontally thrust chin, upturned nose, and elongated ear lobes. (See Chapter 1, Figure 6, for comparison with the ear spools of a New Georgia warrior.) Like the contrasting black and white design on the prow carving, the body of the canoe has rows of circular, oval, z-shaped, arrow-like, and irregularly shaped shells inlaid in a mosaic-like technique on various parts of the canoe—along the edges of the upturned prow, along the inner edge of the canoe, and at a point slightly above the point of contact with the water. These inlaid shell decorations served as a form of wealth in many areas of the central Solo-

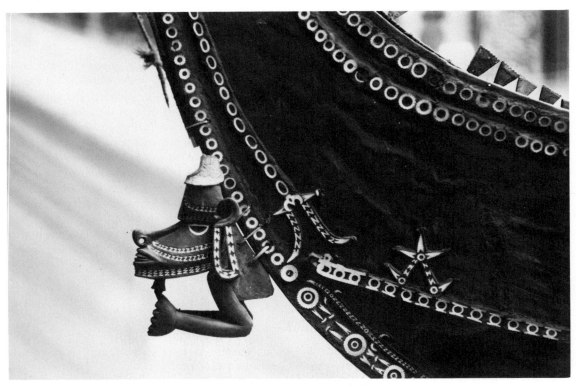

25.   Central Solomon Islands (Island Melanesia) detail of a Vella Lavella Island war canoe with prow figure.

mons, and can therefore be seen as decorating the war canoe with accumulated wealth of the clan which made and used it. The shell inlay may have also served as an element of protection, with particular patterns having magical significance to the makers and users of the canoe. In mortuary contexts, small shell rings were sometimes attached to the orbital areas of a chief's skull, and their appearance on head-hunting war canoes may be a symbolic reference to head hunting and the powers derived from the aquiring of enemies' skulls. Some of the decorations on this canoe may represent inverted frigate bird heads and beaks. This bird image is common in the art of the Solomon Islands and may be included on the canoe as a way of aiding the canoe in its "flight" over the water.

A second canoe prow [26], from Santa Anna Island, also has an elaborate decorated prow, as well as inlay of shell and painted decorations along its sides. This canoe is sitting within a canoe shed surrounded by carved ancestral posts (visible in the top center, as well as in silhouette in the background). The prow is raised many feet above the earth and terminates in a pointed form with hanging raffia-like decorations. Similar hangings are found farther down the front, near the water line. The sides of the canoe are decorated in contrasting white, red, and black patterns, some of which look like rows of similarly shaped canoes along the surface of the water. The sharp triangular designs which point toward each other beneath the rows of canoe shapes suggest the toothy mouth of a crocodile or some kind of fish—perhaps a shark.[21]

Small coffins used to contain the skulls of high-ranking warriors and chiefs were sometimes carved in the form of sharks. A group of seven of these carved coffins can be seen next to the canoe prow (to the left in the photograph), set

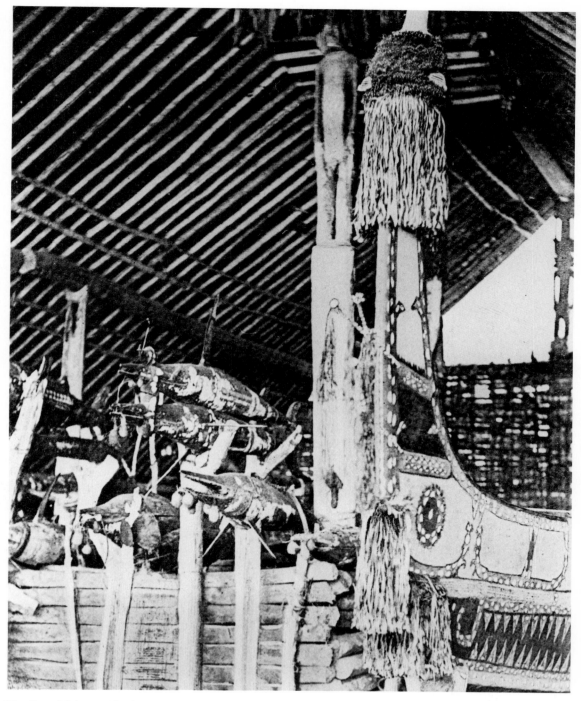

26.   Central Solomon Islands (Island Melanesia) interior of a Santa Anna Island canoe house with decorated canoes, ancestor figures, and shark-shaped coffins.

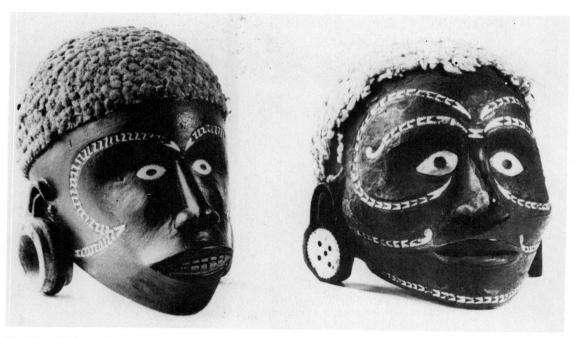

27. Central Solomon Islands (Island Melanesia) two modeled ancestor skulls from New Georgia Island.

upon raised fork-shaped support posts, as if running together in a school. These shark coffin images are somewhat naturalistic in overall form, with emphasis given to the shark's sharp pointed snout with rows of teeth, pointed back-curved dorsal fins, prominent pectoral fins, and pointed curved caudal (tail) fins.

In New Georgia, ancestral skulls [27] were overmodeled to try to re-create a naturalistic likeness of the deceased. Unlike the overmodeled skull from the Iatmul on the Sepik River (Chapter 8, Figure 24), these two overmodeled skulls are painted a contrasting black against the white inlaid cut shells. Here the curved patterns on the forehead, cheeks, and the lower chin (on the one on the right) replicate tattoo patterns. In contrast, the swirling curved facial patterns on the Iatmul overmodeled skull replicated facial painting patterns worn by the deceased during ceremonies. Both of these heads from New Georgia Island have short-cropped hair made from vegetal material, whereas the Iatmul head had human

hair. The light color of the New Georgia hair echoes a cosmetic practice of coloring hair with light-colored ochres. Both of these heads have elongated ear lobes inserted with large, circular, decorative ear plugs (also seen on the New Georgia man in Chapter 1). The full-lipped mouths with teeth showing and the cut-shell inlaid eyes give each modeled skull a sense of animation and alertness, rather than the quietude of death.

Cut-shell plaques with anthropomorphic and zoomorphic images [28,29] were made on Choiseul Island for use on small mortuary huts which contained the skull and some of the bones of important chiefs. These plaques always have a large, circular, shell-like, disc-shaped form below, with varied human and animal shapes in an openwork pattern above. In the example shown in Figure 28 two profile figures with pointed heads sit facing away from the center figure, which appears to be a squatting large-headed figure with rounded ears. The central figure is frontal, with its arms raised outward and

28. Central Solomon Islands (Island Melanesia) cut-shell grave ornament for a skull house from Choiseul Island, with human and bird images.

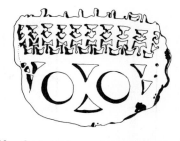

29. Central Solomon Islands (Island Melanesia) cut-shell grave ornament for a skull house from Choiseul Island.

attached in a graceful curve to the profile figures sitting in a knee-elbow-chin pose. The profile of a frigate-like bird and a pair of circular shell-ring shapes above the central figure complete the composition. In another example [29], ring shapes with a negative curved triangular space beneath them suggest the orbits of the eyes and the nose of a human skull. A double row of squatting anthropomorphic figures is set in a rectangular shape above. Damage to the top row of figures allows only portions of their legs to remain visible.

Shell inlay was also found on woven wicker war shields from New Georgia and/or Santa Isabel Island.[22] The front view of two shields and a back view of the one on the left [30] illustrate the contrast between the plain woven wicker back and the decorated front. Both shields have several hundred pieces of cut shell inlaid on the surface, creating a series of anthropomorphic images as well as geometric boxlike, curved, and linear forms. An elongated figure with arms raised is found on both shields, as are small faces near the center point of the edges and the center of the bottom. Perhaps the central figure is some form of protective spirit figure reserved for special shell-inlaid shields used by chiefs in ceremonial or warfare contexts, while the small heads and faces in other parts of the composition allude

to the head-hunting practices which were common in New Georgia and Santa Isabel well into the last decades of the nineteenth century.

A pair of tortoise shell and tridacna shell ornaments [31] (called *kap-kap*) clearly illustrates the differences between central and southern Solomon Islands design. The concentric circular, almost filigree patterns on the central Solomons *kap-kap* on the left contrast with the asymmetrical angular pattern of design on the southern Solomon Islands *kap-kap* from Santa Cruz Islands on the right.[23] The Santa Cruz piece has a frigate-bird shape near the center, with triangular pointed shapes placed symmetrically on either side of a thin central strut. The central Solomons *kap-kap*, on the left, has cowrie shell negative shapes around its outer tortoise shell border, with other curved, linear, and irregular e-like shapes placed in circular arrangements as one moves toward the center. As one moves even further toward the center, the pattern changes to an intermittent series of double half-circular shapes sitting on thin circular lines. The center of the design contains four displayed human images, with outstretched fingers, arms, and legs. The figures appear to be standing on four pointed shapes with serrated edges. These shapes radiate out from a center point like the points of a compass.

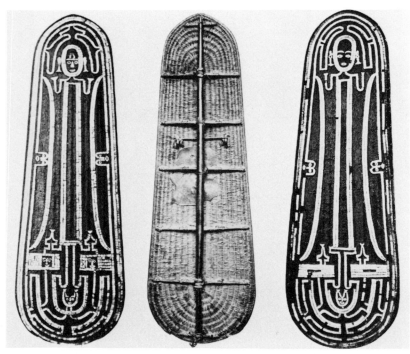

30. Central Solomon Islands (Island Melanesia) woven wicker war shields with inlaid shell. From Santa Isabel Island.

31. Central Solomon Islands (Island Melanesia) tridachna and tortoise shell chest ornaments (called *kap-kaps*) from Choiseul Island (left) and Santa Cruz Island (right, from eastern group).

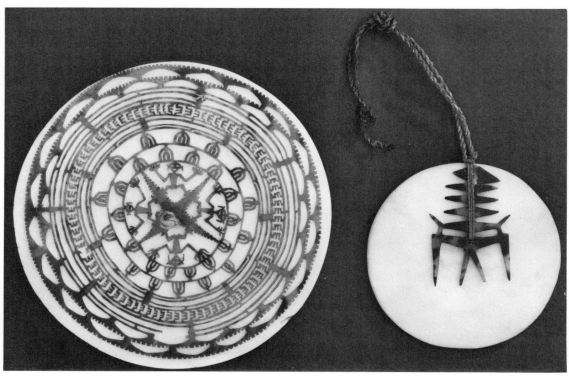

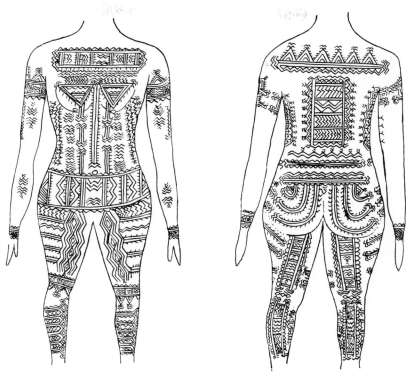

32. Central Solomon Islands (Island Melanesia) tattoo patterns on females from Santa Anna and Santa Catalina Islands.

Body tattoos used by women on Santa Anna Island [32] illustrate an attitude toward patterning the human body that is parallel to that found throughout the central Solomon Islands in canoe decoration and inlaid war shields. Starting at puberty and continuing over a period of a couple of years, young Santa Anna women were tattooed on their front and back with complex geometric patterns, many of which were based upon such things as birds, insects, fish, ornaments, the rainbow, and leaves. The chevron shapes found on both sides of the chest, stomach, and on the upper and lower arms represent the frigate bird in flight, and patterns encircling the upper arms and wrists are based upon wristlets of red- and white-colored shell money. The patterns on the front of the upper thighs are based upon repeated dragonfly motifs, while the thin zigzag patterns on the outside of the upper arms are based upon a small local fish. The large horizontal patterns across the upper back are based upon an ornament of red and white shells which is hung over the shoulders. And the curved shapes on the buttocks are based upon the rainbow. The overall effect of these complex geometric patterns transforms the body. When completely tattooed, the woman was likened to a locally found small fish with brightly patterned markings.[24]

# 10
# Art of Polynesia

The islands of central, eastern, and marginal Polynesia range from tropical (Tahiti, Marquesas, and Hawaii) to temperate (New Zealand) and have different flora and fauna available to their inhabitants. The tropical islands are all volcanic in origin and have varied forests, grasslands, and coastal regions. Fishing was an important source of food for the peoples of Tahiti, the Marquesas, and Hawaii, as well as for the Maori of New Zealand. Species ranging from small shellfish to large sharks, dolphins, and, in some regions, whales, were harvested from the sea. In all four areas birds were a valuable source of food, and their feathers and skins were used on sacred objects and for personal adornment. Agricultural products included bananas, sweet potatoes, taro, breadfruit, ferns, and sugar cane. In all regions many species of wild plants were exploited for food and useful products.

The Marquesas Islanders and the Maori of New Zealand had chieftainships, whereas the Tahitians and Hawaiians were more stratified, with fully developed kingships. Intragroup and intergroup competition for resources was common at the time of early European contact in the eighteenth century on all four islands, and these conditions fostered a state of nearly constant warfare. Specialization was common in Polynesia, and people were trained to be a specific type of worker or ruler according to their position at

birth (or through exceptional personal accomplishment). Habitations varied according to functional type, with grasses, trees, and stones the most common building materials. Due, in part, to the availability of abundant natural resources, the Maori of New Zealand developed large-scale, wooden-plank storage and communal houses. The more stratified religious systems of Polynesia brought about specialist classes of priests and the need for temples and other religious buildings. In comparison to the smaller hamlet and village concentrations found on Island New Guinea and Island Melanesia, many Polynesian islands had large concentrations of people and dwellings around important chiefs, rulers, and religious centers.

The languages of Tahiti, Hawaii, and the Maori of New Zealand are related historically, and they are all part of an Austronesian subgroup called proto-Tahitic, whereas the languages of the Marquesas are part of an Austronesian subgroup called proto-Marquesic, which developed separately from the other three. It is impossible to get accurate estimates of the pre–European contact populations in these four islands, although it is clear that there were many thousands of people living on each of these Polynesian islands in the later part of the eighteenth century. Recent census figures of native speakers from these four regions reveal that today there

SOCIETY ISLANDS

HAWAIIAN ISLANDS

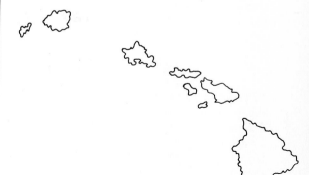

MARQUESAS ISLANDS

NEW ZEALAND

Map 12. POLYNESIA

are approximately sixty-six thousand Tahitian speakers, two hundred fifty Hawaiian speakers, five thousand Marquesan speakers, and one hundred thousand Maori speakers (of a total of two hundred thousand Maori).

## Art of the Society Islands, Central Polynesia

In contrast to the tribal societies in Melanesia, the peoples of central, eastern, and marginal Polynesia [Map 12] were organized into various classes and castes. In the Society Islands (particularly Tahiti) at the time of European contact in the late-eighteenth century, there were four distinct social classes. Family descent was determined through both maternal and paternal lines. These classes included (from highest- to lowest-ranking) royal families, high-ranking chiefs, land-owners, and workers. The lowest class, the workers, did not own land and served as laborers and retainers for the classes above them.[1]

In ancient times, all the inhabited islands in the Society group were divided into districts according to the various clan affiliations of the two upper classes, known collectively as the titled Arii.[2]

An additional institution in Tahiti, and elsewhere in the Society Islands, was called the *arioi.* It was a specialist group whose members came from all four classes, and who served as a traveling troupe of singers, dancers, orators, and musicians. Their patron god was Oro, the god of war. Since they practiced infanticide within their society, new recruits had to be brought in from outside on the basis of talent or inspiration.

Religion in the Society Islands included the worship of at least three types of deities. The first type included important national deities (called *atua* or *akua*), such as the creator god Taroa, his son Tane, the messenger god Ro'o (associated with protecting people from sorcery), the wind and navigator god Ru, and another war god, Tu. The second type, deities at a more domestic level (called *oromantua*), were often deified culture heroes or deities associated with a particular spe-

cialist group such as fishermen, net makers, farmers, doctors, carpenters, builders, canoe makers, wood workers, thatchers, hairdressers, the *arioi,* the dead, spirit chasers, ghosts, and apparitions. The third class of deities, known collectively as *ti'i,* was more numerous than the first two classes. They seem to have been of two basic types, those that were protective and those that were malevolent. Canoe prow figures [1 and 2], deity figures [3 and 4], ancestor figures, and boundary figures probably represented the protective *ti'i,* while a host of carved images and stick figures [5] probably represented malevolent *ti'i* spirits. These carved images and stick figures are often referred to as sorcerers' images, since they are used in rites of the malicious sorcery deity Ti'i—a deity who brings illness and death to mankind.[3]

Wood carvings were used extensively on sailing and war canoes as well as on single and double plank-built vessels without sails; however, such carvings do not seem to have been used on single dugout canoes. A late-eighteenth-century watercolor of a Tahitian double canoe of the type used for interisland travel [1] illustrates canoe prow and stern carvings of various sorts. The vessel has a rigging to accommodate a sail, and on each of the double bows is a horizontally oriented animal-like form, although the drawing is not detailed enough to clearly identify the source of the images. On the two sterns, there are carved pillars topped by standing human figures. On the stern to the right, a second human image faces the front of the canoe. A contrast of angular and curved body parts is clear even in silhouette, and all three figures appear to have pointed chins and rounded upper heads.[4]

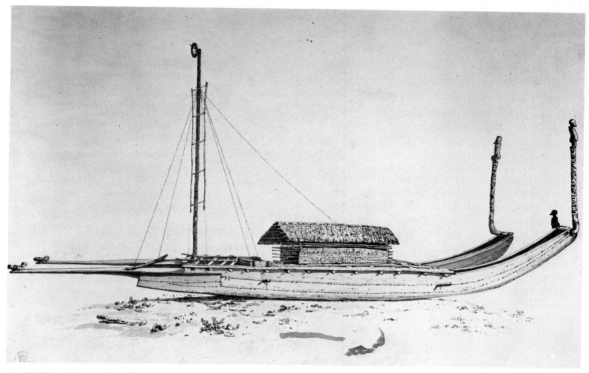

1. Tahitian (Society Islands, central Polynesia) two-hulled plank-built traveling canoe with mast, and prow and stern carvings.

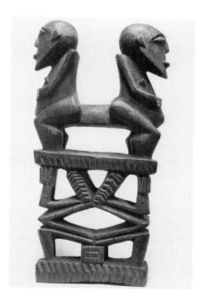

2. Tahitian (Society Islands, central Polynesia) wooden canoe carving with back-to-back figures.

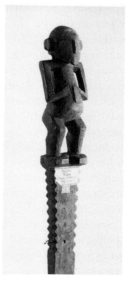

3. Tahitian (Society Islands, central Polynesia) wooden staff deity figure, possibly the creator god Taroa.

263

Large double-hulled plank-built war canoes were in existence in the Society Islands during the last quarter of the eighteenth century. One of Captain Cook's shipmates, George Forster, gave an account of these double war canoes, and it serves as a firsthand account of a rich and varied sculptural tradition for canoes:

The heads and sterns were raised several feet out of the water, particularly the latter which stood up like long beaks, sometimes near twenty feet high, and were cut into various shapes. A white piece of cloth was commonly fixed between the two beaks of each double canoe in lieu of an ensign. . . . At the head there was a tall pillar of carved-work, on the top of which stood the figure of a man, or rather of an urchin, whose face was commonly shaded by a board like a bonnet, and sometimes painted red with ochre. These pillars were generally covered with bunches of black feathers, and long streamers of feathers hung from them. . . . A fighting stage was erected towards the head of the boat, and rested on pillars from four to six feet high, generally ornamented with carving.[5]

Virtually none of the large double war canoes and the sculptures used on them have survived the various religious, economic, and social changes forced upon the islanders by Europeans in the late-eighteenth and early-nineteenth centuries. One carving that probably served as a canoe decoration is shown in Figure 2 and has a single pair of back-to-back figures standing on top of a pair of highly abstracted back-to-back figures. The two figures on top have fully developed buttocks and sharp angular jaws and chins —traits often found in Society Island carvings. They seem to have their tongues sticking slightly out—a trait which might allude to the carving's protective function on the canoe. Beneath the top figures, the back-to-back abstracted forms create a large diamond-shaped negative form and an angular symmetrical pattern quite different from the curving naturalistic figures above.[6]

In addition to canoe carvings, there were several types of wood sculpture found near, or used within, the confines of sacred temple areas called *marae*. Among these objects were three-dimensional wood carvings conceived both as single and multiple figures. Shortly after European contact in the eighteenth century, one of Captain Cook's companions, Joseph Banks, saw and described carvings of this sort. Banks observed that their "*marai*'s also are ornamented with different kinds of figures, one sort of which represent many men standing on each other's heads; they have also the figures of animals." In 1774, during a visit to the islands, a Spanish missionary noted, "We also saw on the other side of the *Imaroy* [sic] three pretty high posts elaborately carved, on[e] broader than the others: on this broadest one there were five women rudely sculptured, nude and obscene. On the other two posts were carved heads and portions of what seemed to be men's bodies."[7]

According to Banks, some *marae* images were painted:

At almost every point was painted a *morai* or burying place and many within land. They were like those of Oboreonoo raised into the form of the roof of a house, but these were cleaner and better kept and also ornamented with many carved boards set upright, on the tops of which were various figures of birds and men; on one particularly a figure of a cock painted red and yellow in imitation of the feathers of that bird. In some of them were figures of men standing on each others heads which they told me was the particular ornament of Burying grounds.[8]

Unfortunately, none of the elaborate *marae* carvings and royal deity images described in the eighteenth century have survived to the present day. Several dozen human figures of varying size, shape, and purpose, as well as a few sennit-wrapped clublike images of the war god Oro are all that remain of what was obviously a major sculptural tradition in wood in the Society Islands.[9]

A single staff god image from Tahiti is shown in Figure 3 and is generally said to represent Taroa, the creator god. Without precise collec-

tion records, however, it is impossible to be certain about such an attribution.[10] The image is consistent with other known Society Island figures, and has the combination of angular and rounded forms so characteristic of this style. The shaft below has a serrated edge, suggesting that this was, in fact, a deity figure meant to be elevated when used.

Several freestanding figures from the Society Islands have survived until today. A front and side view [4] of a large, standing male figure may also be some form of deity, although we cannot be certain of his identity. This figure has a characteristic squared-off treatment of the upper arm and shoulder region, compared to a more full-bodied treatment of the legs and calves. The head embodies the angular and curvilinear mixture noted previously in canoe carvings. The protruding navel area has great importance in Society Island religion, as does the fontanelle of the head.[11]

Throughout the Society Islands, carved prestige objects such as fly whisks were used as emblems of status and rank. There is evidence that fly whisks were carved as presents for visiting kings and high priests from neighboring districts and islands. This custom may account, in part, for the large number of fly whisks which entered European and American collections at an early date and which have survived until today. Such objects were given to the captains of visiting European ships. Fly whisks from the Society Islands were sometimes elaborately carved with human figures in a back-to-back position at the butt end, and many had a raised central carved ring with miniature pig heads in a circular row, and incised and low-relief geometric patterns on the handle. Sennit was often wrapped into geometric patterns near the bottom of the handle, which terminated in long strands of human hair. The fly whisk illustrated on the left side of five Society Island pieces [5] has a double figure, although the

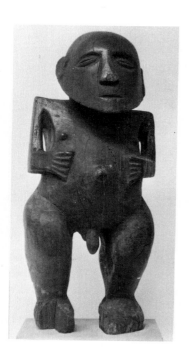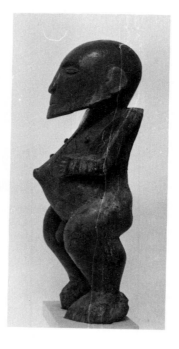

4. Tahitian (Society Islands, central Polynesia) wooden male deity figure (two views).

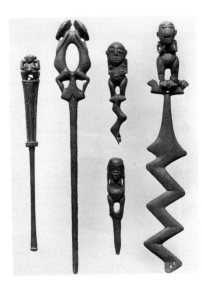

5. Tahitian (Society Islands, central Polynesia) wooden fly-whisks, fan handles and god sticks.

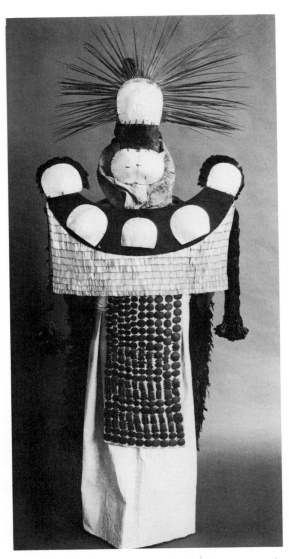

6. Tahitian (Society Islands, central Polynesia) mourner's costume made of pearl shell, tortoise shell, coconut shell, feathers, bark cloth, and sennit.

second figure cannot be seen from the angle shown here. The small figure is stocky, has rectangular upper arms and shoulders, and a full, more rounded lower body. The next piece (second from the left) is probably a fan handle with a pair of back-to-back figures separated by a rounded, oval negative space created by their arched backs. The protruding stomachs on each of these figures and arms placed on their upper stomach are consistent with other Society Island figures, as well as with staff gods from the Austral Islands. Each of the three remaining figures is set on top of a staff. The zigzag form on two of these staffs suggests that the figures above may be sorcerer's images, or some form of household deities, both known generally as *ti'i*. The fifth small figure, with a short pointed staff below, may also be one of these *ti'i* images.

One of the most fascinating and enigmatic art forms to have come down to us from the Society Islands is the late-eighteenth-century chief mourner's costume shown in Figure 6. Tortoise shell pieces and large, shaped, sea shell parts were combined with bark cloth and feathers to create one of the truly spectacular masking forms from central Polynesia. The crescent-shaped pectoral area beneath the head plate and the feather headdress may allude symbolically to a crescent moon

shape—perhaps a symbolic spirit canoe. Early accounts from the late-eighteenth century suggest that the spirit depicted by this costume was very powerful and greatly feared, and was to be avoided at all costs.[12]

The refined naturalism and smooth shiny surfaces of Society Island wooden sculpture contrast greatly with the more varied treatment of human forms found in the art of the Marquesas Islands in eastern Polynesia.

## Art of the Marquesas Islands, Eastern Polynesia

The Marquesas Islands were settled starting about two thousand years ago. The archaeological evidence is varied, yet points primarily to western Polynesia—that is, Tonga and Samoa as the probable early homelands of immigrants to the Marquesas Islands.[13] By the time of sustained contact with Europeans, in the late-eighteenth and early-nineteenth centuries, a distinctly Marquesan style of wood and stone carving had evolved, as well as localized treatments of body decoration, especially in tattooing. The male and female Marquesan Islanders had distinct patterns over various parts of their bodies. The serrated patterns across the male's chest (as seen in Chapter 1, Figure 5) represent shark's teeth, while the double symmetrical patterns slightly lower on his chest, along his lower abdomen, upper thighs, and outer lower thighs are "brilliant eye" motifs. Patterns along the outer edge of his upper legs, down to a point near his knee, represent a sword motif. The symmetrical patterns over his upper arms and lower arms refer to patterns found on the bottom and inside of ceremonial bowls, respectively. The pattern about the wrist, which closes off the tattoo patterns from the hands, is known by a name which refers to a garden enclosure. A coiled pattern at the ankle bones (inside) is based upon a coiled shellfish. In addition, the shoulder joints and kneecaps are decorated with a circular pattern probably based upon a warrior's tridacna shell and tortoise shell ornament. Many of these patterns have a symbolic reference to warfare and killing power—activities and traits common in traditional Marquesan

society at the time of sustained contact with Europeans in the early nineteenth century.[14]

The female Marquesan Islander's tattoo patterns (Chapter 1, Figure 5) are not as extensive as those of her male counterpart, as her torso and shoulders are devoid of tattoo patterns. Her arm and leg patterns, in contrast to those of the male, are organized almost completely in rows, at right angles to the vertical frame of her body. Her arms are covered from the lower part to the armpits with four pairs of patterns, representing the bottom and inside of a bowl. From a point just above her upper thighs, she is covered, down to and including her toes, with motifs including the garden enclosure, brilliant eye, tortoise (or wood louse), coiled shellfish, and more tortoise (or wood louse) patterns. The symbolism of these patterns on the female lacks the aggressiveness and overt war-related imagery of the male, and probably refers to the different female role in Marquesan society—one oriented toward fertility and sustenance.

The large war club from the early-nineteenth century shown in Figure 7 is called *uu* and documents the use of varied levels of relief sculpture on functional war clubs. The striking end of the club is anthropomorphic, with a forehead and high-arching browlike forms containing a pair of circular sunburst eyes. Each eye has a moderately high-relief face in its center. Below this, sticking out from the center of a raised ridge, is a single head in moderate relief. On the upper curved forehead, a simplified face is incised with clearly recognizable eyes, broad-nostriled nose, and

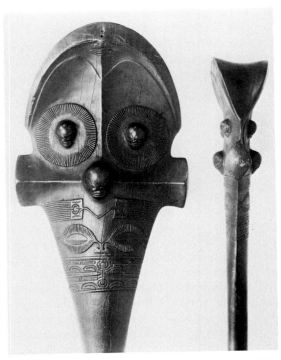

7. Marquesas Islands (eastern Polynesia) wooden war club.

were images, covered with bark cloth, representing deities. It is possible that this unique specimen served as a deity and was attached to a house board on a sacred temple.

One of the most beautiful and exotic art forms used by warriors and high-ranking persons in the Marquesas Islands was the tridacna shell and cut tortoise shell headdress (called *uhikana*). The example shown in Figure 9 was collected in the first decade of the nineteenth century. So, it retains traditional Marquesan stylistic traits and is virtually devoid of European influence. The woven sennit headband has a white circular-shaped ornament with an elaborately cut tortoise shell overlay, creating a stark contrast of light and dark. The designs radiate outward in four directions, as was seen in the *kap-kap* shell ornament from the Solomon Islands (Chapter 9, Figure 31). However, this Marquesan *uhikana* has more varied negative spaces between the solid forms. Displayed zoomorphic (or anthropomorphic) creatures are suspended between four leaf-shaped forms inside a pierced outer border replete with

wide mouth with a thin sliver of a tongue articulated. On the handle of the shaft beneath the center relief face are symmetrical patterns, including a set of eyes and a nose, as well as designs that may derive from body tattoo patterns. The small human-like heads in varied levels of relief are *tiki* faces, a source of protection and aggressive killing power for the war club and its user. The club was, at one time, buried in the earth and has been rubbed with coconut oil, thereby creating a dark, shiny, reflective surface.[15]

An unusual wooden object covered with bark cloth is shown in Figure 8 and may have served as either a tattoo model or as some form of deity. The object has a large-eyed face with a wide-open mouth, and is covered with a variety of tattoo-like patterns. In other parts of Polynesia, particularly in Easter Island and Tahiti, there

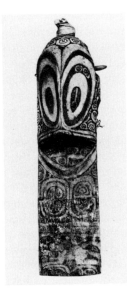

8. Marquesas Islands (eastern Polynesia) bark cloth effigy or tattoo-model figure.

9. Marquesas Islands (eastern Polynesia) tortoise and tridachna shell headdress ornament.

small dot holes. The effect is twofold; the small animals appear to be moving outward toward the periphery of the tortoise shell, while the leaf shapes appear to be moving inward, to counteract and balance the design.

Throughout the Marquesas Islands, local chiefs and priests set up sacred architectural environments, including ceremonial dance grounds (*tohua*) and mortuary grounds (*me'ae*). A *me'ae* at Oipona in Puamau Valley on Hiva Oa Island contained some of the largest and best-carved stone deity images anywhere in the Marquesas Islands.[16] The largest, a male deity named Takaii [10], is eight feet six inches tall and four feet wide at the shoulders. He is stocky, with a large broad-shaped head, and a wide-lipped mouth with a thin tongue showing (as in the war club described earlier). His broad nostrils nearly touch his circular-ringed eyes. His pectoral region is articulated by a pair of thin surface planes, while his hands are set low on his stomach on either side of his navel area. His legs and buttocks are heavy-set, a trait common to Marquesan sculpture. Although now broken off, his upper arms were originally cut free from his torso. Massive stone sculpture such as this was common to these islands, whereas massive wood sculpture was common to temples in the big island of Hawaii in marginal Polynesia.

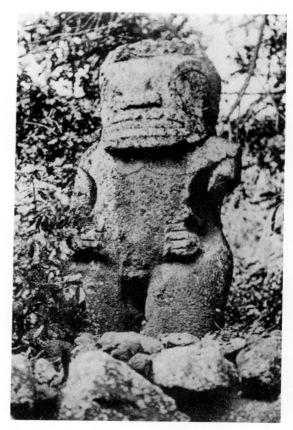

10. Marquesas Islands (eastern Polynesia) stone sculpture representing a male deity called Takaii. From Hiva Oa Island.

## Art of Hawaii, Marginal Polynesia

The Hawaiian Islands lie in marginal Polynesia, due west of Mexico, north of the equator [Map 12]. The peoples who populated the islands in the first millennium A.D. were Austronesian speakers with ocean-voyaging outrigger canoes, and plant and fishing technologies derived from central Polynesia, via Micronesia and, in their distant past, Indonesia. The stratified chieftain and royal traditions in place in Hawaii at the time of contact with Europeans in the eighteenth century were probably developed from the Marquesas Islands and the Society Islands—the probable homelands of the ancestors of the Hawaiian Islands. Early accounts of explorers, traders, and missionaries give some insight into the vital artistic traditions as they existed on Hawaii, Oahu, and Kauai within the Hawaiian chain at that time.

The French explorer Bougainville described the architecture, sculpture, and rites he saw on the island of Hawaii in 1798. His description included a walled-in temple precinct surrounded by a moat or ditch. The entrance and exit were guarded by monumental-sized sculptures of boundary deities, while a semicircle of large, wooden temple images stood in disarray near a raised sacrificial platform, which stood before an oracle tower used by priests to communicate with various deities. The layout and sculptural and architectural format of Hawaiian temples differed from the sacred *marae* in the Society Islands in that the Hawaiian temple area was an active center for processions and ritual. And it did not include an area reserved as a burial ground, as was common in Tahiti and surrounding islands in the Society chain.[17]

The large temple image (*akua ka'ai*) illustrated in Chapter 1, Figure 21, is seventy-nine inches high; it is from the big island of Hawaii, and probably represents the god of war, Kukailimoku. The aggressive and athletic posture of the figure, with well-defined pectoral area, upper arms, and thigh muscles, suggests a true-to-life warrior physiognomy. The exaggerated size of this figure and the wide-open defiant mouth are in keeping with warfare, and suggest the protective power dwelling within a war god. The face and headdress are combined into an aggressive-looking, snarling form nearly one half the size of the entire body. The hands are summarily done, with slightly curved palms which belie the ferocity of the head and pent-up power implicit in the sculptural rendering of the arms, legs, and torso.

A smaller temple image [11] (called *akua ka'ai*), over forty inches tall, illustrates a more complex and elongated sculptural style from the Kona coast of the big island of Hawaii. The treatment of the facial gestures on this figure also shows aggression and defiance. However, its body is not as stocky nor as massive as is the case in the larger temple image. It has an elaborate, pierced headdress, probably based upon flora associated with particular deities and rituals. It stands upon a pointed staff, which was stuck into the ground during ceremonies.

Sometimes, feather-covered basketry images representing Kukailimoku [12], the god of war, and Lono, the god of agriculture, were used as surrogates for the large temple images. Recent research suggests that the crested helmeted varieties, as shown in Figure 12, depict Kukailimoku, and that the combination of hair- and feather-covered images probably represents Lono.[18] In the case of the war god image, the aggressive facial expression that we saw in the temple images is slightly more restrained. In festivals and war campaigns, these feather-covered images were placed on top of poles and carried as a type of banner image to represent the god. Between rituals and periods of warfare, the images were kept in sacred temples under the care of a priest. The combination of tropical bird's tail feathers, dog's teeth, shells, nuts, and human hair creates a visually arresting bustlike form.

Smaller-scale figure sculptures representing

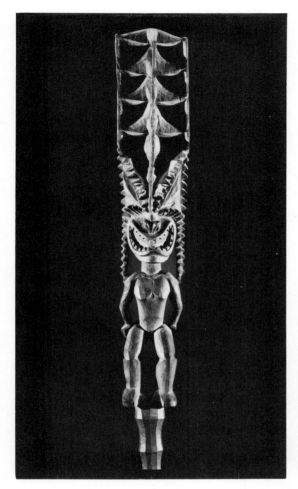

11. Hawaiian Islands (marginal Polynesia) wooden staff god image from Hawaii.

portions and details of facial structure and added-on features. The staring inlaid shell eyes and the pegged-in human hair on their heads give them a lifelike quality that adds to their presence as ancestral beings. In contrast to figure sculptures from the Society Islands, here the breasts are clearly articulated and are given sculptural emphasis. Like other Hawaiian figures they appear to be capable of great muscular effort, although these figures suggest great power being held in check.

Sculptural treatment was also given to a variety of utilitarian objects, such as drums, poi bowls, dishes, and stools. According to Hawaiian tradi-

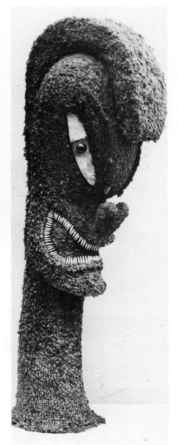

12. Hawaiian Islands (marginal Polynesia) basketry war god image covered with feathers.

ancestors were traditional art forms in Hawaii at the time of contact. Some male and female ancestor figures (called *'aumakua*), slightly over two feet tall, have survived from the late-eighteenth to the mid-nineteenth centuries. The pair of female ancestor figures shown in figure [13] are from the big island of Hawaii, and they epitomize sturdy, controlled muscular power. They are both a great deal more naturalistic than the deity figures already discussed, especially in the pro-

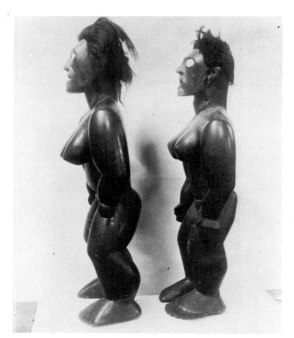

tion, a rival chief and members of his family would be represented in inferior supportive positions on such objects as food bowls and stools, as a way of magically damaging their positive spirit power (*mana*). These unclean and subservient contexts associated these people with negative spirit power (*tapu*). A scrap basin with two athletically posed female figures carved on each end [14] is a good example of such a vessel. The inset human molars were probably from a slain enemy, and their use in connection with *tapu* foods adds spiritual insult to the slain person.

Given their powerful positions, royal personages and their retinue of priests and warrior chiefs sought to distinguish themselves visually from others, of lesser rank, by wearing colorful featherwork capes [15], cloaks, helmets, and elaborately painted bark-cloth–covered [16] or feather-covered aprons and coverings.[19] These

13. Hawaiian Islands (marginal Polynesia) wooden female ancestor figures.

14. Hawaiian Islands (marginal Polynesia) wooden bowl with two figures.

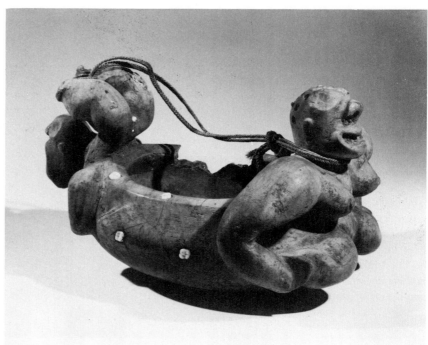

15. Hawaiian Islands (marginal Polynesia) feather capes with geometric patterns.

16. Hawaiian Islands (marginal Polynesia) painted bark cloth.

prestige display objects were often created from rare materials, such as the feathers of tropical birds that are difficult to catch. In Hawaii, as in other areas of Polynesia, red and yellow feathers are not only associated with high-ranking persons, but also with deities. In contrast to sculptural interpretations of the human form found in the Hawaiian Islands, these prestige arts were frequently covered with colorful geometric patterns. The two small feather-covered capes shown in Figure 14 have alternating patterns of yellow and dark-red feathers arranged in symmetrical triangular and cresent-shaped forms. In some ways the geometric elements on these Hawaiian feather capes bring to mind the stark geometric patterns of the Tahitian mourner's costume [6] and prestige arts made for chiefs in western Polynesia (especially Tonga and Samoa).

A similar use of geometric shapes in complex patterns is found in the painted bark cloth used by high-status individuals in the Hawaiian Islands. Many of the large pieces collected in the eighteenth century have been cut up and placed in "pattern" books to accompany the early editions of Cook's voyages. One of the few painted bark cloth pieces to remain intact is shown in Figure 16. In this large piece a complex attitude toward dividing up the rectangular composition is evident, with subtle horizontal and vertical divisions of the cloth and zigzag, triangular, and linear patterns reminiscent of contemporary art works of the Op art school. Unlike the feather cloaks and capes, which tended to be symmetrical, these painted bark cloths have a semblance of randomness, although there are subtle and highly aesthetic design principles in the composition.

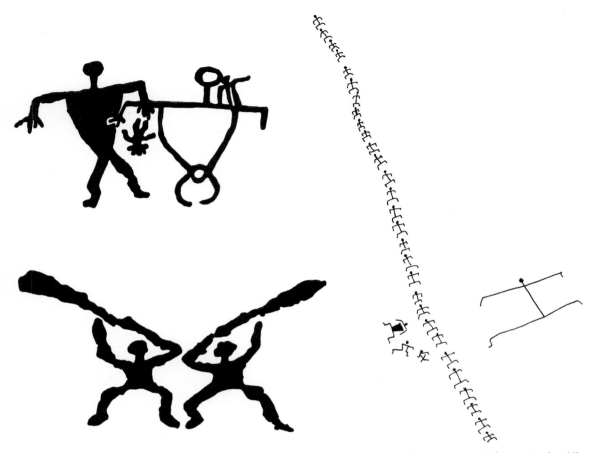

17.  Hawaiian Islands (marginal Polynesia), Island of Hawaii, petroglyphs depicting a birth scene (top left), a pair of paddle dancers or warriors (bottom left), and a line of warrior marchers (right).

Throughout the Hawaiian Islands various petroglyphs were created on rock surfaces. Many of them are merely abstract geometric shapes, often combined in complex compositions. The meanings of these complex pre–European contact petroglyphs are unknown. Other, more realistic images vary in meaning, including what appears to be a birth scene [17, top left], a ceremonial paddle dance (or act of warfare) [17, bottom left], and a group of warriors marching in single file [17, right].

### Art of the Maori of New Zealand, Marginal Polynesia

One of the most exciting art traditions to be found in Polynesia is that of the Maori people of New Zealand. The ancestors of the Maori arrived in New Zealand about A.D. 900–1000 from central and eastern Polynesia. Over the next several hundred years other groups arrived and gradually, by about the sixteenth to the eighteenth centuries, a distinctive artistic style that is typically Maori developed. At the time of European contact in 1768, there were several distinct

schools of Maori art on the north and south islands of New Zealand. Much of the art that was collected in the nineteenth century was affected by the introduction of new tool technologies.[20]

The early sculptural art forms, from about A.D. 1200–1500, which have survived from the colonization phase of Maori culture, have stylistic traits that point to eastern and central Polynesia, especially the Marquesas and the Hawaiian Islands and the Austral Islands, respectively. Many of these art works were carved in wood and served as bowls or vessels. Central Polynesian–derived art forms were more complex and delicate, and included works in stone, bone, and shell.[21]

At the time of the first sustained contact with European explorers, in the 1770s, the Maori were spread throughout the north island and concentrated in the upper half of the south island. They were divided into at least two dozen distinct tribes in the north and less than half a dozen in the south island. At this time there was evidence of aggressive warlike behavior within and between the various tribes, and there was a

strong emphasis on territorial boundaries and the political and military power of chiefs. Fortifications were commonly associated with defendable palisades, often overlooking a harbor from which one could launch war canoes. Descriptions of these fortified villages, with surrounding fences and carved gateways, suggest that the conditions of life in many areas of New Zealand were fraught with fear and anxiety about the power and potential aggression of one's rivals in nearby and adjacent regions. Most Maori art was associated with the stratified social structure and the complex religious system of polytheism.[22]

The Maori war canoe was one of the most impressive works of military art found anywhere in the South Pacific, and Captain Cook saw dozens of these large war canoes during his visit to New Zealand in the late-eighteenth century. As many as forty warriors, accompanied by priests and chiefs, could fit into a single dugout war canoe. The prows on these war canoes differed in composition from one area to the next, and the style of the northern island's east coast war canoe prow [18] has a protective figurehead with arms outstretched, face jutting forward, and

18.   Maori of New Zealand (marginal Polynesia) wooden war canoe prow. From Tolaga Bay, Pourewa Island.

an aggressive tongue sticking out parallel to the water. There are double spiral forms in the center of the composition, with a series of birdlike heads (known as *manaia*) found interspersed within. Below this there is a sea monster which symbolizes destructive forces. An ancestor figure, seated looking back at the warriors within the canoe, is protective. Once again we see the balance between destructive, death-related symbols and creative/protective symbols on a single object of art. A similar theme can be seen in the raised vertical stern carving from an east coast canoe [19]. A small ancestor figure faces the interior of the canoe, while bird-headed *manaia* figures are seen all about the interlace carving, eating the ribs and spiral shapes. This symbolizes the destructive elements of the universe.

Simpler canoe carvings were found on smaller fishing canoes. These usually had a single protruding figurehead, with a protruding head on the bow piece and a simple, raised stern piece which had very little relief or pierced carving.[23]

Another type of Maori art, which often has explicit bird/human composite imagery, is found on carved coffins (also called bone boxes). These coffins were often placed in sacred burial caves, and were used to contain the preserved tattooed heads and bones of high-ranking Maori chiefs and famous warriors. They vary in complexity from composite forms with a female bird-human image [20, top left and right] to simple abstracted bird's egg shapes [20, bottom left and right]. In the complex example (on the top in Figure 20), from a site near Auckland, the female bird-human figure with a smaller figure below may represent the creator goddess Hina and her son. The figure of Hina has both human and birdlike characteristics, with three-fingered hands and feet and birdlike eyes. Her legs are curved forward and backward as if to suggest movement. According to some Maori traditions, the small figure beneath Hina's pubic area represents her firstborn son, who is trying to return to the womb. Hina supposedly clamped down with her

legs and crushed him, thereby bringing death to all humankind. The two carved coffins on the bottom in Figure 20 are much simpler in form, and have wide-open, toothy, aggressive-looking mouths set on cylindrical or egg-shaped bodies. The association of bird-human images with death may be related to a widespread Maori belief in the spirit of the dead taking on the form of a bird and flying westward to the land of the dead.[24]

19. Maori of New Zealand (marginal Polynesia) wooden war canoe stern carving. From Koputaroa.

20. Maori of New Zealand (marginal Polynesia) three carved wooden burial chests.

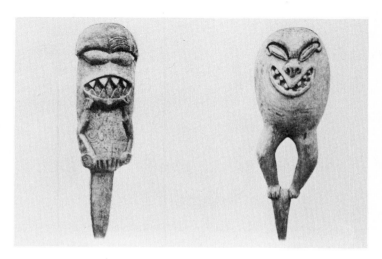

Some carved decorative combs and ancestral amulets made of hard materials like stone, bone, and jade have this basic bird-human form as a style characteristic. Four early-nineteenth-century examples of *hei tiki*, a carved jade amulet, are shown in Figure 21. All four examples have an embryonic bird and human shape with large (inset) circular eyes, three-fingered hands, three-toed feet, and a head cocked to one side. These were worn by both men and women as ancestral heirlooms and amulets and may have had magical powers associated with fertility and virility in their traditional pre–European context.

Other impressive prestige objects used by the Maori included carved feather boxes used to store sacred feathers and other treasures. Three views of an intricately carved box [22] illustrate the Maori use of low-, medium-, and high-relief

carving in a single piece. The raised high-relief handle on the top of the lid has an undulating friezelike series of interconnected shapes which terminate at each end in bird-headed *manaia* figures devouring curved shapes. Similar high-relief heads are carved in pierced profile on each end of the box (two on each end), facing each other and devouring a decorated curved form. On the bottom of the box (bottom photograph) one can see that these four *manaia* heads are attached to low-relief female bodies set in profile. Their bodies and heads are covered with spiral and curved designs based on Maori tattoo (*moko*) patterns.[25] A second pair of frontal figures in low relief are placed in the center of the composition (on the bottom of the box). They both have one of their three-fingered hands placed in their open figure-eight-shaped mouths, and they relate sty-

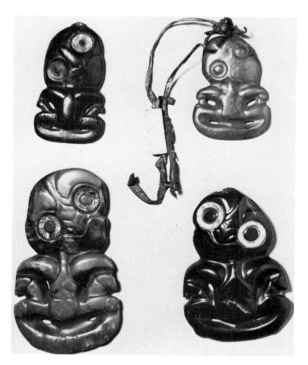

21.   Maori of New Zealand (marginal Polynesia) green stone amulets called *hei tiki*.

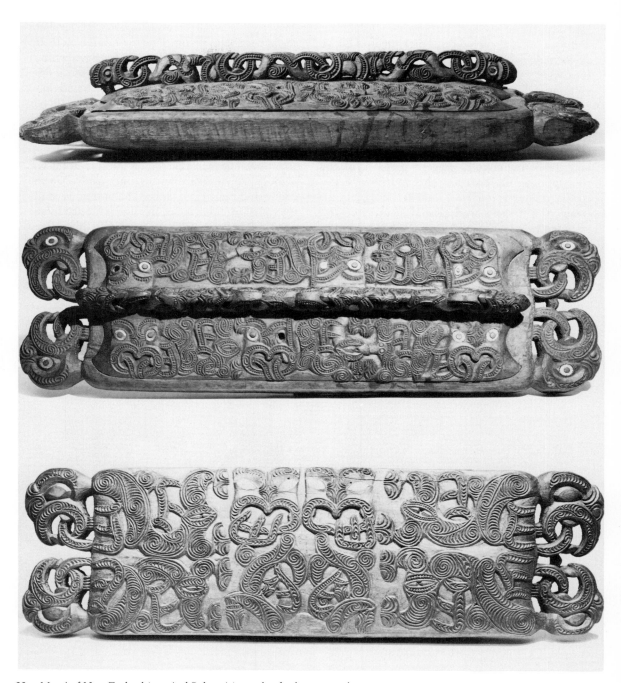

22.   Maori of New Zealand (marginal Polynesia) wooden feather storage box.

listically to the six low-relief figures (two male and four female) carved on top of the box lid. A single male figure on each side is placed foot-to-foot with a female, and his erect penis is shown entering a female figure's vagina, in the act of copulation. Each female figure has another female figure placed over her on the box lid, with the vagina of each female clearly indicated. The fact that this feather box includes both *manaia* and copulating couples suggests that it is meant to symbolize the constant ebb and flow of the forces of death (*manaia*) and life (copulation). Inlays of cut shells were placed in many of the rounded eyes of the figures on the feather box.

Short, one-handed wood and bone clubs often had carved protective *tiki* figures on one of their edges and a carved, full-volumed *tiki* head on the butt end. In the early-nineteenth-century clubs illustrated in Figure 23 there are various levels of surface embellishment. The two outer clubs (at the left and right in the photograph) have most of the surface covered with intricate patterns. The patterns on the left-hand club may be based upon feather motifs, while the right-hand club has mostly spirals and zigzag motifs. The *tiki* protective figures carved on the striking edges differ from club to club in their naturalism versus abstraction. The figure carved on the club at the left is more human-like than the ones carved on the center and right-hand clubs. The butt ends of the two outside clubs (the center one is hidden by the attached bark cloth) terminate in an abstracted *tiki-manaia* profile head, another form of protective symbolism for the warrior who used the war club.

Themes of life and death, the exploits of

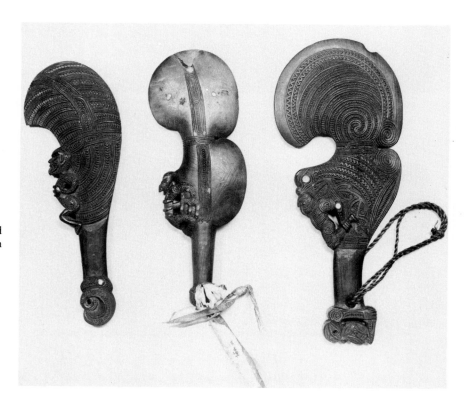

23. Maori of New Zealand (marginal Polynesia) wooden hand clubs.

famous culture heros, deities, and ancestors are all depicted on elaborate Maori council houses. The council house was a multipurpose religious and cultural center in traditional Maori life, especially by the middle of the nineteenth century.[26] A large council house called Rauru [24–26 and Color Plate 16] illustrates this house type and documents a style of Maori carving from about the 1840s to the turn of the century. Work on this house was begun by a Ngati-Whaoa Maori tribal chief named Te Waru in the early 1840s in honor of his beautiful young wife. While it was being built, Te Waru inadvertently committed a *tapu* act by entering the partially finished house smoking a pipe. He failed to properly cleanse the house by prescribed rituals after committing this *tapu* act, and he had the carvers continue carving. Shortly after, a series of misfortunes befell Te Waru and his wife, and subsequent wives and children. Work on the house stopped, and many years later (in the late 1890s) Te Waru was convinced by a European named Charles E. Nelson to complete the house with all the proper attendant Maori rituals. Shortly after its dedication ceremony in 1900, the two Maori priests who had participated in the ceremony died, and Te Waru moved back to his ancestral home at Paeroa, where he died a tragic death a few years later.[27] The house was sold to a museum in Hamburg in the first decade of the twentieth century, and stands intact today as a testimony to Maori art, history, and religion.

The facade of this Maori council house [24 and 25] shows a finely carved warrior figure standing on a gable mask set over a support post carved with human and animal images. The warrior figure represents the Maori god Tutanekai (a war god), the lover of the moon goddess, Hinemoa. The support figure at the bottom of the support post represents the god Tane-i-te-pupuke, a deity associated with light, fertility, and male power. The carved threshold, side support planks, and diagonally placed roof planks are carved in various levels of relief, with images

of *manaia* and other mythological Maori spirits. Over the doorway and window are carved lintels showing a female flanked by *manaia* and small childlike figures. The female probably represents the goddess Hinemoa, associated with life and birth. When one enters and exits the council house, one is symbolically killed and reborn, a transformation already described for Iatmul men's houses (Chapter 8).

A central support post in the interior of the council house is illustrated in Color Plate 16 and shows the naturalistic treatment of the figures on these posts. This type of figure usually represents a named ancestor of one of the tribes that migrated to New Zealand many hundreds of years ago. The elaborate painted patterns on the ceiling are based upon flora found in the sea and the surrounding forests. The alternating red relief boards contrast with the colorful geometric woven patterns set in vertical rows throughout the house interior.[28]

Two of the interior relief boards are shown in Figure 26. The one on the left represents the deity Maui hauling up a fish, which symbolizes the island of New Zealand, created by Maui during the period of creation. The second panel (on the right) represents Maui trying to reenter his mother's (Hine-nui-te-Po) womb just before she clamps her legs together, crushing him and bringing death to mankind.

Another important traditional form of Maori architectural sculpture is the chief's carved storage house (*pataka*). This type of raised wooden storage house was used to store the chief's treasures, such as garments, carved boxes with ornaments, weapons, implements, and certain kinds of dried foods, such as birds and fish. In the example shown here [27], built about 1820 by chief Haere Huka of the Ngati Whakane Arawa tribe, there is a profusion of ancestor and *manaia* figures over various surfaces. The naturalistic figures on the lower support posts and at the apex of the gable are probably ancestors of Haere Huka. The two barge boards (*maihi*) along the

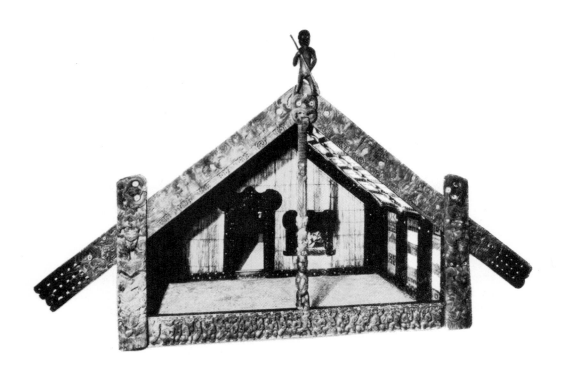

1. War god figure
2. Gable mask
3. Male deity figure
4. Threshold board
5. Support plank
6. Roof plank
7. Door lintel
8. Window lintel

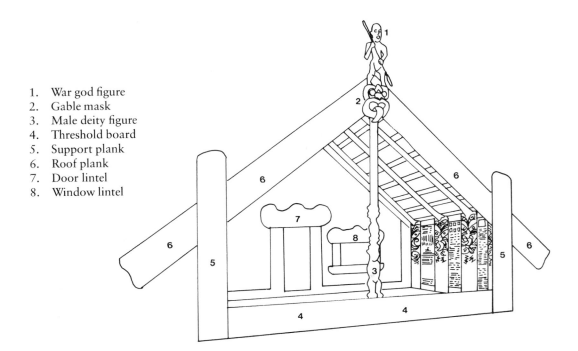

282

26.  Maori of New Zealand (marginal Polynesia) relief panels of male and female deities from the interior of a meeting house called Rauru.

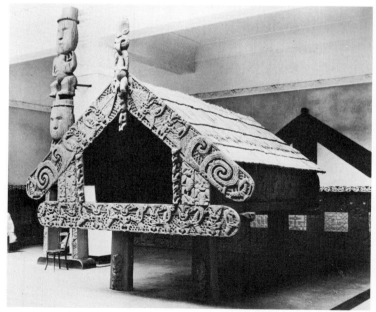

24.  (opposite top) Maori of New Zealand (marginal Polynesia) facade of a meeting house called Rauru.

25.  (opposite bottom) Maori of New Zealand (marginal Polynesia) plan of the facade of a meeting house called Rauru.

27.  Maori of New Zealand (marginal Polynesia) carved chief's storage house, 1820.

edge of the roof are carved with frontal ancestor and profile *manaia* figures, some of which overlap images of whales (the ultimate food source for the Maori). The tails of the whales overlap beneath the figure at the apex of the gable. The four-sided upright slabs (*amo*) between the roof barge boards and the horizontal threshold board (*paepae*) each have two figures carved within them in low relief. These figures may be associated with fertility. The ancestor and *manaia* figure combinations probably symbolize the forces of life and death in the Maori universe.

# Glossary

**asie usu:** Male and female sculptures made by the Baule of the Ivory Coast to represent malevolent bush spirits. The surface of this type of sculpture has encrustations of sacrificial patina in contrast to the smooth, shiny surfaces found on spirit spouse sculptures (see *blolo bian* and *blolo bla* below).

**bi pane:** A double-curved shell ornament worn by Asmat warriors. The ornament is inserted in a hole in the septum. The double curve represents the curved tusks of a wild boar. Symbolically, this ornament is associated with aggression, head-hunting, and warlike power.

**blolo bian:** A male sculpture made by the Baule of the Ivory Coast to represent a spirit husband. The surface of this type of sculpture is smooth and shiny in contrast to the encrusted surface found on *asie usu* bush spirit figures (see above).

**blolo bla:** A female sculpture made by the Baule of the Ivory Coast to represent a spirit wife. The surface of this type of sculpture is smooth and shiny in contrast to the encrusted surface of *asie usu* bush spirit figures.

**coups:** The actual touching of the enemy during battle. Among many Plains Indian peoples of North America, social distinction for a warrior was tied to his exploits during battle. One of the most honored was the coup.

**dream time:** An Australian aboriginal concept of a mythological time which still exists and can be contacted through proper ritual and the creation of certain art forms.

**Duk-Duk:** A cone-shaped male spirit mask used by the Duk-Duk society among the Tolai of east New Britain in Island Melanesia.

**flying fox:** A fruit-eating bat commonly found throughout Island New Guinea. The flying fox image is used in Asmat art to symbolize head-hunting because these animals eat the "heads" (fruit) off trees.

**hemlaut:** The generic name for several types of woven-basketry masks which terminate on top in a large umbrella form. The Sulka of east New Britain in Island Melanesia are the primary makers of this mask type.

**ibeji:** The cult of the twins among the Yoruba of Nigeria. Also, the name given to miniature male and female figures carved for worship by the cult.

**ikenga:** The personal shrine figure of the head of the household among the Ibo of Nigeria.

**iniet:** A sorcery society found among the Tolai of east New Britain and among the peoples of southern New Ireland in Island Melanesia. The *iniet* use carved chalk figures and decorated dance wands in their rituals.

**inua:** An inner human-like spirit. Among Eskimo peoples of Alaska and Canada there is a belief that all things possess an *inua*.

**jipae:** A nocturnal funerary festival among some Asmat people of Island New Guinea. Elaborate basketry masks and costumes are made to represent the deceased ancestors.

**kachina:** This word has at least three distinct meanings among the Hopi and other pueblo peoples of the Southwestern United States: (1) the generic name for a class of underworld deities and spirits who come above ground during the ceremonial season each year; (2) the name of the mask and masked dancer impersonating one of these underworld deities or spirits; (3) the name given to a miniaturized carving meant to represent the dancer and the spirit.

**kap-kap:** A circular tortoise shell and tridachna shell ornament worn by warriors and high-ranking people in several Melanesian Islands, including the central and southern Solomon Islands, and in parts of New Ireland and east New Britain.

**kavat:** The generic name for barkcloth helmet masks

285

used in night dances of the Uramot Baining of east New Britain.

**kepong:** A northern New Ireland mask with elaborate pierced and painted composite human and animal forms. The *kepong* is used as part of a clan display during Malanggan rites.

**kiva:** An underground ceremonial chamber with painted frescos, carved and painted altar displays, ground paintings, and sculptures. *Kivas* are commonly found in Anasazi archaeological sites and among contemporary Hopi people. The *kiva* serves as a symbolic point of transition between the underworld of the kachinas and the everyday world of the Hopi above. Generalized agricultural and human fertility rituals are carried out in Hopi kivas.

**kuduo:** A lost-wax cast brass treasure vessel for storing gold dust and valuables. Used by Asante notables in Ghana. Emblems of royal authority and power, such as leopards killing prey animals and the ruler as executioner, are often depicted in high relief on the lid of the vessel.

**labret:** A plug inserted beneath (or above) the lip as a form of personal adornment. These lip-plugs were common among Alaskan Eskimo and Northwest Coast Indian peoples.

**lost-wax cast (*cire-perdue*):** A technique of casting in metal in which a figure is modeled in beeswax, covered with layers of clay slip and clay, then heated. The wax melts away and the negative shape (void) is filled with molten metal. It is then cooled and the clay mold is broken away, resulting in a metal replica of the original wax model.

**Malanggan:** The name of a ceremony in northern New Ireland that commemorates the dead and celebrates fertility, gift exchanges, and the initiation of youth. It is also the name of the carvings associated with this ceremony.

**mana:** A belief among Polynesian peoples in the positive spirit power inherent in sacred objects and high-ranking people. This positive power was dangerous to persons of lesser rank or to those who did not know how to manipulate sacred objects. One's *mana* could be weakened by exposure to negative spirit power (see *tapu* below), by association with unclean substances, or by the machinations of a priest or sorcerer.

**manaia:** A bird-beaked, somewhat reptilian-looking image found in Maori art in New Zealand. It is associated with death and destructive forces.

**matua:** A northern New Ireland mask with elaborate pierced and painted human and animal forms and an aggressive face. Associated with warlike and cannibalistic bush spirits.

**mbari:** Sculpted clay architectural constructions made by the Ibo of Nigeria as a presentation to various deities. Frequently made to help counteract sickness, death, drought, and other misfortunes which may have befallen the community.

**mbis pole:** A vertically oriented carved pole used by the coastal Asmat of Island New Guinea as a spirit vessel for their ancestors killed in head-hunting raids.

**mendaska:** A huge composite barkcloth mask used by the Uramot Baining of east New Britain in daytime ceremonies. These ceremonies are associated with the harvest, initiation of youth, and mourning the dead.

**modeling:** The shaping of soft substances such as clay and wax to create sculptural forms.

**ndop:** Carved, seated, portrait-like figures used by Kuba kings in Zaire as surrogates in their absence.

**Oba:** The name for the king of the Bini people at Benin in Nigeria.

**ogboni:** A society of elders among the Yoruba of Nigeria. This society determines the line of succession of Yoruba kings and is associated with judiciary and medicinal functions.

**Oni:** The title name given Yoruba kings in Nigeria.

**orisha:** The generic name for deities in Yoruba religion.

**petroglyph:** A painted, pecked, or incised pattern or image made on the surface of a natural rock, boulder, or wall.

**potlatch:** A giving feast common among the Haida, Tlingit, and Kwakiutl peoples of the Northwest Coast of North America. At a potlatch, great quantities of food, clothing, blankets, coppers, and ceremonial items are distributed by chiefs as an indication of their wealth and generosity.

**reliquary figure:** Guardian figures used by the Fang and Kota peoples of Gabon to watch over ancestral remains. These figures were placed in or on bark boxes or woven baskets filled with the skeletal relics.

**scarification:** A permanent body decoration created by cutting and scarring the surface of the skin. Among dark-skinned peoples this cutting often produces a raised (celloid) permanent scar.

**susu:** The generic name given to several types of cone-shaped bark and/or woven-basketry masks made by the Sulka people of east New Britain in Island Melanesia.

**tapu:** A belief among Polynesian peoples in the negative spirit power inherent in certain foods, activities (like

cooking or bathing), sacred objects, and exposure to persons of different rank or status. The word taboo derived from the Polynesian word *tapu*.

**tatanua:** A northern New Ireland mask with a raised crestlike, helmet-shaped headdress associated with mourning the dead during Malanggan rites.

**tattooing:** A permanent body decoration created by embedding pigments into the skin through the use of sharp needle-like instruments. Colors are often applied in linear patterns or as solid shapes.

**totemic:** A religious belief among people who trace their mythological ancestors to various flora, fauna, spirits, or manmade or natural objects.

**tubuan:** A cone-shaped female spirit mask used by the Duk-Duk society of the Tolai people of east New Britain and southern New Ireland.

**uramon:** A canoe (without a bottom) that is used by interior Asmat peoples as a spirit vessel for their ancestors who have been killed in head-hunting raids.

**vungvung:** The generic name for composite barkcloth helmet masks used in Uramot Baining night dances. Unlike the *kavat* helmet mask, the *vungvung* mask has a long barkcloth-covered bamboo tube extending from its mouth and a long tail and spire shapes sticking out from its back and top. Side panels made from cut pandanus leaves sewn in elaborate patterns hang on either side of the *vungvung* mask during the night dance.

**wenet:** A seated pose with knees, elbows, and chin pulled together. Among the Asmat of Island New Guinea the *wenet* pose is associated with ancestors and the praying mantis.

**x-ray style:** A style of painting in which interior skeletal, musculature, and interior body organs are shown along with exterior surfaces and contours. This type of painting is common in the Oenpelli area of Arnhem Land in northern Australia.

# Notes

CHAPTER 1
Introduction

1. Goetzmann et al. (1984); Honour (1975); Lorant (ed.) (1946); and Truettner (1979).
2. The twenty volumes of photographs of Native Americans (1907–1930) by E. S. Curtis are a primary source for turn-of-the-century photographs. Virtually all natural history museums throughout the United States and in Europe have early ethnographic photograph archives of use to the student of Native American art.
3. Goetzmann et al. (1984).
4. Swan (1886).
5. This photograph was taken about 1940 by Paul Gebauer. Thousands of his field photographs (35mm black-and-white and color slides) are now housed in the Robert Goldwater Library, Paul Gebauer Collection, of The Metropolitan Museum of Art in New York.
6. Tessmann (1910).
7. See various entries on South Pacific tattooing in Hanson and Hanson (1984).
8. Steinen (1925).
9. Webster (1898).
10. See general books on Native American, African, and South Pacific art in the bibliography for discussions of masking.
11. For a good introduction and overview of portrait masks of the Northwest Coast see King (1978).
12. Colton (1959); Dockstader (1954); Erickson (1977); Fewkes (1901, 1903); and Washburn (1980).
13. Basden (1938) and Cole and Aniakor (1984).
14. Griaule (1938).
15. Brooklyn Museum (1973).
16. Large collections of Iatmul art, including various masks, can be found in the Völkerkunde museums in Basel, Berlin, Hamburg, and Stuttgart, as well as in the Museum of Archaeology and Ethnology at Cambridge, England. The Field Museum of Natural History in Chicago and The Metropolitan Museum of Art in New York also have large collections of Iatmul art.
17. My own field work among the Sulka was done in 1983. Interpretations of Sulka art are based upon interviews with over twenty-five Sulka elders who were accomplished art makers. Special thanks go to Mr. Chris Issac, a native Sulka speaker, from the National Museum and Art Gallery in Papua New Guinea for his help during our stay among the Sulka.
18. Symbolism in art related to garden or bush products is commonly found among peoples of Island New Guinea and Island Melanesia.
19. This pattern was found in the Haida and Tlingit peoples studied in this text.
20. Emmons (1916).
21. Many early field photographs from the Bamum people are in the Photograph Archives of the Basel Mission.
22. For an extensive discussion of the palace and the functions of its rooms and courtyards see Tardits (1980). A complete catalogue of the contents of the Palace Museum at Foumban was recently published by Geary (1983).
23. Personal communication with Anthony Forge, September 19, 1986.
24. Ibid.

25. Willey (1966).
26. Compare early kachina dolls collected by Voth (1901) for the Field Museum of Natural History in Chicago and recent ones published by Colton (1959) and Erickson (1977).
27. Eymann (1963).
28. Vastokas (1973/74) and Vastokas and Vastokas (1973).
29. Cole (1982).
30. Chaffin and Chaffin (1979); Perrois (1976); and Soderberg (1956).
31. Fagg and Forman (1959) and Dam-Mikkelsen and Lundaek (1980).
32. Damm (1969) and Powell (1883).
33. Kaeppler (1982).
34. Spencer (1914).
35. Berndt et al. (1964).

## CHAPTER 2
## Alaskan Eskimo Art and Art of the Northwest Coast

1. Fitzhugh, Kaplan et al. (1982).
2. Nelson (1899).
3. Nelson (1899); Ray (1961, 1969, 1981); and Vastokas (1971/72).
4. Nelson (1899).
5. Blodgett (1978); Carpenter (1973); Disselhoff (1935); Ray (1966, 1967); and Vastokas (1967).
6. Abbot (1981); Boas (1897); MacDonald (1981, 1983); and Smyly and Smyly (1973).
7. MacDonald (1983).
8. King (1978).
9. Barbeau (1957) and Drew and Wilson (1980).
10. Hawthorn (1967).
11. Boas (1897).
12. Gunn (1967); Holm (1974, 1983); and Nuytten (1982).
13. Boas (1897); Hawthorn (1967); McLaren (1978); and Walens (1981).
14. King (1978).
15. Waite (1966).
16. Jonaitis (1985); Laguna (1972); and Siebert and Forman (1967).
17. Various design influences were brought to the Northwest Coast by traders, explorers, missionaries, settlers, government officials, and Native Americans from other regions of North America.
18. Boas (1898).
19. Emmons (1907).
20. Shotridge (1919, 1928, 1929) and Siebert and Forman (1967).
21. Emmons (1916).
22. Ibid.
23. Jonaitis (1978, 1985).
24. Jonaitis (1975).
25. Laguna (1972) and Jonaitis (1985).
26. Jonaitis (1982) and McLaren (1978).
27. Jonaitis (1980).

## CHAPTER 3
## Art of the Southwestern United States

1. Gladwin et al. (1938); Haury (1976); and Willey (1966).
2. Haury (1976).
3. Haury (1976); Jernigan (1978); Kent (1983); and Tanner (1976).
4. Hawley in Gladwin et al. (1938, pp. 282–289).
5. Schaafsma (1980).
6. Wellmann (1979).
7. Brody (1977); Carlson (1978); Cosgrove and Cosgrove (1932); Fewkes (1923); Schaafsma (1972).
8. Willey (1966).
9. Cohodas (1978); Farmer (1954); and Smith (1952, 1972).
10. Dutton (1962).
11. Hibben (1966, 1975).
12. Judd (1954) and Martin (1940).
13. Brody (1977).
14. Fewkes (1906) and Stephen (1936).
15. Antes, Petrasch, Franzke, and Haberland (1980); Colton (1947, 1959); Eiseman (1961); Erickson (1977); Fewkes (1901, 1903); and Washburn (1980).
16. Ibid.
17. Dorsey and Voth (1901) and Fewkes (1899).
18. Voth (1901).
19. Ibid.
20. Stephen (1936).
21. Colton (1959).
22. Fewkes (1895, 1902).
23. Voth (1903).
24. Stephen (1936).
25. Schaafsma (1980).
26. Wade and McChesney (1981).

## CHAPTER 4
## Art of the Woodlands Period and of the Mississippian Period, and Art of the Great Lakes and Plains

1. See especially the recent overview of pre-contact Woodlands art by Brose, Brown, and Penny (1985).
2. Penny (1980) and Swartz (1970).
3. Silverberg (1968) and Squire and Davis (1848).
4. Brose and Greber (1979); Brown (1979); Moorehead (1922); Shetrone (1926, 1930); and Willoughby (1922).
5. The use of certain reptilian and predatory animal imagery in Hopewell art may have been associated with high-ranking religious and/or political elites who used these animals as emblems of their status and powers.
6. Brose, Brown, and Penny (1985).
7. This alert facial expression suggests that the figures were created to be lifelike and may have been ancestral images.
8. Brose, Brown, and Penny (1985) and Swanton (1946).
9. Swanton (1946) and Waring (1967).
10. Brown (1975, 1976); Fundaburk and Foreman (1957); Howard (1968); MacCurdy (1913); and Waring and Holder (1945).
11. Howard (1968) and Waring and Holder (1945).
12. Wilson (1985).
13. Flint (1973); Paris (1969); and Quimby (1960).
14. Gebhard (1969) and Grant (1967). See Wellmann (1979) for a survey of North American rock art.
15. Vastokas and Vastokas (1973).
16. Detroit (1986); Densmore (1929); Landes (1968); and Hoffman (1888).
17. The underwater panther, the horned serpent, and the thunderbird are the three most common supernaturals depicted in Great Lakes art, especially from the early contact period.
18. Traders, missionaries, settlers, soldiers, and others moved freely throughout the Great Lakes region in the seventeenth and eighteenth centuries, bringing with them visual images from other Native American and European groups.
19. Detroit (1986).
20. Hultkrantz (1973).
21. Dorsey (1894); various bibliographic entries by Ewers (1939–1985); Hultkrantz (1973); Kroeber (1900, 1901); and Wissler (1904, 1907, 1910).
22. Catalogue card entries for this painted robe at the Field Museum of Natural History, Chicago.
23. See also Ewers (1939, 1957, 1981); Feder (1967); Goetzmann et al. (1984); Hail (1983); Krieger (1928); Maurer (1979); and Thomas and Ronnefeldt (1976).
24. The taking of scalps preceded the coming of the Europeans by at least several hundred years. Evidence of scalping has been found in archaeological contexts in the Plains region of North America.
25. Corum (1975).
26. Laubin and Laubin (1977).
27. Ewers (1955, 1980); Hail (1983); and Wissler (1910).

## CHAPTER 5
## West African Art of Mali, the Ivory Coast, and Ghana

1. Griaule (1938).
2. Laude (1973).
3. Ibid.
4. Ibid.
5. Personal communication with Tamara Northern, early 1970s.
6. Spini and Spini (1977) and N'Diaye (1973).
7. Laude (1973).
8. Griaule (1938); Laude (1973); and Vogel and N'Diaye (1985).
9. De Mott (1979, 1982) and Griaule (1938).
10. Goldwater (1960) and Zahan (1960).
11. Goldwater (1960) and Zahan (1960).
12. Goldwater (1960) and Zahan (1960).
13. Goldwater (1960).
14. De Grunne (1980).
15. Ezra (1986); Goldwater (1960); and Imperato (1983).
16. Glaze (1981); Goldwater (1964); and Richter (1979).
17. Goldwater (1960).
18. Glaze (1981).
19. Ibid.
20. Ibid.
21. Vogel (1977).
22. Vogel (1977, 1981).
23. Vogel (1973, 1977, 1981).
24. Himmelheber (1972).
25. Cole and Ross (1978) and McLeod (1981).
26. Cole and Ross (1978) and Sarpong (1971).
27. Cole and Ross (1978).
28. Cole and Ross (1978) and McLeod (1981).
29. Garrard (1980) and Menzel (1968).
30. Cole and Ross (1978).
31. Ibid.
32. Ibid.

CHAPTER 6
Art of Nigeria

1. Eyo and Willett (1980); Shaw (1970); Willett (1967).
2. Eyo and Willett (1980) and Willett (1967).
3. Shaw (1970).
4. Equestrian imagery is widespread in the art of many sub-Saharan groups, including the Bamana, Dogon, Senufo, Bobo, Ibo, Igala, Ijo, Yoruba, Asante, and Benin, to name a few.
5. Eyo and Willett (1980) and Willett (1967).
6. Willett (1967).
7. Ibid.
8. Ibid.
9. Ibid.
10. Ben Amos (1980); Bradbury (1973); Dark (1973); Davidson (1966); Egharevba (1960); Eyo and Willett (1980); Luschan (1919); Read (1910); Read and Dalton (1899); Ryder (1969); Wolf (1965).
11. See illustration in Willett (1971, figure 83).
12. Luschan (1919) and Read and Dalton (1899).
13. Ben Amos (1980); Bradbury (1973); Dark (1973); and Eyo and Willett (1980).
14. Dark (1975, 1982).
15. Fraser (1972) and Schonfeld (1982).
16. Bradbury (1973).
17. Bradbury (1973) and Luschan (1919).
18. Dark (1982); Luschan (1919); Pitt-Rivers (1900); Read and Dalton (1899); and Wolf (1965).
19. Fagg (1963).
20. Eyo and Willett (1980); Ezra (1984); and Read (1910).
21. Bascom (1969); Cordwell (1983); Fagg and Pemberton (1982); Fraser (1972); Lawal (1985); and Thompson (1971).
22. Cordwell (1983) and Thompson (1973).
23. Fagg and Pemberton (1982); Lawal (1971); and Pemberton (1975).
24. Morton-Williams (1960); Ojo (1973); Roache (1971); and Williams (1964).
25. Morton-Williams (1960); Ojo (1973); Roache (1971); and Williams (1964).
26. Houlberg (1973); Stoll and Stoll (1980); and Thompson (1971).
27. Drewel and Drewel (1983).
28. Ibid.
29. Fagg and Pemberton (1982); Ojo (1978); and Vander-Heyden (1977).
30. Discussions with Henry and Margaret Drewel about the symbolism of this door greatly helped me in beginning to understand its complex imagery.
31. Boston (1977); Cole and Aniakor (1984); and Vogel (1974).
32. Cole (1982) and Cole and Aniakor (1984).
33. Cole and Aniakor (1984) and Jones (1984).

CHAPTER 7
Art of Central Africa

1. Fernandez (1966, 1973, 1975, 1977); Perrois (1972); Tessmann (1913); and Soderberg (1956).
2. Fernandez (1977) and Tessmann (1913).
3. Tessmann (1913).
4. Fernandez (1966) and Vogel (1985).
5. Fernandez (1966) and Vogel (1985).
6. Tessmann (1913).
7. Ibid.
8. Ibid.
9. Guillaume (1917).
10. Geary (1983a&b); Gebauer (1979); Northern (1975, 1984); and Rudy (1972).
11. Geary (1983a&b) and Northern (1975, 1984).
12. Tardits (1980).
13. Geary (1983b).
14. Geary (1983b); Northern (1984); and Wittmer (1979).
15. Cornet (1982) and Vansina (1968, 1972, 1978).
16. Cornet (1982).
17. Ibid.
18. Cornet (1982) and Vansina (1972).
19. Cornet (1982) and Vansina (1972).
20. Adams (1978) and Cornet (1982).
21. Cornet (1975, 1982) and Vansina (1968, 1978).

CHAPTER 8
Australian Aboriginal and Island New Guinea Art

1. Berndt and Berndt (1954); Berndt (ed.) et al. (1964); Mountford (1948); Spencer (1914); White and O'Connell (1982).
2. Jelinek (1978); Maynard (1979); McCarthy (1958, 1964); Mountford (1964).
3. Spencer (1914).
4. From a photograph taken by the author in 1971.
5. Berndt (ed.) et al. (1964).
6. Berndt (ed.) et al. and Berndt and Berndt (1948).
7. Berndt (ed.) et al. and Berndt and Berndt (1948).
8. Mountford (1958).
9. Goodale (1959) and Mountford (1956, 1958).
10. Mountford (1958).

11. Konrad, Konrad, and Schneebaum (1981) and Rockefeller and Gerbrands (1967).
12. Emst (1957) and Rockefeller and Gerbrands (1967).
13. This change was first brought to my attention in a lecture by Douglas Newton in 1986.
14. Gerbrands (1967); Kuruwaip (1974); and Rockefeller and Gerbrands (1967).
15. Rockefeller and Gerbrands (1967) and Emst (1957).
16. Konrad, Konrad, and Schneebaum (1981); Rockefeller and Gerbrands (1967); and Schneebaum (1985).
17. Konrad, Konrad, and Schneebaum (1981).
18. Bateson (1936); Holden (1975); Kelm (1966/68); and Mead (1934).
19. Dinerman (1981); Holden (1975); Kelm (1966/68); and Mead (1934).
20. Bateson (1936) and Kelm (1966/68).
21. Head hunting was associated with warfare in many areas of the Sepik River and in nearby highland areas to the north and south.
22. Hauser-Schaublin (1978) and Bateson's catalogue notes at the Museum of Archaeology and Ethnology at Cambridge, England.
23. Wirz (1955).
24. Beier (1976); Forge (1960, 1962, 1965, 1967); Kaberry (1940/41); Koch (1968); and Losche (1982).
25. Personal communication with Anthony Forge (1986).
26. B. Hauser-Schaublin field photograph. See also Tuzin (1972).
27. Personal communication with Anthony Forge (1986).
28. Leach and Leach (eds.) (1982); Malinowski (1920, 1922, 1935); Newton (1975); and Seligman (1910).
29. Beier (1974); Narubutal (1975); Scoditti (1977); and Seligman and Dickson (1946).
30. Austen (1945); Berndt (1958); Leach (1954, 1958); Malinowski (1920); Newton (1975).
31. Leach (1954, 1958) and Tindale (1959).

CHAPTER 9
Art of Island Melanesia

1. Bateson (1931/32); Clark (1976); Corbin (1976, 1979, 1984); Read (1931/32); and Poole (1943).
2. Corbin field notes from the Uramot, Kairak, and Chachet Baining from 1972/73, and from the Uramot Baining in 1982/83.
3. Bateson's valuable unpublished 1927/28 field notes on the Baining are currently housed at the Library of Congress, Washington, D.C. Many of his photographs are in the Haddon Photograph Archive, Museum of Archaeology and Ethnology, Cambridge, England.
4. Ibid.
5. It is unclear from Uramot informants whether or not this anthropomorphic mask type is a revival of an earlier type or has been derived from the ancestor mask tradition of the neighboring Tolai peoples.
6. Clark (1976) and Corbin field notes from 1982/83.
7. Bateson's unpublished field notes on the Sulka are currently housed at the Library of Congress, Washington, D.C. Many of his photographs are in the Haddon Photograph Archive, Museum of Archaeology and Ethnology, Cambridge, England. My own 1983 research among the Sulka was sponsored by the National Museum and Art Gallery, Boroko, Papua New Guinea, and funded by a City University of New York Faculty Research Award. Special thanks go to my translator and co–field worker, Mr. Chris Issac, a native Sulka speaker from the National Museum and Art Gallery.
8. Corbin (in press, 1988).
9. Corbin unpublished field notes (1983).
10. B. Craig's "Report of Field Trip to Sulka Area, Wide Bay, East New Britain Province, 3rd–10th January 1982" (MS) and R. Hill's "Report on a Field Trip to the Sulka" (MS), both made in 1982 for the Department of Anthropology at the National Museum and Art Gallery, Boroko, Papua New Guinea, offer valuable information about recent Sulka and Sulkanized Mengen art forms.
11. Churchill (1890); Errington (1974); Powell (1883); and Webster (1893).
12. Corbin (1976) and Damm (1969).
13. Danks (1892) and Meyer (1911).
14. Koch (1982); Kroll (1937); Meier (1911); and Spiegel (1979).
15. Groves (1936) and Peter (1982).
16. Billings (1967/68); Bodrogi (1967); Hall (1919, 1935); Helfrich (1973); Lewis (1969, 1979); McCarthy (1945); Powdermaker (1931/32, 1933); Spiegel (1973).
17. I would like to thank Louise Lincoln of the Minneapolis Institute of Art for bringing these early New Ireland masks to my attention in 1984.
18. Spiegel (1971).
19. Many of these Malanggan carvings were collected before the First World War.
20. Guppy (1887).
21. Balfour (1905); Edge-Partington and Joyce (1904);

Haddon and Hornell (1936/38); de Tolna (1904); Waite (1979); Woodford (1909).

22. Edge-Partington (1906); Hugel (1906); and Waite (1983).
23. Joyce (1935); McCarthy (1946); and Shuster (1964).
24. Kuper (1926).

CHAPTER 10
Art of Polynesia

1. Oliver (1974) and Henry (1928).
2. Henry (1928).
3. Ibid.
4. Haddon and Hornell (1936/38).
5. Forster (1777, pp. 61–62).
6. Barrow (1979) and Charleux (1980).
7. Beaglehole (1962, p. 385) and Padres Diary in Corney (1913, vol. 2, p. 209).
8. Beaglehole (1962, p. 298).
9. Barrow (1979).
10. Archey (1965). In 1971 I photographed this staff god at the Basel Mission, where it was said to be from the Marquesas Islands. Recently the piece was transferred to the Museum für Völkerkunde, Basel, where its true identity was not known. Since then it has been properly identified as being from central Polynesia, most likely from Tahiti, in the Society Islands.
11. This emphasis on the head and the protruding navel is common in the art of the Society Islands.
12. Barrow (1979); Buck (1943); Handy (1927); and Rose (1978).
13. Bellwood (1977, 1978).
14. Handy (1922) and von den Steinen (1925/28).
15. Dodge (1939); Duff (1969); Gathercole, Kaeppler, and Newton (1979); Guiart (1963); Kaeppler (1978); Linton (1923); Linton and Wingert (1946); Schmitz (1971); Teilhet (1973); von den Steinen (1925/28); and Wardwell (1967).
16. Baessler (1900) and Linton (1925).
17. Bellwood (1977, 1978) and Cox and Davenport (1974).
18. Buck (1957) and Kaeppler (1982).
19. Kaeppler (1975) and Kooijman (1972).
20. Mead (ed.) et al. (1984).
21. Ibid.
22. Bellwood (1977, 1978) and Fox (1976).
23. Archey (1977); Barrow (1969); Haddon and Hornell (1936/38); McEwen (1966); Mead (ed.) et al. (1984); and Vayda (1960).
24. Fox (1983); Rivers (1918); and Skinner (1918).
25. Simmons (1983).
26. Cowan (1930/34) and Phillips (1952, 1955).
27. Ibid.
28. Ibid.

# Bibliography

General References

Anderson, R. L., *Art in Primitive Societies,* Englewood Cliffs, N.J., 1979.

Bateson, G., "Style, Grace, and Information in Primitive Art," in A. Forge (ed.), *Primitive Art and Society,* London and New York, 1973, pp. 235–255.

Boas, F., *Primitive Art,* New York, 1927 (New York: Dover, 1955).

Brain, R., *The Decorated Body,* New York, 1979.

Catlin, G., *Notes of Eight Years' Travels and Residence in Europe,* New York, 1848.

Christensen, E. O., *Primitive Art,* New York, 1955.

Corbin, G. A., "The Primitive World," in *Encyclopedia of World Art,* vol. 16, New York, 1983, pp. 9–25.

Dalton, O. M., "Notes on an ethnographical collection from the West Coast of North America . . . formed during the voyage of Captain Vancouver 1790–1795 . . . now in the British Museum," *Internationales Archiv für Ethnographie,* vol. 10(1897), pp. 225–245.

Dam-Mikkelsen, B., and T. Lundbach (eds.), *Ethnographic Objects in the Royal Danish Kunstkammer 1650–1800,* Copenhagen, 1980.

Dorsey, G. A., "The Department of Anthropology of the Field Columbian Museum, A Review of Six Years," *American Anthropologist,* vol. 2(1900), pp. 247–265.

Duly, C., *The Houses of Mankind,* London, 1979.

Ebin, V., *The Body Decorated,* London, 1979.

Einstein, C., *Negerplastik,* Munich, 1915.

Feder, N., "The Malaspina Collection," *American Indian Art Magazine,* vol. 2, no. 3(1977), pp. 40–51, 80–82.

Feest, C., *The Art of War,* London, 1980.

Foreman, C. T., *Indians Abroad, 1493–1938,* Norman, Okla., 1943.

Forge, A. (ed.), *Primitive Art and Society,* London, 1973.

Fraser, D. F., *Primitive Art,* Garden City, N.Y., 1962.

——— (ed.), *The Many Faces of Primitive Art,* Englewood Cliffs, N.J., 1966.

——— (ed.), *Village Planning in the Primitive World,* New York, 1968.

Frobenius, L., *The Voice of Africa,* London, 1913 (2 vols.).

Graburn, N. H. H. (ed.), *Ethnic and Tourist Arts,* Berkeley, Calif., 1976.

Greenhalgh, M., and V. Megaw (eds.), *Art in Society: Studies in Style, Culture and Aesthetics,* New York, 1978.

Greenwood, J., *Curiosities of Savage Life,* London, 1863 (2 vols.).

Harper, J. R., *Paul Kane's Frontier,* Fort Worth, Tex., 1971.

Haselberger, H., "Method of Studying Ethnological Art," *Current Anthropology,* vol. 2(1961), pp. 341–355.

Heikamp, D., "American Objects in Italian Collections of the Renaissance and Baroque," *International Conference on First Images of America: The Impact of the New World on the Old,* Los Angeles, 1975 (University of California).

Honour, H., *The New Golden Land: European Images of America from the Discoveries to the Present Time,* New York, 1975.

Jopling, C. F. (ed.), *Art and Aesthetics in Primitive Societies: A Critical Anthology,* New York, 1971.

King, J. C. H., "Eighteenth Century Pacific Collections in the British Museum," *American Indian Art Magazine,* vol. 6, no. 2(1981), pp. 32–39.

Layton, R., *The Anthropology of Art,* London, 1981.

Lechtman, H., and R. Merrill (eds.), *Material Culture,* Saint Paul, Minn., 1977.

Lyman, C. M., *The Vanishing Race and Other Illusions: Photographs of Indians by Edward S. Curtis,* New York, 1982.

Manhattan House, *The Secret Museum of Mankind,* New York, c. 1900.

Otten, C. M. (ed.), *Anthropology and Art: Readings in Cross-Cultural Aesthetics,* Garden City, N.Y., 1971.

Parry, E., *The Image of the Indian and the Black Man in American Art,* New York, 1974.

Pericot-Garcia, L., J. Galloway, and A. Lommel, *Prehistoric and Primitive Art,* New York, 1967.

Powell, J. W., "Esthetology, or the Science of Activities Designed to Give Pleasure," *American Anthropologist,* vol. 1, no. 1(1899), pp. 1–40.

Quinn, D. B., *The American Drawings of John White,* London, 1964.

Ratzel, F., *Völkerkunde,* Leipzig, 1887 (3 vols.).

Read, C. H., "An Account of a Collection of Ethnographical Specimens Formed During Vancouver's Voyage in the Pacific Ocean 1790–1795," *Journal of the Royal Anthropological Institute,* vol. 21(1891), pp. 99–108.

Rowe, J. H., "Ethnography and Ethnology in the Sixteenth Century," in *The Kroeber Anthropological Society Papers,* no. 30(1964), pp. 1–19.

Rustow, A., "Die Objekte der Malaspina-Expedition," *Baessler Archiv,* vol. 22(1939), pp. 172–204.

Silver, H., "Ethnoart," *Annual Review of Anthropology,* vol. 8(1979), pp. 267–307.

Smith, B., *European Vision and the South Pacific, 1768–1850,* Oxford, England, 1960.

Smith, M. W. (ed.), *The Artist in Primitive Society,* New York, 1961.

Spofford, A. R., "Rare Books Relating to the American Indian," *American Anthropologist,* vol. 3(1901), pp. 270–285.

Thomsen, T., *Albert Erkhout,* Copenhagen, 1938.

Washburn, D. K. (ed.), *Structure and Cognition in Art,* Cambridge, Mass., 1983.

Wingert, P. S., *Primitive Art: Its Traditions and Styles,* New York, 1962.

Wood, J. G., *The Uncivilized Races of Men in All Countries of the World,* Hartford, Conn., 1870 (2 vols.).

## North America

Abbott, D. N. (ed.), *The World Is as Sharp as a Knife: An Anthology in Honour of Wilson Duff,* Victoria, British Columbia, 1981.

Antes, H., E. Petrasch, A. Franzke, and W. Haberland, *Kachina-Figuren der Pueblo-Indianer Nordamerikas aus der Studiensammlung Horst Antes,* Karlsruhe, 1980.

Barbeau, M., *Haida Carvers in Argillite,* Bulletin No. 139, National Museum of Canada, Ottawa, 1957.

Blodgett, J., *The Coming and Going of the Shaman: Eskimo Shamanism and Art,* Winnipeg, 1978.

Boas, F., "The Decorative Art of the Indians of the North Pacific Coast," *American Museum of Natural History Bulletin,* 9(1897), pp. 123–176.

———, "The Social Organization and the Secret Societies of the Kwakiutl Indians Based upon Personal Observations and on Notes Made by Mr. George Hunt," *National Museum Annual Report,* 1895/1897, pp. 313–738.

———, *The Religion of the Kwakiutl Indians,* Columbia University Contributions to Anthropology, 10(1930).

Brody, J. J., *Mimbres Painted Pottery,* Albuquerque, N.M., 1977.

Brose, D. S., and N. Greber (eds.), *Hopewell Archaeology,* Kent, 1979.

Brose, D. S., J. A. Brown, and D. W. Penney, *Ancient Art of the American Woodland Indians,* Detroit, 1985.

Brown, J. A., "Spiro Art and Its Mortuary Contexts," in Elizabeth P. Benson (ed.), *Death and the Afterlife in Pre-Columbian America,* Washington, D.C., 1975, pp. 1–32.

———, "The Southern Cult Reconsidered," *Midcontinental Journal of Archaeology,* vol. 1, no. 2(1976), pp. 115–135.

———, "Charnel Houses and Mortuary Crypts: Disposal of the Dead in the Middle Woodland Period," in Brose and Greber (1979), pp. 211–219.

Carlson, R. L., "Review of *Mimbres Painted Pottery* by J. J. Brody," *American Indian Art Magazine,* vol. 3, no. 2(1978), pp. 70–72.

Carpenter, E., *Eskimo Realities,* New York, 1973.

Coe, R. T. (ed.), *Sacred Circles: Two Thousand Years of North American Indian Art,* London, 1976.

Cohodas, M., "Style and Symbolism in the Awatobi Kiva Mural Paintings," *Phoebus,* 1(1978), pp. 9–21.

Collins, H. B., et al., *The Far North: 200 Years of American Eskimo and Indian Art,* Washington, D.C., 1973.

Colton, H. S., "Hopi Deities," *Plateau,* 20(1947), pp. 10–16.

———, *Hopi Kachina Dolls, with a Key to Their Identification,* Albuquerque, N.M., 1959.

Corum, C. R., "A Teton Tipi Cover Depiction of the Sacred Pipe Myth," *South Dakota Historian,* vol. 5, no. 2(1975), pp. 229–244.

Cosgrove, H. S., and C. B. Cosgrove, "The Swarts Ruin: A Typical Mimbres Site of Southwestern New Mexico,"

*Papers of the Peabody Museum of Archaeology and Ethnology,* vol. 15, no. 1(1932).

Curtis, E. S., *The North American Indian: Being a Series of Volumes Picturing and Describing the Indians of the United States and Alaska,* Cambridge, Mass., 1907–1930 (20 vols.).

Densmore, F., "Chippewa Customs," *Bureau of American Ethnology Bulletin,* 86(1929).

Dewdney, S., and K. E. Kidd, *Indian Rock Paintings of the Great Lakes,* Toronto (University of Toronto Press, Quetico Foundation Series 4), 1962.

Disselhoff, H. D., "Bemerkungen zu einigen Eskimo-Masken der Sammlungen Jacobson aus dem Berliner Museum für Volkerkünde," *Baessler Archive,* Band 18(1935), pp. 130–137.

Doctstader, F., *Indian Art in America,* Greenwich, Conn., 1960.

Dorsey, G. A., and H. R. Voth, "The Oraibi Soyal Ceremony," *Field Museum of Natural History Anthropological Series,* 3(1901), pp. 5–59.

Dorsey, J. O., "A Study of Siouan Cults," *Bureau of American Ethnology Annual Reports,* 11(1894), pp. 351–544.

Drew, L., and D. Wilson, *Argillite Art of the Haida,* Vancouver, 1980.

Dutton, B. P., *Sun Father's Way: The Kiva Murals of Kuaua,* Albuquerque, N.M., 1962.

Eiseman, F. B., "Notes on the Hopi Ceremonial Cycles," *Plateau,* 34(1961), pp. 18–22.

Emerson, T. E., *Mississippian Stone Images in Illinois,* Illinois Archaeological Survey, Circular No. 6, 1982.

Emmons, G. T., "The Chilkat Blanket," *Memoirs of the American Museum of Natural History,* vol. 3, no. 14(1907).

———, "The Whale House of the Chilkat," *Anthropological Papers of the American Museum of Natural History,* 19, part 1(1916), pp. 1–33.

Erickson, J. T., *Kachinas: An Evolving Hopi Art Form?,* Phoenix, Ariz., 1977.

Ewers, J. C., *Plains Indian Painting: A Description of an Aboriginal American Art,* Palo Alto, Calif., 1939.

———, "The Horse in Blackfoot Indian Culture, with Comparative Material from Other Western Tribes," *Bureau of American Ethnology Bulletin,* 159(1955).

———, "Early White Influence upon Plains Indian Painting: George Catlin and Carl Bodmer Among the Mandan, 1832–1834," *Smithsonian Miscellaneous Collections,* vol. 134, no. 7(1957).

———, "Artifacts and Pictures as Documents in the History of Indian-White Relations," in Smith, J. F., and R. M. Kvasnicka (eds.), *Indian-White Relations: A Persistent Paradox,* Washington, D.C., 1976, pp. 101–111.

———, "The Making and Use of Maps by Plains Indian Warriors," *By Valor and Arms,* vol. 3, no. 1(1977), pp. 36–43.

———, "Three Effigy Pipes by an Eastern Dakota Master Carver," *American Indian Art Magazine,* vol. 3, no. 4(1978), pp. 51–55, 74–75.

———, "Saddles of the Plains Indians," in Ahlborn, R. E. (ed.), *Man-made Mobile: Early Saddles of Western North America,* Smithsonian Studies in History and Technology, 39(1980), pp. 72–84.

———, "The Use of Artifacts and Pictures in the Study of Plains Indian History, Art, and Religion," in Cantwell, Anne-Marie E., J. B. Griffon, and N. A. Rothschild (eds.), *The Research Potential of Anthropological Museum Collections,* Annals of the New York Academy of Sciences, 376(1981), pp. 247–266.

———, "Water Monsters in Plains Indian Art," *American Indian Art Magazine,* vol. 6, no. 4(1981), pp. 38–45.

Feder, N., *North American Indian Painting,* New York, 1967.

———, *American Indian Art,* New York, 1969.

———, *Two Hundred Years of North American Indian Art,* New York, 1971.

Feest, C. F., *Native Arts of North America,* New York, 1980.

Fewkes, J. W., "The Winter Solstice Altars at Hano Pueblo," *American Anthropologist,* n.s. 1(1899), pp. 251–276.

———, "An Interpretation of Katcina Worship," *Journal of American Folklore,* 14(1901), pp. 81–94.

———, "Hopi Katcinas Drawn by Native Artists," *Bureau of American Ethnology Annual Report,* 21(1903), pp. 3–126.

———, "The Sun's Influence on the Form of Hopi Pueblos," *American Anthropologist,* n.s. 8(1906), pp. 88–100.

———, "Designs on Prehistoric Pottery from the Mimbres Valley, New Mexico," *Smithsonian Miscellaneous Collections,* vol. 74, no. 6(1923).

Fitzhugh, W. W., S. A. Kaplan, et al., *Inua Spirit World of the Bering Sea Eskimo,* Washington, D.C., 1982.

Flint Institute of Arts, *Art of the Great Lakes Indians,* Flint, Michigan, 1973.

Fundaburk, E. L., and M. D. F. Foreman (eds.), *Sun Circles and Human Hands: The Southeastern Indians Art and Industries,* Luverne, Alabama, 1957.

Furst, P. T., "The Roots and Continuities of Shamanism," *arts canada,* nos. 184/187(1973–1974), pp. 33–60.

Gebhard, D., "The Shield Motif in Plains Rock Art," *American Antiquity,* vol. 31, no. 5(1966), pp. 721–732.

———, *The Rock Art of Dinwoody Wyoming,* Santa Barbara, Calif., 1969.

Goetzmann, W. H., et al., *Karl Bodmer's America,* Omaha, Nebr., 1984.

Gladwin, H. S., et al., *Excavations at Snaketown: Material Culture,* Globe, Ariz., 1938.

Grand Rapids Public Museum, *Beads: Their Use by Upper Great Lakes Indians,* Grand Rapids, Mich., 1977.

Grant, C., *Rock Art of the American Indian,* New York, 1967.

Gunn, S. W. A., *Kwakiutl Houses and Totem Poles,* Vancouver, 1967 (2nd ed.).

Haberland, W., *The Art of North America,* New York, 1964.

Hail, B. A., *Hau Kola! The Plains Indian Collection of the Haffenreffer Museum of Anthropology,* Bristol, R.I., 1980.

Hall, H. U., "Some Shields of the Plains and Southwest," *University of Pennsylvania Museum Journal,* vol. 17, no. 1(1926), pp. 36–61.

Hall, R. L., "In Search of the Ideology of the Adena-Hopewell Climax," in Brose, D. S., and N. Greber (eds.), *Hopewell Archaeology: The Chillicothe Conference,* Kent, Ohio, 1979, pp. 258–265.

Haury, E. W., *The Hohokam, Desert Farmers and Craftsmen: Excavations at Snaketown, 1964–1965,* Tucson, Ariz., 1976.

Hawthorn, A., *Art of the Kwakiutl Indians,* Seattle, 1967.

Hibben, F. C., "A Possible Pyramidal Structure and Other Mexican Influences at Pottery Mound, New Mexico," *American Antiquity,* vol. 31(1966), pp. 522–529.

———, *Kiva Art of the Anasazi at Pottery Mound,* Las Vegas, 1975.

Hoffman, W. J., "Pictographs and Shamanistic Rites of the Ojibwa," *American Anthropologist,* o.s. 1(1888).

Holm, B., *Northwest Coast Indian Art: An Analysis of Form,* Seattle, 1965.

———, "The Art of Willie Seaweed: A Kwakiutl Master," in Richardson, M. (ed.), *The Human Mirror: Material and Spatial Images of Man,* Baton Rouge, La. (1974), pp. 59–90.

———, *Smoky-top: The Art and Times of Willie Seaweed,* Seattle, 1983.

Howard, J. H., "The Southeastern Ceremonial Complex and Its Interpretation," *Missouri Archaeological Society Memoirs,* 6(1968).

Hudson, C., *The Southeastern Indians,* Nashville, Tenn., 1976.

Hultkrantz, A., *Prairie and Plains Indians,* Leiden, Holland, 1973.

Jernigan, E. W., *Jewelry of the Prehistoric Southwest,* Albuquerque, N.M., 1978.

Jonaitis, A., "Land Otters and Shamans: Some Interpretations of Tlingit Charms," *American Indian Art Magazine,* vol. 4, no. 1(1978), pp. 62–66.

———, "The Devilfish in Tlingit Sacred Art," *American Indian Art Magazine,* vol. 5, no. 3(1980), pp. 42–47, 77.

———, "Sacred Art and Spiritual Power: An Analysis of Tlingit Shaman's Masks," in Mathews, Z., and A. Jonaitis (eds.), *Native North American Art History,* Palo Alto, Calif., 1982, pp. 111–136.

———, *Art of the Northern Tlingit,* Seattle, 1985.

Judd, N. M., *The Material Culture of Pueblo Bonito, Smithsonian Miscellaneous Collections,* 124(1954).

Kent, K. P., *Prehistoric Textiles of the Southwest,* Albuquerque, N.M., 1983.

King, J. C. H., *Portrait Masks from the Northwest Coast of America,* London, 1978.

Krieger, H. W., "American Indian Costumes in the United States National Museum," *Smithsonian Institution Annual Reports,* 1928.

Kroeber, A. L., "Symbolism of the Arapaho Indians," *American Museum of Natural History Bulletin,* 13(1900), pp. 69–86.

———, "Decorative Symbolism of the Arapaho," *American Anthropologist,* 3(1901), pp. 308–336.

Laguna, F. de, *Under Mount Saint Elias: The History and Culture of the Yakutat Tlingit,* Smithsonian Contributions to Anthropology, 7(1972) (3 vols.).

Landes, R., *Ojibwa Religion and the Midewiwin,* Madison, Wisc., 1968.

Laubin, R., and G. Laubin, *The Indian Tipi: Its History, Construction, and Use,* Norman, Okla., 1977.

Lorant, S. (ed.), *The New World: The First Pictures of America, Made by John White and Jacques Le Moyne and Engraved by Theodore De Bry,* New York, 1946.

MacCurdy, G. G., "Shell Gorgets from Missouri," *American Anthropologist,* 15(1913), pp. 395–414.

MacDonald, G. F., "Cosmic Equations in Northwest Coast Indian Art," in D. N. Abbott (ed.), Victoria, British Columbia, 1981, pp. 225–238.

———, *Haida Monumental Art; Villages of the Queen Charlotte Islands,* Vancouver, 1983.

Mallery, G., "Picture Writing of the American Indians,"

*Bureau of American Ethnology Reports,* 10(1893), pp. 3–807.

Martin, P. S., and F. S. Willis, "Anasazi Painted Pottery," *Field Museum of Natural History Anthropological Memoirs,* 5(1940), pp. 1–284.

*Masterworks of Indian and Eskimo Art from Canada,* Société des Amis du Musée de l'Homme, Paris, 1969.

Maurer, E. M., "Symbol and Identification in North American Indian Clothing," in Cordwell, J. M., and R. A. Schwarts (eds.), *The Fabrics of Culture: The Anthropology of Clothing and Adornment,* New York, 1979, pp. 119–142.

McKern, W. C., et al., "Painted Pottery Figurines from Illinois," *American Antiquity,* vol. 10(1945), pp. 295–302.

McLaren, C. S., "Moment of Death: Gift of Life, a Reinterpretation of the Northwest Coast Image 'Hawk,' " *Anthropologica,* vol. 20, nos. 1–2(1978), pp. 65–90.

Moorehead, W. K., "The Hopewell Mound Group of Ohio," *Field Museum of Natural History Publications,* vol. 9, no. 5(1922), pp. 73–181.

———, *Etowah Papers: 1: Explorations of the Etowah Site in Georgia,* New Haven, Conn., 1932.

Nelson, E. W., "The Eskimo About Bering Strait," *Bureau of American Ethnology Annual Report,* 1(1899), pp. 1–518.

Nuytten, P., *The Totem Carvers: Charlie James, Ellen Neel, and Mungo Martin,* Vancouver, 1982.

Penny, D. W., "The Adena Engraved Tablets: A Study of Art Prehistory," *Midcontinental Journal of Archaeology,* vol. 5, no. 1(1980), pp. 3–38.

Phillips, P., and J. A. Brown, *Pre-Columbian Shell Engravings from the Craig Mound at Spiro, Oklahoma,* part 1, Peabody Museum of Archaeology and Ethnology, Harvard University, Cambridge, Mass., 1978.

Quimby, G. I., *Indian Life in the Upper Great Lakes 11,000 B.C. to A.D. 1800,* Chicago, 1960.

Ray, D. J., *Artists of the Tundra and the Sea,* Seattle, 1961.

——— (ed.), "The Eskimo of St. Michael and Vicinity as Related by H. B. W. Edwards," *Anthropological Papers of the University of Alaska,* vol. 13, no. 2(1966), 143 pp.

———, *Eskimo Masks: Art and Ceremony,* Seattle, 1967.

———, *Graphic Arts of the Alaskan Eskimos,* Washington, D.C., 1969.

———, *Aleut and Eskimo Art: Tradition and Innovation in South Alaska,* Seattle, 1981.

Rustow, A., "Die Objekte der Malaspina Expedition im Archeölogischen Museum zu Madrid," *Baessler Archiv,* 22(1939), pp. 172–204.

Samuel, C., *The Chilkat Dancing Blanket,* Seattle, 1982.

Schaafsma, P., *Rock Art in New Mexico,* Santa Fe, 1972.

———, *Indian Rock Art of the Southwest,* Santa Fe, 1980.

———, "Kachinas in Rock Art," *Pacific Discovery,* vol. 33, no. 3(1980), pp. 20–27.

Schaafsma, P., and C. Schaafsma, "Evidence for the Origins of the Pueblo Katchina Cult as Suggested by Southwestern Rock Art," *American Antiquity,* vol. 39, no. 4, part 1, (1974), pp. 535–545.

Shetrone, H. C., "Explorations of the Hopewell Group of Prehistoric Earthworks," *Ohio Archaeological and Historical Quarterly,* vol. 35, no. 1(1926), pp. 5–227.

———, *The Moundbuilders,* New York, 1930.

Shotridge, L., "War Helmets and Clan Hats of the Tlingit Indians," *The University Museum Journal* (Philadelphia), 10(1919), pp. 43–48.

———, "The Emblems of the Tlingit Culture," *The University Museum Journal* (Philadelphia), 19(1928), pp. 350–377.

Siebert, E., and W. Forman, *North American Indian Art: Masks, Amulets, Wood Carvings and Ceremonial Dress from the Northwest Coast,* London, 1967.

Silverberg, R., *Mound Builders of Ancient America: The Archaeology of a Myth,* Greenwich, Conn., 1968.

Smith, W., "Kiva Mural Decoration at Awatovi and Kawaika-a," *Peabody Museum of American Archaeology and Ethnology Papers,* 37(1952).

Smyly, J., and C. Smyly, *The Totem Poles of Skedans,* Seattle, 1973.

Squier, E. G., and E. H. Davis, *Ancient Monuments of the Mississippi Valley, Comprising the Results of Extensive Original Surveys and Exploration,* Washington, D.C., 1848 (1973 edition by AMS Press, Inc., New York).

Stephen, A. M., *Hopi Journal,* edited by E. C. Parsons, New York, 1936 (2 vols.).

Swan, J. G., "Tattoo Marks of the Haida Indians of Queen Charlotte Islands, B.C., and the Prince of Wales Archipelago, Alaska," *Fourth Annual Report of the Bureau of Ethnology,* 4(1886), pp. 66–73.

Swanton, J. R., "The Indians of the Southeastern United States," *Bureau of American Ethnology Bulletin,* 137(1946).

Swartz, B. K., Jr. (ed.), *Adena: The Seeking of an Identity.* A symposium held at the Kitselman Conference Center, Ball State University, Muncie, Indiana, 1970.

Tanner, C. L., *Prehistoric Southwestern Craft Arts,* Tucson, Ariz., 1976.

Thomas, D., and K. Ronnefeldt, *People of the First*

*Man: Life Among the Plains Indians in Their Final Days of Glory. The Firsthand Account of Prince Maximilian's Expedition up the Missouri River, 1833–34,* New York, 1976.

Truettner, W. H., *The Natural Man Observed: A Study of Catlin's Indian Gallery,* Washington, D.C., 1979.

Vastokas, J. M., "The Relation of Form to Iconography in Eskimo Masks," *The Beaver,* outfit 298 (Autumn 1967), pp. 26–31.

———, "Continuities in Eskimo Graphic Style," *arts canada,* 192/193(1971–1972), pp. 69–83.

———, "The Shamanic Tree of Life," *arts canada,* 184/185/186/187(1973–1974), pp. 125–149.

Vastokas, J. M., and R. K. Vastokas, *Sacred Art of the Algonkians: A Study of the Peterborough Petroglyphs,* Peterborough, Ontario, 1973.

Voth, H. R., "The Oraibi Powamu Ceremony," *Field Columbian Museum Anthropological Series,* vol. 3, no. 2(1901), pp. 67–158.

———, "The Oraibi Qaqol Ceremony," *Field Columbian Museum Anthropological Series,* vol. 6, no. 1(1903), pp. 1–46.

Walker Art Center, *American Indian Art: Form and Tradition,* Minneapolis, 1972.

Waring, T., "The Southern Cult and Muskhogean Ceremonial," in Williams, S. (ed.), *The Waring Papers,* Peabody Museum of American Archaeology and Ethnology, Harvard University, Cambridge, Mass., 1967, pp. 30–69.

Waring, A. J., and P. Holder, "A Prehistoric Ceremonial Complex in the Southeastern United States," *American Anthropologist,* 47(1945), pp. 1–34.

Wellmann, K. F., *A Survey of North American Indian Rock Art,* Graz, Austria, 1979.

Wicke, C. R., "Pyramids and Temple Mounds: Mesoamerican Ceremonial Architecture in Eastern North America," *American Antiquity,* vol. 30, no. 4(1965), pp. 409–420.

Willey, G., *An Introduction to American Archaeology. Volume 1: North and Middle America,* Englewood Cliffs, N.J., 1966.

Williamson, R. A., et al., "Anasazi Solar Observatories," in Aveni, A. F. (ed.), *Native American Astronomy,* Austin, 1977.

Willoughby, C. C., "The Turner Group of Earthworks, Hamilton County, Ohio," *Papers of the Peabody Museum of American Archaeology and Ethnology, Harvard University,* vol. 8, no. 3(1922), pp. 1–98.

Wilson, L. A., "Southern Cult Images of Composite Human and Animal Figures," *American Indian Art Magazine,* vol. 11, no. 1(1985), pp. 46–57.

Wissler, C., "The Decorative Art of the Sioux Indians," *American Museum of Natural History Bulletin,* vol. 18(1904), pp. 231–277.

———, "Some Protective Designs of the Dakota," *American Museum of Natural History Anthropological Papers,* vol. 1, part 2(1907), pp. 19–54.

———, "Material Culture of the Blackfoot Indians," *American Museum of Natural History Anthropological Papers,* vol. 5, part 1(1910).

## Africa

Adams, M. J., "Kuba Embroidered Cloth," *African Arts,* vol. 12, no. 1(1978), pp. 24–39, 106–107.

———, *Designs for Living: Symbolic Communication in African Art,* Cambridge, Mass., 1982.

Bascom, W. R., *Ifa Divination; Communication Between Gods and Men in West Africa,* Bloomington, Ind., 1969a.

———, *The Yoruba of Southwestern Nigeria,* New York, 1969b.

———, *African Art in Cultural Perspective: An Introduction,* New York, 1973.

Ben-Amos, P., *The Art of Benin,* London, 1980.

Biebuyck, D. (ed.), *Tradition and Creativity in Tribal Art,* Berkeley, Calif., 1969.

Boston, J. S., *Ikenga Figures Among the Northwest Igbo and the Igala,* Lagos and London, 1977.

Bradbury, R. E., *Benin Studies,* London, 1973 (edited by P. Morton-Williams).

Brincard, M-T., *The Art of Metal in Africa,* New York, 1982.

Chaffin, A. and F., *L'Art Kota: Les Figures de reliquaire,* Mendon, 1979 (text in English and French).

Cole, H. M., *African Arts of Transformation,* Santa Barbara, Calif., 1970.

———, *Mbari: Art and Life Among the Owerri Igbo,* Bloomington, Ind., 1982.

Cole, H. M., and C. C. Aniakor, *Igbo Arts, Community and Cosmos,* Los Angeles, 1984.

Cole, H. M., and D. H. Ross, *The Arts of Ghana,* Los Angeles, 1978.

Cordwell, J. M., "The Art and Aesthetics of the Yoruba," *African Arts,* vol. 16, no. 2(1983), pp. 56–59, 93–94, 100.

Cornet, J., *Art from Zaire,* New York, 1975.

———, *Art Royal Kuba,* Milan, 1982.

Dark, P. J. C., *An Introduction to Benin Art and Technology,* Oxford, England, 1973.

————, "Benin Bronze Heads: Styles and Chronology," in McCall, D. F., and E. G. Bay (eds.), *African Images: Essays in African Iconology,* New York, 1975, pp. 25–103.

————, *An Illustrated Catalogue of Benin Art,* Boston, 1982.

Davidson, B., *African Kingdoms,* New York, 1966.

Delange, J., *The Art and Peoples of Black Africa,* New York, 1974.

De Mott, B., *Dogon Masks: A Structural Study of Form and Meaning,* Ann Arbor, Mich., 1979.

Drewel, H. J., and M. T. Drewel, *Gelede: Art and Female Power Among the Yoruba,* Bloomington, Ind., 1983.

Egharevba, J., *A Short History of Benin,* Ibadan, Nigeria, 1960.

Eyo, E., and F. Willett, *Treasures of Ancient Nigeria,* New York, 1980.

Ezra, K., *African Ivories,* New York, 1984.

————, *A Human Ideal in African Art: Bamana Figurative Sculpture,* Washington, D.C., 1986.

Fagg, W. B., *Nigerian Images,* London, 1963.

————, *African Tribal Images,* Cleveland, Ohio, 1968.

Fagg, W. B., and W. B. Forman, *Afro-Portuguese Ivories,* London, 1959.

Fagg, W. B., and J. Pemberton, *Yoruba Sculpture of West Africa,* New York, 1982.

Fernandez, J. W., "Principles of Opposition and Vitality in Fang Aesthetics," *Journal of Aesthetics and Art Criticism,* vol. 25, no. 1(1966), pp. 53–64.

————, "The Exposition and Imposition of Order: Artistic Expression in Fang Culture," in d'Azevedo, L. (ed.), *The Traditional Artist in African Society,* Bloomington, Ind., 1973, pp. 194–220.

————, *Fang Architectonics,* Philadelphia, 1977.

Fernandez, J. W. and R. L., "Fang Reliquary Art: Its Qualities and Qualities," *Cahiers d'études africaine,* vol. 60(1975), pp. 723–746.

Fraser, D. (ed.), *Village Planning in the Primitive World,* New York, 1966.

———— (ed.), *African Art as Philosophy,* New York, 1972.

————, "The Fish-legged Figure in Benin and Yoruba Art," in Fraser and Cole (1972), pp. 261–294.

Fraser, D., and H. M. Cole (eds.), *African Art and Leadership,* Madison, Wisc., 1972.

Garrard, T. F., *Akan Weights and the Gold Trade,* London, 1980.

Geary, C. M., "Bamun Two-figured Thrones: Additional Evidence," *African Arts,* vol. 16, no. 4(1983), pp. 46–53, 86–87.

————, *Things of the Palace: A Catalogue of the Bamun Palace Museum in Foumban (Cameroon),* Wiesbaden, 1983.

Gebauer, P., *Art of Cameroon,* New York, 1979.

Glaze, A. J., *Art and Death in a Senufo Village,* Bloomington, Ind., 1981.

Goldwater, R., *Bambara Sculpture from the Western Sudan,* New York, 1960.

————, *Senufo Sculpture from West Africa,* New York, 1964.

Griaule, M., *Masques dogons,* Paris, 1938.

Grunne, B. de, *Ancient Terracottas from West Africa,* Louvain-La-Neuve, Belgium, 1980.

Guillaume, P., *Sculptures nègres,* Paris, 1917.

Heyden, M. vander, "The Epa Mask and Ceremony," *African Arts,* vol. 10, no. 2(1977), pp. 14–21, 91.

Himmelheber, H., "Gold-plaited Objects of Baule Notables," in Fraser and Cole (1972), pp. 185–208.

Houlberg, M. H., "Ibeji Images of the Yoruba," *African Arts,* vol. 7, no. 1(1973), pp. 20–27, 91–92.

Imperato, P. J., *Buffoons, Queens and Wooden Horsemen: The Dyo and Gouan Societies of the Bambara of Mali,* New York, 1983.

Jones, G. I., *The Art of Eastern Nigeria,* Cambridge, England, 1984.

Lamb, V., and J. Holmes, *Nigerian Weaving,* Roxford Press, Hertingfordbury, Herts, England, 1980.

Laude, J., *The Arts of Black Africa,* Berkeley, Calif., 1971.

————, *African Art of the Dogon: The Myths of the Cliff Dwellers,* Brooklyn, N.Y., 1973.

Lawal, B., *Yoruba "Sango" Sculpture in Historical Retrospect,* Ann Arbor, Mich., University Microfilms, 1971.

————, "Ori: The Significance of the Head in Yoruba Sculpture," *Journal of Anthropological Research,* vol. 41, no. 1(1985), pp. 91–103.

Leiris, M., and J. Delange, *African Art,* New York, 1968.

Luschan, F. von, *Die Altertumer von Benin,* Berlin, 1919 (3 vols.) (1968 edition by Hacker Art Books, New York).

McLeod, M. D., *The Asante,* London, 1981.

McNaughton, P. R., "Bamana Blacksmiths," *African Arts,* vol. 12, no. 2(1979), pp. 65–71, 92.

Menzel, B., *Goldgewichte aus Ghana,* Berlin, 1968.

Morton-Williams, P., "The Yoruba Ogboni Cult in Oyo," *Africa,* 30(1966), pp. 362–374.

Northern, T., *The Sign of the Leopard: Beaded Art of Cameroon,* Storrs, Conn., 1975.

————, *The Art of Cameroon,* Washington, D.C., 1984.

Ojo, J. R. O., "Ogboni Drums," *African Arts,* vol. 6, no. 3(1973), pp. 50–52, 84.

———, "The Symbolism and Significance of Epa-type Masquerade Headpieces," *Man,* n.s. vol. 13, no. 3(1978), pp. 455–470.

Pemberton, J., III, "Eshu-Elegba: The Yoruba Trickster God," *African Arts,* vol. 9, no. 1(1975), pp. 20–27, 66–70, 90.

Perrois, L., *La Statuaire fan, Gabon,* Paris, 1972.

Pitt-Rivers, L. F., *Antique Works of Art from Benin,* London, 1900.

Rattray, R. S., *Religion and Art in Ashanti,* London, 1927.

Read, C. H., "Note on Certain Ivory Carvings from Benin," *Man,* vol. 10, no. 29(1910), pp. 49–51.

Read, C. H., and O. M. Dalton, *Antiquities from the City of Benin and from Other Parts of West Africa in the British Museum,* London, 1899.

Richter, D., "Senufo Mask Classification," *African Arts,* vol. 12, no. 3(1979), pp. 66–73, 93–94.

Roache, L. E., "Psychophysical Attributes of the Ogboni Edan," *African Arts,* vol. 4, no. 2(1971), pp. 48–53, 80.

———, "The Art of the Ifa Oracle," *African Arts,* vol. 8, no. 1(1974), pp. 20–25, 87.

Robbins, W. M., *African Art in American Collections,* New York, 1966.

Ross, D., "The Iconography of Asante Sword Ornaments," *African Arts,* vol. 11, no. 1(1977), pp. 16–25, 90–91.

Ross, D., and T. F. Garrard, *Akan Transformations: Problems in Ghanaian Art History,* Los Angeles, Museum of Cultural History, University of California, Monograph Series, No. 21, 1983.

Rudy, S., "Royal Sculpture in the Cameroon Grasslands," in Fraser and Cole (1972), pp. 123–135.

Ryder, A. F. C., *Benin and the Europeans, 1485–1897,* London, 1969.

Sarpong, P., *The Sacred Stools of the Akan,* Tema, Ghana, 1971.

Schonfeld, W. L., "Part Human, Part Divine," *Connoisseur,* vol. 209, no. 841(1982), pp. 92–93.

Shaw, T., *Igbo-Ukwu: An Account of Archaeological Discoveries in Eastern Nigeria,* Evanston, Ill., 1970 (2 vols.).

Sieber, R., "Kwahu Terracottas, Oral Traditions and Ghanaian History," in Fraser and Cole (1972), pp. 173–183.

Soderberg, B., "Ancestor Guardian Figures and Ancestral Baskets Among the Bakuta," *Ethnos,* 21(1956), pp. 105–117.

Stoll, M., and G. Stoll, *Ibeji Zwillungsfiguren der Yoruba/Twin Figures of the Yoruba,* Munich, 1980.

Tardits, C., *Le Royaume Bamoum,* Paris, 1980.

Tessmann, G., *Die Pangwe,* Berlin, 1913 (2 vols.).

Thompson, R. F., *Black Gods and Kings: Yoruba Art at U.C.L.A.,* Los Angeles, 1971.

———, "Sons of Thunder: Twin Images Among the Oyo and Other Yoruba Groups," *African Arts,* vol. 4, no. 3(1971), pp. 8–13, 77–80.

———, "Yoruba Artistic Criticism," in d'Azevedo, W. L. (ed.), *The Traditional Artist in African Societies,* Bloomington, Ind., 1973, pp. 18–61.

Vander-Heyden, M., "The Epa Mask and Ceremony," *African Arts,* vol. 10, no. 2(1977), pp. 14–21, 91.

Vansina, J., "Kuba Art and Its Cultural Context," *African Forum,* vol. 3, no. 4/vol. 4, no. 1(1968), pp. 12–27.

Vansina, J., "Ndop: Royal Statues Among the Kuba," in Fraser and Cole (1972), pp. 41–53.

———, *The Children of Woot: A History of the Kuba Peoples,* Madison, Wisc., 1978.

———, *Art History in Africa: An Introduction to Method,* London, 1984.

Vogel, S. M., "People of Wood: Baule Figure Sculpture," *Art Journal,* vol. 33, no. 1(1973), pp. 23–26.

———, *Gods of Fortune: The Cult of the Hand in Nigeria,* New York, 1974.

———, *Baule Art as an Expression of a World View,* Ann Arbor, Mich., University Microfilms, 1977.

———, "Beauty in the Eyes of the Baule: Aesthetics and Cultural Values," *Working Papers in the Traditional Arts,* Philadelphia, 6, 1980.

——— (ed.), *For Spirits and Kings: African Art from the Tishman Collection,* New York, 1981.

———, *African Aesthetics: The Carlo Monzino Collection,* Torino, Italy, 1985.

Vogel, S. M., and F. N'Diaye, *African Masterpieces from the Musée de l'Homme,* New York, 1985.

Wahlman, M., "Yoruba Pottery-making Techniques," *Baessler Archiv,* N. F., 20(1972), pp. 313–346.

Wassing, R. S., *African Art: Its Background and Traditions,* New York, 1968.

Willett, F., *Ife in the History of West African Sculpture,* London, 1967.

———, *African Art: An Introduction,* London, 1971.

Williams, D., "The Iconology of the Yoruba Edan Ogboni," *Africa,* 34(1973), pp. 139–166.

———, *Icon and Image: A Study of Sacred and Secular Forms of African Classical Art,* London, 1974.

Wittmer, M. K., "Bamum Village Masks," *African Arts,* vol. 12, no. 4(1979), pp. 58–63, 92.

Wolf, S., "Europäer-Darstellungen auf Benin-Rechteckplatten: Bemerkungen zur Ikonographie und Datierung," *Dresden Stadtlichen Museum für Völkerkunde, Abhandlungen und Berichte,* 24(1965), pp. 111–164.

Zahan, D., *Sociétés d'initiation bambara: Le N'domo, le Kore,* Paris, 1960.

———, *Antilopes du soleil: Arts et rites agraires d'Afrique noire,* Vienna, 1980.

## The South Pacific

Archey, G., "The Art Forms of Polynesia," *Auckland Institute and Museum Bulletin,* no. 4, 1965.

———, *Whaowhia Maori Art and Its Artists,* Auckland, 1977.

Austen, L., "Native Handicrafts in the Trobriand Islands," *Mankind,* vol. 3, no. 7(1945), pp. 193–198.

Baessler, A., *Neue Südsee-Bilder,* Berlin, 1900.

Balfour, H., "Bird and Human Designs from the Solomon Islands, Illustrating the Influence of One Design over Another," *Man,* vol. 5, no. 50(1905), pp. 81–83.

Barrow, T. T., *Maori Wood Sculpture of New Zealand,* Wellington, 1969.

———, *Art and Life in Polynesia,* London, 1971.

———, *The Art of Tahiti and the Neighboring Society, Austral and Cook Islands,* London, 1979.

Bateson, G., "Further Notes on a Snake Dance of the Baining," *Oceania,* vol. 2(1931/1932), pp. 334–341.

———, *Naven,* Cambridge, England, 1936.

Beaglehole, J. C. (ed.), *The Endeavor: Journal of Joseph Banks, 1768–1771,* Sydney, 1962 (2 vols.).

Beier, U., "Aesthetic Concepts in the Trobriand Islands," *Gigibori,* 1(1974), pp. 38–39.

Beier, U., "Haus Tambarans in Maprik: Revival or Tourist Attraction," *Gigibori,* 3(1976), pp. 20–30.

Bellwood, P., *Man's Conquest of the Pacific,* London, 1977.

———, *The Polynesians: Prehistory of an Island People,* London, 1978.

Berndt, R. M., "A Comment on Dr. Leach's 'Trobriand Medusa,'" *Man,* vol. 58, no. 65(1958), pp. 65–66.

Berndt, R. M., and C. H. Berndt, "Sacred Figures of Ancestral Beings of Arnhem Land," *Oceania,* 18(1948), pp. 309–326.

———, *Arnhem Land: Its History and Its People,* Melbourne, 1954.

Berndt, R. M. (ed.), et al., *Australian Aboriginal Art,* New York, 1964.

Billings, D. K., "Malanggan and Memai in New Ireland," *Oceania,* 38(1967/1968), pp. 24–32.

Bodrogi, T., "Ein Beitrage zur Kunst der Gunantuna," *Acta Ethnographica,* vol. 8, nos. 3/4(1959), pp. 345–348.

———, "Malangans in North New Ireland," *Acta Ethnographica,* vol. 16, nos. 1/2(1967), pp. 61–77.

Buck, P. H., "The Feather Cloak of Tahiti," *Journal of the Polynesian Society,* 52(1943), pp. 12–15.

———, *Arts and Crafts of Hawaii,* Bernice P. Bishop Museum, Honolulu, Special Publication, no. 45, 1957.

Charleux, M., "Une Grotte funéraire sur l'ile Moorea," *Journal de la Société des Océanistes,* 36(1980), pp. 128–132.

Clark, P., *Engini (Firedance),* Rabaul, Papua New Guinea, 1976.

Churchill, W. "The Duk-Duk Ceremonies," *Popular Science Monthly,* vol. 38(1890), pp. 236–246.

Corbin, G. A., "A Brief Note on a Tolai Mask Called Alor," *Pacific Art Newsletter,* no. 3 (June 1976), pp. 17–20.

———, *The Art of the Baining of New Britain,* Ann Arbor, Michigan, University Microfilms, 1976 (doctoral dissertation, Columbia University, 1976).

———, "The Art of the Baining: New Britain" and "Bibliography," in S. M. Mead (ed.), *Exploring the Visual Art of Oceania,* Honolulu, 1979.

———, "The Primitive World," *Encyclopedia of World Art: Supplement,* 16(1983), pp. 9–25.

———, *Salvage Art History Among the Sulka of Wide Bay, East New Britain, Papua New Guinea,* in press.

———, "The Central Baining revisited: 'Salvage' Art History Among the Kairak and Uramot Baining of East New Britain, Papua New Guinea," *Res,* 7/8(1984), pp. 44–69.

Corney, B. G. (ed.), *The Quest and Occupation of Tahiti by Emissaries of Spain During the Years 1772–1776,* London, 1913–1919 (3 vols.).

Cowan, J., and Sir M. Pomare, *Legends of the Maori,* Wellington, 1930–1934, 2 vols.

Cox, J. H., and W. H. Davenport, *Hawaiian Sculpture,* Honolulu, 1974.

Cox, J. H., and E. Stasack, *Hawaiian Petroglyphs,* Honolulu, 1970.

Damm, H., "Bemerkungen zu den Schadelmasken aus Neu-britannien (Südsee)," *Jahrbuch des Museum für Völkerkunde zu Leipzig,* 26(1969), pp. 85–116.

Danks, B., "Burial Customs of New Britain," *Journal of*

*the Anthropological Institute,* vol. 21, 4(1892), pp. 348–356.

Dinerman, I. R., "Iatmul Art as Iconography (New Guinea)," *Anthropos,* 76(1981), pp. 807–824.

Dodge, E. S., *The Marquesas Islands Collection in the Peabody Museum of Salem,* Salem, Massachusetts, 1939.

Duff, R. (ed.), *No Sort of Iron: Cook Bicentenary Exhibition Souvenir Handbook,* Christchurch, New Zealand, 1969.

Edge-Partington, J., "Decorated Shields from the Solomon Islands," *Man,* 6(1906), pp. 129–130.

Edge-Partington, J., and T. A. Joyce, "Note on Funerary Ornaments from Rubiana and a Coffin from Santa Anna, Solomon Islands," *Man,* vol. 4, no. 86(1904), pp. 129–131.

Emst, P. Van, "Seven Ceremonial Canoes," *I.A.E.,* XVIII (1957), pp. 63–66.

Errington, F., *Karavar: Masks and Power in a Melanesian Ritual,* Ithaca, N.Y., 1974.

Forge, A., "Paint—A Magical Substance," *Palette,* 9(1962), pp. 9–16.

———, "The Abelam Artist," in M. Freedman (ed.), *Social Organization: Essays Presented to Raymond Firth,* London and Chicago, 1967.

———, "Art and Environment in the Sepik," *Proceedings of the Royal Anthropological Institute for 1965,* 1966, pp. 23–31.

——— (ed.), *Primitive Art and Society,* London and New York, 1973.

———, "Style and Meaning in Sepik Art," in Forge (ed.), 1973.

Forster, J. G. A., *A Voyage Around the World in His Britannic Majesty's Sloop Resolution, Commanded by Captain James Cook, During the Years 1772, 3, 4, and 5 . . . ,* London, 1777 (2 vols.).

Fox, A., *Prehistoric Maori Fortifications in the North Island of New Zealand,* Monograph no. 6 of the New Zealand Archaeological Association, Auckland, 1976.

———, *Carved Maori Burial Chests: A Commentary and a Catalogue,* Auckland, 1983.

Gathercole, P., A. L. Kaeppler, and D. Newton, *The Art of the Pacific Islands,* Washington, D.C., 1979.

Gerbrands, A. A., *Wow-Ipits: Eight Asmat Woodcarvers of New Guinea,* The Hague, 1967.

Goodale, J. C., "The Tiwi Dance for the Dead," *Expedition,* vol. 2, no. 1(1959), pp. 3–13.

Groves, W. C., "Shark Fishing in New Ireland," *Mankind,* vol. 2, no. 1(1936), pp. 2–6.

Guiart, J., *The Arts of the South Pacific,* New York, 1963.

Guppy, H. B., *The Solomon Islands and Their Natives,* London, 1887.

Haddon, A. C., and J. Hornell, *The Canoes of Oceania,* Honolulu, 3 vols., 1936–1938 (1975 reprint in a single volume).

Hall, H. U., "New Ireland Masks," *University Museum Journal,* 10(1919), pp. 184–187.

———, "Malagan of New Ireland," *University Museum Bulletin,* vol. 5, no. 4(1935), pp. 2–11.

Handy, W. C., "Tattooing in the Marquesas," *Bernice P. Bishop Museum Bulletin,* 1(1922).

———, "Handicrafts of the Society Islands," *Bernice P. Bishop Museum Bulletin,* 42(1927).

Hauser-Schaublin, B., "Mai-Masken der Iatmul, Papua New Guinea: Stil, Schnitzvorgang, Auftritt und Funktion," *Verhandlungen der Naturforschenden Gesellschaft in Basel,* 87/88(1978), pp. 119–145.

Helfrich, K., *Malanggan 1: Bildwerke von Neuirland,* Berlin, 1973.

Henry, T., "Ancient Tahiti," *Bernice P. Bishop Museum Bulletin,* 48(1928).

Holden, G., "Kanganaman Haus Tambaran," *Gigibori,* vol. 2, no. 2(1975), pp. 47–58.

Hoogerbrugge, J., *Irian Jaya: The Art of Woodcarving in Irian Jaya,* Jayapura, 1977.

Hugel, A. von, "Decorated Shields from the Solomon Islands," *Man,* vol. 6, nos. 21 and 33(1906), p. 33.

Jelinek, J., "Mimi, or the Archaic Art of Arnhem Land," *Archaeology and Physical Anthropology in Oceania,* vol. 13, nos. 2/3(1978), pp. 229–233.

Joyce, T. A., "Forehead Ornaments from the Solomon Islands," *Man,* vol. 35, no. 108(1935), pp. 97–100.

Kaberry, P. M., "The Abelam Tribe, Sepik District, New Guinea," *Oceania,* 11(1940/1941), pp. 233–258, 343–367.

Kaeppler, A. L., *Artificial Curiosities: An Exposition of Native Manufacturers Collected on the Three Pacific Voyages of Captain James Cook,* Bernice P. Bishop Museum, Honolulu, Special Publication, no. 65, 1978.

Kaeppler, A. L., "Genealogy and Disrespect: A Study of Symbolism in Hawaiian Images," *Res,* 3(1982), pp. 82–107.

Kelm, H., *Kunst vom Sepik,* Berlin, 1966–1968 (3 vols.).

Koch, G., *Kultur der Abelam, Die Berliner Maprik-Sammlung,* Berlin, 1968.

———, *Iniet: Geister in Stein, Die Berliner Iniet-Figuren Sammlung,* Berlin, 1982.

Konrad, G., "On the Phallic Display in the Asmat," *An Asmat Sketch Book,* no. 6, 1978, pp. 86–93.

Konrad, G., U. Konrad, and T. Schneebaum, *Asmat Leben mit den Ahnen,* Glashutten, 1981.

Kooijman, S., "Tapa in Polynesia," *Bernice P. Bishop Museum Bulletin,* 234(1972).

Kroll, H., "Der Iniet. Das Wesen eines Melanesischen Geheimbundes," *Zeitschrift für Ethnologie,* 69(1937), pp. 180–219.

Kuruwaip, A., "The Asmat bis Pole: Its Background and Meaning," *Irian,* vol. 3, no. 2(1974), pp. 32–78.

Laufer, C., "Notizin zur materiellen Kultur der Sulka," *Acta Ethnographica,* 11(1962), pp. 447–455.

Leach, E., "A Trobriand Medusa," *Man,* vol. 54, no. 158(1954), pp. 103–105.

———, "A Trobriand Medusa? A Reply to Dr. Berndt," *Man,* vol. 58, no. 90(1958), p. 179.

Leach, E., and J. Leach (eds.), *The Kula: New Perspectives on Massim Exchange,* Cambridge, England, 1982.

Lewis, A. B., "Sulka Masks," *Field Museum News,* vol. 5, no. 4(1934), p. 2.

Lewis, P. H., "Changing Memorial Ceremonial in Northern New Ireland," *Journal of the Polynesian Society,* 82(1973), pp. 141–153.

———, "Art in Changing New Ireland," in S. M. Mead (ed.) (1979), pp. 378–391.

Linton, R., "The Material Culture of the Marquesas Islands," *Bernice P. Bishop Museum Memoirs,* Honolulu, vol. 8, no. 5(1923).

———, "Archaeology of the Marquesas Islands," *Bernice P. Bishop Museum Bulletin,* Honolulu, 23(1925).

Linton, R., and P. S. Wingert, *Arts of the South Seas,* New York, 1946.

Lomas, P., "Malanggans and Manipulators: Land and Politics in Northern New Ireland," *Oceania,* vol. 50, no. 1(1979), pp. 53–66.

Losch, D., *The Abelam, A People of Papua New Guinea,* Sydney, 1982.

Luschan, F. v., "Shield aus New-Britannien," *Zeitschrift für Ethnologie,* 32(1900), p. 496.

Malinowski, B., "Kula: The Circulating Exchange of Valuables in the Archipelagoes of Eastern New Guinea," *Man,* vol. 20, no. 51(1920), pp. 97–105.

———, "War and Weapons Among the Natives of the Trobriand Islands," *Man,* vol. 20, no. 5(1920), pp. 10–12.

———, *Argonauts of the Western Pacific,* London, 1922.

———, *Coral Gardens and Their Magic,* New York, 1935.

Maynard, L., "The Archaeology of Australian Aboriginal Art," in S. M. Mead (ed.) (1979), pp. 83–110.

McCarthy, F. D., "The Art of Malangan in New Ireland," *Australian Museum Magazine,* 8(1945), pp. 397–403.

———, *Australian Aboriginal Rock Art,* Sydney, 1958.

McEwen, J. M., "Maori Art," in *An Encyclopaedia of New Zealand,* Wellington, 1966.

Mead, M., "Tamberans and Tumbuans in New Guinea," *Natural History,* vol. 34, no. 3(1934), pp. 234–246.

Mead, S. M. (ed.), *Exploring the Visual Art of Oceania,* Honolulu, 1979.

Mead, S. M. (ed.), et al., *Te Maori: Maori Art from New Zealand,* New York, 1984.

Meier, J., "Steinbilder des Iniet-Geheimbundes bei den Eingebornen des nordöstlichen Teiles der Gazelle-Habinsel, Neupommern (Südsee), *Anthropos,* 6(1911), pp. 837–867.

Meyer, P. O., "Die Schiffahrt bei den Bewohnern von Vuatom (NeuPommern, Südsee)," *Baessler-Archiv,* 1(1911), pp. 255–268.

Mountford, C. P., *Records of the American-Australian Scientific Expedition to Arnhem Land, Vol. 1: Art, Myth and Symbolism,* Carlton, Australia, 1948.

———, "Expedition to the Land of the Tiwi," *National Geographic Magazine,* 109(1956), pp. 417–440.

———, *The Tiwi: Their Art, Myth & Ceremony,* London, 1958.

———, "The Artist and His Art in an Australian Aboriginal Society," in M. W. Smith (ed.), *The Artist in Tribal Society,* London, 1961.

Narubutal, Chief, "Trobriand Canoe Prows: Fourteen Pieces from the National Collection in the Papua New Guinea Museum," *Gigibori,* vol. 2, no. 1(1975), pp. 1–14.

Newton, D., *Massim: Art of the Massim Area, New Guinea,* New York, 1975.

Oliver, D. L., *Ancient Tahitian Society,* Honolulu, 1974.

Peter, H., "Haifanggerate aus Neuirland auf einer Abbildung in Abel Janszoon Tasmans Journal, 1643," *Wiener Ethnohistorische Blätter,* 23(1982), pp. 3–23.

Powdermaker, H., "Mortuary Rites in New Ireland," *Oceania,* 2(1931/1932), pp. 26–43.

———, *Life in Lesu: The Study of a Melanesian Society in New Ireland,* London, 1933.

Powell, W., *Wanderings in a Wild Country,* London, 1883.

Poole, Mrs. J. W., "Still Further Notes on a Snake Dance of the Baining," *Oceania,* 13(1943), pp. 224–227.

Powell, W., *Wanderings in a Wild Country,* London, 1883.

Read, W. J., "A Snake Dance of the Baining," *Oceania,* 2(1931/1932), pp. 232–244.

Rivers, W. H. R., "Maori Burial Chests," *Man,* vol. 18, no. 58(1918), p. 97.

Rockefeller, M. C., and A. A. Gerbrands (ed. and intro.), *The Asmat of New Guinea,* New York, 1967.

Rose, R., "Symbols of Sovereignty: Feather Girdles of Tahiti and Hawaii," *Pacific Anthropological Records,* vol. 28, no. 8, Bernice P. Bishop Museum, Honolulu.

Schmitz, C., *Oceanic Art, Myth, Man, and Image in the South Seas,* New York, 1971.

Schneebaum, T., *Asmat Images from the Collection of the Asmat Museum of Culture and Progress,* Keuskupan Agats, Irian Jaya, 1985.

Schuster, C. J., "Kapkaps with Human Figures from the Solomon Islands," *Acta Ethnographica,* 13(1964), pp. 213–279.

Scoditti, G. M. C., "A Kula Prowboard: An Iconological Interpretation," *L'Uomo,* vol. 1, no. 2(1977), pp. 199–232.

Seligman, C. G., *Melanesians of British New Guinea,* Cambridge, England, 1910.

Seligman, C. G., and T. E. Dickson, " 'Rajim' and 'Tabuya' of the D'Entrecasteaux Group," *Man,* vol. 46, no. 112(1946), pp. 129–134.

Simmons, D. R., "Moko," in S. M. Mead and B. Kernot (eds.), *Art and Artists of Oceania,* Palmerston North, New Zealand, 1983.

Skinner, H. D., "Maori Burial Chests," *Man,* vol. 18, no. 59(1918), pp. 97–98.

Spencer, B., *Native Tribes of the Northern Territory of Australia,* London, 1914.

Spiegel, H., "Soul-boats in Melanesia: A Study in Diffusion," *Archaeology and Physical Anthropology in Oceania,* vol. 6, no. 1(1971), pp. 34–43.

——, "Some Aspects of New Ireland Malanggan Carvings," *Archaeology and Physical Anthropology in Oceania,* vol. 8, no. 2(1973), pp. 134–161.

——, "The Chalk Figures of Southern New Ireland and the Gazelle Peninsula and Their Relationship to Other South Pacific Areas," in J. M. Cordwell (ed.), *The Visual Arts, Plastic and Graphic,* The Hague, 1979.

Stephan, E., and F. Graebner, *Neu-Mecklenburg (Bismarck-Archipel): Die Küste von Umuddu bis Kap St. George,* Berlin, 1907.

de Tolna, F. R., *Vers L'Ecueil de Mimcon après Huit ans dans l'Ocean Pacific et Indien,* Paris and Vienna, 1904.

Teilhet, J. (ed.), *Dimensions of Polynesia,* San Diego, 1973.

Tindale, N. B., "A Trobriand Medusa?" *Man,* 59(1959), pp. 49–50.

Tuzin, D. F., "Yam Symbolism in the Sepik: An Interpretative Account," *Southwestern Journal of Anthropology,* vol. 28, no. 3(1972), pp. 230–254.

Waite, D. B., "Aspects of Style and Symbolism in the Art of the Solomon Islands," in S. M. Mead (ed.) (1979), pp. 238–264.

——, "Shell-inlaid Shields from the Solomon Islands," in S. M. Mead and B. Kernot (eds.) (1983), pp. 114–136.

Wardwell, A., *The Sculpture of Polynesia,* Chicago, 1967.

Webster, H. C., *Through New Guinea and the Cannibal Countries,* London, 1898.

White, J. P., and J. F. O'Connell, *A Prehistory of Australia, New Guinea and Sahul,* New York, 1982.

Wirz, P., "La Signification du serpent et de l'oiseau sur le territoire du Sepik," *Bulletin des Musées Royaux d'Art et d'Histoire,* 27(1955), pp. 63–76.

Woodford, C. M., "Further Note on Funerary Ornaments from the Solomon Islands," *Man,* vol. 5, no. 20(1905), pp. 38–39.

——, "The Canoes of the British Solomon Islands," *Journal of the Royal Anthropological Institute,* 39(1909), pp. 306–316.

# Index